SHAPING AN AMERICAN LANDSCAPE

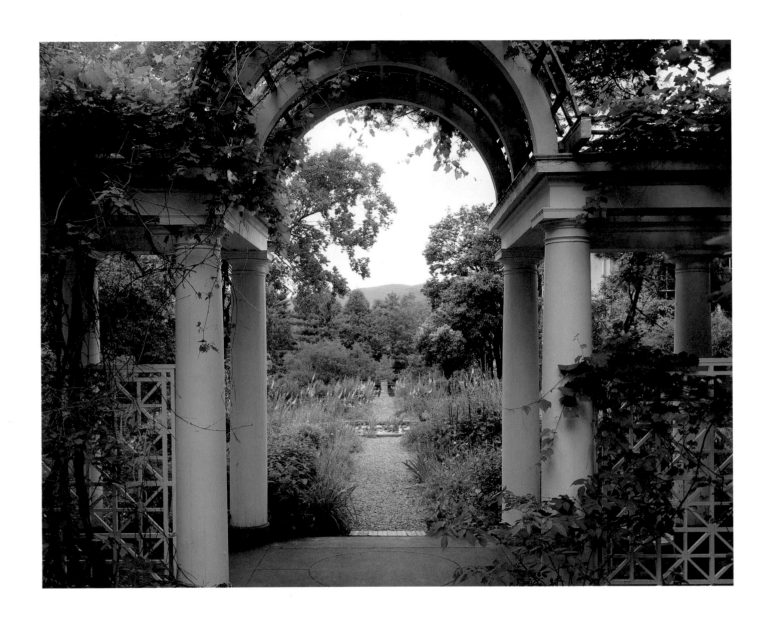

SHAPING AN AMERICAN LANDSCAPE

LANDSCAPE

The Art and Architecture of Charles A. Platt

Keith N. Morgan

with essays by

REBECCA WARREN DAVIDSON · DEBORAH S. GARDNER

ERICA E. HIRSHLER · MAUREEN C. O'BRIEN

Hood Museum of Art, Dartmouth College

University Press of New England, Hanover and London

Co-published and distributed by University Press
of New England, Hanover, NH 03755

This exhibition was organized by the Hood
Museum of Art, Dartmouth College. The exhibi-
tion and catalogue have been supported in part
by a grant from the National Endowment for
the Arts, a federal agency. This catalogue has
been published with the assistance of the Getty
Grant Program. Additional support has been
provided by the Ray Winfield Smith 1918 Fund,
the Marie-Louise and Samuel R. Rosenthal
Fund, and the William B. and Evelyn A. J. Hall
Fund.

EXHIBITION SCHEDULE:

Hood Museum of Art
Dartmouth College
Hanover, New Hampshire 03755-3553

March 25–May 28, 1995

The Octagon
The Museum of The American Architectural
Foundation
1799 New York Avenue, NW
Washington, D.C. 20006-5292

June 19–September 19, 1995

The William Benton Museum of Art
University of Connecticut
145 Glenbrook Road U-140
Storrs, Connecticut 06268-2140

October 31–December 22, 1995

Library of Congress Cataloging-in-Publication
Data

Morgan, Keith N.
 Shaping an American landscape : the art
and architecture of Charles A. Platt / Keith N.
Morgan ; with essays by Rebecca Warren David-
son . . . [et al.].
 p. cm.
Catalog of exhibition held in 1995 at the Hood
Museum of Art, the Octagon, and the William
Benton Museum of Art.
 Includes bibliographical references and index.
 ISBN 0–87451–704–4 (cl).
 ISBN 0–87451–705–2 (pa)
 1. Platt, Charles A. (Charles Adams),
1861–1933—Exhibitions. I. Platt, Charles A.
(Charles Adams), 1861–1933. II. Davidson,
Rebecca Warren. III. Hood Museum of Art.
IV. Octagon (Washington, D.C.) V. William
Benton Museum of Art. VI. Title.
N6537.P535A4 1995
709'.2—dc20 94–31831

Cover illustration: *Larkspur (Garden at High
Court, Cornish)*, 1895 (cat. no. 42)

Frontispiece: View from the pergola, Dingleton
House, the Augusta and Emily Slade residence,
Cornish, New Hampshire, designed 1904–5.

To the Charles A. Platt family,

who have been faithful guardians

of his artistic legacy.

CONTENTS

LENDERS TO THE EXHIBITION

Addison Gallery of American Art, Phillips Academy, Andover, Massachusetts

Avery Architectural and Fine Arts Library, Columbia University

The Century Association

Richard Cheek

Sterling and Francine Clark Art Institute

Jeffrey W. Cooley, The Cooley Gallery, Inc., Old Lyme, Connecticut

The Corcoran Gallery of Art

The Hartford Steam Boiler Inspection and Insurance Company

Hirschl & Adler Galleries, New York

Hood Museum of Art, Dartmouth College

The Montclair Art Museum

Museum of Fine Arts, Boston

National Academy of Design

National Park Service, Frederick Law Olmsted National Historic Site

The New York Public Library

The Parrish Art Museum, Southampton, New York

Members of the Platt Family

Spanierman Gallery, New York

St. Botolph Club, Boston

Heirs of Lawrence Hoe Taylor and Edith Howard Taylor

Mr. Graham Williford

Anonymous Private Collectors

PREFACE

⊷⊜⊶

Etcher, painter, landscape designer, architect: the long and highly successful career of Charles A. Platt encompassed all of these disciplines, and in each one he was recognized as a leader by his contemporaries. In spite of the great esteem in which he was held during his lifetime, Platt's oeuvre has never been examined in its entirety. Perhaps this is precisely because his accomplishments were so varied at a time when artistic practice was becoming increasingly specialized.

The extraordinary range of Platt's work is, however, critical to our understanding of the nature of his achievement. As the contributors to this catalogue argue, it is all of a piece, bound together by a distinctive aesthetic that sought to reconcile the legacy of the past—particularly the still-vital stylistic traditions of the Renaissance—with the multifarious demands of modern life, and by a deep understanding of and respect for the landscape.

Had he wished to do so, there is no doubt that Platt would have continued to prosper as a painter or etcher, the fields in which he first gained widespread recognition. Yet it is not surprising that he eventually turned to landscape design and architecture. In this work he was able to give broader scope to his many talents and, more importantly, to bring these together in the development of works of art that would give order to and enrich the lives of those who experienced them. For Platt, the fundamental purpose of architecture and landscape design was, to borrow a phrase of Geoffrey Scott's, the creation of "a humanised pattern of the world, a scheme of forms on which our life reflects its clarified image."

Because Platt was a prominent member of the large group of artists known as the Cornish colony and several of his earliest houses and gardens were designed for friends and neighbors in Cornish, New Hampshire, it is fitting that the Hood Museum of Art undertake this study of his career. In addition to providing us with a broader understanding of the many ways in which he contributed to the development of the rich artistic legacy of the region, this catalogue and the exhibition it accompanies also offer important insights into the complex set of factors that informed Platt's work and, to a certain extent, determined the course of his career.

*

I am grateful to have this opportunity to recognize and to thank all those who have helped us with this project. Our greatest debt of gratitude is owed to Barbara MacAdam, the museum's curator of American Art, who first proposed the exhibition and has coordinated every aspect of its development. Without her intimate knowledge of the subject, her considerable organizational skills and keen eye for detail, and, most importantly, her patience, an undertaking of this complexity and scale would simply not have been possible. Many other members of the staff gave countless hours of their time to the successful realization of the exhibition and catalogue. Our registrar, Kellen Haak, and his staff handled, with their usual efficiency and skill, the myriad details of packing and shipping the works of art presented in the exhibition. Credit for the elegant installation is due the museum's curator of exhibitions, Evelyn

Marcus, and her assistants, Nicolas Nobili and Cristina Pellechio. The development of the various programs presented in conjunction with the exhibition was overseen by our associate director, Suzanne Gandell; our curator of education, Lesley Wellman, and her staff; and our curator of academic programming, Katherine Hart. Through their collaborative efforts we have been able to work closely with students and faculty and to reach out in various ways to public audiences throughout the region.

I would also like to thank Andrew Garthwaite of Randall T. Mudge & Associates, whose assistance with the design of several important architectural features was invaluable, and Melissa Stroud, curatorial assistant, who compiled the chronology for this catalogue and helped Ms. MacAdam with the preparation of the manuscript and loan requests. We are also grateful for the help of Meredith Timbers and Alfred Patetta, both members of the Dartmouth College Class of 1994, and Mina Kim, Dartmouth College Class of 1996. Barbara Reed, librarian of the Sherman Art Library, and her staff were, as always, extremely helpful in locating reference materials for this project.

Special acknowledgment should be made of the generous financial assistance from the National Endowment for the Arts, which awarded the museum a grant for the implementation of this project, and to the Getty Grant Program. Presentation of the exhibition at the Hood Museum of Art has been made possible through the support of the Ray Winfield Smith 1918 Fund, The Marie-Louise and Samuel R. Rosenthal Fund, and the William B. and Evelyn A. J. Hall Fund.

We are grateful to the members of the Platt family, who have responded with great generosity to the requests of our guest curator, Keith Morgan, for information and the loan of objects to the exhibition. The Platt Family Trust, which has ensured the careful preservation of the Platt House in Cornish and its contents, has also graciously assisted Professor Morgan in his efforts. At an earlier stage in his research he benefited greatly from the memories and advice shared by William Platt, Margaret Platt, and Geoffrey Platt.

At Gwinn, the Mather estate outside of Cleveland, Lucy Ireland Weller, the director, and William Tapley, the grounds superintendent, were quick to respond to Professor Morgan's requests for information and assistance. Robin Karson, author of a forthcoming study of Gwinn, kindly read and criticized the early drafts of the essay about Gwinn in this catalogue. We are also indebted to Patricia Maus of the Northeast Minnesota Historical Department for her assistance in identifying the location and possible construction date for the James Duane Ireland House in Duluth, Minnesota, and to Jeffrey Brown, Dartmouth College Class of 1961, for generously sharing his research on Platt and assisting us with the identification of paintings for the exhibition.

It has been a pleasure to work closely with the staffs of the two institutions to which this exhibition will travel: the Octagon, in Washington, D.C., and the William Benton Museum of Art in Storrs, Connecticut. I am especially grateful to the directors of these institutions, Nancy Davis and Paul Rovetti, for their interest in and support of this project.

The production of this catalogue has enabled us to work once again with the University Press of New England. We were delighted to have an opportunity to do so, and have benefited enormously from the guidance of Thomas L. McFarland, director, and Thomas M. Johnson, associate director. We are also grateful to Mike Burton, assistant director for design and production, for the elegant design of this book, and to managing editor Mary Crittendon, whose diligent supervision of this project has been critical to its success.

Without the generosity of those individuals and institutions who agreed to lend significant works by Platt from their collections, this exhibition would simply not have been possible. In addition to expressing our heartfelt thanks for their support, I would like to acknowledge the kind assistance of the staff

of the Avery Architectural and Fine Arts Library at Columbia University, especially Janet Parks, curator of the drawing collection, and her assistant Dan Kary; Julia van Haaften, curator of photography at the New York Public Library; Penny Jencks; Jock Reynolds, Susan Faxon, and Denise Johnson of the Addison Gallery of American Art, Phillips Academy, Andover, Massachusetts; and the Art Committee of the Century Association.

We are also grateful to the scholars who have contributed essays to this catalogue and have also been involved in many different ways in the development of the exhibition. Their enthusiasm for this undertaking and their willingness to share information and ideas resulted in a process that was truly collaborative and a balanced survey of Platt's career that represents a significant contribution to our understanding of American art.

Finally, I would like to express our deepest thanks to Professor Keith Morgan, who made time in an already busy schedule to serve as guest curator for this exhibition. It has been a great pleasure to work closely with him on this project over the past several years, and we are grateful for all that he has helped us to accomplish.

TIMOTHY RUB

Director

Hood Museum of Art

SHAPING AN AMERICAN LANDSCAPE

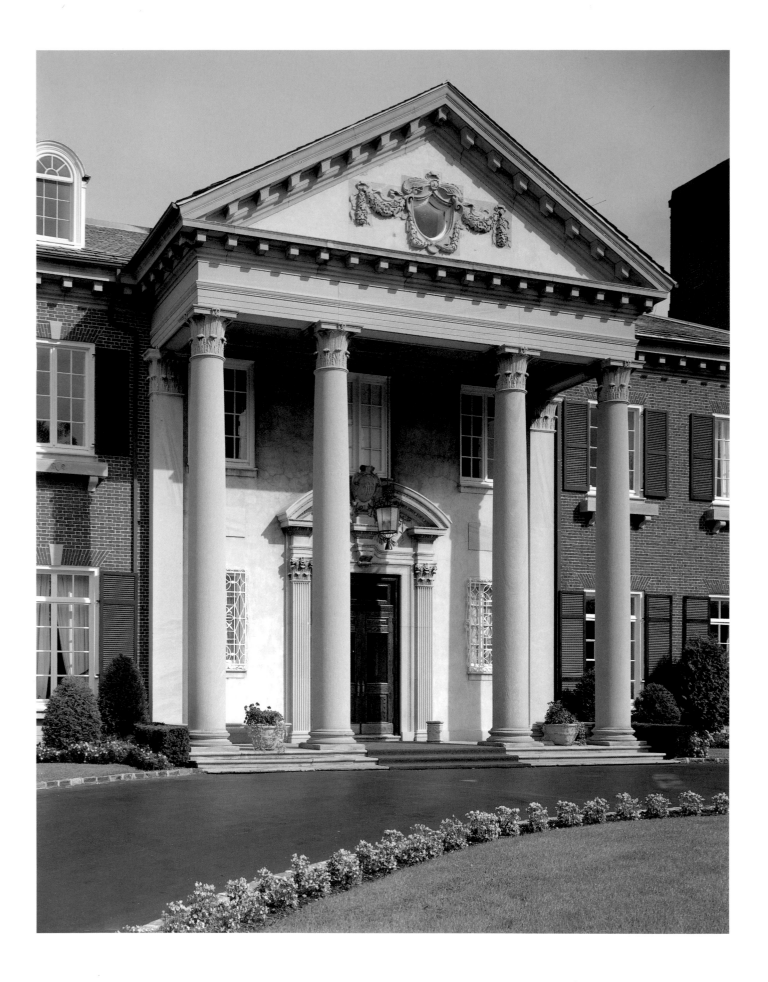

Charles A. Platt and the Promise
of American Art

KEITH N. MORGAN

DURING A CAREER that spanned more than five decades, Charles Adams Platt (1861–1933) achieved national recognition in etching, painting, landscape architecture, and architecture and made important contributions to the American arts in each phase of his work. Furthermore, Platt came to dominate his times in the fields of domestic architecture and landscape design, particularly with the country houses he designed from 1890 through 1915. Widely published in this country, his work was also discussed in the international architectural press, being favorably compared with that of the celebrated English architect Sir Edwin Lutyens.[1] The *Monograph of the Work of Charles A. Platt*, published in 1913, was not only the first commercially produced monograph on a contemporary American architect but was considered by many designers to be "the bible" for the best in modern work.[2] More recently, with the advent of post-modernism and the renewed interest in a classical tradition, Platt has returned to favor as an inspiration for the work of many contemporary architects and landscape architects. Although his significance as a domestic architect and landscape designer is generally acknowledged today, his production as an etcher and painter remains relatively unstudied and was more influential than is currently understood.[3] A critical examination of Platt's career can also help us understand the central role he and other artists played in shaping American cultural identity at the turn of the century and in producing a new American landscape—both a physical landscape in two and three dimensions and an intellectual landscape.

*

Charles A. Platt (fig. 1.2) was born on October 16, 1861, into an environment of intellectual and artistic sophistication that allowed him to nurture his several talents.[4] His father, John Platt, was a corporate lawyer who provided a comfortable standard of living for his family in New York City.[5] A founding member of the Century Association, the pre-eminent club for "gentlemen engaged or interested in letters and the fine arts," John Platt connected his family to the world of New York's leading artists and writers.[6] Mary Cheney Platt, Charles's mother, was a member of the important silk mill-owning family from Manchester, Connecticut.[7] Two of her uncles, John and Seth Wells Cheney, pursued artistic training in Europe and had successful careers in painting, crayon portraiture, and engraving, providing young Charles with family role models for his aspirations to become an artist.

Like most members of his generation in

FIG. 1.1
Entrance portico, The Manor House, the John T. Pratt residence, Glen Cove, New York, designed 1909–11.

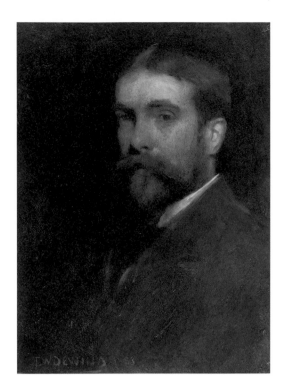

New York, Platt began his artistic training at the National Academy of Design, enrolling in the Antique School in 1878 and adding life drawing classes the following year.[8] To study painting, he supplemented this traditional education with membership in the Art Students League, where he came under the influence of Walter Shirlaw and William Merritt Chase.[9] More important than his academic training in New York was the friendship he began in 1879 with the Philadelphia painter and printmaker Stephen Parrish, whom he met while on summer vacation at Bolton Landing, New York. Parrish urged Platt to explore the newly revived art of etching. Platt produced his first plate in 1880 after spending a second summer vacation with the Parrish family at Gloucester, Massachusetts. Rapidly winning the nickname of the boy etcher, Platt became the youngest member of the recently established New York Etching Club, the key organization for the etching revival in the United States, and quickly rose to a position of influence and financial success.

In his etched work, Platt typically depicted the landscape, often choosing coastal or marine subjects wherein he explored the effects of atmosphere and light on water (see fig. 2.26). Like other members of the etching revival, which was then at its height, he was determined to make etching a fine art—something "suggestive rather than elaborated."[10] His approach to the medium was informed most significantly by the sketchy understatement typical of the mature etchings of the American expatriate artist James McNeill Whistler and by the exacting technical control found in the prints of the English artist Seymour Haden, whom Platt met on his first visit to England in 1882. Platt's rapid mastery of this medium is indicative of his precocious entry into new fields of artistic expression without the benefit of academic training.

Although Platt created some of his finest etchings during the 1880s, by the early years of that decade he had begun to focus primarily on painting. Feeling that he had exhausted the educational resources of New York City, he decided to go to Paris in 1882 for a five-year sojourn.[11] Platt worked independently during his first two years there, spending the summers in Normandy or in Holland, where he came under the influence of Jacob Maris and the Dutch School of landscape painting. Like these artists, he favored harbor scenes and gentle rural landscapes, rendering them in restricted, subdued tonalities. Throughout this period his work in oil and etching were interrelated; identical subjects appear in both media, although the paintings place a greater emphasis on atmospheric effects. In 1884, he joined the Académie Julian, studying the figure under the supervision of Jules Joseph Lefebvre. The circle of friends that he formed in Paris included fellow Americans Kenneth Cranford, Henry Oliver Walker, Willard Metcalf, Kenyon Cox, Will Low, and Dennis Miller Bunker, as well as expatriate artists such as Frank Myers Boggs. He had only modest success with his painting submissions to the annual Salons, where his painting of *The Etcher* (see fig. 3.16), the fruit of his close study of the figure at Julian's, was hung on the line in 1885. He

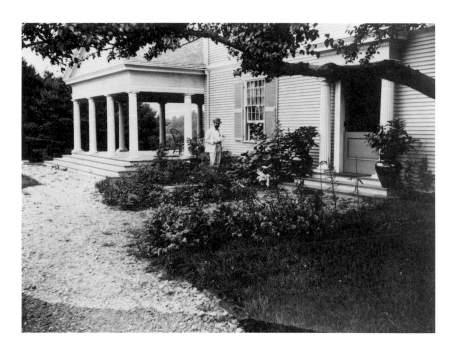

did, however, exhibit etchings at the Salon every year that he was in Paris.

While in Europe, he met Annie C. Hoe, a fellow New Yorker whom he married in Florence on April 10, 1886, while recovering from a bout of "Roman fever."[12] Annie's father, Colonel Richard March Hoe, was a manufacturer of printing presses, and the family lived on an estate in the Bronx. The Hoes traveled extensively in Europe, spending the years of the Civil War in Paris. The newlyweds' happiness was short-lived, however, for both of their fathers died in the summer of 1886, events that brought them back to New York until October. Yet another tragedy followed when Annie Platt died in Paris on March 18, 1887, losing twin girls in childbirth. Platt returned to New York but only slowly regained his momentum as an artist.

Important to Platt's recovery from these tragedies and to the continued refinement of his ideas on art was his decision to join his Paris colleague, H. O. Walker, at Cornish, New Hampshire, in the summer of 1889. There Platt joined a summer colony of artists, writers, and other professionals who had been attracted to the New Hampshire hills

by the sculptor Augustus Saint-Gaudens.[13] Among the members of the colony were the painters Thomas Wilmer Dewing and Maria Oakey Dewing; Platt's etcher teacher, Stephen Parrish, and his son, Maxfield; the muralist Kenyon Cox; and sculptors Daniel Chester French and Herbert Adams, as well as Saint-Gaudens. Cornish would be Platt's summer residence for almost every year until his death. After suggesting the design for Walker's house in 1889, Platt purchased land near Walker the following summer and designed a simple house and studio for himself (fig. 1.3).[14] He later expanded this house and garden as both his needs and his resources increased (fig. 1.4). Cornish revived Platt's life as a painter as well. He continued to exhibit regularly with the Society of American Artists, the National Academy of Design, and the New York Etching Club, ultimately winning the Webb prize for landscape painting from the Society of American Artists in 1894. In the summer of 1893 he married Eleanor Hardy Bunker, the recent widow of Platt's close friend and fellow painter, Dennis Miller Bunker. By this time, however, he had begun to explore three-dimensional ways of working with the landscape as well. Over the next two decades, Cornish would serve as a laboratory for Platt to test his growing interest in designing houses and landscapes.

Instrumental in the development of his ideas on architecture and landscape architecture was a study tour that Platt made soon after establishing himself in Cornish. Although Platt had visited Italy during his student years, he returned in the spring of 1892 with a specific mission: to record the villa gardens of the Renaissance.[15] He devised this trip to complete the education of his younger brother, William Platt, who was training to become a landscape architect in the office of Frederick Law Olmsted, whom Charles felt had prejudiced his brother against the architectonic tradition in gardening.[16] For several months the brothers traversed the peninsula, making measured drawings, sketches, and photographs (fig. 1.5) of approximately twenty-five sites. The following year, Platt published two

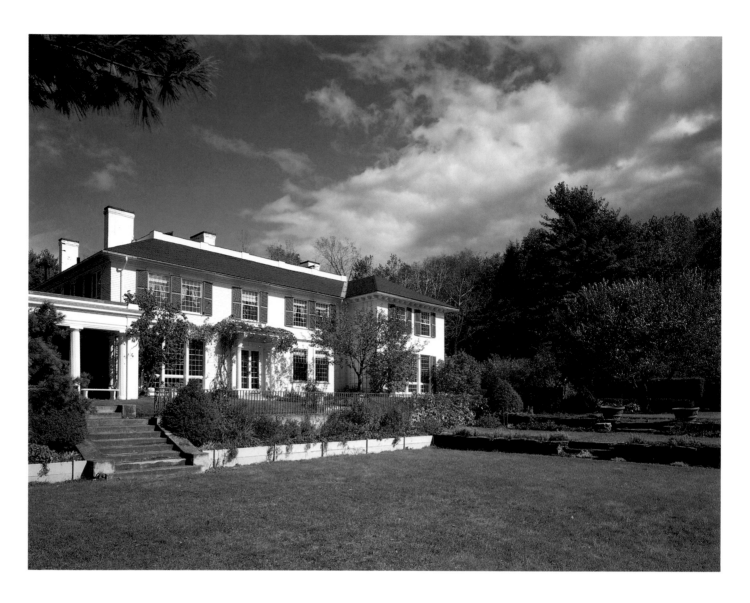

articles in *Harper's Magazine* on the gardens of Italy, which he combined and expanded in 1894 as *Italian Gardens*, the first illustrated book in English on the gardens of Renaissance and baroque Italy.[17]

Enriched by Platt's watercolor drawings (see fig. 4.3), etchings, and photographs, *Italian Gardens* became the most important document in the emerging American formal garden revival and launched Platt on a new career as a landscape architect. The key element of this modest book was Platt's photographs, through which he interpreted the surviving characteristics of the Italian villa garden.[18] Platt directed his readers to the geometrically configured outdoor "rooms" of the Italian villa, aligned with the house by straight paths, walls, and plantings. He also emphasized the use of flowers in the Italian gardens he had recorded, thereby tying the architectonic forms of these sites to the horticultural interests of his own generation. This publication rapidly attracted clients who asked Platt to adapt these ideals to American conditions.

Even before his tour of Italy, Platt had designed houses and gardens that were inspired by a knowledge of the Renaissance. Following the completion of his own house in Cornish in 1890, Platt was commissioned by his neighbor, Miss Annie Lazarus, to design a hilltop villa in 1891. The prominent location

FIG. 1.4
Charles A. Platt residence, Cornish, New Hampshire, designed 1890, 1892–1912. Photography by Richard Cheek by courtesy of *The Magazine ANTIQUES*.

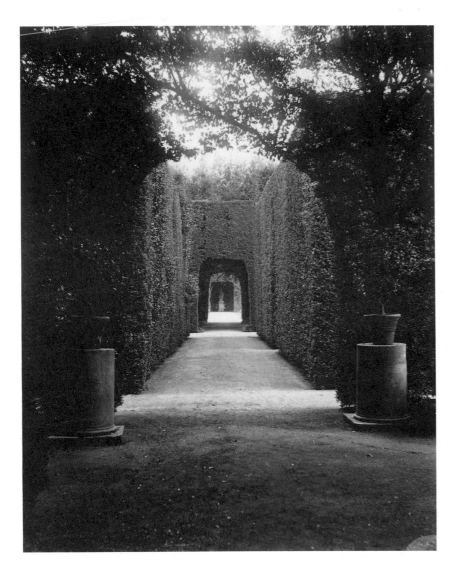

FIG. 1.5
Alley, Quirinal Gardens,
Rome. Charles A. Platt
photograph, 1892 (cat.
no. 53).

and the ambitions of his client led Platt to propose a U-shaped, two-storied, stuccoed house with a single-story loggia surrounding the central courtyard (fig. 1.6). Showing the strong relationship between his work in two and three dimensions, Platt painted a landscape of High Court (see fig. 3.26), the name for Miss Lazarus's villa, which allowed him to explore the views of the property from surrounding sites, such as his own. Similarly, he carefully considered the placement of the house and the design of the gardens to frame views of the landscape, especially the Connecticut River valley and Mount Ascutney, across the river in Vermont. Having obviously no training as an architect or landscape architect, he called upon his friend, the archi-

tect Stanford White, for assistance with drafting and with the design of details.[19]

After his tour of Italy in 1892, Platt's subsequent projects afforded him the opportunity to merge the principles of design he had derived from the Renaissance villas with the casual conditions of summer life in New England. Two later houses for Misses Grace and Edith Lawrence (1896), a concert pianist and her sister, and for the architectural critic Herbert Croly (1897) suggest his solution. Rough-hewn, horizontal boards cover simple volumes topped by low-hipped roofs with deep overhangs (fig. 1.7). Loggias and porches extend the living areas into the outdoors, where gardens continue this development along clear sight lines from the house (fig. 1.8). The integration of interior and exterior spaces that Platt had praised in *Italian Gardens* became the organizing principle for his domestic architecture and gardens. Other Cornish projects of this period included residences for the novelist Winston Churchill (1901–4) (fig. 1.9) and houses and studios for sculptors Herbert Adams (1903) and Emily Slade (1904–5).

Platt's garden designs signaled a radical departure from the established tradition, represented by the naturalistic plans of the Olmsted office. His success as a landscape architect was almost immediate. When in 1902 Guy Lowell published *American Gardens*, a survey of and apologia for the new formal garden movement, Platt was the most liberally illustrated representative, appearing in the company of the Olmsted office and architects Wilson Eyre and McKim, Mead & White, among others.[20]

For Platt, entering architecture "through the garden gate" was a natural progression. With the aid of family and influential friends such as Augustus Saint-Gaudens and Herbert Croly, Platt quickly attracted a loyal and influential group of patrons. Beyond Cornish, his important early commissions were for gardens to embellish houses designed by others. The most significant of these projects were two frequently published gardens in Brookline, Massachusetts. The earlier,

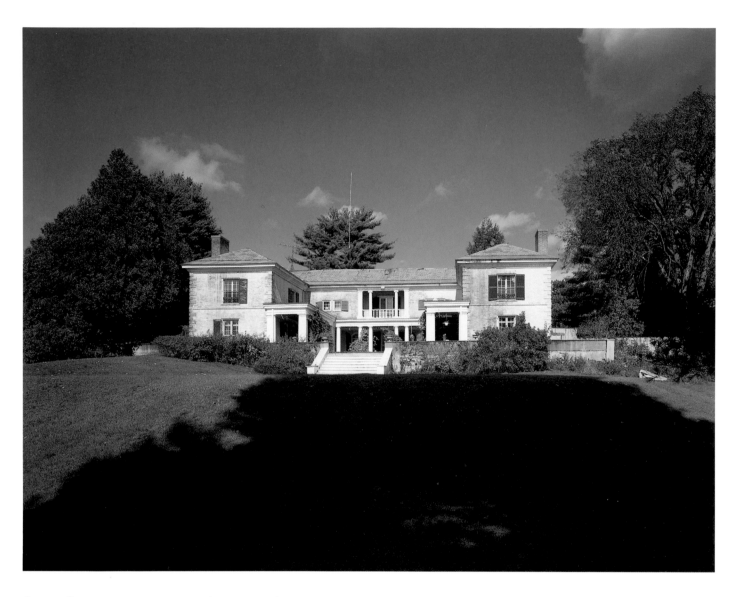

for Faulkner Farm (1897–98), the estate of Charles and Mary Pratt Sprague, was a full restatement of the characteristic components of the Italian villa garden (see fig. 4.9). It included a woodland garden above the house, a walled flower garden to the east, and a broad grassed terrace overlooking the estate to the south and the service area to the west.[21] At Weld (see figs. 4.14, 4.15), two hills closer to Boston, Platt designed an Italian-inspired landscape composed of flower garden, grove, and bowling green for Mrs. Sprague's cousin, Isabel Anderson, and her ambassador husband, Larz.[22] Both of these commissions attracted rapid media attention and established Charles A. Platt as the

new interpreter of the Italian garden for America.

From 1898, when Platt changed his occupational listing in the New York City Directory from "artist" to "architect," and into the 1910s, he worked principally as a domestic architect, especially as a designer of country houses, which he felt represented the best opportunity to produce "a work of art in architecture."[23] These commissions were acclaimed for their restrained scale and character, for their expression of a clear sense of order, and for the careful integration Platt achieved between house, garden, and site. His early friendship with Herbert Croly, the leading force at the *Architectural Record*,

FIG.1.6
High Court, the Annie Lazarus residence, Cornish, New Hampshire, designed 1901. Photography by Richard Cheek by courtesy of *The Magazine ANTIQUES.*

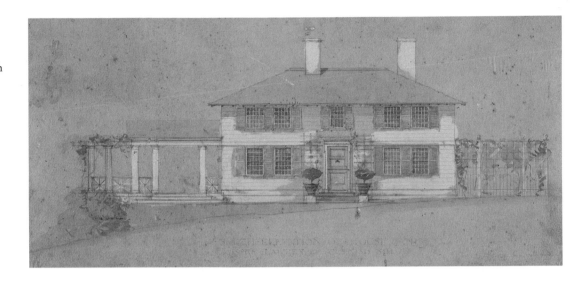

FIG. 1.7
Rendering by Charles A. Platt of south elevation of the Misses Grace and Edith Lawrence residence, Plainfield, New Hampshire, about 1896 (cat. no. 57).

FIG. 1.8
Herbert Croly residence, Cornish, New Hampshire, designed 1897 (illustrated in Herbert Croly, "The Architectural Work of Charles A. Platt," the *Architectural Record,* March 1904, p. 195.)

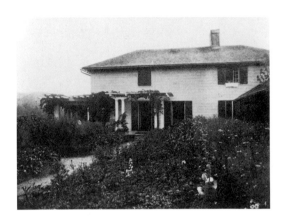

meant that Platt's projects were regularly and positively reviewed in that and in other professional magazines (fig. 1.10).[24] One must remember, however, that Platt had served no apprenticeship and had attended no school of architecture. He always felt somewhat of an outsider in his new profession. Despite his complete lack of academic training, he competed successfully in a market with other prominent architects of the period, many of whom had studied in schools both in the United States and abroad and had served lengthy apprenticeships in well-known firms. By 1904, however, when Croly wrote a lengthy review of his work to date, Platt's success as an architect was assured.[25] His stature in the field was recognized in 1913, when the Architectural Book Publishing Company re-

leased a *Monograph of the Work of Charles A. Platt*, with an introduction by the art critic Royal Cortissoz.

Not surprisingly for someone trained as a landscape painter and etcher, Platt placed primary importance on the relationship of the house with its surroundings. Indeed, the plan became the element by which a Platt house was known and for which it was most highly praised. With the exception of the few early gardens he designed for houses by other architects, Platt demanded that his clients give him control of the house and its landscape.[26] Platt believed that symmetry or its effect was the ideal for architectural and site development. Though some of his early houses and gardens contained awkward elements in functional organization, by the opening years of this century he had achieved maturity as a planner, both inside the house and beyond.

Within the house, Platt organized the major rooms to capitalize upon sunlight and views. He relied unswervingly upon rectilinear forms and their interconnection through corridors and sight lines. No visitor to a Platt house was ever uncertain about which rooms were important public spaces or how they were related. The entrance hall, often with staircase, was centered on the entrance facade, and either a loggia or the principal living area was placed in the center of the

garden facade or facing the principal view. Although the scale of the houses depended on the needs and abilities of his clients, Platt insisted on generous proportions and ample ceiling heights, generally between ten and twelve feet on the main floor.

In nearly all of his commissions, Platt selected and arranged the furnishings and other interior appointments. He developed a consistent philosophy of interior architecture:

... first, that structure is the basis from which form arises; second, that decoration is an element of architectural design and that its purpose is to accentuate architectural lines and proportions; and third, that a completely furnished room may be likened to a composition in which the various components—architectural motives, decorative features and furnishing—bear a definite relationship to each other and to the whole. There should be continuity between interior architecture and interior decorations just as in a painted picture the work is entirely that of one artist.[27]

His training and his sensitivity as a painter-etcher thus led him to think of any project as a composition in both two and three dimensions.

The evolution of Platt's career as a domestic, and especially as a country house, architect can be measured in a series of stages. Platt continued to use the design that he had developed for the smaller houses of Cornish as a formula that he considered appropriate for more modest summer places. Typically frame structures sheathed with either roughly textured horizontal boarding or wide shingles painted white, these summer houses nestled into the hilly landscapes of Connecticut, Vermont, Maine, or New Hampshire with familiar assurance.

By 1901, however, Platt was receiving commissions for more substantial houses, country estates rather than summer retreats. The finest of his early designs in this mode was for Maxwell Court (1901–3), the residence of a mill-owning family, on a site overlooking Rockville, Connecticut.[28] Here the

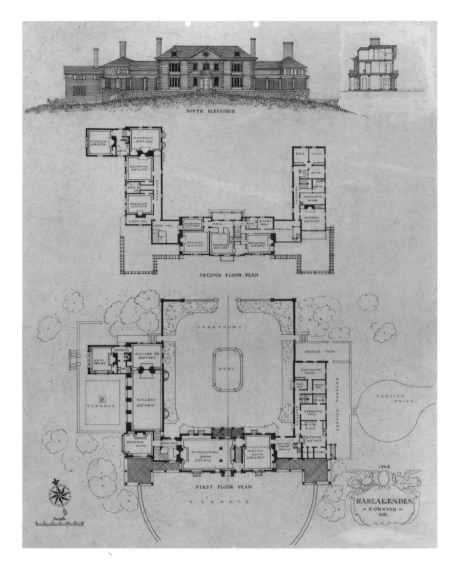

entrance elevation (fig. 1.11) announced a new scale and the use of more substantial materials, a clearer geometric order, and the manipulation of interior and exterior space through the inset loggia above the main door. With the service yard and formal garden concealed behind walls to the left and right respectively, the overall site plan (see fig. 4.12) was a refinement of the earlier garden at Faulkner Farm, now interlocked with a house to Platt's own designs.[29]

Platt's work during the middle of the first decade of this century reflects his interest in simple massing, emphasized by stuccoed exterior walls, often over poured concrete or metal lathing covered with a thick coat of cement. Concern for fireproofing had been

FIG. 1.9
South elevation and first and second floor plans, Harlackenden Hall, the Winston Churchill residence, Cornish, New Hampshire, 1901–4 (cat. no. 58).

FIG. 1.10
View from rear loggia of Alderbrook, the George Nichols residence, Katonah, New York, designed 1906, 1909–11. (Cover illustration for the *Architectural Record*, vol. 43, October 1918.)

FIG. 1.11
Entrance elevation, Maxwell Court, the Francis Maxwell residence, Rockville, Connecticut, designed 1901. Courtesy members of the Platt family.

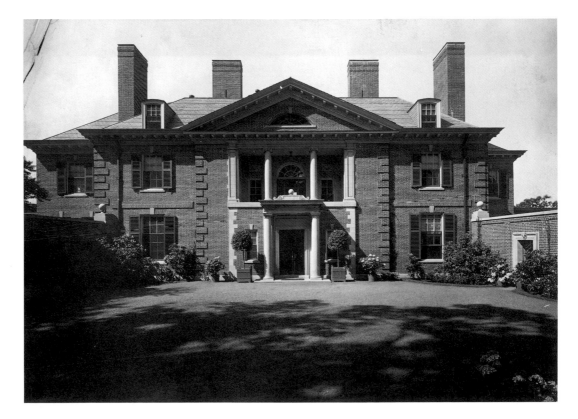

fueled by the popularization of the private automobile and the distrust of the combustion engine. Examples range from the compact Henry Howard house (1905) in Brookline, Massachusetts, where a garage was incorporated at the basement level, to Alderbrook (fig. 1.10), the poured concrete, brickencased country house for George L. Nichols, 1906, in Katonah, New York. These construction methods often encouraged Platt to adopt purer shapes and to minimize exterior ornament. Gwinn (1907–8), the William G. Mather estate near Cleveland, Ohio, is perhaps the finest of these designs and is certainly the best preserved of all of Platt's country houses and gardens.[30] Timberline (fig. 1.12), the W. Hinckle Smith house (1907) in Bryn Mawr, Pennsylvania, was another excellent, but now lost, exercise in this mode.

Not all clients were willing to accept the severity of these designs, where the proportions and rhythm of mass and void were at the heart of the composition. Others wished to live in residences that linked them to specific Anglo-Saxon architectural traditions (fig. 1.13), especially those of Georgian England or colonial America. One of the most extensive of these projects was "The Manor House," a country estate for John T. Pratt in Glen Cove on the north shore of Long Island.[31] The commanding, five-part plan of the main house was extended even further by a service wing on one side and formal garden on the other. The monumental entrance portico (fig. 1.1) focused the large-scale composition and ushered visitors into an environment inspired by the English country houses of the late Georgian period. Other designs, such as Eastover, the George T. Palmer house (1906) in New London, Connecticut, took its cue and its name from an American colonial landmark, Westover, in Virginia.

Initially inspired by the architecture of the Italian Renaissance, Platt frequently returned to it as a source. The somewhat boxy, stuccoed forms used for Gwinn were softened by its terraced garden setting overlooking Lake Erie. In the same years, Platt developed several villa and palazzo projects, especially two

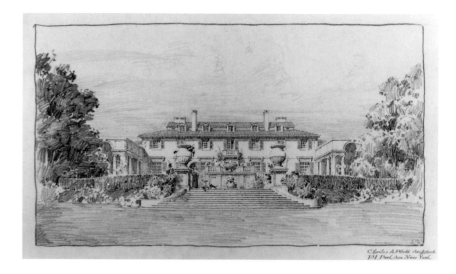

other country houses on the shores of the Great Lakes.[32] The larger of these was Villa Turicum (1908–18), a country estate for Harold and Edith Rockefeller McCormick at Lake Forest, Illinois (fig. 1.14). With resources from two of the wealthiest families in the country, the clients commissioned a country house and gardens that grew incrementally in scale and character. After rejecting proposals for this site by James Gamble Rogers and Frank Lloyd Wright, the McCormicks turned to Platt because of his Italian sympathies. The abilities and the interests of the clients pushed Platt to rival the sources he had visited so often, as seen in a comparison of his photograph of the entrance to the Villa Mondragone at Frascati (fig. 1.15) and the entrance facade of Villa Turicum (fig. 1.16). The highlight of the estate's grounds was a four-terraced water staircase that connected the rear courtyard of the house with the swimming pool at the lake shore and yacht basin. Platt continued to receive commissions for country houses until the end of his life and occasionally even provided designs for the children of previous clients.

Although Platt made his reputation as an architect of country houses, he earned a substantial income from urban projects as well. Not surprisingly, most of that work was in New York City, primarily through commissions from one major client, the Vincent

FIG. 1.12
Rendering by Schell Lewis of rear elevation of Timberline, the W. Hinckle Smith residence, Bryn Mawr, Pennsylvania, 1907 (cat. no. 62).

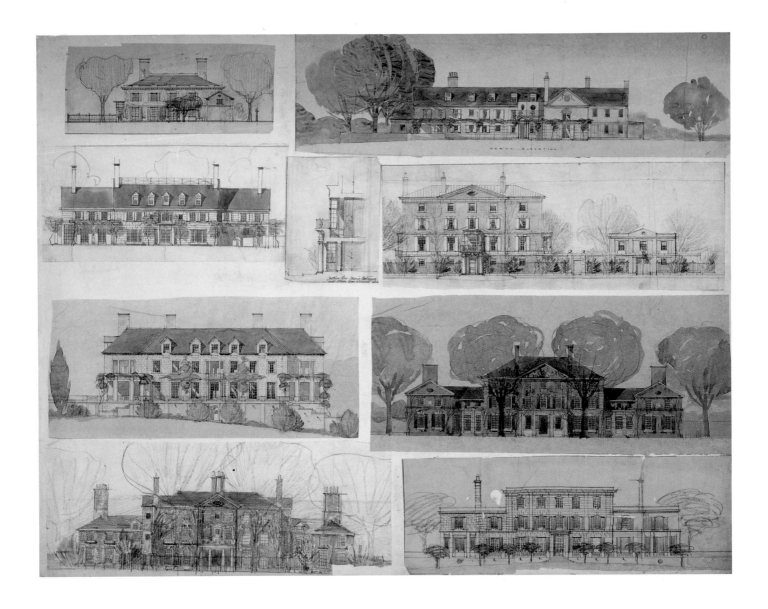

Astor estate office. Platt worked for the Astor estate from 1906 through 1932, converting existing buildings and designing new commercial structures and apartment buildings. These designs were generally more formulaic than the country houses, as he helped the Astor estate to convert their extensive real estate holdings from the tenements owned by the previous generation to apartments (fig. 1.17) for the middle and upper classes. Indeed, much of Platt's urban work was concerned with shaping a new environment for residence, work, and leisure of the moneyed class. And several of his clients commissioned houses for both town and country. Town house commissions of distinction for individual clients provide the more interesting counterpoints to these Astor estate projects, as discussed by Deborah Gardner in her essay in this catalogue.

Platt's country house clients often returned to him with institutional commissions, and by the 1920s his efforts were more fully devoted to master planning and design of academic buildings and museums. The patron who was individually responsible for the most important series of commissions was the Detroit industrialist Charles Lang Freer.[33] In 1913 he invited Platt to design a museum (fig. 1.18) for the Mall in Washington that would

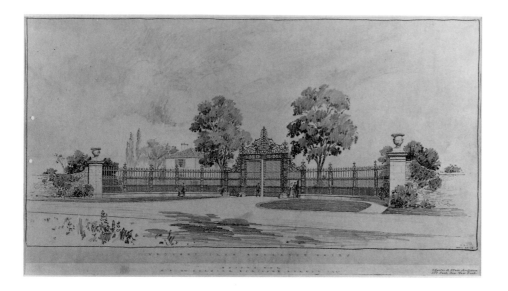

contain the collection of Asian and American
art that he had donated to the nation. This
project was the most intensely studied of
Platt's career and required a decade to com-
plete because of complications with Freer's
finances and the labor and supply problems
caused by World War I. Once again, the
Renaissance provided the foundations for
Platt's design, a palace for art with a central
courtyard (fig. 1.19) for contemplation. The
critical acclaim Platt received for this design
made Platt one of the most popular archi-
tects for museum buildings. In fact, he
designed eight other examples, including a
scheme for a National Gallery of Art (fig.
1.20), for which Congress failed to authorize
funding.[34]

The museum commissions brought Platt
national recognition, but more of his time by
the 1920s was spent on academic projects for
colleges, universities, and private schools.
These projects often included campus master
planning, engaging Platt's talents as an archi-
tect and a landscape architect on a large scale.
In many ways, he simply expanded his design
ideals developed for country estates so that
the principal units were interlocking build-
ings (fig. 1.21) set within a carefully con-
trolled landscape. The most significant of
these commissions were his designs for the

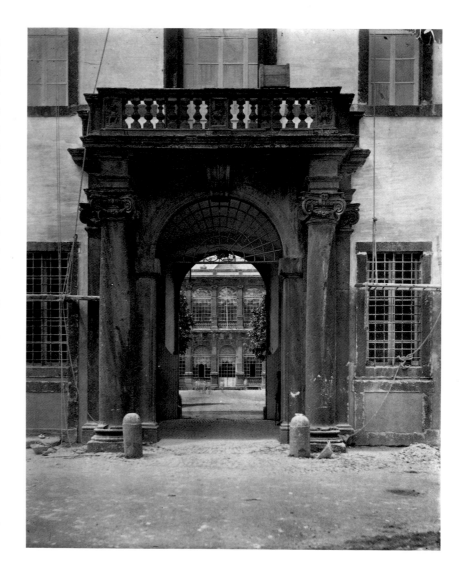

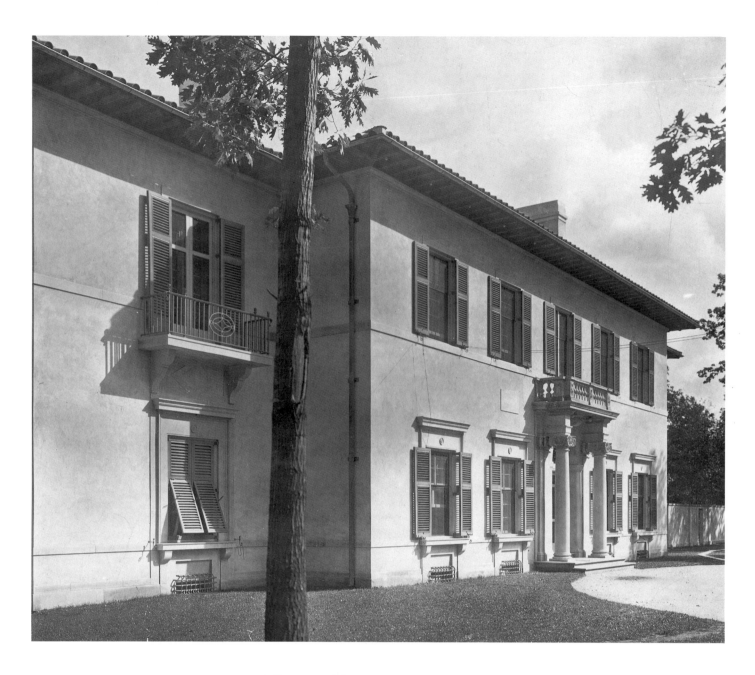

University of Illinois and for Phillips Acade-
my in Andover, Massachusetts. From 1922
through 1928, Platt guided a substan-
tial expansion of the University of Illinois.
His master plan (see fig. 4.16) perpetu-
ated the rectilinear geometry of the earlier
sections of the campus and proposed a sys-
tem of compactly designed building units—
T- and U-shaped structures facing onto
malls and streets and defining courtyards
behind.[35]

At Andover, Platt was given an even larger
role due to the backing of Wall Street financier
and academy trustee Thomas Cochran. Platt
challenged Cochran to create an ideal envi-
ronment for education:

Why not surround them with the very best in
architecture and nature and fine arts? Why not a
bird sanctuary, a really fine library, a topnotch art
gallery, a good Colonial church with an organ?
Why not a few broad vistas, some lawns and ter-
races, even some notable lectures and concerts—
all instruments of culture?[36]

This statement by Platt shows his concern with creating an ideal physical and intellectual landscape at Andover. Platt and Cochran accomplished all of this and more. They demolished, moved, and significantly altered existing buildings, opened vistas and courtyards, and constructed a new chapel, library, commons, art museum, administration building, classroom building, and dormitories. Coming near the end of his career and life, the institutional landscape of Phillips Andover is as clear a corporate statement of Platt's goals for visual culture as any of his widely recognized country estate designs.

<p style="text-align:center">*</p>

Throughout his life, Platt was sensitive to and celebratory of a distinctive American landscape (fig. 1.22). His earliest efforts as an etcher and painter demonstrated his talent for recording and creating a sense of place. It was not so much Platt's style as his subject—his persistent emphasis on landscape—that helped set him apart from other artists of his generation. His love of landscape emerged first and remained the most consistent in his work as an etcher. He sought picturesque compositions in which he could explore qualities of line, light, and atmosphere. In painting, Platt's contemporaries generally sought to express their ideal of beauty in the form of the (usually female) figure, often portrayed as a historical or allegorical personage. Platt rarely painted the figure and never the nude. Furthermore, though Platt's association with other Cornish artists may have inspired him to brighten his palette and achieve a more classically balanced arrangement of form, he never adopted the allegorical subjects and classicizing figures favored by his closest colleagues there, such as Thomas Dewing, H. O. Walker, George de Forest Brush, and Kenyon Cox.

A consistent attitude toward the natural environment became the bridge to and foundation for Platt's three-dimensional work as well. His modulation from etching and painting to photographing and, finally, to designing landscapes was surprisingly seamless. Platt's close study of the gardens of Italy began as a casual diversion for the artist and became the basis for his career as an architect. Having crystallized the principles of the Italian garden, he adapted these ideals for the landscape of the American summer house or country estate. And he achieved rapid success as an architect because he based his designs on the careful interpretation of house and site. Even in his designs for buildings in the city, he was concerned with establishing and maintaining a commitment to a consistent urban landscape. For that reason, he opposed the skyscraper as a destroyer of quality in the

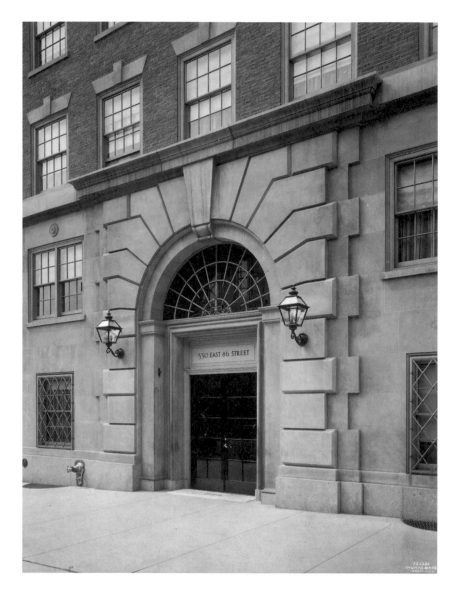

FIG. 1.17
Entrance to 530 East 86th Street, New York, New York, designed 1927–28. Courtesy members of the Platt family.

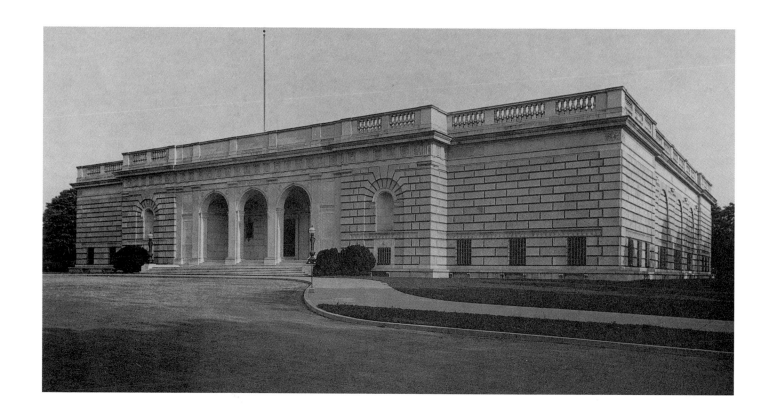

FIG. 1.18
Entrance facade, Freer
Gallery of Art, Washing-
ton, D.C., designed 1913,
opened 1923 (cat. no. 79).

FIG. 1.19
Freer Gallery of Art, Wash-
ington, D.C., under con-
struction, about 1922.
Photography Collection,
Miriam and Ira D. Wallach
Division of Art, Prints and
Photographs, The New
York Public Library, Astor,
Lenox and Tilden Founda-
tions.

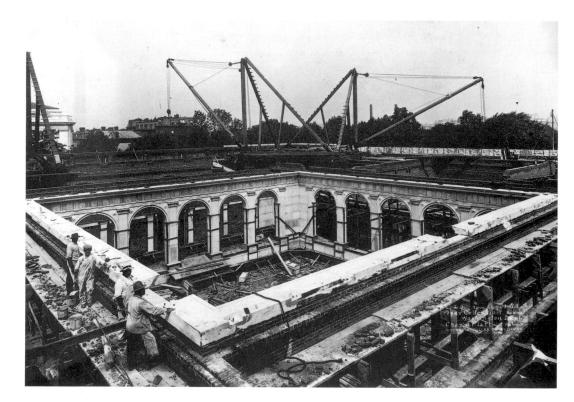

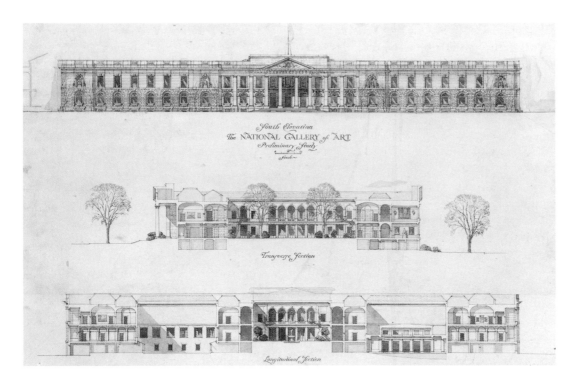

larger urban composition and sought to de-emphasize height in the tall buildings he designed. Similarly, in his institutional work in the 1920s, especially in his campus plans for universities and boarding schools, Platt sought to create balanced and focused arrangements on the land. In all these arenas, Platt provided a formula that was easily recognized and understood. His varied landscapes—more picturesque at the beginning of his career and more classic at the end—were carefully coordinated compositions of the basic elements of line, mass, and color. These were landscapes of intellect, in which the artist sought to achieve an idealized, self-sufficient perfection.

To achieve this distinctive vision of landscape, Platt relied upon photography to bring his ideas into focus. He used photographs, both those he had made and purchased, in the development of his art in all phases of his career. At least as early as his student years in Europe he was purchasing photographs as guides to sites of picturesque interest and commissioning photographers to frame or alter a particular view for later reproduction in his etching or painting studio.[37] The essays

to follow discuss photographs Platt used as guides for the production of his etchings and paintings (see fig. 2.29).

More significant were the record photographs of the gardens of Italy that he made during the spring of 1892 and subsequently published as illustrations for his book, *Italian Gardens* (1894). In his introduction, he compared his photographs to the engravings in Percier and Fontaine, *Choix des plus célèbres maisons de plaisance de Rome et de ses environs* (Paris, 1824), the only existing source that he noted on this topic. Platt observed that

the art of photography has been perfected since their treatment of the subject, and the object of the present writer has been by its means to illustrate, as far as possible, the existing states of the more important gardens of Italy, leaving out the matter of research altogether, since a more profitable study of the subject can be made as a result of these reproductions of nature.[38]

This statement reinforces Platt's belief in the power of the image over the word (indeed he would never write another book) and in the value of photography as a guide for the artist. Like most architects and landscape architects of his generation, Platt assembled a substantial photograph collection that he mounted in albums organized by topic—Italian fountains, English ironwork, French châteaux. These albums document the visual resources available to the designer, in combination with an office library collection of approximately two hundred published volumes.[39] Platt's architect son, Geoffrey, recalled:

Basic to the design process was his architectural library. . . . These books provided a vocabulary perfectly natural to C. A. P. and his designers, who molded the material in their own way. Whatever detail or design they found relevant to the project at hand was only a starting point. It was studied exhaustively, modified, and adapted to be part of a new composition.[40]

Thus, Platt saw photographs as both art objects and as documents that were invaluable to his work in other arts. Indeed, the high level of specificity and the complex set of historic and cultural references in the art of this generation are heavily indebted to the opportunities provided by the popularization of photography.

*

Platt has frequently been cited as an exemplar of the cultural movement referred to as the American Renaissance.[41] Indeed, in some ways he was the American Renaissance artist *par excellence* because no one else could match the range or coherence of his production. The term American Renaissance has been explained by contemporary and later scholars as the cosmopolitan association of late nineteenth-century American visual culture with classical European civilization, particularly with the legacy of the Italian Renaissance.

Espousing a history-based design philosophy and a thorough knowledge of and reliance upon Renaissance-inspired forms, both the artists of this movement and their patrons self-consciously cast themselves in the reflected glory of the classical tradition as they sought to establish it as the model for contemporary American civilization. This enterprise resulted in the creation of private and public ensembles that stipulated a respect for a selective view of history and an integration of the arts. The earliest efforts, dating from the mid-1880s, were recast on a grander scale at the Chicago World's Columbian Exposition in 1893, which offered a persuasive vision of the new American metropolis and set the course for architecture and urban planning in this country for a generation to come.[42]

While acknowledging that Platt's aesthetic was shaped in large measure by the cultural goals of the American Renaissance, it is equally important to understand his distinctive place within this movement—as a man apart. In every aspect of his career, he attempted to express a highly personal artis-

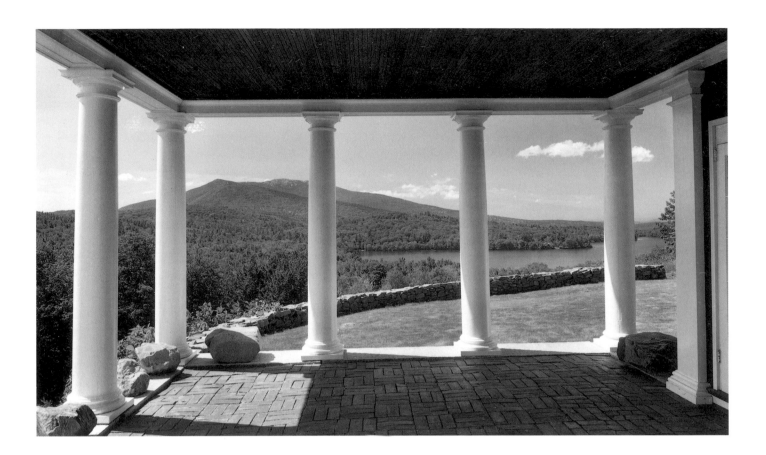

tic vision, what he called "one's sense of the beautiful."[43] This vision was inspired by a comprehensive but selective knowledge of the past, a belief in art for art's sake, and the pursuit of an abstract ideal of smooth, balanced, complete forms. In his paintings and etchings, this aesthetic evolved from a reliance on picturesque irregularity to a demonstration of the restrained and the beautiful in the natural environment. Platt's pursuit of these goals in architecture and landscape design was deeply informed by his training in the pictorial arts, a background unique among the architects of his generation. This experience imbued Platt with a distinctive sense of spatial order and visual coherence, enabling him to create compositions of carefully integrated forms that functioned effectively in both two and three dimensions.

Reacting to the eclectic visual borrowings of an earlier generation of architects, Platt focused on a limited number of historical models, carefully chosen for their relevance to the task at hand.[44] Emphasizing selectivity and the rigorous adaptation of these models to the needs of his clients, he sought throughout his career to create a synthesis, bringing the best of the past into vital contact with the present. Platt considered his work, however, to be thoroughly "modern" in the best sense of the word. For him, this designation did not imply the invention of a new style but rather an intelligent and critical approach to the past coupled with a thorough understanding of contemporary conditions. Platt's attitude (and the quality of his work) was clearly expressed by Frank Lloyd Wright, a vocal opponent of the use of historic forms, when he once wryly noted that Platt "was a very dangerous man—he did the wrong thing so well."[45] In broader terms, this conflict between the historically informed approach of artists like Platt and the self-conscious

FIG. 1.22
View of Dublin Lake and Mount Monadnock from the loggia of the E. Lindon Mellus residence, Dublin, New Hampshire, designed 1901.

modernity of Wright and others was central to the debate over visual high culture at the turn of the century.

Platt's position within this generation of artists turns on the issue of artistic collaboration. From the 1880s onward, the ideal of a marriage of the arts to produce physical settings of impressive richness had been promoted by architects, painters, and sculptors. Obviously, Platt played a different role in this equation because he would often "work for himself." He ultimately became an architect because he was able to control total environments and could provide, when appropriate, his own paintings, etchings, or photographs as decorations for the rooms.

Beyond this issue of his own multiple artistic endeavors lies the important interconnection of key communities of designers. For example, since Platt was not a sculptor, he frequently had to go to others to complete the sculptural embellishments of his country houses and public buildings. He was, moreover, often chosen as the architect and landscape architect to design the setting for sculpture by his friends.[46] These kindred spirits included Augustus Saint-Gaudens, Daniel Chester French, and Herbert Adams, among others. Similarly, Platt was the mentor to younger artists, such as the landscape architect Ellen Shipman or the sculptor Paul Manship, giving them important roles in his projects.[47]

While seeking to maintain his aesthetic ideals, Platt also functioned as a professional in a capital economy, consciously working to develop a product that would attract and retain a sophisticated clientele. Although he had been a supporter of the noncommercial ideal of art etching, he was very shrewd and successful in marketing his prints and did accept some jobs as an illustrator for books and articles. He was not as successful in selling his paintings, which may have been one of the reasons that he moved into the fields of architecture and garden design. Here Platt was a consummate salesman—he alone in his architectural office was responsible for client relations—and managed throughout his

career to have his projects favorably reviewed and widely publicized. His social connections—through family, the circle of artists of which he was a part in the summer colony of Cornish, New Hampshire, and the friendships formed in New York around the poker table of the Players club or the lunch table of the Century Association—provided access to the group of patrons who would sustain his work. His accomplishments must also be measured against a changing professional environment in which a successful man without academic credentials or apprenticeship was the rare exception in New York.

Platt succeeded because he produced a highly desirable product and understood how to publicize his work. Though the growth of consumer culture in the late nineteenth century has been primarily studied as an expression of the taste of the developing middle class, it can be charted on other levels as well.[48] Platt's work, for example, should be seen as a product that was created to serve the needs of a specific segment of American society. He provided his clients with a complete range of services: architecture, landscape architecture, and interior design, quite often planning the furnishing and the art work for the building as well. Thus Platt, like Frank Lloyd Wright, sought to control the entire ensemble, which became a landscape of consumerism informed by the architect's taste.

The mission to shape American culture pursued by Platt and others must also be measured against the larger realities of urban America at the beginning of the twentieth century, particularly against the singular example of New York City where Platt had his office and produced much of his work. For too long, the members of Platt's generation have simply been defined either as proponents of an elite culture or as crusaders bent on improving "how the other half lives." These are obviously the two extreme views of numerous interconnecting and overlapping currents that help to explain the decades that bracket the turn of the century. The "genteel tradition" cannot be considered in isolation

from the social and political problems that beset American cities at that time.

How did Platt respond to these conditions? His urban architectural projects are a natural arena in which to measure the conflict between what Platt believed and the contemporary forces he was required to confront. At times anti-urban, anti-commercial, or anti-technological, Platt projected a positive view of the city, one made better through control and design. Again, his client network somewhat determined the kinds of commissions he sought and received. Still, Platt was an opponent of the skyscraper, finding it destructive of the urban visual environment.[49] Instead, he designed town houses, apartment buildings, and commercial structures of relatively modest height, where he could base his designs on historical forms and maintain a pedestrian scale. By contrast, the country house, the typology for which he is primarily known, was an environment that he could totally control and that would not be compromised by surrounding structures.

Platt remained committed to a distinct architectural philosophy and was fortunate to attract a range of clients who understood and embraced what he could offer them. He took special care to develop a close working relationship with his clients, not simply because it was a good business practice but, more importantly, because he felt it was his obligation as an artist to broaden and refine their taste.

The role that Platt sought to play in shaping contemporary visual culture parallels that envisioned for the new American professional by his friend Herbert Croly, the architectural critic turned political philosopher, in his seminal book, *The Promise of American Life*, published in 1909.[50] Croly had commissioned Platt in 1897 to design his summer house in Cornish, New Hampshire, and had written the earliest important criticism of Platt's work as an architect and landscape designer.[51] In the concluding chapter of *The Promise of American Life*, he saw the architect as the model for a new class of leaders —"constructive individuals," in his words,

whom Croly believed could achieve a unity of national purpose. "There is only one way," he wrote,

in which popular standards and preference can be improved. The men whose standards are higher must learn to express their better message in a popularly interesting manner. The manner in which the result is to be brought about may be traced by considering the case of contemporary architecture.[52]

Dismissing the average, well-trained architect whose "first object is to get and keep the job, and his second is to do good work," Croly's "exceptional architect":

has a monopoly of his own peculiar qualities. Such merit may not be noticed by many people; but it will probably be noticed by a few. . . . If he be an intelligent as well as a sincere and gifted designer, his work will, up to a certain point, grow in distinction and individuality; and as good or better examples of it become more numerous, it will attract and hold an increasing body of approving opinion. The designer will in this way have gradually created his own special public. Without in any way compromising his own standards, he will have brought himself into a constructive relation with a part at least of the public and will soon extend beyond the sphere of his own personal clientele. In so far as he has succeeded in popularizing a better quality of architectural work, he would be by way of strengthening the hands of all his associates who were standing for similar ideals and methods.[53]

In Croly's terms, then, Platt needs to be seen as a new type of cultural engineer, the rationalized and historically based quality of whose work would, as the ripples from a pebble in a pool, gradually expand to influence and inform the work of a generation. In this fashion, he would bridge the gap between individualism and collectivity, which Croly saw as the problem and promise of American life.[54] Platt certainly was successful in building several loyal constituencies of critics, who published admiring reviews of his work in the

architectural press; of architects and landscape designers, who studied and emulated his projects; and, most importantly, of clients, who came to him because they wanted "a Platt house" or "a Platt garden."

*

The world of Croly and Platt was clearly elitist, with the new culture-shapers enlightening those around them and beyond them. Nevertheless, the centralization of design fostered by the *Architectural Record*, where Croly was an editor, and the monographs issued by the Architectural Book Publishing Company, such as the Platt volume of 1913, reinforced this process of dissemination. Croly's progressivism in the political realm had its roots firmly planted in his architectural criticism, and Platt was the architect who most clearly corresponded to this vision. As such, we can connect the seemingly benign, elitist world of the American Renaissance with the larger cultural, social, and political movements of this generation.

It is not surprising that Platt was invited to write a brief essay on "Herbert Croly and Architecture" for a special edition of *The New Republic,* published in 1930 in Croly's memory.[55] Platt recalled: "An architectural theme was not, for him, merely an episode in the day's work. He cared for the subject, was keen upon its right development in this country and sensitive to all its aspects." Stepping back to a more philosophical level, Platt observed:

In the domain of sociology he was a progressive, as we all know. He followed the same principle in his attitude toward art, but he was also a reasoned traditionalist, persuaded both by instinct and by study that our evolution needs to be steadied by careful consideration of the precedent. When he philosophized about the architectural development of his time—and he was always philosophical, he never forgot the lesson of the past—all this made him a sound educational influence.[56]

The "promise of American life" thus becomes the promise of American architecture or American art. Platt naturally assumed this persona of "constructive individual" throughout his successive careers from the early 1880s until his death in 1933. No other figure of this generation presents a comparable integration and control of all the arts. Platt's work, as a case study, thus permits a higher level of cultural analysis than that of any other member of this generation.

The country houses of the 1900s and 1910s are perhaps the most instructive objects for examination. Here Platt worked for a clientele that either understood the quality of his work or who, in selecting Platt, acknowledged their need for professional advice at all stages. In these commissions, Platt provided the guiding hand for everything from the selection of the site to the large-scale development of the property, the general configuration of the gardens, the design of the house, and the choice of furnishings and art works (which frequently included paintings, etchings, watercolors, and photographs by Platt, or work by the circle of friends with whom he surrounded himself in New York City and in Cornish, New Hampshire). Platt could thus shape intellectual and visual landscapes of power and sophistication that he and his patrons intended to serve as models for American society at large—the work of "constructive individuals" informing the promise of American art.

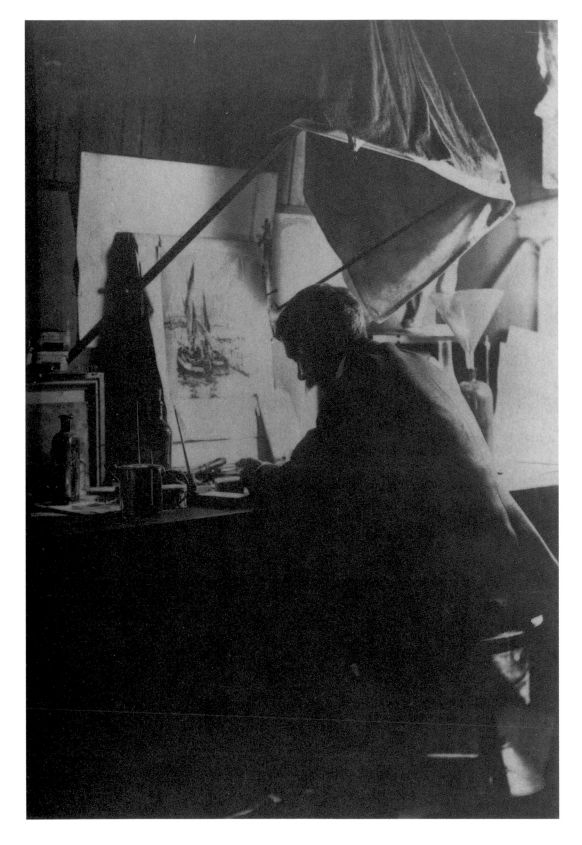

FIG. 2.1
Charles A. Platt in his
etching studio, New York,
1888. Courtesy, members
of the Platt family.

2

The Etchings of Charles A. Platt

MAUREEN C. O'BRIEN

CHARLES ADAMS PLATT's rapid ascent and remarkably long reign as a leader of America's late nineteenth-century painter-etcher movement were supported by his unquestionable aptitude for the medium of etching. The accident of birth that placed Platt in New York City in the 1870s augured the success of his print-making career, positioning him to become the youngest member of a set of artists who would promote and sustain the etching revival of the next decade. In 1876 the American public experienced a newfound enthusiasm for etchings at the Centennial Exhibition in Philadelphia, where the painter and reproductive etcher Peter Moran won a gold medal for *The Return of the Herd*,[1] one of thirty-seven prints he exhibited alongside the predominantly European display of etchings at the fair. When Moran's etchings were exhibited at the National Academy of Design in New York the following year, a group of artists and amateurs came together to found the New York Etching Club, an association that flourished until the early 1890s while serving as a model for etchers in other American cities.

A young New Yorker with strong artistic aspirations, Platt was poised to take advantage of the changes in process and point of view that were infiltrating the New York art world from Europe in the late 1870s. In 1878, the year he entered the National Academy of Design as a student, the school's galleries housed the first exhibition of the Society of American Artists. The focus of this group was defined by the commitment to modern painting espoused by young, European-trained artists such as William Merritt Chase and Walter Shirlaw. When Platt studied under these men at the Art Students League, he learned painting techniques that were already a generation ahead of those practiced by the artists in the circle of the New York Etching Club.

Despite an enlightened sympathy to the concept of a freehand printmaking process (that is, one that valued suggestion more than reproduction and praised the autographic quality of an individual artist's line), most of the club's members, born before mid-century, came to the art of etching with habits formed during the peak years of literal American landscape and genre painting. Those who preferred landscape work found a new level of personal expression in both the techniques and the pastoral subjects of Barbizon paintings. Grazing cows and flocks of sheep abounded in the prints of Peter Moran and J. A. S. Monks, while woodland interiors,

NOTE: References to etchings made by Platt before 1890 are followed in this essay by an "R." and the number assigned to them in Richard A. Rice, *A Descriptive Catalogue of the Etched Work of Charles Adams Platt* (New York: The DeVinne Press, 1889).

viewed with post–Civil War nostalgia, characterized the landscape etchings of contemporaries such as James C. Nicoll, Robert Swain Gifford, and George Henry Smillie. Henry Farrer, a founding member of the New York club, had been a follower of John Ruskin and of the precepts of Pre-Raphaelitism as applied to landscape painting. Through crispness of line and clarity of light, his etchings suggested a spirituality in nature that was absent from the canons of the new painting.

It was to Platt's advantage that his etching debut was guided by an artist who maintained a liberated approach to technique. Stephen Parrish, a Philadelphian who was fifteen years older than Platt, had discovered on his first trip to Europe in 1867 that modern painting could produce effects of "color and massiveness and breadth" that he had never before thought possible.[2] Inspired by his trip abroad, Parrish nevertheless delayed the beginning of his own career until 1877, when he sold his stationery business and devoted his energies to making art.[3] Platt first met Parrish at Bolton Landing, New York, during the late summer of 1879,[4] when both men were using their emerging talents to explore the possibilities of landscape painting. The bond they forged during a sketching jaunt to nearby Warrensburg led to reunions during the two following summers. When Platt joined Parrish in East Gloucester, Massachusetts, in 1880, the older artist shared the skills he had learned from Peter Moran the previ-

ous fall and initiated Platt in the art of etching. From the work of that summer and the next, Platt produced a precocious body of work that quickly led to recognition by artists and critics alike.

In light of such early acclaim, it seems judicious to weigh the praise heaped on Platt (and on the small army engaged in the painter-etcher movement) against the potential for critical enthusiasm to confuse novelty with true innovation. Boosted by Sylvester R. Koehler's *American Art Review*, a journal that was introduced in 1879 for the express purpose of publishing "Original Painter Etchings by American Artists," a fledgling artist like Platt was confronted with the task of sustaining his early momentum while continuing to develop as an artist. Both his well-known family connections (Koehler contrasted Platt's realism with the "New England transcendentalism" of his forebear, artist Seth Wells Cheney)[5] and the strong start offered him by Parrish's lessons attracted attentive critics to Platt's etchings and challenged him to succeed. He made his first plate in December 1880, utilizing the *plein air* sketches he had done in Gloucester. This print, *Gloucester Harbor* (R. 1), was one of six he submitted to an exhibition of American etchings arranged by Koehler for the Museum of Fine Arts, Boston, in April 1881.[6] When later that year Platt became the subject of the twenty-fifth installment in Koehler's series "The Works of American Etchers," he had already etched seventeen plates and—

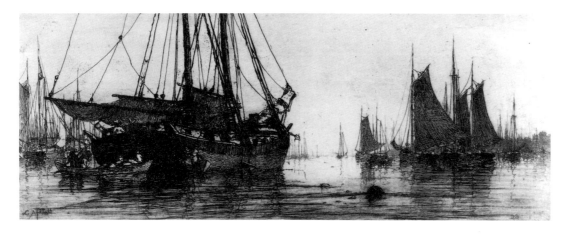

FIG. 2.2
Fishing Boats, 1881 (cat. no. 3).

FIG. 2.3
A March Evening, 1881
(cat. no. 1).

indicative of his high standards for finished work—had destroyed a number of these as unsatisfactory.[7]

Although a novice to etching in 1881, Platt had already completed nearly three years of academic training as a painter. By this point he displayed a preference for landscape over figure painting, and particularly for coastal subjects rather than inland views (fig. 2.2). He found little to inspire him in contemporary architecture and selected urban subjects such as *Shanties on the Harlem* (1881–82, R. 15) or *Thames St., Newport* (1881, R. 17), only when they could be characterized by their picturesque dilapidation. Even his *Little River, Hartford* (1881, R. 18), with a view of the capitol's dome, gave prominence to the lines of clothing hung to dry on the rear walls of old buildings. The shanties, wharves, and fishing boats recorded in his first Gloucester etchings foreshadowed a decade-long fascination for masts and sails and beached craft in the harbors of the North Atlantic. In his earliest prints he also explored seasonal and twilight effects in the manner of Parrish and Henry Farrer. Works such as *A March Evening* (fig. 2.3), *Sunset: The Cod Fleet* (1881, R. 8), and *Twilight: Gloucester* (1881, R. 10) appropriated the moody appeal of American tonalist painting and tested the atmospheric potential of plate tone.

With growing confidence, and with the stimulation of new territories, Platt quickly expanded both his repertoire and the size of his plates. The first summer's resources in Gloucester and Cape Ann were replaced with wilder scenery of less familiar towns in New Brunswick and Nova Scotia in his works of late 1881 and 1882. Platt was guided again by Parrish, who had devoted himself to etching for the six months preceding the 1881 trip and eagerly attended its possibilities. In late July 1881, Parrish wrote to Sylvester Koehler that he had been reading up on the provinces, ". . . and with what I hear from other sources about the odd craft & folks, and the strange shore effects of the Bay of Fundy at low tide &c. I anticipate a treat to say the least."[8] Both etchers rose to the potential of their subjects, and despite the limitations of his etching experience, Platt proved capable of mimicking and varying Parrish's effects in scenes based on drawings of his own. *Portland on the St. John* (fig. 2.4), a large plate that Platt completed the following winter and exhibited at both the Society of Painter-Etchers, London, and the New York Etching Club exhibitions that spring, demonstrated his broad grasp of the medium and his ability to adapt from the works of others. As if in response to Parrish's slightly smaller *Fishermen's Houses—Cape Ann* of 1881 (fig. 2.5), Platt displayed his entire catalogue of picturesque and architectural harbor effects,

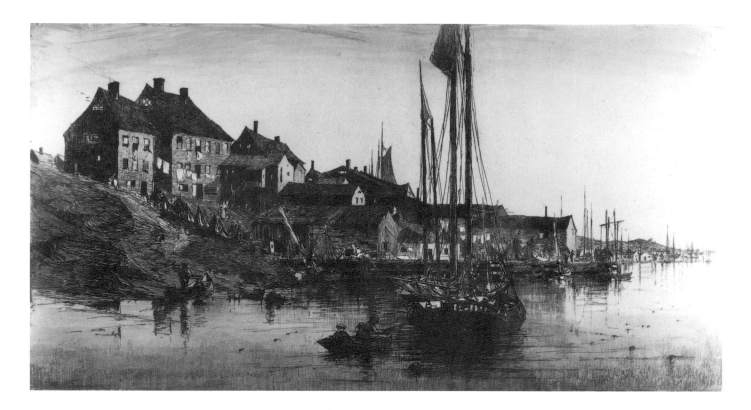

FIG. 2.4
Portland on the St. John,
1882 (cat. no. 4).

ranging from the back-lit silhouettes of the humble houses with their steep roofs and flickering windows to the disappearing perspective of masts along the barren coastline. Typically, he rejected narrative and minimized genre elements in his pictures. When figures appeared, sitting in dinghies, hanging out wash, or feeding chickens, they were always anonymous *staffage* and never the curious folk eagerly sought out by Parrish.

Although Koehler had linked Platt to the school of British etcher Francis Seymour Haden, the works of Haden's brother-in-law, James McNeill Whistler, offer more pertinent references to Platt's etchings of this period. Known to American artists through P. G. Hamerton's *Etching and Etchers*—the contemporary painter-etcher's bible and technical guide—and through an article by W. C. Brownell that appeared in *Scribner's Magazine* in 1879, Whistler's etchings were familiar even to artists who had not yet seen the original works.[9] Although Platt did not share the adulation of Whistler that was demonstrated by young Americans such as Otto Bacher, who encountered him in Venice in the summer of 1880,[10] he was too intelligent to ignore the importance of Whistler's prints. *Billingsgate* (fig. 2.6), an 1859 etching from Whistler's Thames series, had been praised by Hamerton for its very beautiful and subtle "variety of inclination of the masts."[11] Quick to learn and absorb, Platt created his own choreographed arrangement of masts in the large *Provincial Fishing Village* (fig. 2.7), a work he reserved for submission to the New York Etching Club in 1883.[12]

Platt gave another nod to Whistler in *Interior of Fish-Houses* (fig. 2.8), a second print that was shown in both New York and London in 1882. Here he evoked the contrasting doorways, passages, and courtyards that were familiar motifs in Whistler's early works such as *The Lime Burner*, 1859 (fig. 2.9), as well as in some of the Venetian etchings that were exhibited in America in 1881.[13] The influential art and architecture critic Mariana Griswold Van Rensselaer selected Platt's *Interior of Fish-Houses* for reproduction in her 1883 article for *The Century Magazine* entitled "American Etchers." Like Koehler in 1881, she was generous in her view of Platt's po-

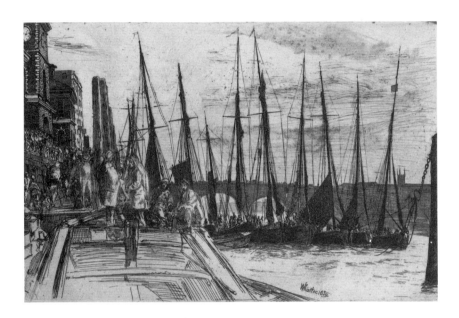

tential. Calling him a "very young man" (he was, even then, only twenty-two), she described the good influence of Stephen Parrish on Platt's subjects and methods. She predicted, "his taste is artistic, his individuality is visible, and his master is a good one, so we may hope the three facts will work together till the former predominate in an art of first-rate quality."[14] Returning to a consideration of Platt's etchings in 1886, Van Rensselaer emphatically distinguished her assessment of Platt's style from that of Parrish. In reference to works shown by the two artists at a recent exhibition in New York, she now saw a contrast of qualities:

Mr. Parrish, I should say, showed a stronger personality in his work; was more enthusiastic, more fervent, more poetic; his aims were more ambitious, less simple, and (so to say) modest; but he did not realize them so perfectly as Mr. Platt realized his. Mr. Platt had, in truth, arrived at a mastery over his art which Mr. Parrish—wrestling with more difficult desires—had not yet arrived at.

FIG. 2.7
Provincial Fishing Village,
1882 (cat. no. 5).

I do not mean a mastery of its technical resources, a mastery in hand, so much as a mastery of eye and thought.[15]

When Platt departed for Europe in the spring of 1882, his reputation as an etcher was firm. He had been admitted to the New York Etching Club and the Society of Painter-Etchers, London, and his work would soon be represented at the First International Special Exhibition of Graphic Art in Vienna.[16] His stated intention was to study painting in Paris, but he continued etching when time and circumstances allowed. Once abroad, he became a faithful correspondent to his family and provided illuminating details of his interests, his travels, and his progress as an artist between 1882 and 1886.[17]

Upon arriving in London, Platt took it upon himself to call on the founder of the Society of Painter-Etchers, Seymour Haden. Despite the influential position assigned to Haden by contemporary American critics, Platt's opinion of this prominent British etcher revealed his own youthful skepticism and self-confidence. When he visited Haden at his home in Mayfair on a Sunday afternoon in June 1882, he found "a pleasant rather oldish kind of a man with grey hair and a very red face." Haden complimented the young artist on the etchings he had shown in the society's first exhibition in March, but the conversation then turned to Haden, "and there," Platt wrote, "it rested all the time I was there."[18]

Platt was particularly interested in Haden's printing rooms, which were outfitted with "positively everything that was ever invented in the printing line and of course a good deal of it was invented by him." His press, which was being operated that day by the renowned English printer Frederick Goulding, was "probably the finest in the world," yet Platt was convinced that the proofs being pulled could have been executed better by the firm of Kimmel & Voigt in New York.[19] Although Haden's participation in the actual printing was limited, he had firm ideas about the proper procedure for creating the plate. He explained to Platt that he insisted on drawing

FIG. 2.8
Interior of Fish-Houses,
1881 (cat. no. 2).

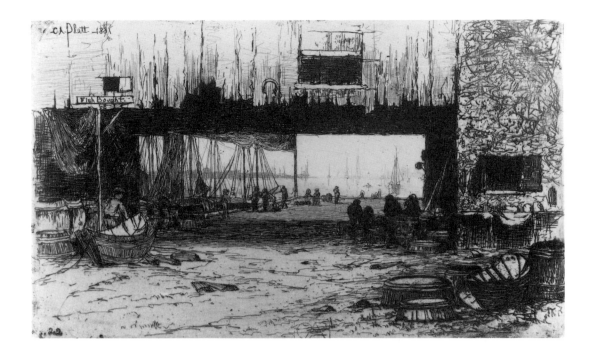

on the plate out-of-doors and then biting it in the etching room at the top of his house. Before Platt left, Haden brought out his extensive collection of Rembrandt etchings and gave his visitor an autographed copy of his pamphlet on Rembrandt and his students. In his letter home, Platt registered admiration for Haden's broad knowledge of his craft but refrained from praising his art. He encouraged his family to attend the British etcher's American lecture tour when it took place during the coming autumn.

Platt did not remain in London long enough to accept Haden's offer of a tour of the Thames and its beauties, but he did make a brief sail on his own, traveling down the river as far as Woolwich. He was tempted by the picturesque boats, old houses, and streets he saw, "but the tendency of all these things would be to make me etch," he wrote, "and at present, for some little time I wish to keep out of that."[20] He was still discussing picturesque scenes when he traveled through Belgium that summer, especially admiring the colored sails of the boats in Antwerp harbor. To his great disappointment, however, the charm of the fishing craft was diminished by the modern buildings that were replacing old

structures along the quays, and he continued to search for houses he described as "the rale old shtock." When he finally settled in Paris, he remained true to his word and devoted himself to painting until the following year.

Although Platt resisted making plates during his first months in Europe, his promise to set etching aside had not prevented him from gathering resources for later projects. In a small green sketchbook that he used when he first arrived in London, he had jotted: "photographs — M. F. Hollyer/9 Pembroke Square/W. Kensington."[21] This note was one of the earliest signs of Platt's interest in the medium that would play such an important role in his book on Italian gardens ten years later. It also alludes to the possibility that he would use photography among his reference materials for subsequent paintings and prints. *The Cloisters, Westminster Abbey,* 1883 (fig. 2.10), for example, with the complicated filigree of its iron gateway, suggests Platt's reliance on commercial travel photographs for recalling architectural detail. His sketches from this first summer in Europe were "all in black and white," he wrote, "... and many of them more like notes such as I made last summer in the Provinces."[22] But he

had begun to find this sort of data inadequate for his needs and made a pledge to do carefully studied drawings that would be useful in creating paintings as well as etchings. In the meantime, he continued to collect photographs of picturesque subjects, sometimes enclosing them in letters home. He found that photography shops could be more useful to his search for material than guidebooks: "they are often a guide to finding the good things," he wrote from Le Mans.[23] But locating a photograph with a point of view that he would consider copying proved less fruitful, and for this deficit he rather petulantly blamed the photographers, claiming that they were not artists.[24] In several instances he apologized to his family for sending photographs that did not do justice to his written descriptions. One such occasion was his visit to Mont St. Michel, where the photographs he purchased were inadequate to recall the corners of town that impressed him most.[25]

Platt's opinion of photographers as artists began to change when he reached Honfleur in September of 1882 and made the acquaintance of an Englishman named Ferguson. He wrote enthusiastically to his family that this amateur photographer "had made quite a lot of capital photos of many of the places I had been sketching," and he had assured Platt that he would be happy to shift his camera in order to supply him with a photograph of the exact view he had been working on.[26] The usefulness of such a personalized source cannot be minimized. In addition to providing accurate details, the camera could preserve a specific angle or viewpoint and could offer Platt the means to crop a subject easily through later manipulation of the photographic print. He mined all three of these uses of photography, but infrequently relied on the medium as an exclusive source.

In January 1883, the illustrator and etcher Joseph Pennell visited Platt in Paris while en route to Italy to begin a commission to illustrate William Dean Howells's essays on Tuscan cities for *The Century Magazine*.[27] Platt was cordial to Pennell, but he voiced the criticism that he "looks upon art in the light

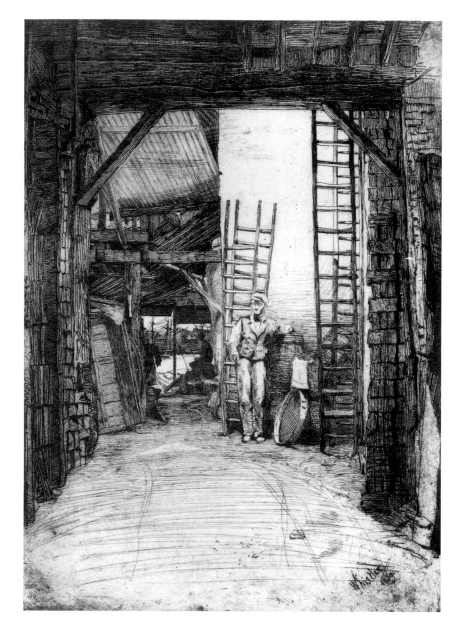

of business and talks about it in that way."[28] Although Platt had turned down the *Century* job,[29] he realized that he might also earn a living from his etchings and assured his family that he would take advantage of opportunities to sell them to publications. Encouraged by his earlier success at exhibitions, he sent etchings to every Paris Salon from 1883 through 1886. He engaged his brother, Jack, to handle sales of his prints at home, and he sold his 1883 plate of *Mud Boats on the Thames* (R. 44) to the New York publishers

FIG. 2.9
James McNeill Whistler, American, 1834–1903. *The Lime Burner*, 1859. Etching and drypoint, 9 7/8 × 6 7/8 inches. The Museum of Art, Rhode Island School of Design. Gift of Richard and Carole Morsilli. 81.257

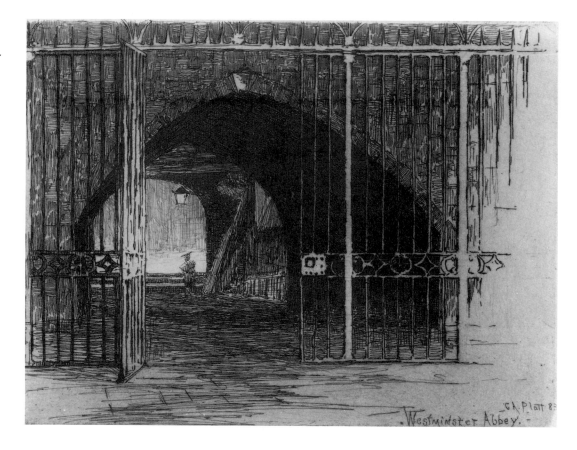

Cassell and Company for use in Sylvester Koehler's *Original Etchings by American Etchers.*

In 1883 Platt began to make commissioned plates, completing the view *Inner Temple Lane* (R. 48) for an edition of Charles Lamb's *Essays of Elia*[30] and an etching of Oxford (R. 49) for G. P. Putnam's Sons.[31] In 1884 he made two Dutch subjects (*Dordrecht from the Maas* [R. 53] and *A Windmill* [R. 54]) for a special subscription edition of Edmondo de Amicis' *Holland and Its People*.[32] The following year he produced another group (*Toledo* [R. 66], *Bridge at Saragossa* [R. 67], and *Old Gate-Tower at Barcelona* [R. 68]) for a revised, deluxe edition of de Amicis' *Spain and the Spaniards*.[33] Among Platt's papers there exists a mounted albumen photograph of Toledo that reveals the extent to which he could rely on photography when necessary. Clearly, he exploited this photograph in his etching *Toledo*, flipping the architectural image in the print, minimally

altering details, and reproducing the shadow cast on the passageway and the figure at its entrance. Although he thought of going to Spain to execute this commission, Platt's letters leave no record that he actually made the trip. In fact, since he wrote to his family from Paris that the fee would scarcely cover the expenses of the journey, there remains the possibility that all three Spanish subjects were based on commercial photographs.[34]

As Platt's appreciation for photography and its uses developed, he decorated his rooms with photographs, sought examples by such noted practitioners as Adolphe Braun,[35] and finally began to take pictures himself. Ever critical of faulty composition, he sent his family a photograph of the marketplace at Honfleur in the fall of 1885 with the comment that it was not taken from the right point of view.[36] But in October he exclaimed that he was becoming skillful with the camera and found it more accommodating than pencil or oils in the damp Hon-

fleur climate.[37] Indeed, a small, dramatically cropped etching of 1887 entitled *Low Tide, Honfleur* (fig. 2.11) bears the imprint of his confidence as a photographer, abstractly reducing the dark shell of a boat by placing it just below a high horizon, then rhythmically repeating its mass in the reflection of the shallow water. Spare, even Japanese in effect, it is one of Platt's most striking and original images.

Clearly Platt's ability to represent nature was not locked into his immediate presence at a site. Although he spent a good deal of time working out-of-doors, he preferred to draw on his plates in the studio. In 1885 he wrote Sylvester Koehler about his print of the previous year, *Rue du Mont Cenis, Montmartre* (fig. 2.12), noting that it was "the first & only etching I have done from nature. . . . Nearly all the drawing on the plate was done there on the spot." He followed this statement with a comprehensive description of his own etching process:

I took the plate down to my studio and bit it immediately, putting in the sky & the wall & the shadow of the wall on the street toward the end and between the bitings. The heavy lines on the wall were drawn from nature, the light & fine ones were done at the very last by using a very fine needle. After that had got well started biting in the bath I poured on pure acid which as you see deepened slightly & then ran the lines together giving a sort of tone which I was after. There was only one state to the plate, I never retouched it at all as far as I can remember & it came out exactly as you see: I use nitric acid half & half with water always a pretty sharp needle with enough tooth to "grab" the copper well: the straight lines in my etchings are bitten for 30 minutes I generally get impatient toward the end & pour on pure acid in parts.[38]

Ordinarily, Platt composed his plates in the studio, referring to sources that included oil, watercolor, and pencil sketches, fully worked up drawings, and photographs. Understandably essential to his development of paintings, the use of oil sketches as models for etchings was as idiosyncratic as his choice not

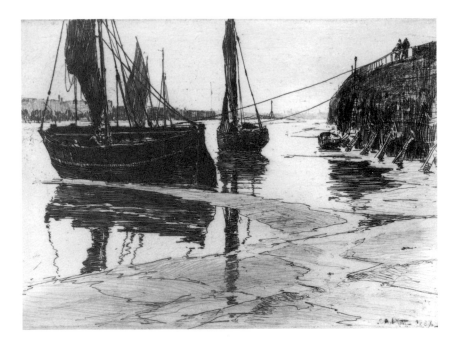

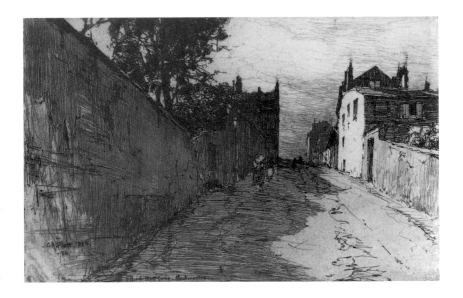

FIG. 2.11
Low Tide, Honfleur, 1887
(cat. no. 19).

FIG. 2.12
Rue du Mont Cenis, Montmartre, 1884 (cat. no. 9).

FIG. 2.13
Canal at Chartres, 1883
(cat. no. 7).

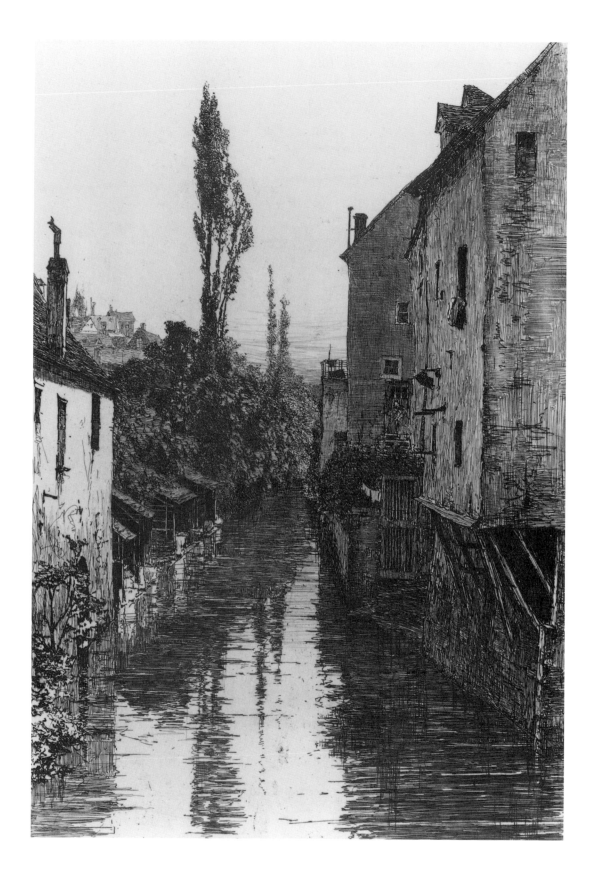

to draw plates out-of-doors. A small oil provided the basis for his *Canal at Chartres*, 1883 (fig. 2.13),[39] and another (fig. 2.14) served as a model for Platt's etching *Au Cinquième, Chartres*, of 1885 (fig. 2.15).[40] In both instances the print clearly reverses the painted image, adding detail while essentially preserving the composition. In the etching *Au Cinquième, Chartres*, the high cropping of the attic roof and the suggestive void of the wall below are two indications of Platt's imaginative transformation of the painted motif. Generous with linear information when it enhanced the picturesque intent of his subject, he refused to elaborate once the impression was complete.

Platt's characteristic clarity and selectivity were immediately noted by those who studied the progress of his etchings. When Van Rensselaer revised her essay on American etchers in 1886, she spoke specifically of Platt's restraint:

He had known precisely what he wanted to do, and precisely what to do and what to leave undone in order to succeed. And the leaving of things undone is no small part of the artist's task with such a craft as etching. In the great *art of omitting* Mr. Platt's is truth accomplished, and this is what gave his prints their simplicity, their harmony, their breadth and unity of effect.[41]

Economy of means was essential to Van Rensselaer's aesthetic, as it was to that of both Haden and Whistler. In his 1886 preface to the publication of *A Set of Twenty-Six Etchings*, Whistler dealt specifically with the concept of restraint. One of his "Propositions," republished in *The Gentle Art of Making Enemies*, repudiated all types of excess in etching, including any attempts to overstep the limits of technique in either plate size or in the use of marginal vignettes known as remarques.[42] Although Platt, in his youthful ambition, sometimes worked on plates as wide as twenty-seven inches (for example, *Deventer*, 1885, R. 63), he was also comfortable with smaller plates; however, he followed Whistler in rejecting the use of the

remarque and focused his attention on the central image. Unlike many American etchers in the 1880s, he refused to seek commercial success in reproductive etchings, although he made a plate of this type, a copy of family friend George Henry Hall's painting *The Clover Market, Cairo*, very early in his career.[43]

Despite Platt's familiarity with the work of both Haden and Whistler, neither artist dominated his development as an etcher. With nationalistic pride, he acknowledged Stephen Parrish as his first master,[44] and, dismissing Haden's indifference, he lectured his parents on the distinction of his countryman: "You

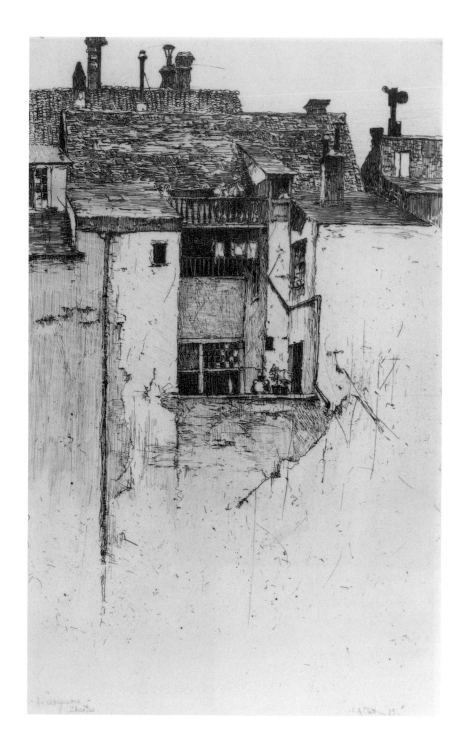

FIG. 2.15
Au Cinquième, Chartres,
1885 (cat. no. 13).

all know, or you ought to know, that Parrish is our man. He is the American Etcher. He works in a totally different way from Seymour Haden. The latter I think is not very broad in his views of other men's etchings so he does not seem to appreciate Parrish."[45] The names of other etchers did not often enter his letters home, but they undoubtedly cropped up in conversations with other artists. Adolphe Appian, an important figure in the earlier French etching revival, was among the foreign artists mentioned by Platt, who admired his coastal scene at the 1882 Salon and even considered entering his painting studio as a student.[46] More important, though not mentioned in his letters, was the influence of Charles Meryon, whose etchings of Paris had been brought to the attention of the French public by Charles Baudelaire. Platt was undoubtedly familiar with Meryon when he began his own plates of the city in the mid-1880s. He could have seen Meryon's prints in Paris and would also have been aware of him through an essay by Frederick Keppel appended to the 1886 version of Van Rensselaer's "American Etchers." At some point Platt acquired an autotype facsimile (published in London in 1886)[47] of Meryon's *La Morgue, Paris* (fig. 2.16), a stunning architectural view of the old city that relates to his own 1886 etching, *Quai des Orfèvres, Paris* (fig. 2.17). References to prints by Meryon also occur in other Parisian subjects by Platt, such as *Under the Pont Marie, Paris* (1887, R. 86), and *St. Gervais, Paris* (1887, R. 88).

Architectural subjects are recurrent in Platt's etchings, but they do not predominate. He delighted in the discovery of old houses that had not been compromised by restoration (figs. 2.18, 2.19) and disdained the modern buildings that had already disrupted the visual integrity of many European towns. When he found a town that met his aesthetic requirements, he usually depicted it as a component of a broader seacoast or landscape view (fig. 2.20). Having found it easier to "etch from oilsketches than to paint from black and

white ones,"[48] he focused his choices accordingly.

Although Platt had been unimpressed with French landscape painting when he first arrived in Paris, he gradually became a convert to its technical merits. He ranked it below that of the Hague School,[49] which he proclaimed the most important contemporary school of landscape painting, but well above that of the English and Germans who "think too much of having some striking incident to illustrate and [that] a little printed matter ought to go along with each picture to make a thing complete."[50]

Platt did not often include figures in his etching compositions, although he acknowledged their appropriateness for certain subjects. The procession that took place on the day of the annual fete of the seaside town of Larmor, for example, made a strong impression on the artist, who described the native costumes in a letter of 1884.[51] This event confirmed the importance of the town's main pier or *quai*, from which a steamer surrounded by fishing boats carried dignitaries (including Platt) out to sea for the ritual blessing of the fishermen's crop. In his 1885 etching *Pier at Larmor* (fig. 2.21), Platt depicted the pier with a central, forthright thrust that commercial photographs tended to circumvent (see fig. 3.15). His view incorporates figures, but they are secondary to the massing of boats at the pier's end, and their presence is mitigated by their scale. This seamless, nonnarrative presence of man in nature represented a Hague School approach that also influenced later Platt subjects, for example, *A Misty Morning* (1888, R. 96), a composition in which men are seen dragging a cart out of the water as they unload a fishing boat.[52]

Another example of Platt's control of the figure in landscape appears in the prints he made in 1886 for Dean Sage's limited edition publication *The Ristigouche and Its Salmon Fishing* (figs. 2.22, 2.23).[53] If Platt made the sketches from nature, he must have done so during the summer of 1885 when he returned to America for a visit with his family. Fishermen appear in three of the four etchings: *Two*

Men Paddling in a Canoe (1887, R. 77; the tailpiece for the chapter, "Tackle and How to Use It"), *Salmon Fishing* (fig. 2.22, also titled "Upsalquitch Pool"), and *Three Fishermen* (1886, R. 76; also titled "Almost Landed"). In spite of the presence of figures, these small prints are distinguished by an abundance of negative space far more than by any narrative quality.

Platt's training at the Académie Julian, where he enrolled in the fall of 1884, improved his skill at figure drawing and also had a visible influence on his etchings. Under the guidance of Jules Joseph Lefebvre and Gustave Rodolphe Boulanger, he began to apply a looser stroke to his paintings. This quality gradually found its way onto his etching plates and generated a style of facture that relieved the crisp linearity of his early work. Although the vertical appeal of the masts of

FIG. 2.16
Charles Meryon, French, 1821–1868. *La Morgue*, 1854. Etching, 9 1/8 × 8 1/8 inches. Museum of Art, Rhode Island School of Design, Providence, Rhode Island. Gift of the Fazzano Brothers. 84.198.786

FIG. 2.17
Quai des Orfèvres, Paris,
1886 (cat. no. 15).

FIG. 2.18
Rye, Sussex, 1884 (cat. no. 8).

FIG. 2.19
Lannion, 1883 (cat. no. 6).

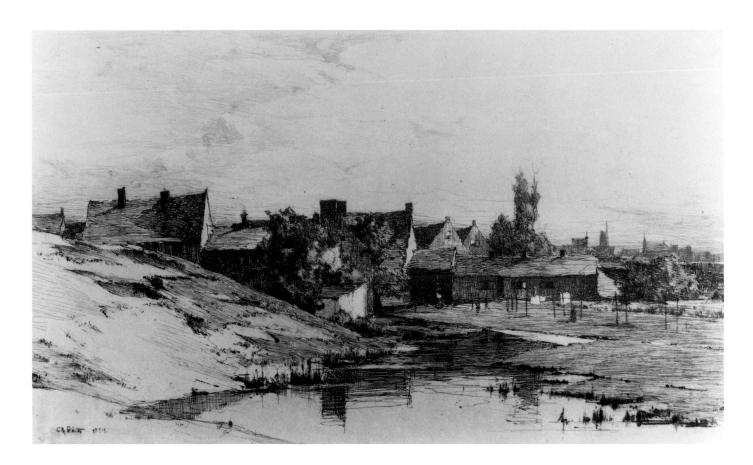

FIG. 2.20
Old Houses Near Bruges,
1884–88 (cat. no. 10).

schooners and sloops kept them from vanishing from his repertoire, Platt's landscapes of the late 1880s, and even his architectural subjects, suggested his enhanced skills with the brush.

Critics identified this shift as early as 1885 when Sylvester Koehler published Platt's *Rue du Mont Cenis, Montmartre,* in his book *Etching.* Koehler noticed "a marvelously painter-like feeling in this etching, as if it were brushwork, and it conveys to us a sense of color, laid on in broad washes,—an effect which is due to the masses of white, gray and black, skillfully kept together and opposed to one another."[54] Over the next few years, these effects became even more pronounced and produced a softer, more reflective mood in Platt's landscape etchings. *A Brittany Landscape* of 1887 (fig. 2.24), with its irregular sandy path and low farm buildings, is a study of rocky pastures and organic vegetation, drawn with long strokes and animated with rich drypoint marks. The existence of an oil

sketch of this subject is a reminder of Platt's interest in creating etchings after his paintings and offers additional evidence of his parallel development in the two mediums. Another drypoint of 1887, *Cape Ann Willows* (R. 92), shows a similar attempt to transfer the soft impression of sandy bluffs and grassy patches onto an etching plate. This painterly tendency emerges with even richer control and variety the following year in the drypoint *Artichoke Bridge* (fig. 2.25), a print in which he simulates a wide range of materials and textures. The contrasting densities of foliage and the distinctions made between clear water and algae in the stagnant pool demonstrate a mastery of technique that is matched by Platt's intense awareness of nature. The introspection that one senses in these landscapes of the late 1880s reflects a turning point in Platt's sentimental education. Both the joy of his courtship and marriage in 1886 and the tragic loss of his wife and unborn twins in 1887 had deepened his

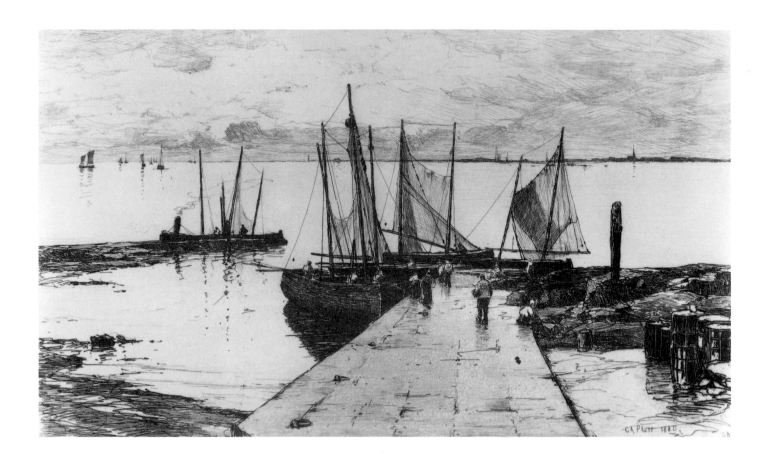

emotional maturity and may have led him to explore both the solace and promise of nature at this point in his career.

In the late 1880s Platt also expanded on another favorite theme: that of ships in port. The death of his father-in-law, printing press manufacturer Richard Hoe, in 1886 and the subsequent return of Platt and his bride to the United States limited the number of etched plates he produced that year. Fortunately, the New York harbor was an untested theme for Platt, and his fresh attempts to characterize it soon drew the attention of American critics. Although the first of these subjects, *South Street, New York* (1886, R. 83), generated only six proofs, the New York etchings of the next few years heightened Platt's reputation when they were exhibited at the Hermann Wunderlich Gallery in November 1889. Two catalogues of Platt's etchings appeared that year: a checklist to accompany the Wunderlich show, and a descriptive catalogue written by Richard A. Rice of Williams College and

published by the DeVinne Press in New York.[55] The latter, listing both proofs and states, became the standard reference for Platt's etched work. By 1889 he had completed nine New York subjects, including two that identified major changes in the city's profile. Surprisingly, neither *Brooklyn Bridge* (1888, R. 98) nor *Buttermilk Channel* (fig. 2.26), with its distant outline of the Statue of Liberty, emphasized these monuments that had so recently become part of the skyline. Perhaps they represented to Platt the unwelcome technologies that were dramatically altering the city of his youth. In his New York etchings, he continued to concentrate on the unchanging silhouettes of tugboats and schooners (fig. 2.27), leaving the celebration of the new to another generation of artists.

From 1889 to 1920 Platt produced only eleven etchings, but despite the redirection of his career, he never abandoned interest in critical approval of his prints. When he finally resettled in New York in 1888, he resumed

FIG. 2.21
Pier at Larmor, 1885 (cat. no. 12).

FIG. 2.22
Salmon Fishing, 1886 (cat.
no. 17).

FIG. 2.23
A Fishing Camp, 1886 (cat
no. 16).

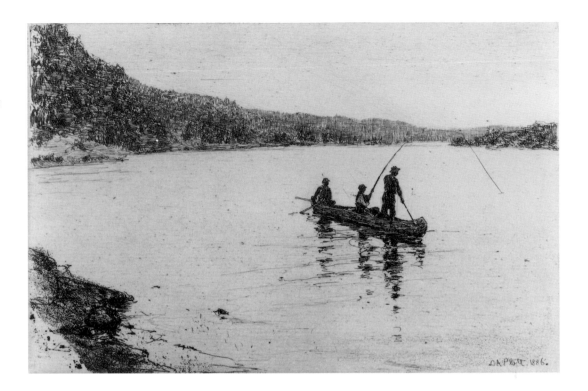

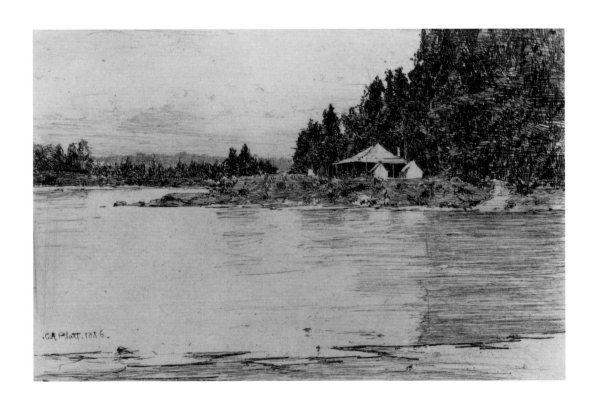

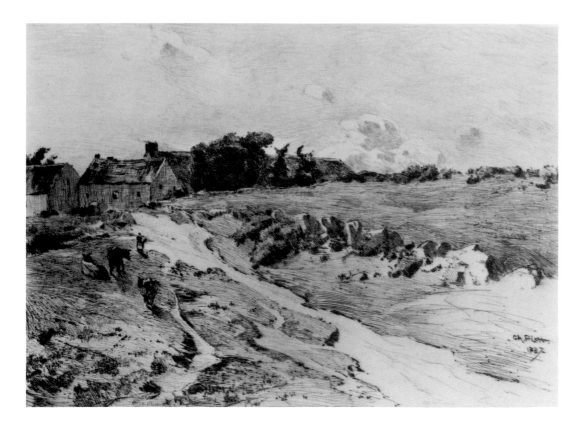

FIG. 2.24
A Brittany Landscape,
1887 (cat. no. 18).

FIG. 2.25
Artichoke Bridge, 1888
(cat. no. 20).

44

FIG. 2.26
Buttermilk Channel, 1889
(cat. no. 21).

FIG. 2.27
*The Two Sloops (East
River)*, 1889 (cat. no. 22).

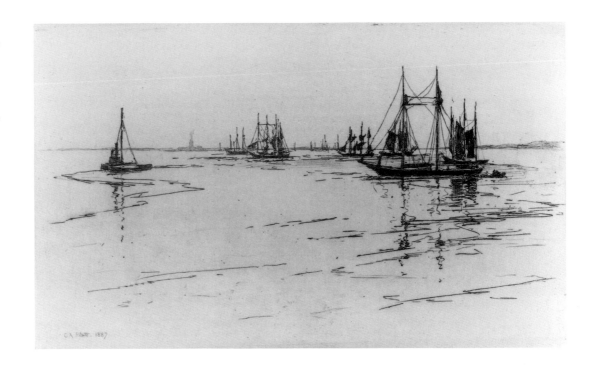

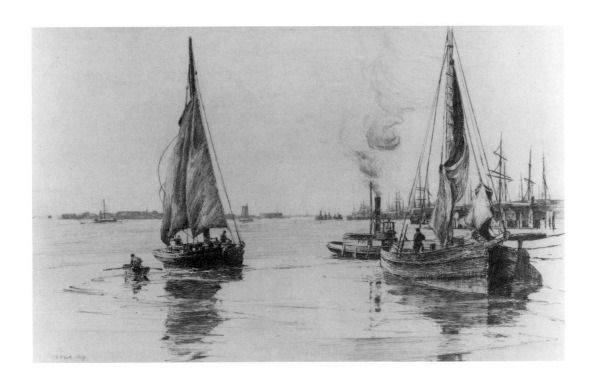

FIG. 2.26
Buttermilk Channel, 1889
(cat. no. 21).

FIG. 2.27
*The Two Sloops (East
River)*, 1889 (cat. no. 22).

active participation in the New York Etching Club exhibitions. The club acknowledged Platt's stature by including an impression of Platt's *Canal Boats and Tugs* (1887, R. 85) in its 1889 catalogue; it reproduced his portrait and a pen and ink drawing after his painting *A Corner in an Etcher's Studio* (see fig. 3.17) in 1891; and in 1892 it featured his etching *Low Tide, Honfleur* (fig. 2.11). Distinguished among his peers, Platt was named to the New York selections committee for etchings to be shown at the 1893 World's Columbian Exposition in Chicago. His own works were awarded a bronze medal at the fair.[56]

When Henry R. Wray's *A Review of Etching in the United States* was published in 1893, Platt's importance was implied in the introduction. "The author has endeavored to treat as little of personalities as possible," Wray wrote, "and for this reason has omitted any mention of even the works of men of such assured standing as Thomas Moran, Jas. D. Smillie, C. A. Platt, and others."[57] In summarizing the American etching revival, this publication also marked the end of its momentum in the nineteenth century. Oversized plates and etched reproductions of paintings had flooded the market, and even the New York Etching Club's president James D. Smillie noted the common consensus that "etching to the New-Yorker is an orange squeezed dry—he has no further use for it or interest in it."[58]

When Platt began to look at the possibilities of pursuing landscape architecture in the early 1890s, he, too, abandoned etching,[59] but the public appeal of his prints remained strong. Print publisher Frederick Keppel mounted an exhibition of 108 of Platt's etchings in 1907, again incorporating Van Rensselaer's comments from the 1886 catalogue.[60] Now recognized in his new field, Platt impressed a critic for the *New York Times* who admitted nostalgia for the subjects of his prints in an article entitled "And He Etches, Too."[61] In the early years of the twentieth century, Platt's New York scenes were already "not of to-day: they register picturesque views and bits of views which are no longer

quite the same owing to changes which have occurred during the two decades past." Still, his reputation as an etcher remained intact, and the exhibition caused the same reviewer to regret "that he should have relinquished the etcher's tool, no matter how much more attractive it may have been to model landscape in an artistic way." Royal Cortissoz's introduction to *Monograph of the Work of Charles A. Platt*, which appeared in 1913, also referred to Platt's beginnings as an etcher but moved quickly on to his more recent architectural accomplishments. Of the etchings, Cortissoz noted that they "interested me then as they do now for their easy composition, their unforced picturesqueness and their strong line."[62]

In the 1920s, following the appearance of two new plates, Platt witnessed a flurry of institutional interest in his etchings: the Brooklyn Museum exhibited a group of twenty-six, given by Frank L. Babbott, including his 1917 etching *The Insel, Holland*;[63] the Cleveland Museum of Art mounted a loan exhibition of Platt etchings;[64] and the John Herron Art Institute in Indianapolis announced the gift of two of Platt's prints.[65] The new works were *The Mountain*, 1920 (fig. 2.28), a planar composition of a snowy landscape seen through a scrim of leafless trees that relates to one of Platt's Cornish photographs (fig. 2.29), and *Meadow Brook*, also 1920. Both were related to paintings of Cornish, New Hampshire, which Platt had made his summer home since 1889. Two other exhibitions kept Platt's name before the public during the 1920s: in 1922 Doll and Richards showed his works in a group show in Boston;[66] and in 1925 The Grolier Club in New York mounted a major exhibition of Platt's etchings, which now numbered 120.[67]

By the date of the Grolier Club retrospective of Platt's etched work, one might have expected public interest to have waned. But the onset of modernism and a fresh memory of the destruction wrought by the First World War had created an even greater longing for picturesque landscapes among Platt's admirers. He continued to be championed by print

FIG. 2.28
The Mountain, 1920 (cat.
no. 23).

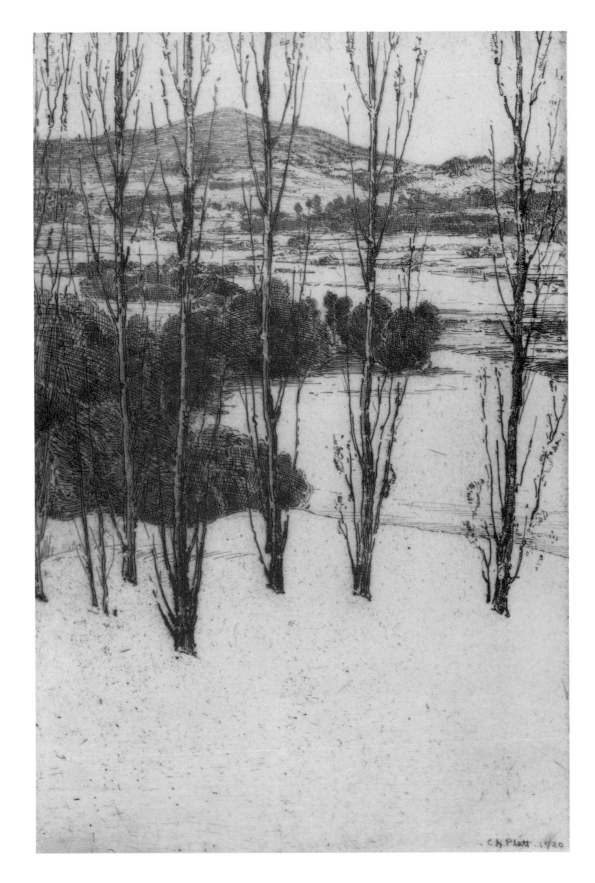

FIG. 2.29
Mount Ascutney, Cornish, New Hampshire. Photograph by Charles A. Platt. Courtesy members of the Platt family.

specialists, and his popularity was bolstered by the fact that a new generation of print-makers had again revived the etching medium in America.[68] In 1927, Frank Weiten-kampf, the distinguished print scholar at the New York Public Library, expanded his earlier appreciation of Platt in an article for *The Print Connoisseur*. The only fault he could find in Platt's Grolier Club show was that his facile, faultless mastery of technique was in itself disconcerting.[69] Weitenkampf himself mounted a memorial show of Platt's

etchings at the New York Public Library in 1934.[70]

When Platt died in 1933 he left a body of prints that included not only etchings and drypoints but also lithographs.[71] Few printmakers of his generation had managed to maintain so constant a profile as he, and none had established a career in a different field while retaining such distinction as a graphic artist. Clearly, the picture painted of Platt in his numerous obituaries portrayed a man of many parts. His skill as an etcher took its place in a list of talents that was dominated by his work as an architect. But while the subjects of his prints could not be considered innovative (and, indeed, a reviewer of Platt's 1938 show at the American Academy of Arts and Sciences thought they lacked marked originality),[72] their appeal to collectors remained strong. They represented to their viewers an art that was both intimate and technically fluent, that revealed personality in the autograph of line, and that suggested a world that could be explored and enjoyed without conflict. In this respect, the traditions embodied by Platt's etchings were a consolation to twentieth-century viewers who could appreciate qualities of composition and effect but who were perhaps not yet ready to accept the disquieting content and technique of the art of the modern era.

The Paintings of Charles A. Platt

ERICA E. HIRSHLER

FIG. 3.1
Charles A. Platt in his
studio, Paris, 1885.
Courtesy members of
the Platt family.

"HE MAKES A WORK of art because he cannot help himself," reported the New York critic Royal Cortissoz of his friend Charles Platt.[1] These words were well suited to describe a man whose engagement with the arts expanded in scale and complexity throughout his life, starting from simple depictions of landscapes in ink and in oil and culminating in the creation of gardens and buildings for which he reshaped nature itself. Platt is best remembered as a landscape designer and architect, but his achievements in these three-dimensional media had their foundations in the artistic principles he developed and nurtured during his earlier years as an etcher and a painter.

Platt had declared his intention to pursue an artistic career by the age of eight, and he began his professional training in his native New York City at the National Academy of Design in 1878, when he was seventeen. His systematic studies, in which he learned first to draw from the antique and then from life, were routine for an aspiring painter, who typically was advised to master the elements of drawing before ever attempting to put brush to canvas. Like many of his peers, Platt was eager to paint, and he supplemented his studies at the academy with painting classes at the Art Students League, attending both institutions concurrently for three years.[2]

Despite his early interest in painting, Platt established himself first as an etcher; his precocious accomplishments in that medium are described elsewhere in this catalogue. His serious work with brush and palette did not begin until 1882, when he left the United States for a period of extended study abroad. Platt sailed from New York in May of that year, proudly noting in a letter to his mother that during the crossing he had been seasick for only two days. His ultimate destination was Paris, the capital of the international art world and a mecca for art students, most of whom sought to enroll at the prestigious national Ecole des Beaux-Arts or at one of the independent art academies that flourished during the last quarter of the nineteenth century.[3] Since Paris was deserted during the summer and October marked the beginning of the art season, Platt clearly intended to spend several months traveling, visiting collections, and sketching the countryside. He landed in England, in the company of the American genre painters George Henry Hall and Jennie Brownscombe, and journeyed on with Hall to Belgium and Paris. By the end of June, Platt was in Chartres, where he rented a room, bought some art supplies, and began, at last, to paint on several "good sized canvases."[4] Reveling in the town's medieval architecture, Platt even made arrangements to use a local miller's small boat for sketching buildings from the River Eure, but after a

week of rainy weather, he lost patience and decided to travel on toward the west to find subjects for his brush.

Without a companion, Platt evidently depended upon the commentary in his guidebook to plan his trip, confessing that he knew nothing about his next destination, Le Mans, except that "Murray [publisher of one of the most popular guides] speaks of it as interesting from its antiquated appearance."[5] His itinerary led him west into Brittany and then northeast to Normandy. He went by train, following Murray's recommended route from Vitré to Rennes, Redon, Vannes, Quimper, Brest, Morlaix, Lannion, Perros-Guirec, Dinan, Mont St. Michel, Grandcamp, Caen, Houlgate, Trouville, and Honfleur, tracing a circular route along the picturesque coast. Despite the fact that Platt headed directly for Brittany during his first excursion into the French countryside, his journals contain no mention of the established colonies of American artists at Pont-Aven and Concarneau, nor of their French colleagues. He seems instead to have been staunchly independent, determined to strike out on his own and to learn from trial and error, more inclined to remain aloof than to attach himself to any particular group or school. His choice of the northwest provinces as his destination was not unusual; these locations were described not only in such tourist guides as Murray's but also in more specialized handbooks, including May Alcott Niereker's *Studying Art Abroad and How to do it Cheaply* of 1879, which described Breton towns where "an artist can rest with delight for many months, as everything . . . is sufficiently attractive to keep the brush constantly busy."[6]

Platt seems to have been most interested in landscape subjects, and both Brittany and Normandy were especially favored by artists who wanted to sketch out-of-doors and to explore the ephemeral effects of light and atmosphere that seemed so enhanced in these seaside locations. As the painter Cecilia Beaux described it, in Brittany "Art and Nature were shown . . . [to be] one and inter-

changeable."[7] Platt had heard the French countryside praised by colleagues and friends in New York and had read descriptions of it in novels and travelogues. Landscape paintings depicting Brittany and Normandy were also widely exhibited in America. These French provinces also provided an opportunity to retreat from contemporary life, a privilege some Americans, including Platt, found especially appealing. They hoped to leave behind the brash and inartistic modernity of life in the United States and, seeking an aesthetic refuge in the past, looked in Europe for the centuries-old rural traditions they believed their native land lacked. Edward Simmons, a New England native who was a resident of the Breton village of Concarneau from 1881 to 1886, recalled: "I felt as if I had suddenly plunged back into the Middle Ages."[8] Like Simmons, Platt consistently sought out villages that were known for their medieval appearance. He commented favorably on the "old houses with projecting storeys, streets where the houses nearly meet at the top, little gables and balconies, . . . old carved windows and doors,"[9] and in his correspondence the term "picturesque" appears repeatedly. It was his highest compliment, and he despaired of any modern improvements that disrupted the old buildings he most admired. Platt also liked traditional Breton costumes but showed no interest in painting them, preferring instead to make architectural studies for etchings and as many landscape sketches as he could manage in the sporadically rainy weather.

Despite his apparent reluctance to join any established art colony, Platt did come across other painters whose work would influence his own. In mid-August 1882 at Grandcamp, he met the American expatriate Frank Myers Boggs, whom Platt described as "just like a Frenchman."[10] Boggs had been in France intermittently for six years and, by 1882, was established as a successful painter of harbor views and picturesque street scenes, the same subjects that most appealed to Platt. The two artists sketched together in the small fishing village of Isigny, and Platt became interested

FIG. 3.2
Low Tide, 1883 (cat. no. 24).

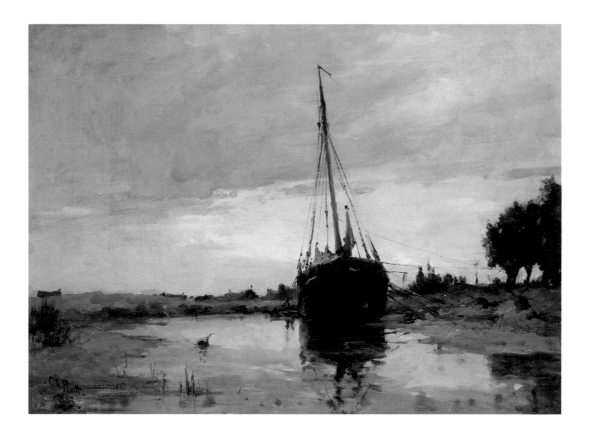

in the watery effects apparent at low tide. He developed this subject further at Houlgate and Honfleur, and it would become the theme of his first finished oils (fig. 3.2).

Platt spent a month at the popular beachside resort of Honfleur, where he was pleased to be reunited with George Hall and family, although the consequent increase in his social activities interfered with both Platt's natural reserve and his single-minded zeal for painting. He complained to his parents that any failure to socialize each evening with various members of the British and American community would cause criticism, "as the young men are scarce."[11] He worked steadily nevertheless, increasing the scale of his oil sketches and completing them more quickly, intending to use them later to create both etchings and finished paintings.

Platt finally settled in Paris in October. Although he had come to Paris to study painting, he spent part of the following months making salable etchings of the scenes he had recorded throughout the summer. He made

arrangements to take over a studio at 34, rue de la Victoire, from Henry Oliver Walker, an American artist whom Platt described as "the kind of man that Henry James writes about as peculiar to Boston." He recognized Walker's Barbizon painting style with the remark, "Bostonians may appreciate [Walker's] work which savors of Corot," an enthusiasm Platt seemed not to share, although he and Walker later would become close friends.[12] Since his new rooms would not be available for several weeks, Platt returned to Chartres, again sketching the old houses and weathered walls of the ancient town and borrowing the miller's skiff to use as a floating studio.

In Paris some weeks later, Platt visited Boggs, who had also returned to the capital for the winter season. He not only admired the elder artist's paintings but envied his financial success, which Platt attributed to the large number of oil sketches Boggs had managed to produce over the summer, all of which had been sold. Platt was concerned

about his finances, and the earnest reports of his economies that are repeated throughout his correspondence seem to indicate Platt's desire to prove to his family that he was not frittering away his youth.[13] Eager to keep his name before the American public (thus encouraging sales), Platt started to make watercolors to exhibit later in New York, comparable works to the etchings that he continued to sell there. His mood turned jubilant when he sold five oil paintings at the end of November—four to an Englishman, Major Forster, and one to a cousin of Platt's friend and fellow artist Stephen Parrish. Platt netted an unexpected nineteen hundred francs and, exhilarated, set about to buy a few pieces of antique furniture for his studio, taking advantage of his proximity to Paris's most famous auction house, the Hôtel Drouot (fig. 3.3).

Buoyed by his success, Platt began to work on a large canvas, hoping to create a painting for the Paris Salon. He did not consider his lack of formal instruction in Paris, nor indeed his relative inexperience as a painter, to be obstacles, noting confidently, "it is the custom over here to do the Salon picture the first thing after getting back from the country." He explained:

Then you get the criticism . . . before it is sent in [to the jury]. My subject is some boats at low tide in the Harbor of Trouville. The tide is running out and the boats are leaning up against the quay, in the distance are some dark buildings and a bridge and a light cloudy sky reflected in the water. . . . I shall do my best but if it is not a success I shall not send it to the exhibition.[14]

Platt devoted himself to the painting for the next several weeks. He returned to Trouville for three days in December, making more sketches to incorporate into his composition. He had never before worked on a canvas of such scale, about five-by-three feet in size, but he pronounced it "about finished" at the end of January and hoped that soon Frank Boggs and several other painters would come to see it and offer their advice.[15]

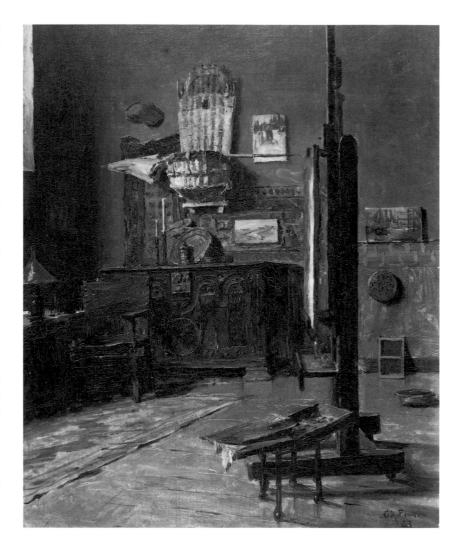

FIG. 3.3
The Artist's Studio, 1883
(cat. no. 25).

Their comments are unrecorded, and Platt's Trouville picture never appeared at the Salon of 1883 (he exhibited only two etchings there). He evidently proposed the painting to the Salon's jury, which accepted work until mid-March, but discussion of the topic all but disappears from Platt's letters by April save for a brief hint in May, and it seems apparent that his painting received one of the disappointing green rejection slips issued by the jury throughout the six-week judging period.[16] It would be Frank Boggs who displayed a scene of boats stranded at low tide under cloudy skies, a view of the port at Isigny where the two Americans had sketched together the preceding summer (fig. 3.4). Boggs's entry was a success; it was purchased immediately by the French government—and Platt strove

to put the experience behind him.[17] He spent the weeks before the Salon opened (and several weeks thereafter) in England, visiting his erstwhile patron Major Forster at his manor in Exbury and sketching along the Thames.

After a brief sojourn in Lacroix St. Ouen on the River Oise north of Paris with two American friends, Kenneth Cranford and Dennis Bunker (fellow New Yorkers and Paris neighbors who were studying with Jean-Léon Gérôme at the Ecole des Beaux-Arts), Platt spent the rest of the summer of 1883 in Dordrecht, in the south of Holland. Dordrecht was one of Holland's oldest and most prosperous municipalities. It was also a popular destination for American painters, who found it easily accessible from the port at Rotterdam as well as suitably picturesque, with its richly decorated houses and functioning windmills.[18] Its situation at the confluence of several rivers ensured its appeal to Platt, who still favored marine landscapes with sailboats and scudding clouds. His decision to spend so much time there may have been influenced by Boggs, who arrived in Dordrecht with his wife a few days after Platt and took a room at the same hotel. Platt enjoyed Holland and found himself drawn to the work of the Hague School, which he proclaimed to be "*the* school of today for landscape."[19]

The artists Platt so admired had rediscovered the pastoral subjects of Dutch art of the seventeenth century, Holland's "golden age." Several of them had studied in France, affiliating themselves with the Barbizon painters, but they returned to Holland to create a new national style. Favoring simple views of their distinctive, sky-filled countryside, these artists considered themselves the heirs of Hobbema, Cuyp, and Ruysdael.[20] In contrast to the deliberate independence from fellow painters Platt had cultivated the preceding summer, he now befriended several members of the Hague School. He first became acquainted with an as yet unidentified Dutch landscapist surnamed Calabar, who provided him with an introduction to Théophile de Bock, formerly a student of the influential marine painter Jan Weissenbruch. Platt pronounced Bock "a capital fellow and an 'A-1' painter," and traveled with him to the Hague,[21] where he was introduced to Jacob Maris, Josef Israels, and H. W. Mesdag, among others, all leading members of the Hague School.

The landscapes of these Dutch artists held great interest for Platt (fig. 3.5). Although the harbors and waterways of Holland lacked the nationalistic resonance for American painters that they held for the Dutch, the subjects nevertheless appealed to Platt, for he had always preferred water scenes with active overcast skies and suffused light. In characterizing the work of the Hague School in 1875, the Dutch critic J. van Santen Kolff wrote that these painters sought "to render an *atmosphere*; they give priority to *tone* rather than *color*. That is why they prefer to paint almost exclusively the effects of overcast weather; . . . they have unveiled the poetry of gray."[22] Platt's image of Dordrecht (fig. 3.6) displays these same characteristics, for its main theme is not architecture but the turbulent gray and white sky, which is painted loosely with thick, broad strokes enlivened with streaks of pink. The sky dominates fully three-quarters of Platt's composition; the silhouette of Dordrecht is reduced to a mere strip of windmills and church domes suspended between clouds and water.

Platt was pleased with his progress and

FIG. 3.5
Jacob Maris, Dutch,
1837–1899. *The Five
Windmills (Les Cinq
Moulins)*, 1878. Oil on
canvas, 32 1/2 × 50 7/8
inches. Courtesy Centraal
Museum Utrecht.

reported to his family that he was working on several pictures for exhibition in New York that would demonstrate his recent achievements. For the first time, perhaps inspired by what he felt he had learned from the Dutch painters he had met, Platt indicated that he thought he should seek formal instruction, although his overtures to the French artist Jean Charles Cazin, "the only landscape painter whose work I like much," went unanswered. Chastened by his experience at the last Salon, he planned no large painting for 1884, confessing that "I have at least found out some of the things that I cannot do."[23] Without the fanfare of the preceding year, Platt still sent two of his smaller paintings to the Salon jury in the spring and proudly reported to his family that "they are hung!" He continued, "the pictures are pretty large landscapes, Dutch subjects, and the best I have ever painted."[24]

One of Platt's 1884 Salon paintings, either *Paysage Hollandais—Novembre* or *Environs de Bruges* (current locations unknown), was rewarded with a prestigious position "on the line in one of the best rooms," an accolade that renewed the young painter's confi-

dence.[25] He described himself as "ready to begin another campaign against nature,"[26] and he set off from Paris in late May, again accompanied by Kenneth Cranford. This summer, Platt returned to Brittany, settling with Cranford in Larmor—a small fishing village about four miles from the large naval base at Lorient.

As he had done in 1882, Platt ignored the established painting colonies of Brittany's southern coast. Though Larmor occasionally had appeared in the work of the French painter Henri Moret, it was not an artistic center but rather the sort of working harbor town with picturesque architecture that Platt most admired. He turned it into an art community of his own, for several weeks after Platt and Cranford had settled there, they were joined by Dennis Bunker, replicating the companionship of the preceding summer at Lacroix St. Ouen. The three were a congenial and hard-working group, eager to make the most of their time abroad.

Platt stayed at Larmor until mid-October 1884, sketching harbor views and images of the rural countryside and almost ignoring the architectural subjects upon which he had

FIG. 3.6
*Dordrecht (Dordrecht on
the Maas)*, about 1883–84
(cat. no. 26).

focused during his last Breton excursion (fig. 3.7). He did draw the distinctive profile of Larmor's twelfth-century church of Notre Dame, whose squat stone spire rose above the huddle of slate-roofed granite cottages that made up the town (fig. 3.8), but he apparently never made a finished painting from the sketch, leaving the theme for his friend Bunker (fig. 3.9). Instead, most of Platt's Larmor views are centered on the beach and harbor (figs. 3.10–3.15, 2.21), where the local fishermen docked and processed their catch of sardines.

Perhaps under Bunker's influence, Platt changed his picture-making strategy from the work that he had produced the preceding summer. Now he raised the horizon line in his landscapes and gave more of his attention to the foreground (fig. 3.10). His intention was not to provide room for more anecdotal detail, for his figures remain incidental, but rather to create a structured and balanced composition enlivened by the tension he created between spatial recession and the surface design of abstract shapes. This system is especially apparent in such paintings as *The Quay, Larmor* (fig. 3.13), where Platt positioned himself above Larmor's two stone piers; this elevated vantage point allowed him to flatten the dark, receding jetties against the pearly gray background of the sea. It is tempting to ascribe Platt's new concentration

The Paintings of Charles A. Platt / 57

upon two-dimensional design to the influence of such painters as James McNeill Whistler, for the latter's reductive compositions and restricted palette provide an obvious precedent for Platt's experimentation. Although Platt never mentioned Whistler's paintings in his correspondence, as a printmaker he was certainly familiar with the older artist's popular etchings, which employ the same compositional technique.

Platt's Larmor paintings bring to life the artistic philosophy he had expressed earlier in 1884:

An artist should interest one's sense of the beautiful and make that his great object. He must have a subject, of course, but he should *use* his subject to make his picture and not use his picture to render the subject.[27]

Here, Platt clearly states his belief in the primacy of design over narrative: the art of picture-making should take precedence over the subject represented. He considered paintings to be not simply descriptive windows through which the viewer could observe other worlds but principally compositional arrangements, carefully produced to achieve the most pleasing balance of forms. Although Platt would never create a nonrepresentational image, it is clear that abstract design was at the heart of his work. This aesthetic creed, in which he finally rejected the descriptions of picturesque detail that had characterized his work, guided Platt throughout the rest of his career as an artist, in all media. As subjects for his paintings, Platt would continue to select pastoral subjects not only for their inherent beauty but also for the opportunity they afforded him to create harmonious arrangements of colors and shapes.[28]

After his successful summer in Brittany, Platt returned to Paris. When a planned trip to Italy fell through because of a cholera epidemic, he at last resolved to enlist in a formal training program.[29] In October 1884, he became a student of the French academicians Jules Joseph Lefebvre and Gustave Rodolphe Boulanger, who offered instruction at the

FIG. 3.7
Landscape with Washerwomen (Peasants and Poplars), about 1884–85 (cat. no. 27).

FIG. 3.8
Larmor, 1884. Pencil
drawing from sketchbook
(cat. no. 48).

FIG. 3.9
Dennis Miller Bunker,
American, 1861–1890.
*Brittany Town Morning,
Larmor*, 1884. Oil on can-
vas, 14 x 22 inches. Terra
Foundation for the Arts,
Daniel J. Terra Collection.

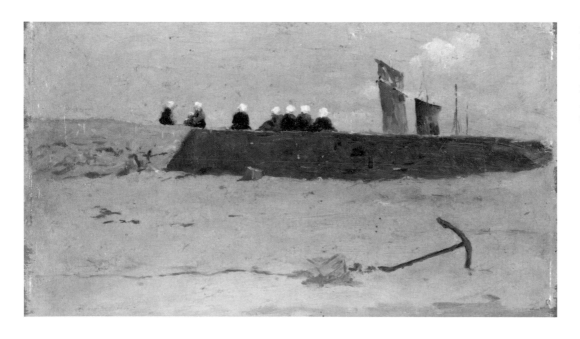

FIG. 3.10
Low Tide, Larmor, 1884
(cat. no. 29).

FIG. 3.11
Breakwater at Larmor,
about 1884 (cat. no. 28).

FIG. 3.12
The Quay, Larmor, 1884.
Pencil drawing from
sketchbook (cat. no. 48).

FIG. 3.13
The Quay, Larmor,
1884–85 (cat. no. 30).

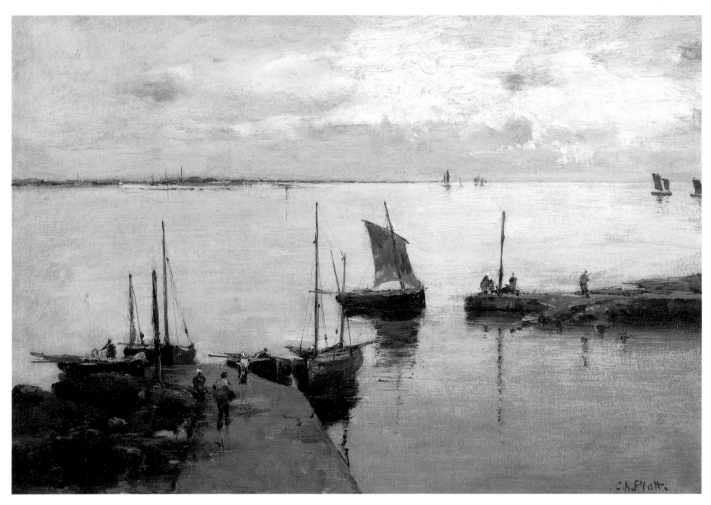

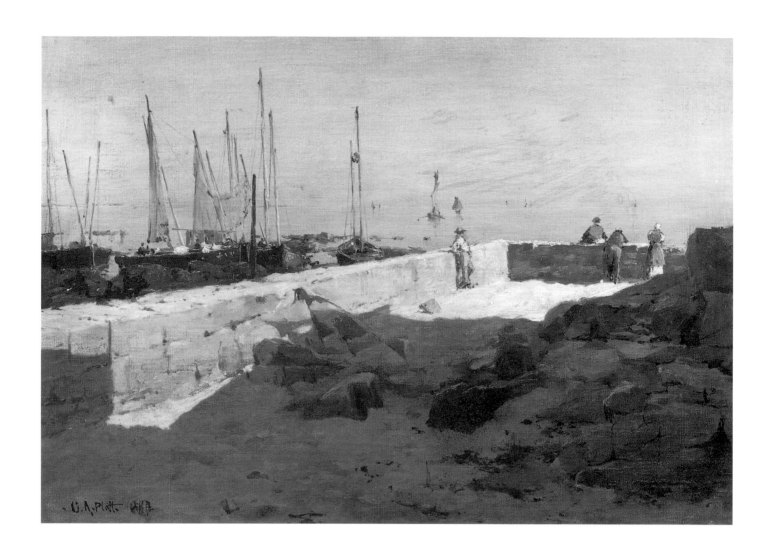

FIG. 3.14
A Calm Afternoon, 1885
(cat. no. 31).

FIG. 3.15
Post card of Larmor harbor, "LARMOR—Les Rochers et la Plage." Private collection.

Académie Julian, one of the most popular schools in Paris for American students.[30] During the time Platt spent at Julian's, from 1884 through the fall of 1885, his colleagues and countrymen included Arthur Wesley Dow, Willard Metcalf, Edmund Tarbell, and John Henry Twachtman, but the shared experience of formal instruction in Paris linked Platt to most of the advanced American painters of his day. Like all academic instructors, Lefebvre and Boulanger emphasized drawing and painting from life and stressed the mastery of the human form as the crucial underpinning for any great accomplishment in the arts. Platt had managed to ignore the figure since the time of his New York training, but he came to realize that the drawing skills it required were crucial even for a landscapist. "It seems a little like beginning over again but for some time I have been feeling very much inclined to paint figures in my pictures much more importantly than I am able to now," Platt confessed to his family. "The only way to do this is just to go to work and plough away at the nude."[31]

Platt had always planned to be a landscape painter, but he now set out to prove that he could create an accomplished figure composition. He dedicated himself to his studies, writing home less frequently and cutting down on his participation in the whirl of social activity fostered by the expatriate community in Paris. His private goal was to create one good figure painting, one that would confirm his newly refined mastery of the human form. He would then return to his preferred landscape subjects. Platt did not discuss this project with his family until it was successfully completed, but he must have worked on it throughout the winter of 1884–85. His demonstration piece, *The Etcher* (fig. 3.16), is a carefully studied and meticulously crafted composition that embodies all of the characteristics of the academic method.

Apparently still wary of the familial disappointment caused by his 1883 Salon experience, Platt revealed his new project to his parents only after it met with favor. He described his recent achievement in a late March letter:

Notwithstanding what I wrote you this winter about not sending to the Salon I was painting a picture, which, had it not been successful, I should certainly not have sent, but my good luck did not desert me & the picture came out alright & was very much liked by M. Boulanger, my professor, & the few others to whom I showed it. So at the time of sending in for the Salon (the 15th of March), I sent. I have just heard that it has been very well received, was very much liked by the jury and will be hung on the line!!!![32]

More typically taciturn, Platt could not contain his excitement; the string of exclamation points in his letter contradicts both his calm description of process and his former discretion. He went on to describe *The Etcher*:

It is a small picture & my first attempt at a figure. It represents an etcher at work in his studio. I took the corner of my own studio & put my own working clothes on the model, all the materials of an aquafortist are in the background and I painted them as I did the figure "my level best." I feel considerably encouraged. Hard work in the school is doing me lots of good & I think if I stick to it long enough I will be able to do something someday.[33]

Platt's painting is a surrogate self-portrait. It is perhaps revealing of Platt's comfortable financial status that a professional model, dressed in Platt's own clothes and posing with Platt's etching supplies, was used in place of the mirror image recorded by most artists who painted self-portraits. That the model was a specialist rather than a friend may attest to Platt's natural reserve. It is significant, however, that Platt represented himself as an etcher, for it indicates clearly that his careers as printmaker and as painter were simultaneous, not sequential. In a single image, he demonstrated his creative ability in both media (see also fig. 3.17).

Platt rewarded himself for his success with a trip home to New York. He spent the sum-

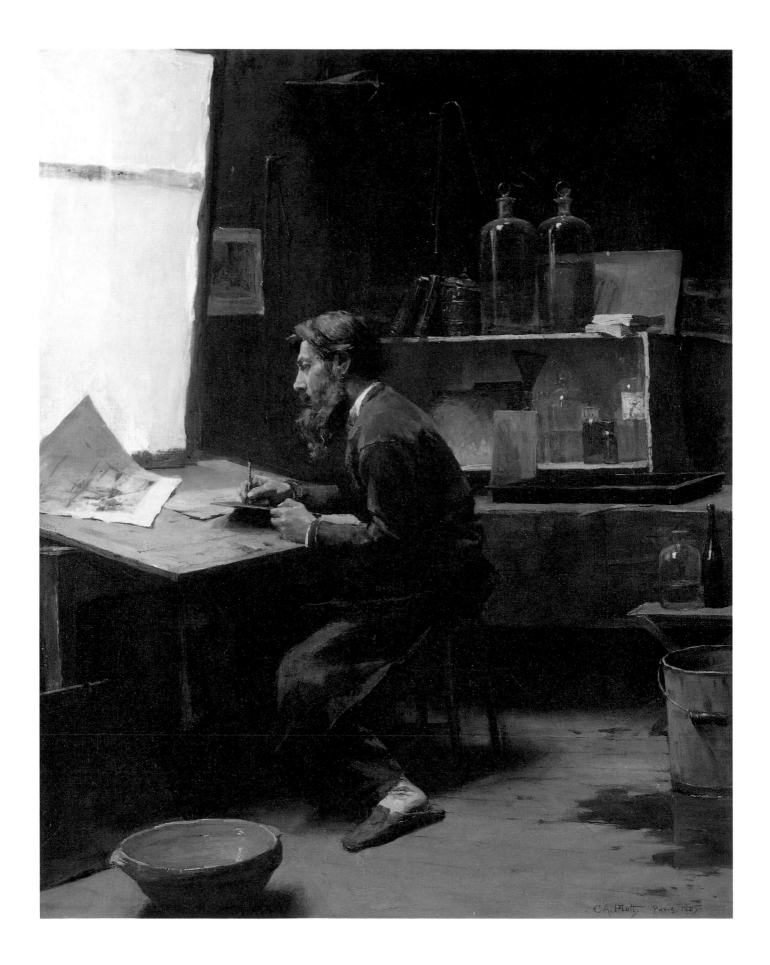

mer of 1885 in the United States but did not take a vacation from picture-making, for his images of the long covered bridge in Hartford, Connecticut, rendered in both oil and ink (figs. 3.18, 3.19), attest to his continued activity. The paintings he produced after *The Etcher* are dominated once again by landscape subjects, another indication that his achievement in figure painting was more a private test than a shift in artistic direction. Upon his return to France in late September, Platt spent almost a month at Honfleur with his old friend Stephen Parrish, working haphazardly on watercolors of the fishing boats and honing his skill at making pictures with a camera, a new fascination for him.[34]

Platt doubtless enjoyed having the photographs he made at Honfleur, for although he dedicated himself to painting out-of-doors during the summer, he continued to work on similar subjects, now in both watercolor and oil, throughout the winter months. He had always relied upon his sketchbooks, commercially available prints, and memory for his compositions; now the photographs he made himself would prove to be equally valuable tools. His working method was distinctly academic, revealing no allegiance to the modernist call to paint only directly from nature.[35] Like most Americans of his generation, Platt came to Europe to immerse himself in tradition.

Platt produced only a few finished watercolors during the winter of 1885–86, concentrating instead on his studies at Julian's. His social life improved considerably in November with Kenneth Cranford's introduction of Colonel and Mrs. Richard Hoe and their daughter Annie, whose smile was "impossible to resist"; she became Platt's main preoccupation.[36] The Hoes were planning to travel to Italy early in 1886, and Platt impulsively decided to join them. He traveled to St. Raphael, spent a few days there with the Parrishes, and headed for San Remo, just over the Italian border. His pleasure at catching up with the Hoes was diminished by the theft at the railroad station of all of his luggage, including his portable easel and sketching stool. It seems as if his loss was more an inconvenience than a calamity, since Platt described the lush Mediterranean countryside as "a succession of pictures, but not the kind I want to paint."[37] He found the southern landscape, with its brilliant sun and deep, rich colors, appealing and unusual but unsuited to his aesthetic temperament, which called for harmony and balance.

During the first week of March 1886, Platt traveled with the Hoes from San Remo south to Genoa, Pisa, and Siena. He visited art galleries and historic sites but made only a few pencil drawings that he described as good enough to use for etchings, explaining that he wanted "something more for my pictures."[38]

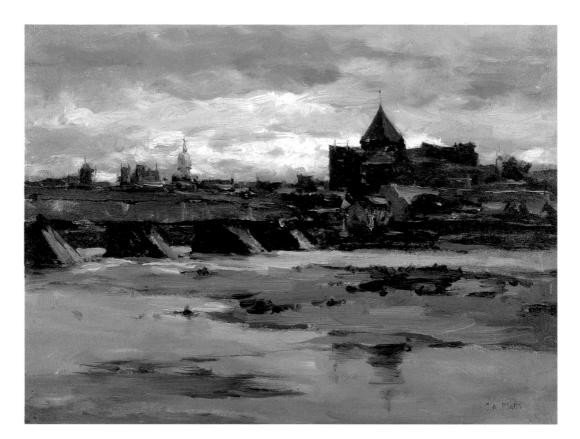

FIG. 3.18
Hartford, Connecticut,
1885 (cat. no. 34).

FIG. 3.19
Hartford Bridge, 1885
(cat. no. 14).

Soon discussions of art stopped altogether in Platt's correspondence, and he confessed that "my journey to Italy was not altogether with a view of seeing the old masters, though I convinced myself that it was."[39] He announced his engagement to Miss Hoe in a March 8 letter to his mother, noting that Annie "possesses all the accomplishments that an artist's wife ought." Despite Platt's extended illness with "Roman fever," contracted on the malarial plains of the Campagna after their brief visit to Rome, the couple married in Florence on April 10, 1886.

The wealth of information about Platt's artistic career that was documented in family correspondence ends abruptly in April 1886, with the apparent loss of subsequent archival materials. It can be assumed, however, that between Platt's illness and his adjustment to married life, he completed little work. The tragic events of the next year, which included the death of his new father-in-law in June 1886, of Platt's own father in

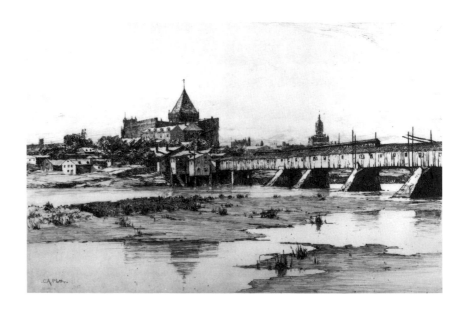

August, and finally of Annie herself in childbirth in March 1887, along with the twins she carried, caused a further hiatus in his activity as Platt struggled to come to terms with these tremendous personal losses.

Annie died in Paris, where the newlyweds had settled in October 1886 after spending a sad and difficult summer in New York. Platt returned again to the United States, seeking the comfort of family and friends. He had never intended to become an expatriate and conscientiously had shipped both paintings and etchings home for regular exhibitions at the National Academy of Design, the Pennsylvania Academy of the Fine Arts, and such other important annual shows as would keep his name before the American public. He now settled in New York City and eventually became part of the city's vibrant artistic and social scene. Among the organizations he joined were the Century Association (in 1887) and the Players (in 1889), two distinguished fraternities that brought him into contact with most of the important figures in the art world as well as with many potential patrons.

Platt had once cautioned his father, himself a prominent Centurion, not to "let any of your Academician friends . . . scare you into thinking that I will lose all capacity to treat American subjects."[40] Like many European-trained painters who sought to unite a modern style with American motifs, Platt joined New York's Society of American Artists, a loose-knit organization that had broken away from the more conservative Hudson River School-oriented National Academy of Design in 1877. Although the society had almost dissolved in the mid-1880s, it had been revitalized under the leadership of William Merritt Chase, and it survived until the formation of "The Ten" in 1897 as the most avant-garde artists' group in America. The society's members included Platt's Paris friends Henry Oliver Walker, Willard Metcalf, and Dennis Bunker, as well as several painters and sculptors who would later form the core of the art colony at Cornish, New Hampshire, including Herbert Adams, Kenyon Cox, Thomas Dewing, and Augustus Saint-Gaudens.

Platt took a studio at 3 North Washington Square in New York, a street once inhabited by the city's social elite. Their elegant Greek Revival row houses had since become the homes of artists and writers; Henry James, whose grandmother lived there, had used it as a setting for his 1881 novel *Washington Square*. By the fall of 1889, when Bunker moved into Platt's building, the square had been crowned with architect Stanford White's great wooden arch. The classical arch became a subject for many contemporary artists, especially in its later marble incarnation, but there is no indication that Platt ever painted it nor, indeed, that he rendered any New York subject in oils at all, although he did make several etchings of the city's harbor (see figs. 2.26, 2.27). The studios at No. 3 did become a gathering place for many of New York's most promising young painters, for as Bunker pointed out in a letter to his fiancée, Eleanor Hardy: "My room is full of men—Walker, Chase, Dewing, Loeffler, Platt—and all talking at once. Sargent has been here and models and I don't know what all."[41] These friendships, fostered in the studio and at the Players club, would soon be cemented in Cornish, New Hampshire.

Platt had always spent his summers away from the city, sketching in rural and picturesque settings, most often near the sea (fig. 3.20). In the summer of 1887, he worked in West Newbury and Gloucester, Massachusetts, with Bunker and Walker. In 1888 he traveled to England with Bunker and then to Holland alone (fig. 3.21),[42] while Walker visited Cornish for the first time. The next summer, Walker persuaded Platt to join him in Cornish. Platt was charmed by the pastoral landscape of the Connecticut River valley, with its distant views anchored by the symmetrical peak of Mount Ascutney; it would become the subject of his paintings for the rest of his career. Just a year later, he bought land, designed a small house, and settled

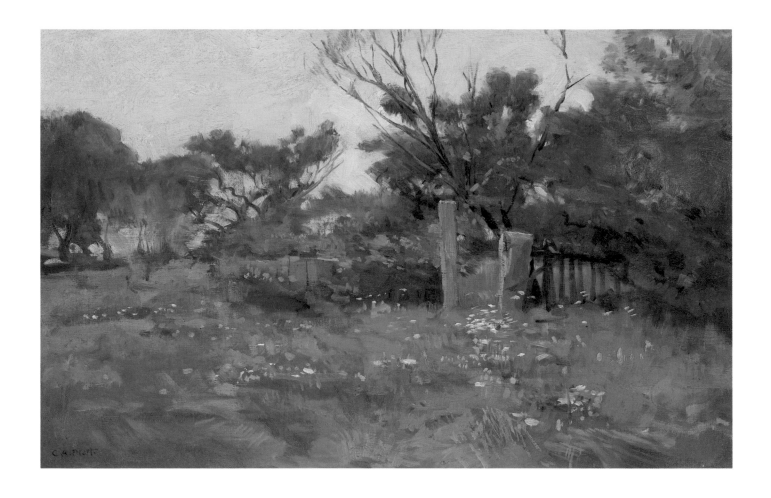

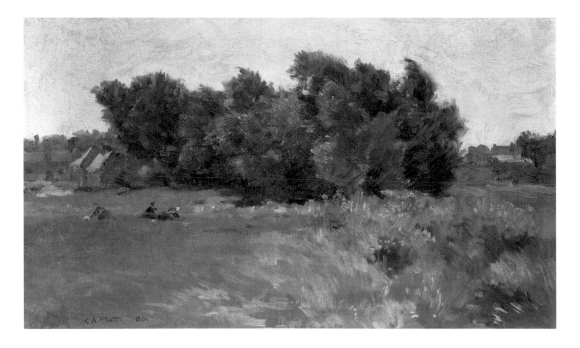

FIG. 3.20
Orchard, East Hampton,
about 1885 (cat. no. 35).

FIG. 3.21
Women in a Field, 1888
(cat. no. 37).

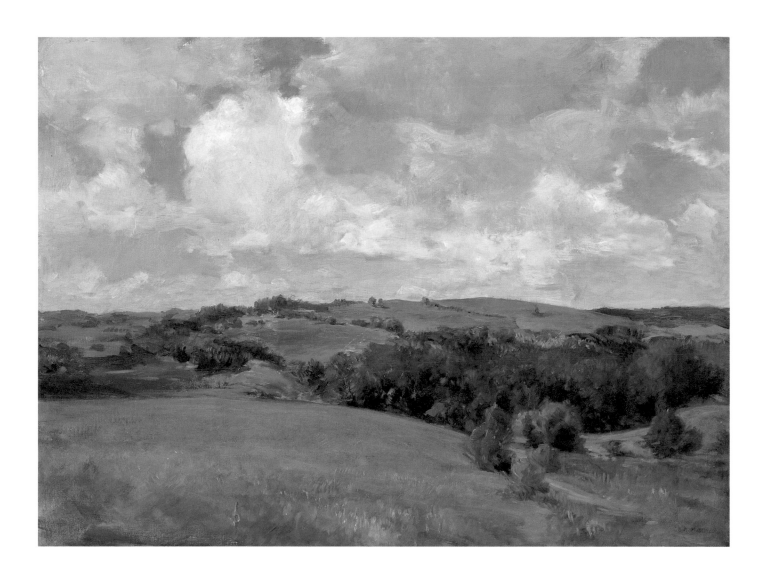

FIG. 3.22
Clouds (Landscape near Cornish), about 1894 (cat. no. 41).

comfortably into Cornish's artistic community.[43] In Cornish, Platt would rediscover his creative powers.

In New Hampshire, Platt could sustain the friendships he had established in New York. Walker was not the only promoter of Cornish, for both Dewing and Saint-Gaudens had summered there for several years, and Platt would soon convince his old friend Stephen Parrish to join them. Bunker visited in July 1890, noting that "Platt is building quite a fine place with a large studio."[44] Platt became preoccupied with architecture that summer, designing both his own house and his first commissioned project, Annie Lazarus's High Court. By 1893, he had regained equilibrium and self-confidence and

had renewed his activities as a painter, sending two of his newest landscapes to the World's Columbian Exposition in Chicago. In July, he wed Eleanor Hardy Bunker, Dennis Bunker's widow, whose marriage to Platt's friend had ended as abruptly and tragically as Platt's own first union.[45] The following year, Platt won the Society of American Artists' prestigious Webb prize for landscape painting for his serene composition *Clouds* (fig. 3.22).

In his paintings of the 1890s, Platt concentrated solely upon the New Hampshire landscape. His pictures include both summer and winter scenes of the area near his new home (figs. 3.22–3.27, 4.1). Just as he first had done in France, Platt favored simple,

FIG. 3.23
Winter Hush, Cornish,
about 1890 (cat. no. 38).

anonymous views in which he could explore the tension between a balanced arrangement of shapes across the flat surface of his canvas and an illusion of spatial recession created by the meandering roads or streams included in his vista. In New Hampshire, Platt was inspired to explore a bright new palette. His snowy winter landscapes include a range of blue, pink, and lavender pigments, while the summer scenes display intense greens that communicate the distinct brilliance of a characteristically American light. He applied his paints quickly, with loose, wet strokes that occasionally flirt with an impressionist technique.

Most of the art produced by the denizens of Cornish reflects their commitment to aestheticism and their dedication to the ideals of harmony and beauty. Many referred to their rural surroundings as an American Arcadia, replete with allusions to that ideal state of peaceful coexistence between man and nature. Dewing in particular populated his Cornish landscapes with nymphs, their classical garb often replaced with the satin evening gowns worn by the ladies at their elaborate entertainments, while Walker and Saint-Gaudens recreated the pageantry of the Renaissance. But Platt had never been a figure painter, and his Cornish paintings are pure landscapes. Timeless in their subjects and nonspecific in their titles, the chronology of these pictures is difficult to establish. Taken as a group, however, they, too, portray an ideal world where landscape elements balance one another and where even

FIG. 3.24
Windsor, about 1910 (cat.
no. 45).

FIG. 3.25
Cornish Landscape, 1919
(cat. no. 46).

FIG. 3.26
High Court, after 1891
(cat. no. 39).

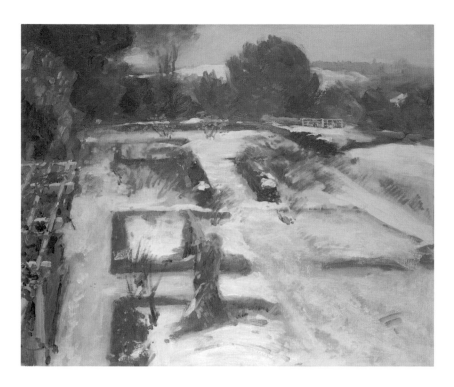

the icy blue snows of winter seem soft and appealing.

Like most of his contemporaries, including Arthur Henry Prellwitz, George de Forest Brush, and John Elliot, Platt generally ignored most signs of human habitation in his Cornish scenes, preferring instead to capture the subtle variations of light and atmosphere upon the distant hills and mountains. This he accomplished not with the panoramic eye of that older generation of painters who had chosen the mountains of New Hampshire and Vermont as subjects but with a more intimate vision, one that came perhaps from comfortable familiarity. Unpopulated as these hills were, they seem nevertheless civilized and human in scale. Far from inspiring the awe and anxiety elicited by the landscapes of an earlier age, Platt's images evoke a sense of place that was described by Maxfield Parrish as "an ideal country, so paintable and beautiful, . . . a place to dream one's life away."[46]

The exceptions Platt made in the purity of his landscape images are the paintings he made of his own architectural creations. Though Platt did paint a distant view of his first architectural commission, High Court (fig. 3.26), emphasizing its relationship to the landscape, he more frequently rendered the gardens that formed such an integral part of his architectural projects. Gardening was a serious avocation among the residents at Cornish, and Eleanor Platt was credited with creating a "labyrinth of flowers"[47] at their own home; however, Platt most often painted the gardens in winter, when the structure of their carefully planned beds was most apparent. He made several images of his own garden in snow, as well as one of the gardens he had created in Cornish for Herbert Croly, an architectural critic and early supporter of Platt's new career in landscape design and architecture (fig. 3.27). These paintings demonstrate Platt's distinctive preference for subtle color harmonies and clear spatial relationships.

Platt's desire to create beauty by the harmonious arrangement of form began to take new directions in the 1890s. At first content to reshape the landscape on canvas, Platt soon began to explore the possibilities of actually reordering the natural environment through garden design and architecture. Significantly, in 1898 Platt changed the listing of his occupation in the New York City directory from "artist" to "architect." His moderate financial and critical success as a painter became overshadowed at the turn of the century by his new, more lucrative and acclaimed efforts as a garden designer and an architect.

Platt continued to paint occasional landscapes for the rest of his life, but rarely exhibited or sold them, explaining to the Corcoran Gallery of Art's director that he parted with his pictures only "reluctantly, except to a museum."[48] His painter's eye, however, continued to inform and enhance his work, selecting views, arranging shapes, and creating harmonious overall designs. Platt was unusual in his skill at producing art in a variety of media, yet throughout his career, he never lost sight of the goal he had expressed as a young painter in France: "an artist should interest one's sense of the beautiful and make that his great object."[49]

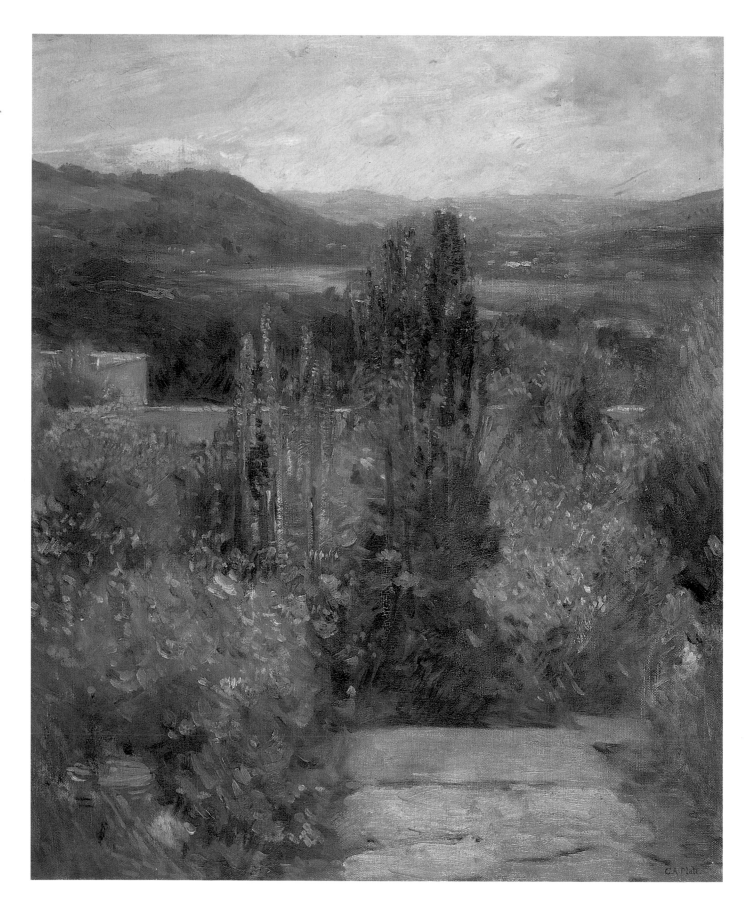

74

Charles A. Platt and the Fine
Art of Landscape Design

REBECCA WARREN DAVIDSON

CHARLES PLATT rarely spoke publicly about his work, nor did he write about his theory of landscape design. In a 1931 interview, however, given near the conclusion of his long and productive career, he stated one of the primary principles informing his approach to design:

The essential truth in country house architecture is that house and gardens together form one single design. They cannot be separated. They must be taken as a whole. That principle has been impressed upon me from the first, mainly, I suppose, through my beginning professional work as a landscape painter not as an architect.[1]

As these remarks imply, any discussion of Platt's work in landscape design must therefore pay particular attention to the relationships—given by nature and enhanced by art—among the garden, the architecture, and the surrounding landscape. Platt's abilities in garden-making were clearly related to his activities as a painter and etcher. In addition, he possessed skills enabling him to create multi-dimensional space in the realms of architecture and landscape; yet, so closely did he see the connections among all these arts, he once characterized the landscape designer as an "artist-gardener."[2] For Charles Platt, the artistic principles governing landscape painting—for example, the skillful handling

of perspective, a balanced composition, and unity of conception—were equally applicable to the creation of architecture and gardens. Within any individual work of art, moreover, all its essential components—be they articulated in paint on canvas, in architecture, or in living nature—should contribute toward an organic unity, one central idea expressing the purpose and meaning of the work. Along with his reinvigoration of so-called formal styles of gardening in the United States, Platt's understanding and mastery of the unifying principles linking the art of landscape design to the fine arts are his greatest contributions to American garden history.

The primary elements of Platt's method of landscape design were already fully in evidence in one of his earliest works, called High Court, originally built for Annie Lazarus in Cornish, New Hampshire, in 1890–91.[3] Set on a hill immediately east of Platt's own property in Cornish, High Court's Italian-inspired loggias and terraces were designed to take advantage of views of Mount Ascutney to the southwest, while the primary vista was sited on axis with the Connecticut River valley. Platt's singular vision of the integration of architecture, garden, and landscape is well illustrated in a painting he made of the views from the garden at High Court (fig. 4.1). The blues of the larkspur in the foreground plantings complement those of the river and the

FIG. 4.1
Larkspur (Garden at High Court, Cornish), 1895 (cat. no. 42).

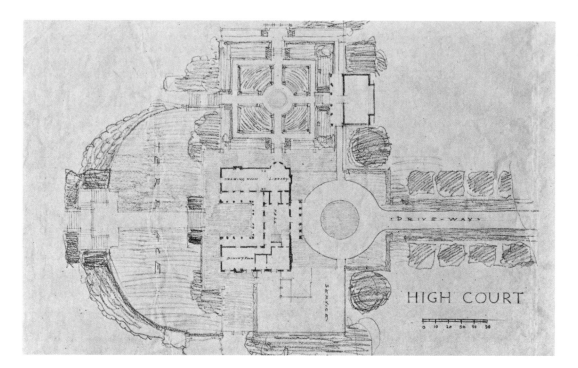

FIG. 4.2
Site plan for High Court,
the Annie Lazarus resi-
dence, Cornish, New
Hampshire, designed 1890.
(Illustrated in *House and
Garden*, September 1902.)

distant hills, while the upright forms of the flowers lead the eye from foreground to background, linking the two parts of the vista. Architecture defines the middle ground, the parapet wall surrounding the terrace serving both to enframe and separate the respective domains of garden and landscape while joining them together in a single composition.

By bringing High Court's entrance drive through the site to the north side of the house (fig. 4.2) and screening the lateral views with trees, however, Platt carefully limited and controlled the visitor's appreciation of this composition. Not until one had passed through the house and emerged onto the south terrace were the dramatic vistas of Ascutney and the Connecticut River valley finally revealed. The primary "garden" space was a simple square, divided into four planting areas. Notable by its absence in Platt's plan for the garden at High Court was an ornamental feature which had distinguished the work of his nineteenth-century predecessors, namely the arrangement of annual flowers in sinuously patterned beds on smooth lawns. Rather, as can been seen in the painting, the plantings in Platt's garden, although confined within an architectural framework,

gave the appearance of luxuriant and unrestrained growth only loosely contained by their simple geometric borders. Surrounded by walls and positioned west of and slightly below the house, the garden square formed a precinct unto itself. At the same time, it was intimately linked to both house and landscape: with the former through the library loggia, and with the latter by means of its own separate terrace and exedra. Cut into the exedra wall was a rectangular opening framing the view of Mount Ascutney like a living landscape painting.[4]

American Gardens: Theory and Practice at the Turn of the Century

Platt's emphasis on the importance of bringing all the components of a design into an organic unity, and on a balanced composition of landscape and architecture, may be traced to two seemingly disparate sources. The first, and by far the most visible influence in his work, was his knowledge and appreciation of the gardens of Italy, which will be discussed in more detail below. Equally significant, however, was the legacy of eighteenth- and

nineteenth-century aesthetic theory—most importantly, in this context, the principles of the picturesque—which Platt would have absorbed during his training as an artist. Theories of the picturesque and the beautiful also exerted a significant influence on garden design during this period, and Platt would most likely have known of them through two primary sources: the writings of Andrew Jackson Downing and the public landscapes of Frederick Law Olmsted.

Although the gardens created by early European settlers in America were predominantly formal—simplified versions of Renaissance geometric gardens—by the early nineteenth century many American gardens were beginning to be patterned after the so-called "natural" or landscape style perfected in eighteenth century England. The espousal of this ideal in the United States was reinforced by the influence of Andrew Jackson Downing (1815–1852), the first American to address the subject of landscape design from a theoretical perspective. In his 1841 *Treatise on the Theory and Practice of Landscape Gardening, Adapted to North America*, Downing had written disparagingly that the "Ancient, Formal, or Geometric Style," whose "beauties . . . were those of regularity, symmetry, and the display of labored art," could be "attained in a merely mechanical manner, with but little study or theory upon the subject." This attitude, coupled with his persuasive presentation of the principles of the "natural" garden in social and moral, as well as aesthetic, terms (particularly the idea that the natural garden was most appropriate to the landscape of a democratic nation), has had a profound and lasting effect on the form and ideology of the American garden.[5] Largely due to Downing's influence, late nineteenth-century American garden designers favored the "natural" style, characterized by curving paths and flowerbeds, rustic adornments, and plantings arranged to suggest that nature had been left largely undisturbed, with only slight improvements from the hand of the artist.

The prestige and visibility of the natural or landscape garden as interpreted by Frederick Law Olmsted (1822–1903) in his designs for public parks in America would also not have passed unnoticed by Charles Platt. Olmsted campaigned vigorously for the appreciation of the natural landscape garden, not only as a fine art but also as a vital and necessary component of American cultural and moral life, bringing both the delights and the lessons of nature to the city dweller. By the end of the century, however, even Olmsted had a number of more formal designs to his credit, most notably in his work on the campus of Stanford University and in the gardens immediately surrounding Biltmore, the estate of George Washington Vanderbilt in Asheville, North Carolina, completed in 1895.[6] The last decades of the nineteenth century also witnessed a tremendous enthusiasm for gardening itself in America, and a spirited discussion of its merits as a fine art appears in the literature of the time. The writings of the architectural critic Mariana G. Van Rensselaer (1851–1934), in particular, not only brought a discussion of gardening as one of the fine arts into the mainstream of American critical thought, but also included a balanced assessment of the relative merits of both the formal and the natural garden, suggesting that each could be used to advantage in the proper setting.[7]

Italian Gardens

Concomitant with these developments was an increasing appreciation of the art, culture, and landscape of Italy on the part of many educated Americans, a phenomenon attested to by the widespread popularity of writers such as Jacob Burckhardt, Walter Pater, and John Addington Symonds.[8] Charles Platt played an important role in this movement by creating a new interest in the Italian garden. Having first visited Italy in 1886 in the course of his artistic studies, Platt returned in 1892, accompanied by his brother William, an apprentice landscape designer in Olmsted's office. While in Italy, the two brothers mea-

sured, sketched, and photographed the gardens of many of the most celebrated sixteenth- and seventeenth-century villas (figs. 4.3–4.5, see also fig. 1.5). The immediate result of this intensive study was a manuscript entitled "Italian Gardens," published by Charles Platt first as two articles in *Harper's New Monthly Magazine* in 1893 and subsequently in book form in 1894.[9]

Italian Gardens was the first monographic treatment of its subject in English and initiated several decades of investigation of the gardens of Italy by American designers and writers.[10] Platt's early effort, however, was undeniably a watershed in the theory and design of American gardens, and its significance is a subject unto itself.[11] In the present context, *Italian Gardens* is of most importance as a revealing statement of Platt's intentions and ideals as a landscape designer.[12] The book demonstrates Platt's efforts to resolve within his own work the assumed disparity between the natural and the formal garden, and thus may be understood in one sense as the theoretical foundation upon which his practice was based. Finally, Platt's book was important because it cast him as a knowledgeable authority on the Italian garden and its adaptation in the United States, and undoubtedly furthered his career in its early stages.[13]

Although Platt's discussion of Italian villa gardens is quite brief and informal (he himself admitted in his conclusion that "it has not been the purpose to make a treatise"), a close reading reveals that the book addresses—both in its text and, more especially, in its illustrations—a number of important principles of landscape design; moreover, these principles operate on three different levels of meaning regarding the creation and appreciation of gardens. First, Platt identified several defining elements he believed to be central to an understanding of the Italian garden. These, it should be emphasized, had to do with the garden's spatial and social characteristics rather than with the decorative or ornamental features on which earlier writers had focused.[14] The most important of the

defining principles of the Italian garden articulated by Platt was, not surprisingly, the unified design of house and garden or, as he put it, the "evident harmony of arrangement between the house and surrounding landscape."[15] Two other qualities Platt perceived as particularly significant and worthy of emulation in American gardens were the concepts of the garden as an outdoor room, or series of interconnected rooms, and of the garden as a humanist expression of place-making—"that sacred portion of the globe," as he said, "dedicated to one's self."[16]

In the second instance, Platt concerned himself with those qualities of the gardens which, while not essentially "Italian" (or belonging exclusively to any other stylistic or geographic category), are basic to all good landscape design. The most important of these—one or more of which Platt mentions in each of his garden descriptions—are harmony, contrast, agreeable proportions, perspective views, simplicity and, especially, the paired qualities of unity and variety. Significantly, these were the same attributes eighteenth- and nineteenth-century theorists had codified as most desirable in the English landscape garden.[17] Finally, Platt's discussion of the Italian garden includes many specific examples of decorative or ornamental features which characterize it as "Italian," for example, the distinctive use of water in stepped cascades and fountains; terracing; statuary; and architectural features such as loggias, walls, and balustrades.

By identifying these characteristics in the gardens included in his book, it seems clear that Platt, even though he may not consciously have intended to "make a treatise," was attempting to show, contrary to what Downing had written, that the design of the classical Italian garden was indeed based on theoretical principles. Moreover, he believed these principles transcended stylistic labels and should be applicable to any garden deserving the name of art, the result being that the Italian garden, while formally unlike the natural garden, had the same intellectual and aesthetic foundation.[18] Further-

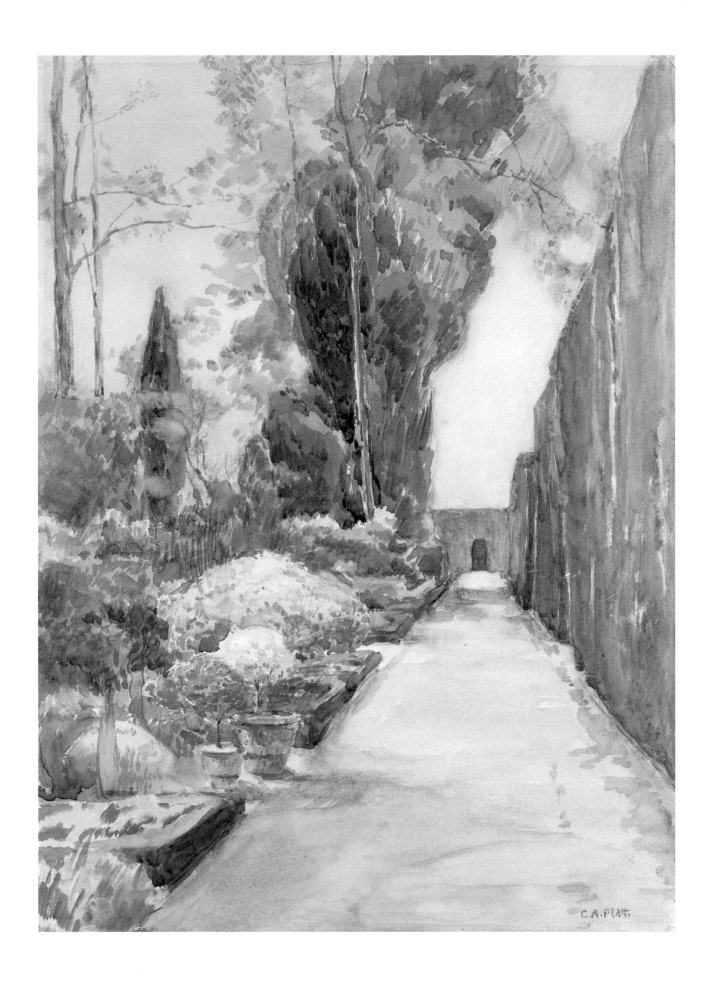

more, Platt's pictorial representation of Italian gardens in his photographs, and his frequent remarks about the charms of their "picturesque," often ruined state, allowed him to associate two very different aesthetics in landscape design. Because of his training and abilities as a landscape painter, Platt seems to have had no difficulty in combining the principles of picturesque composition and classical imagery, particularly as they appeared in the work of such artists as Claude Lorrain. Thus Platt—along with the critic Mariana G. Van Rensselaer—was an important figure in demonstrating, particularly for an American audience, the possibility of effecting a compromise between the so-called formal and natural styles of gardening.

Private Gardens

Charles Platt's work in landscape design encompasses the creation of domestic gardens, settings for outdoor monuments and memorials, and of a number of college campus plans, among other endeavors. By far the majority of his work in the field, however, consisted of the design of private gardens associated with country houses. Platt is estimated to have designed close to one hundred landscape settings during the course of his career, particularly in the years between 1890 (the year of High Court's inception) and 1918 (the conclusion of his involvement with the architecture, gardens, and site planning of the Villa Turicum in Lake Forest, Illinois).[19] Whether working for a public or private client, however, and regardless of the size or style of the commission, it is significant that Charles Platt always maintained his characteristic methods of clearly defining space and of providing a set of elegant, interlocking relationships between the individual parts of the garden and their surroundings.

As noted above, Platt's earliest work had been carried out for his friends and neighbors in the small community of Cornish, New Hampshire.[20] Since at least 1885, when the sculptor Augustus Saint-Gaudens took up

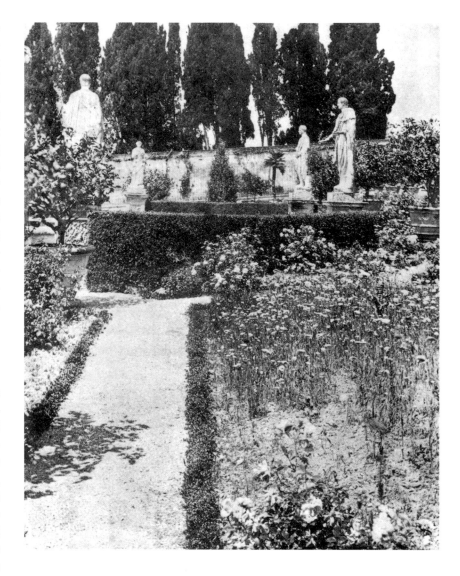

residence there, artists had been drawn to Cornish because of the natural beauty of the landscape, the relatively peaceful but convenient location, and the personality of Saint-Gaudens himself, who seems to have acted as a center around which a social and artistic community formed.[21] Most significant in the present context is that the residents of Cornish were avid and serious gardeners, whose work was the subject of a number of articles in the contemporary critical press.[22] As Ellen Shipman, another Cornish resident who later went on to develop a successful career as a landscape architect, wrote, "Here [in Cornish] was the renaissance of gardening in America."[23]

FIG. 4.4
In the Flower-Garden, Villa Castello, about 1892. (Illustrated in *Italian Gardens*, 1894, p. 139.)

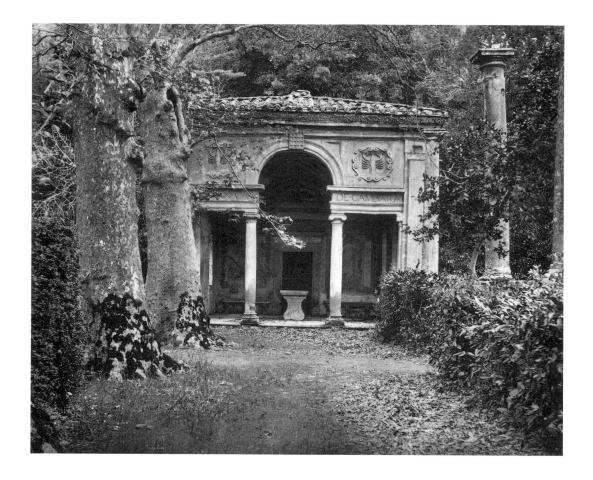

Several aspects of the work of Platt's Cornish neighbors appear to have influenced the development of his approach to garden design. From surviving accounts and photographs, Cornish gardeners at the turn of the century worked in a style sometimes called "old-fashioned" because it was based on contemporary notions of how the first American colonial gardens had been designed. One of the most distinctive features of these gardens was a geometric plan filled with abundant, naturalized plantings. While this idea was certainly not unique to Platt or to the Cornish gardens (it was also a primary principle of the well-known English garden designer Gertrude Jekyll), it was quickly adopted by him, as may be seen in his painting of High Court in fig. 4.1 and in many contemporary photographs of his other gardens, for example, fig. 4.15. Its appeal is not difficult to fathom, for it combined an underlying geometric order with the horticultural exuberance made

possible by new plants discovered in the nineteenth century and, as well, expressed romantic ideas about the beauty and abundance associated with English "cottage" and American colonial gardens.

Platt was also deeply affected by the Cornish landscape, whose characteristics were often compared with those of Italy. Rose Standish Nichols, herself a landscape designer and resident of Cornish, would later justify Platt's formal garden design for Dingleton House (described below) by noting that "few parts of New England bear so strong a resemblance to an Italian landscape as the hills rising above the banks of the Connecticut River opposite the peaks of Mount Ascutney."[24] This long-standing perception surely contributed to the complex of factors which led Platt to conduct his own study of Italian gardens. Important, too, was the general influence of Italian art and culture on his contemporaries in Cornish: Saint-Gaudens, for

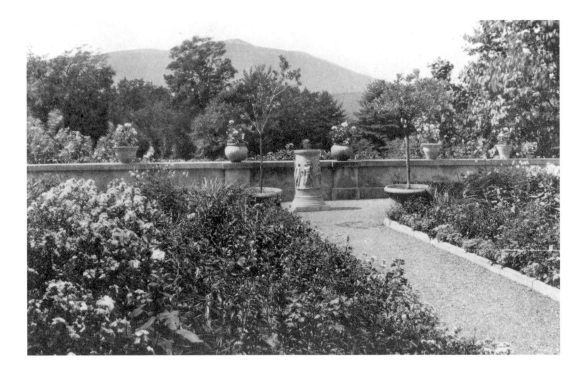

FIG. 4.8
View of Mount Ascutney from the terrace, Dingleton House, the Augusta and Emily Slade residence, Cornish, New Hampshire, designed 1904–5. (Illustrated in *The House Beautiful*, March 1924.)

only by a low wall in the direction of the view, while a pool, a freestanding pergola, and a rose garden lay in the opposite direction, to be experienced on their own terms by turning one's back on the view.

Platt was undoubtedly encouraged in his interest in gardens by the example of his Cornish neighbors. In addition, their commissions were an important early stimulus to his career and provided him with an opportunity to develop his talents in architecture and landscape, which seem to have been longstanding but had previously lacked an outlet for expression.[28] Platt, however, quickly went beyond working only for his fellow artists, taking what he had learned in Cornish and in Italy and bringing it into the realm of professional landscape design. One could say that Platt's knowledge of Italian gardens gave a raison d'être to the formal structure of the Cornish gardens and set an example that, because of widespread interest in Italy in the United States at this time, other garden designers were also moved to adopt.

The lessons Platt had learned in Italy are also evident in his first major garden commission outside of Cornish: Faulkner Farm, for Mr. and Mrs. Charles F. Sprague in Brookline, Massachusetts, built from 1897 to 1898.[29] Although Platt did not have the opportunity to design the house at Faulkner Farm—it had recently been completed by the Boston firm of Little and Browne—this did not prevent him from again devising a plan in which architecture and gardens were unified both organically and functionally (fig. 4.9). The balanced design contains clearly defined spaces that enframe and interact with the house on all sides. Opening out from the forecourt are a regularly planted "grove" on the hill to the northeast, and the house itself with its terraces and gardens to the south. Each side of the house in turn interlocks with the landscape design and corresponds with a major function: to the east (true northeast) is the entrance; to the south, the formal gardens; to the west are views over the valley; and the north faces the service court and its access. Just as Platt's design for the garden casino at Faulkner Farm was modeled after one of the upper pavilions he had photographed at the Villa Lante in 1892 (fig. 4.5), his description of the life of the villa in *Italian Gardens* seems to foreshadow what

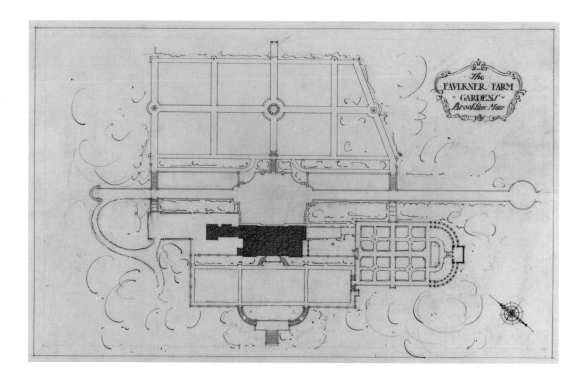

he envisioned for the Spragues in his garden plan at Faulkner Farm: "... here, between the garden and the wood, the family live. If they wish sunshine, they turn one way; and if cool and shade and the sound of running water, the other."[30]

Platt's circulation system smoothly linked all parts of the design together at Faulkner Farm, but it is notable that the connections he defined among the various components are not always, or even usually, axially symmetrical. The approach drive, for example, acts as a spine around which the rest of the design unfolds; yet it does not approach the house on axis but instead runs parallel to it and then through the forecourt to a statue of Juno, which terminates the long vista. The relationship between the formal flower garden and the house and terraces may also be characterized as interlocking rather than axial. As can be seen in the plan (and also in the view of the house from the garden casino, fig. 4.10), the garden is centered not on a major doorway but rather to one side of a loggia at the southeast corner of the house. Communication between the lower terraces and the garden is by way of a double flight of

steps leading to a small, off-center landing overlooking both areas. Platt's oblique, interlocking connections between spaces at Faulkner Farm facilitate one of his primary objectives in design, that of controlling views into the landscape. The approach drive is lined with low walls and plantings concealing both the formal gardens as well as more distant vistas. Only after completing the 90-degree turn necessary to enter the house and pass through to the terrace is the rest of the design revealed.

Earlier discussions of Faulkner Farm have emphasized the strong formal resemblances between Platt's design and the Villa Gamberaia at Settignano, near Florence (fig. 4.11), noting particularly the similarity of the long straight roadway, or passage, bisecting the plan and the rectangular, subdivided garden with its semicircular terminus.[31] Even more significant, however, are the subtle lessons in spatial relationships Platt seems to have learned from the Villa Gamberaia and other Italian villas.[32] As at Gamberaia, the circulation system Platt designed for Faulkner Farm is not axially related to the house but rather parallel to it. In addition, neither

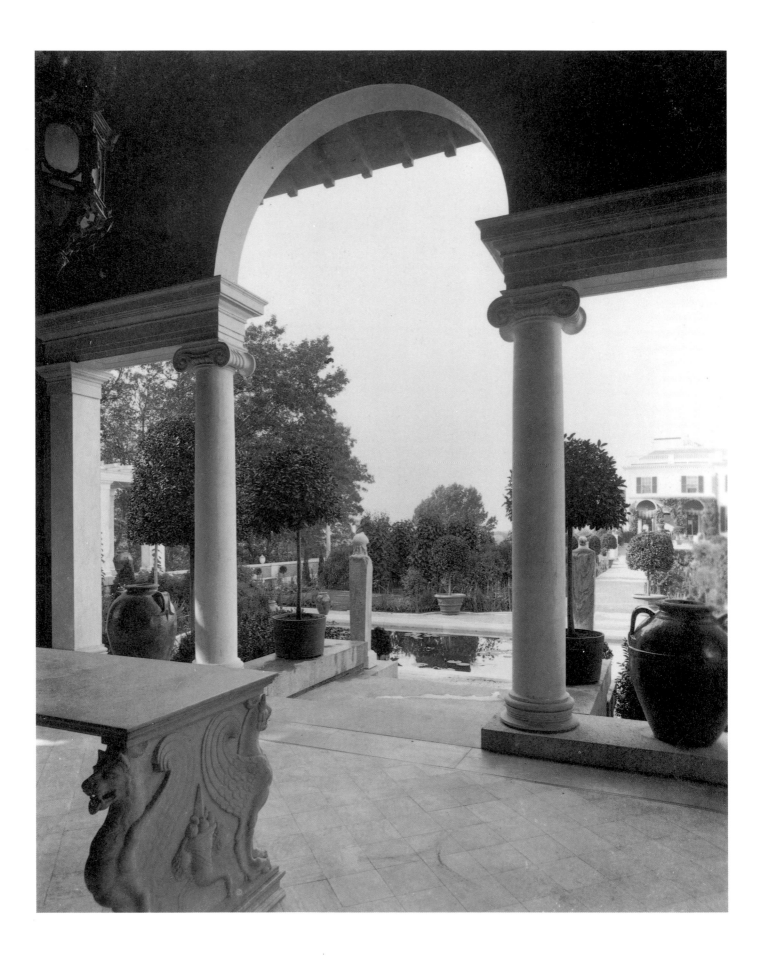

FIG. 4.10
View from the pavilion towards the house, Faulkner Farm, the Charles F. Sprague residence, Brookline, Massachusetts, designed 1896–97 (cat. no. 60).

FIG. 4.11.
Villa Gamberaia at Settignano plan, measured drawing by Edward G. Lawson, about 1916. (Illustrated in *Landscape Architecture*, vol. 8, January 1918, following p. 76.)

garden is centered on the house facade, even on the minor facade each faces.[33] Although Platt's solutions are not identical to those at Gamberaia, the results are the same, and they are invaluable to the subtlety and elegance of the design. In the first instance, attention is focused beyond the house to the landscape, enabling Platt to control views of that landscape (a model he would later use again with great success at Maxwell Court, fig. 4.12). In the second, Platt's design successfully connects his garden with a "garden facade" (which was not originally designed to receive it) by means of an off-center loggia and a raised terrace acting as an outdoor room.

With the completion of the gardens at Faulkner Farm, Platt was well situated at the start of what would eventually become a career not only as a garden designer but as the most successful country house architect practicing in the early twentieth century. There were probably few people in America with the resources to commission substantial gardens who had not heard of Platt's work for the Spragues, for Faulkner Farm was one of the most widely published gardens of its day, and the venues in which it appeared were among the most prestigious.[34] Platt himself

seems to have recognized this moment as a critical one in his career, for in 1897, while at work on Faulkner Farm, he began to identify himself as "architect" (rather than "artist," as he had done previously) in a city directory for New York.[35] In subsequent years, the simple but functionally sophisticated plans Platt devised for houses and domestic gardens secured his reputation and firmly established his practice not only as an architect of country houses but of academic, commercial, and cultural buildings as well. Nevertheless, it is his country houses and gardens for which he will be principally remembered. Although varying widely in cost and size—from the simple but beautiful water vista through the garden at the Villasera (fig. 4.13, see also fig. 6.16) to the elaborate lakeside cascade at the Villa Turicum, both now regrettably demolished—all are informed by the principles Platt developed in the early commissions discussed above: sensitivity to the natural advantages of the site; a notion of the garden as a spatial, architectural construct; and an emphasis on providing functional, organic relationships among spaces.

One other private garden designed by Charles Platt cannot be omitted from any dis-

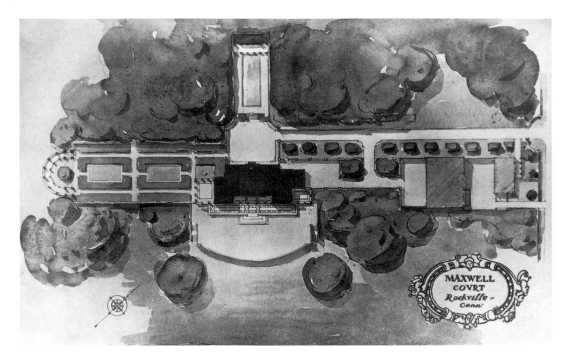

FIG. 4.12
Site plan for Maxwell
Court, the Francis T.
Maxwell residence,
Rockville, Connecticut,
about 1901. (Illustrated in
*Monograph of the Work
of Charles A. Platt, 1913,*
p. 2.)

cussion of his work as a landscape architect, both because—even more than Faulkner Farm—it was the basis of his fame in his own lifetime and because it illustrates the development of Platt's concept of the garden as architecture out-of-doors. The garden of Weld, completed in 1901 for Mr. and Mrs. Larz Anderson in Brookline, Massachusetts, is also in some respects an anomaly in Platt's work (figs. 4.14, 4.15). Although he always advocated close links between the house and garden as a theoretical ideal, Platt nevertheless did at times design gardens in isolation from the houses they were intended to complement. Whether Platt did this in response to the demands of the client or whether it was his own choice is not clear, for he is not known to have made any public statements relating to this aspect of his art.

In any case, Weld is a particularly notable example of this separation of house and garden, and it is interesting that another garden he designed in the same year, that of Glen Elsinore for Mr. and Mrs. Randolph M. Clark in Pomfret, Connecticut, is situated at a greater distance from the house than that which separates the garden and house at

Weld. Although Platt did not design the houses at either Weld or Glen Elsinore, a similar circumstance at Faulkner Farm did not prevent him from bridging the separation between the two. In the case of both Weld and Glen Elsinore, however, the gardens seem to have been conceived of by their owners as separate domains from the architecture. At Glen Elsinore, three subdivided squares containing richly planted flowerbeds were contained on all sides by structures or architectural elements—a casino, colonnades and walls, pergolas, and balustraded terraces. For the Andersons at Weld, Platt also created a distinctly separate garden space, sunken, walled, and screened from the house by a thickly planted "grove" and "bowling green," in the Italian tradition of a *giardino segreto.*

Seeking a possible justification for Platt's design at Weld, one critic wrote that it was

an especially interesting illustration of a sane and reasonable manner of adding a garden to a house without outraging the individuality and memories and associations of the house, without yielding up any principle of design proper to the garden itself, without disturbing a native landscape which

FIG. 4.13
Vista through garden looking west, Villasera, the Rev. Mr. and Mrs. Joseph Hutcheson residence, Warren, Rhode Island, designed 1903–6. (Illustrated in *Monograph*, 1913, p. 48.)

remains still an unaffected neighbourhood, free from any accent.[36]

Knowing Platt's interest in linking house, garden, and landscape under a variety of situations, however, it is likely that the wishes of his clients played a determining role in the decision to build a garden clearly separate from the house. At Weld, for example, the Andersons (like many other wealthy patrons of the era) had a "collection" of gardens representing various cultures. The northwest portion of their eighteen-acre estate was developed by Little and Browne as a "water garden"—really an English landscape garden—with a "Temple of Love" modeled on that at Versailles. Flanking this area to the north was a polo field, and to the south a Chi-

nese garden, also by Little and Browne. Closest to the house (at the northeast corner) was a Japanese garden, and on the house terrace itself was the Andersons' remarkable collection of bonsai and topiary, some of which also graced the Italian garden in season.[37] Thus the owners of Weld seem to have viewed their gardens almost as set-pieces, each exquisitely designed and furnished but conceived of as separate rather than related entities, and must have communicated this viewpoint to Platt. The idea, and use, of the garden as a setting for theatrical events—as a separate, enclosed world of its own—may have contributed to this notion. In particular, Isabel Anderson often used Platt's gardens at Weld for staging poetry readings, plays, and social events.

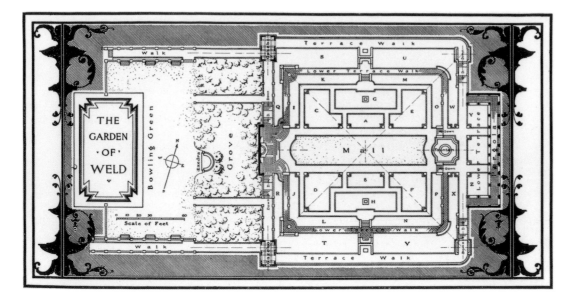

FIG. 4.14
The Plan of the Garden and Its Planting, Weld, the Mr. and Mrs. Larz Anderson residence, Brookline, Massachusetts, garden designed 1901. (Illustrated in *House and Garden,* March 1904, p. 107.)

FIG. 4.15
Garden looking northwest, Weld, the Mr. and Mrs. Larz Anderson residence, Brookline, Massachusetts, garden designed 1901. Courtesy The Society for the Preservation of New England Antiquities.

Whatever the reasons for its form and placement, Platt's garden at Weld again shows his distinctive approach to orchestrating spatial relationships. As is apparent on the plan (fig. 4.14), there is no axial approach from house to garden. A bowling green, surrounded by balustrades and a colonnade, introduced the sequence of gardens. Four lateral paths were cut through the intervening grove, which led—either by making a 90-degree turn or in a slightly off-center meeting—to twin gazebos overlooking the formal garden. The best views of the garden were thus withheld by the plantings of the grove until one of these paths had been traversed. From here, one could turn and go down a flight of steps to enter the garden or view the "pattern" of paths and plantings from above, but always from an oblique angle. The gazebos also appear on the plan as interlocking elements joining two noncontiguous paths, that is, the outer walks of the bowling green/grove and the upper terrace walks of the garden (the garden as a whole being somewhat wider than the bowling green or grove). This shift in plan, or discontinuity from grove to garden, can only have been deliberately introduced. The dialectic between "Garden" and "Grove" was a concept Platt had articulated in his discussion of a number of different vil-

las (for example, the Villa Lante) in *Italian Gardens,* and here he seems to have deliberately emphasized their separate but linked natures.

In addition to its remarkable spatial layout, Weld also offers a striking illustration of Platt's interest in "furnishing" a garden as an outdoor room. From the photographs that exist of this now almost completely destroyed space (fig. 4.15), it was indeed lavishly appointed, with fountains, a pergola, and a generous amount of statuary, architectural fragments, benches, and urns.[38] Complementing the architectural furnishings was a wealth of flowers,[39] which Platt believed were an essential component even of the gardens of Italy and on the presence or absence of which he had frequently remarked in his book.[40]

Public Landscapes

Although the gardens Charles Platt created for private individuals predominate in both their number and influence, no account of his work as a landscape designer would be complete without at least a mention of the many institutional commissions he received throughout his career. Among the most sig-

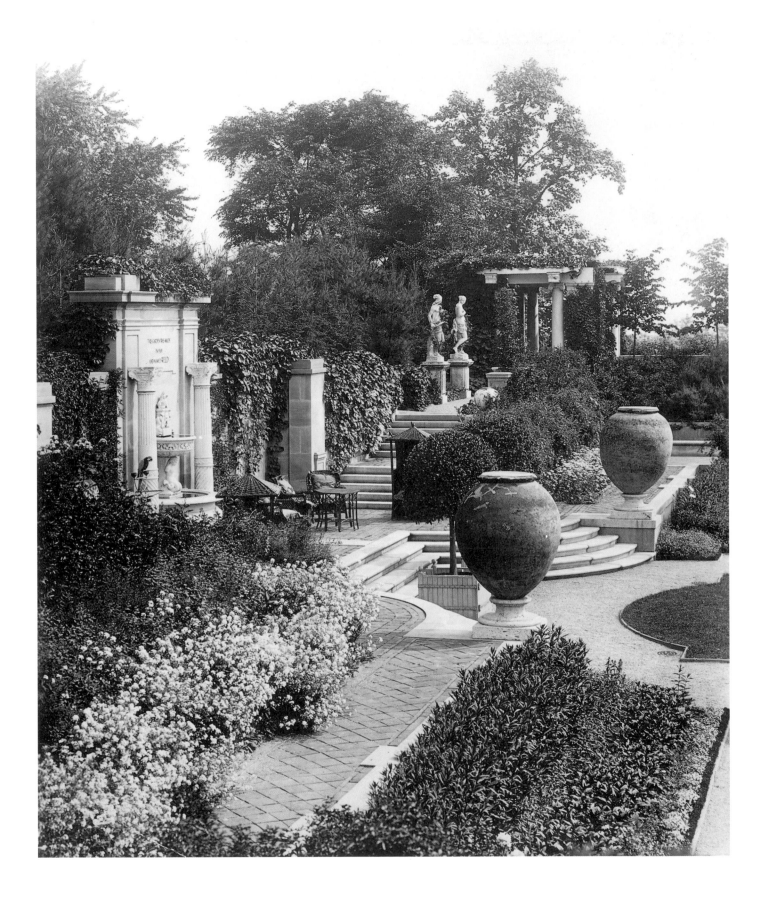

nificant of these projects were his site plans for educational institutions such as Johns Hopkins University (1912–33), the University of Illinois (1921–33), Phillips Academy, Andover (1922–30), and Dartmouth College (1926–31). Platt developed a master plan for the University of Illinois at Urbana/Champaign (fig. 4.16) and was also the architect of a number of campus buildings.[41] His plan for Illinois shows a strong Beaux-Arts influence, with a dominant central axis (determined earlier by the Olmsted Brothers landscape design firm) and several secondary cross-axes. Around these are grouped individual quadrangles in a balanced but not symmetrical arrangement. In the as-yet-undeveloped area to the south, Platt devised dramatic diagonal axes leading to garden quadrangles, a scheme reminiscent of Pierre Charles L'Enfant's plan for Washington, D.C., as well as more generally of urban planning ideas from the City Beautiful movement of the era.

From 1916 to 1921 Platt served as a member of the National Commission of Fine Arts, giving him the opportunity to participate in a number of design decisions on proposals for both architecture and landscape in the nation's capital (at a time when he was working on his design for the Freer Gallery of Art, which would itself become a significant presence on the Mall). One of the projects with which the commission was concerned was Meridian Hill Park, on 16th Street in northwest Washington, a rare example of an American public park influenced by European formal gardens, particularly by the Italian water stair and the French *tapis vert*. Originally begun in 1914 to the designs of George Burnap and Horace Peaslee, lack of public funds and other delays extended its construction over more than twenty years. Platt's advice on Meridian Hill was apparently sought on a number of occasions, even after his official service on the commission had concluded. He particularly influenced the design of the lower park, near the cascade, where the commission had been dissatisfied with proposals for a solid wall separating the park from the street and, in 1928, adopted Platt's suggestion to change the wall to a parapet "with seats and open balustrade sections, similar to the Villa Borghese in Rome."[42]

Conclusion

In summary, Charles Platt's work in the field of landscape design played a pivotal role in the revitalization of interest in gardening as a fine art and in the critical discussion of the garden as part of the cultural and social life of early twentieth-century America. Platt uniquely combined in one person the skills of painter, landscape designer, and architect, and these abilities, along with his knowledge of and interest in the classical gardens of Italy, resulted in his singular understanding of both the pictorial and spatial qualities of landscape design. What is more remarkable, he attempted—with some degree of success—to communicate the important qualities of garden design to the general public through his writings and photographs, as well as by the built works he created. His studies of Italian villas contain not only a presentation of their fundamental design principles and ornamental qualities but also an attempt to associate the Italian garden with eighteenth- and nineteenth-century notions of beauty and propriety in the art of landscape. In this way, he inspired a renewed interest in gardening as a fine art in early twentieth-century America and, more specifically, made the Italian garden an important model for a succeeding generation of landscape designers. At the same time that his writings provided a theoretical justification for the formal garden, the popularity of his garden designs made the model he had proposed acceptable in a social and functional sense.

Thus Platt was unquestionably a key figure in effecting the transition from the natural style of gardening which dominated landscape design in this country in the nineteenth century to the renewal of interest in the formal garden in the early twentieth. To say only this, however, does not convey the complexity or the syncretic nature of his achievement.

FIG. 4.16
Plan for the development of the campus, University of Illinois, February 4, 1922 (cat. no. 81).

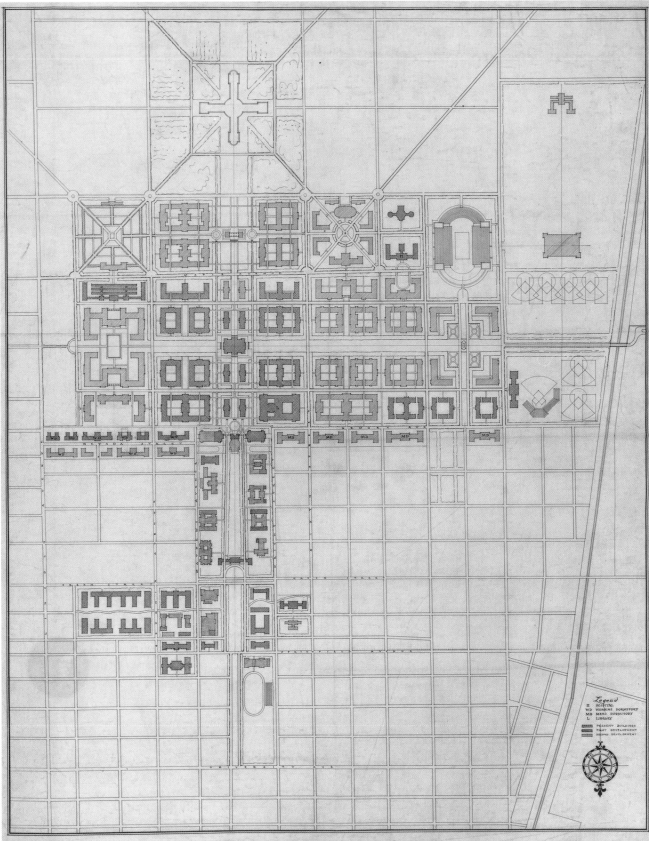

Scale 300 ft to the Inch

Plan for the Development of the Campus
of the
UNIVERSITY of ILLINOIS

Charles A. Platt Architect
101 Park Ave New York City
Feb 4 1922

In both his writings and his designs, Platt's work contains references to principles of landscape art which had the authority of historic precedent but which, at the same time, were adapted for modern use. In addition, they combine elements of both the picturesque and the classical traditions. Platt's importance in the history of early twentieth-century American design is based not only on the fact that he suggested a change from natural to formal styles, or from picturesque to classical imagery, but that he made possible a kind of garden imagery which contained elements of all of these, and which is still an integral part of garden design theory today. This quality of his work was recognized and appreciated by a number of his contemporaries. The architect Aymar Embury, for example, remarked that "the most interesting characteristic of [Platt's] work is the fact that he uses the formal so informally."[43] And Herbert Croly, for whom Platt designed a house and garden in Cornish (see figs. 1.8 and 3.27) and who was one of his most sympathetic interpreters in the critical press, wrote:

It may seem surprising to people, who are the victims of the supposed antithesis between "naturalistic" and formal gardens, that a man who had achieved high success as a landscape painter, and whose great distinction consists in his appreciation of the proper landscape values, that such a man should be particularly identified with the better establishment of the formal garden in this country; but in truth the antithesis between the formal and the "naturalistic" garden is one which arose only during a recent period, when the "formal" garden, as transplanted to England, became rigid and stiff.[44]

Platt's achievement, however, should also be understood as representative of the aesthetic ideals of his own age, which were manifest in a number of separate but related cultural phenomena in the larger society. His search for first principles of design in historic models—particularly those of the Italian Renaissance—was paralleled by similar pursuits throughout architecture, painting, sculpture, and urban design in the United States during this period. Platt's connections with the developing profession of landscape architecture through his brother, and later through his own colleagues, and with the art of gardening as a part of everyday life in Cornish, provided a forum in which his particular talents were brought to fruition. In addition, Platt contributed to the definition of the work of garden design as a fine art and to the formation of important partnerships between landscape architects and architects during an era which provided unprecedented opportunities for building in the domestic sphere. While later generations of American landscape architects would be less than comfortable with the work done during the so-called "Country Place Era," there is no question that the profession came into its own during these years and that the private and the public work landscape architects were able to create in their own right laid the foundations for the profession as it has evolved to the present day.[45]

Closely associated with these developments in the profession of landscape architecture, and in a similar syncretic vein, Platt's influence on American garden design generally may be characterized as both conservative and avant garde. It was most obviously conservative in providing the garden with the same kind of classical models and first principles which were being sought for other arts during this period. At the same time, his rational and architectural garden structure also seems, in retrospect, to have allowed for a freedom of interpretation and improvisation on new themes in contemporary garden design, particularly in providing a structure for American experimentation with the more naturalistic planting styles of the so-called English Cottage, Arts and Crafts, and American Colonial Revival modes. Finally, Platt's most important contribution to American landscape design deserves to be restated: a way of thinking about the garden as necessarily a part of its architectural context and

of the larger landscape. Platt had first derived this principle from his studies of Italian gardens. However, it was his own particular genius that enabled him to combine a diverse historical legacy with an understanding of contemporary uses of the garden to produce designs which are among the most beautiful and functional ever created in the United States and which continue to reward study today.

5

Charles A. Platt in New York,

1900–1933

DEBORAH S. GARDNER

CHARLES A. PLATT lived and worked in New York City during one of the most vibrant building periods in the city's history. His architectural practice, clientele, and urban legacy were all shaped by the dynamics of municipal development from the 1890s to the early 1930s. Platt's early success as an etcher and painter and his social background facilitated access to wealthy patrons in a city that was the center of American capital, while the works he produced there were configured by the special status and size of New York among American cities.

Modern New York came into being in 1898 through a consolidation that joined together Brooklyn, the Bronx, Manhattan, Queens, and Staten Island into one metropolis of over three hundred square miles with a total population of 3,400,000. At the turn of the century, it was the largest American city, the busiest port, the major point of entry for immigrants to the United States, the leading manufacturing center, and the headquarters for most major corporations. Over the next thirty years, New York's famous skyline took shape (fig. 5.1). Its image would influence the development of other American cities, for better or for worse, as would the city's pioneering housing legislation, its regulations governing land use (zoning), and its efforts to adopt the principles of the City Beautiful

movement and to foster regional planning. The great Beaux-Arts monuments of the first decade of the new century—the magnificent civic gates of Pennsylvania Station and Grand Central Terminal, and the imperial settings for culture at the New York Public Library and the Metropolitan Museum of Art and for commerce at the New York Stock Exchange—created a public profile of metropolitan splendor that would endure until after World War II. The numerous bridges, subways, and tunnels that by 1930 linked the five boroughs and, beyond them, the suburbs of New York, Connecticut, and New Jersey, established patterns of residential and work life in the tri-state region that would prevail for decades.

The wealth that was generated by New York's role as the nation's business center, the location of the largest and most important banks, exchanges, insurance companies, and law firms, enriched numerous aspects of the city's life. Such wealth endowed foundations, underwrote philanthropic social services, funded medical and scientific research, created zoos and botanic gardens, and ornamented parks and major thoroughfares. The city's wealth was a force, too, in sustaining New York's dominance of American cultural and intellectual life, both high and low, with its numerous publishing houses, orchestras and opera companies, and legitimate theater,

FIG. 5.1
Skyline of Lower Manhattan, early 1930s. Private post card collection, New York, New York.

97

ethnic, and vaudeville productions. Wealth generated in the city was used by New Yorkers to purchase large tracts of land on Long Island and in Westchester County and in summer resorts in the mid-Atlantic states and New England, and to ornament them with large country houses set amidst beautifully landscaped gardens and grounds. In fact, Platt's initial success as an architect was tied to this "country house movement"; in turn, it provided the foundation for his New York commissions.[1]

In Manhattan, there were great extremes of wealth and poverty. Stately uptown mansions built by Vanderbilts, Astors, and their peers, and private art and library collections assembled by successful businessmen like Henry Clay Frick and John Pierpont Morgan, Sr., offered a striking contrast to the poverty and sprawl of the tenement districts, where more than a million people, including many recent immigrants, lived by 1910. In the middle of the social scale was a diverse cohort of white-collar workers and professionals who staffed increasingly larger corporate and government offices and a variety of urban institutions, such as public schools, banks, and hospitals. They lived in brownstones and apartment houses and frequented the public museums, parks, and libraries that had been built since the Civil War.

New York drew talented people from around the country to offer their services in its unique market and to collaborate and compete with one another. Overwhelmingly, professionals such as attorneys and architects practiced independently, treasuring their autonomy and contracting their services to clients on a job-by-job basis. The economic niche from which they drew their clientele was established early in their careers. The commissions that came to architects such as Charles Platt, who was able to attract wealthy and influential clients, were significantly different from the work received by those who had to depend on speculative builders, city bidding processes, or small-scale investors.

Several other factors shaped the careers of architects in the city: their participation in professional organizations, such as the New York Chapter of the American Institute of Architects and the Architectural League of New York; their willingness to serve with public agencies such as the Art Commission and on investigative boards such as the New York City Improvement Commission; their voluntary assistance in judging student work at the architectural schools; and their participation in major public competitions.

The influence of architects on their profession and public taste was enhanced not only by their prominence in civic and cultural life but also by the visibility of their work in assorted publications. The location of many firms with national practices and many of the country's most celebrated designers in the city naturally made New York the center of the architectural press. Criticism and comment were readily available to an educated public in specialized journals such as the *Architectural Record*, in general circulation magazines like *Harper's*, and in newspapers like the *New York Times* and the *New York Tribune*. Initiated by Mariana Griswold Van Rensselaer in the 1880s in the pages of *The Century* and carried forward on a regular basis by Russell Sturgis and Montgomery Schuyler in the 1890s, the tradition of architectural criticism was extended the following decade by the incisive voices of Herbert Croly and Royal Cortissoz. Those architects whose work was favored by these and other publications benefitted enormously from the attention.

Platt's designs were featured and acclaimed in articles and books written by Croly, an editor of the *Architectural Record*, who was also an astute political commentator and a longtime friend and client of the architect.[2] Cortissoz, the art critic of the *New York Tribune* for over fifty years and the author of myriad articles and books on such artists as Augustus Saint-Gaudens and John LaFarge, valued the classicism of Platt's work and its ties to traditional forms, associations that he believed promoted order and harmony in society.[3]

From the 1890s to the early 1930s, New

York offered well-educated and socially connected architects extraordinary opportunities. The wealth available to individuals and public agencies, and changing concepts regarding private consumption and public amenities, revised the scope of building programs and promoted the collaboration of architects and artists on a scale that had never before existed in American history. Clients, architects, and artists met and mingled socially, and these ties translated into commissions and cordial working relationships that extended over many years. As Mariana G. Van Rensselaer judiciously noted in 1887,

So intimate is the temporary relationship between client and architect that we cannot wonder or condemn if the former sometimes chooses his executive chiefly for the reason that he is a friend or relative or that, although a stranger, he belongs to the same social stratum as himself.[4]

Such circumstances were the basis for the architectural career of Charles Platt. Beginning with summer house commissions from friends and relatives in the 1890s, he was soon receiving work from their circles of business and social acquaintances. With each completed project, the network was extended. For example, Platt designed a house in 1904 in Barrytown, New York, for John Jay Chapman, an author and political journalist whom he knew as a fellow member of the Century and Players clubs. The next year Platt was commissioned by Chapman's sister-in-law, Mrs. C. Temple Emmet, to design a house in St. James, Long Island.

From 1902 until his death in 1933, these kinds of contacts molded Platt's work in New York City. During an era when the cityscape in all its dimensions was being radically reshaped, the range of his practice there was fairly narrow. It was primarily residential—town houses and apartment buildings—with some commercial structures and a few one-of-a-kind projects. Work in New York was no doubt circumscribed by the demands of Platt's very successful country house practice before World War I and the large number of commissions he received after the war for museums, memorials, and campus plans and buildings in other parts of the country.

It was thus Platt's friends and colleagues at the major contemporary firms—McKim, Mead & White, Carrère & Hastings, Delano & Aldrich, Trowbridge & Livingston, Howells & Stokes, or John Russell Pope—who designed the architectural landmarks of the era that so impressed New Yorkers and visitors alike. During his decades of practice, the new campuses of Columbia, New York University, and the City College were built, as were outstanding religious buildings such as the Madison Square Church and St. Thomas and St. Bartholomew's Episcopal Churches. Enormous department stores; business temples like the Chamber of Commerce; and numerous clubs, theaters, and monuments such as the Maine Memorial at Columbus Circle also attracted customers, audiences, and tourists. Platt did not actively seek these projects or any of the great civic commissions such as the U.S. Customs House at Bowling Green, the Municipal Building, or the New York County Courthouse that were eagerly pursued by the most prominent architects of the day. This reluctance to compete undoubtedly had to do with personal predilection. With the success of his practice elsewhere, he may have felt disinclined to shift limited staff resources to such chancy ventures. In addition, he may have believed that his lack of formal academic training in architecture put him at a disadvantage with his professional peers.[5]

Because of his busy practice, Platt carefully selected the aspects of civic and professional life to which he could devote his time, basing these decisions on his interests and expertise. Unlike such contemporaries as I. N. Phelps Stokes, Grosvenor Atterbury, and Ernest Flagg, Platt did not publicly engage in debates on great issues of the day such as how to improve the design of low-income housing, whether to limit the height of buildings, or how to reconstruct the city's civic center. He did serve, however, on an Architects Advisory Committee chaired by

Harvey Wiley Corbett of the Regional Plan Committee for New York and Its Environs. Platt sought no office or appointment within the major professional organizations in New York, but he did accept requests to serve as a juror on major architectural competitions; such positions were regarded as a recognition of achievement and talent.[6] Platt was held in high esteem by his colleagues, considered by William Adams Delano "an all-round artist, . . . a good and loyal friend, much beloved by his fellows."[7] He was honored, too, with an exhibition of his etchings at the Grolier Club, the oldest American club devoted to "book arts" and a pioneer sponsor of exhibitions on books and prints.[8]

Although Platt was not a member of the Grolier, he did belong to several other clubs through which he maintained important social and professional contacts. By the late nineteenth century, clubs had become important elements of male middle- and upper-class urban culture. They proliferated in New York, representing social, political, professional, educational, sports, religious, and ethnic interests. The wealthy had their grand social clubs—the Union, New York Yacht, Knickerbocker, University, Union League, and Metropolitan—which emulated London institutions and whose members had well-established family pedigrees. Professionals often belonged to several clubs, those that were specific to their work, such as the Lawyers Club and the Engineers Club, and others that broadened their social and business networks.[9]

Platt belonged to the Century (officially, The Century Association), which originated in several short-lived, antebellum literary organizations. When it was incorporated in 1847 under the leadership of William Cullen Bryant, Asher B. Durand, and Henry T. Tuckerman, the Century's goal was to attract a broader membership that would allow "authors, artists, and amateurs of letters and the fine arts" to mingle and cultivate "social enjoyment."[10] From its beginning, the Century membership included prominent men from all walks of life; among them was Platt's father, John, a successful lawyer. By 1891, the growth of the membership necessitated a larger facility, and McKim, Mead & White was commissioned to design the new building on 43rd Street between Fifth and Sixth Avenues. Modeled on a sixteenth-century Veronese palazzo, it was a path-breaking design that has been called the "paradigm for the monumental clubhouse."[11] A special feature was an art gallery for the exhibition of members' works.

Platt had been elected to the Century in 1887, one of many distinguished architects to join the roster.[12] Though he often lunched with his colleagues at an architects' table that might include John Russell Pope and Henry Bacon, he was also remembered by his contemporary Frank Jewett Mather, Jr., as a "shy but companionable member who, though his art was in the classic tradition, frequented the table in the northeast corner of the Dining Room, then sometimes called the Bolshevik Table."[13] Platt was the first architect to be elected president (1928–30) of the club, succeeding statesman Elihu Root. William Adams Delano reported that the honor made the other architects feel

that the profession had, at last, gained its rightful place in the sun; but Charles did not feel the sun's warmth. He was never happy on the throne; he was too modest and lacked the self-confidence to preside comfortably at our meetings. It was a relief to him, and a regret to us, when ill health compelled him to resign from the presidency, as it did after a brief reign of three years.[14]

Platt was also a member of the Players, a club founded in 1888 by Edwin Booth, the great Shakespearean actor. Booth and his friends in the theater were inspired by the example of the Garrick Club in London but planned to include men from other professions so as to broaden the intellectual and social horizons of the actors. Booth bought a brownstone at No. 16 Gramercy Park and asked Stanford White to renovate the residence into a club. When it opened on December 31, 1888, the building had dining and

entertainment spaces as well as a library for books and theater-related collections and bedrooms for Booth and others.

Platt was nominated in 1889 for membership in the Players by two friends, the architect Stanford White and the artist Thomas W. Dewing. Joining him within a year or two were architects John M. Carrère, Thomas Hastings, Jr., Richard M. Hunt, and Russell Sturgis; White's partners Charles McKim and William Mead had been founding members. Platt frequented the club often when his offices were located at 20th and 24th Streets. Stimulating, friendly conversation was a hallmark of the club. Something of the atmosphere and the mix of members is conveyed in a reminiscence by author Arthur Maurice about his first visit to the grill room in 1901:

The spirit of awe, quite proper in a then youthful neophyte, was heightened by the round table of that day. It seemed draped with a kind of august majesty. Gathered around it, if memory serves correctly, were Mark Twain, then living in the club, and Augustus Saint-Gaudens, and Stanford White, and Brander Matthews, and Mr. Gilder and Mr. Johnson of the "Century", and the painters, Coleman and Dewing and Simmons and Reid.[15]

In addition to the many grand club buildings with their elegant quarters, elaborate rules, and costly fees, New York also harbored a host of smaller, more intimate, and less formal organizations, many of which sprang up after 1900. One of these was the Coffee House, founded in 1915 by Platt's friends Frank Crowninshield, Chester Aldrich, and Paul Manship, and by other arts and literary figures like Finley Peter Dunne, Fritz Kreisler, and Guy Lowell. Crowninshield was the editor of *Vanity Fair* and a popular figure in publishing circles. The new club was meant to be a refuge from the regulations and stuffiness of such long-established institutions as the Knickerbocker Club—"a revolt against the marble palace idea, . . . very simple and cheap." Thus, "bankers and brokers" were not welcome, although notables from many other professions were admitted.

Artists, theater people, and writers predominated, including such well-known personalities as Robert Benchley, Douglas Fairbanks, Charles Dana Gibson, Childe Hassam, Frederick MacMonnies, Maxfield Parrish, Cole Porter, Owen Wister, and P. G. Wodehouse.[16]

Platt was an early member of the Coffee House, as were friends and clients Herbert Croly, novelist Winston Churchill, lawyer Charles Burlingham, John Jay Chapman, playwright Louis Shipman, and Royal Cortissoz. Among Platt's architectural peers, William Adams Delano, Bertram Goodhue, Thomas Hastings, C. Grant LaFarge, John Russell Pope, and Joseph Urban were members. The club rented modest quarters at 54 West 45th Street in the midtown district that was home to many clubs, large and small. The Coffee House rooms were furnished with comfortable chairs, a long communal eating table, and prints and other illustrations made or donated by its members. The club was convenient to Platt for a quick, convivial lunch or dinner since it was just a few short blocks from his office at 101 Park Avenue (40th Street) in the famous Architects' Building, where numerous firms and suppliers had their quarters.

These clubs were representative of the comfortable, well-to-do component of New York society (although some of their literary and artistic members were certainly familiar with the bohemian arts and literary subculture percolating in Greenwich Village that would set the stage for modernism); and most of their members were largely shielded from contact with the population at the lowest end of the income scale in New York. Enormous waves of immigrants from 1890 onward created a large, poorly paid labor pool. Various philanthropies attempted to better their lives: through encouraging Americanization through settlement house programs, improving health by requiring plumbing in tenements and by building public baths and gymnasiums, and providing access to education through public schools and a public library branch system that was funded by Andrew Carnegie. These efforts were meant to ame-

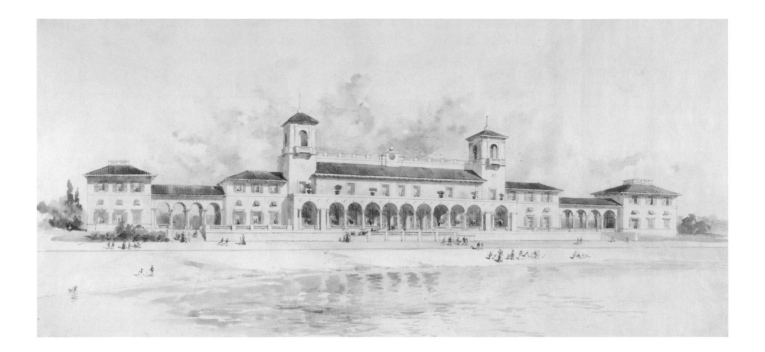

liorate living conditions without changing the basic structure of an unfettered free enterprise system that created such problems.

Charles Platt's contact with the tenement districts was indirect: his friend Mrs. Josephine Shaw Lowell had worked among the tenement dwellers of the Lower East Side; his client Vincent Astor had inherited a number of run-down tenements as part of his real estate empire.[17] It is somewhat ironic, then, that among Platt's earliest New York commissions, two—a recreation center and a commemorative fountain—were connected to philanthropy concerned with tenement dwellers.

Platt's very first New York project was a group of beach pavilions commissioned in 1902 by Charles M. Schwab, then president of the United States Steel Corporation. Facilities such as parks, playgrounds, and recreational piers were considered important for the education, health, and social well-being of city children and frequently inspired generous gifts during the early years of the twentieth century. The Richmond Park Beach Association was a charity created by Schwab to operate this recreational complex for a

thousand children on the Staten Island shore (fig. 5.2). Platt chose a classical design:

A long colonnade, open both on the sea and the land side, and finished at the end by two pavilions. The pavilion to the left is used for [staff] offices and living rooms; the pavilion to the right for the pantry, kitchen and the like.[18]

The children ate at tables in the space enclosed by the colonnade. The whole complex was somewhat elevated to catch the breeze, and from it the children could see the beach and ocean on one side and the inland play areas on the other. "The impression it produces," wrote Herbert Croly in the first published overview of Platt's practice, "is of a dignity corresponding with the almost institutional nature of the charity, yet it is also gracious, and within the colonnade, the effect is even gay and exhilarating."[19]

Platt's second project was perhaps more fulfilling personally because of his friendship with Mrs. Josephine Shaw Lowell. He designed the fountain honoring her, which was built in Bryant Park and dedicated in May 1912.

FIG. 5.2
Rendering of the waterfront elevation of Richmond Beach Park, Huguenot, Staten Island, New York, 1902 (cat. no. 68).

When Mrs. Lowell died in November 1905, she was one of the most respected women in New York City.[20] Widowed during the Civil War, she had devoted the rest of her life to investigating and finding solutions to the social problems of the day. She worked through government agencies such as the State Board of Charities and helped to establish nonprofit organizations such as the New York Charity Organization Society (COS) to encourage cooperation and efficiency among charitable agencies. After coming to realize that charity and philanthropy were insufficient to alter the fundamental conditions of poverty, Mrs. Lowell helped organize the Working Women's Society (later the Consumer's League) to support better wages and working conditions. She also founded the Women's Municipal League, an organization that would continue its efforts to improve public services through the Progressive era, and she was active in the anti-Tammany campaigns of the 1890s to reform city government. Through these varied activities she was known and admired by many members of the city's civic leadership.

Soon after Lowell's death, a committee chaired by Seth Low, a former mayor of Brooklyn and of New York City and retired president of Columbia University, was established to build a memorial in her honor. Low was a longstanding friend of Lowell, having founded the COS with her in 1882. Among those assisting with the project were lawyer Charles C. Burlingham, an influential advisor on judicial reform and civic matters to public officials, and a recent Platt client, Mrs. Frederick S. Lee.

Platt probably received the memorial commission because he was a friend of Mrs. Lowell and well acquainted with Lee and Burlingham.[21] As Burlingham later recalled, one summer in the late 1890s Mrs. Lowell came to Cornish, New Hampshire, to visit him and his wife (a former schoolmate of Mrs. Lowell's daughter), and they invited Platt and sculptors Augustus Saint-Gaudens and Herbert Adams to dinner. Awed by her reputation, they were uncomfortable until a humorous exchange between Platt and Mrs. Lowell finally broke the ice at dessert. "After that," Burlingham recounted, "they were all at ease with her."[22]

The Department of Parks and the Art Commission approved Platt's fountain design in 1909 for Corlears Hook Park in the Lower East Side neighborhood where Mrs. Lowell had been a district visitor for the COS.[23] In the spring of 1911, before construction, the location was changed to Bryant Park, a much more prominent site. It was adjacent to the new home of the New York Public Library, just nearing completion on Fifth Avenue between 40th and 42nd Streets. The Lowell fountain (fig. 5.3) was placed near a life-size memorial to poet William Cullen Bryant, designed by Platt's friend Herbert Adams.[24] Lowell was the sister and widow of Union army heros killed in the Civil War and the daughter of fervent abolitionists; Bryant was a dedicated anti-slavery journalist and supporter of Lincoln. The proximity of the two

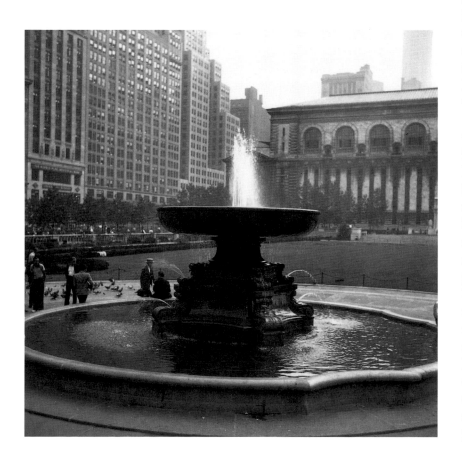

FIG. 5.3
Lowell Fountain, Bryant Park, dedicated 1912. New York City Parks Photo Archive.

memorials was fitting and appropriate. More than three hundred people subscribed to the cost of the fountain, the first major monument to a woman to be erected in New York City.[25]

Platt's Renaissance-style fountain was a harmonious addition to the terrace in front of the Bryant memorial. The design was derived from Platt's memories of numerous Italian fountains in the town centers and the private gardens he had studied many years before. Composed of a beautiful broad pink granite basin whose waters overflowed into a larger lower pool, the fountain complemented the formal layout of Bryant Park and the Renaissance-inspired design of the library.[26] Altogether, it was one of the outstanding City Beautiful complexes of the time.

The beach pavilions and the Lowell fountain, with the social issues involved, were unusual commissions among Platt's urban oeuvre; rather, his practice was sustained by an elite rich enough to pay for two building types that became emblematic of New York City from 1900 to 1930: the apartment house and the skyscraper. Platt was a leader in the development of the luxury apartment house, although he declined involvement with the excitement of skyscraper development from 1900 to 1930.

During this era the tall building underwent a continuous stylistic and technological evolution—even as critics bemoaned the proper aesthetic mode for ever higher towers—and New York's singular skyline was created for all the world to applaud. Platt, like other architects of his generation and social background, such as McKim, Mead & White and Carrère & Hastings, was not drawn to the design challenge of the very tall building, a hotly debated topic among architects, architectural critics, developers, and the business community.[27] Almost every year, or so it seemed, a new building in Manhattan claimed the distinction of being the tallest in the world. Between the completion of the Park Row Building in 1899 at 33 stories and the Woolworth Building in 1913 at 62 stories, new towers successively set records. Many buildings of forty or more stories were built in the 1910s and 1920s. When the race to increase height heated up again, the winner, the Empire State Building, completed in 1931 and topping out at 102 stories, set a record that would not be challenged for over forty years.

In comparison, some of the same big-name architectural firms that declined skyscraper work did design apartment houses, although most apartment buildings were the products of specialists who worked for speculative builders.[28] Apartment-style living for respectable families, on the European model, was introduced in New York in 1869 with the construction of the Stuyvesant, designed by Richard Morris Hunt. After 1900, as land costs rose in Manhattan and made new town house construction more and more costly, apartment houses for the middle and upper classes began to attract developers on a larger scale.[29]

Over the next thirty years, four developments in respectable apartment house design influenced Platt. First, the layout of the large, ornate apartment suite successfully mimicked the amenities and complexity of the town house. Second, the cooperative form of financing an apartment building was less costly than building or buying a row house and also assured selection of one's neighbors. In the co-op, an architect could work with the owners to personalize the design of the individual layouts. Third, the courtyard building, modeled on the typical nineteenth-century Parisian apartment complex, assured restricted access to the building, permitted such accommodations as private gardens, and improved ventilation. Finally, the studio-style apartment, combining living quarters and a large artist's studio in a duplex arrangement, introduced a new spatial dimension to the "flat." One of the earliest of these, built at 25 West 67th Street in 1901 as a cooperative, was saluted by Herbert Croly for the ingenuity with which it provided well-lit work space and "pleasant, wholesome and genial domestic surroundings" for a moderate amount of money. Croly was ecstatic about the studio:

"It provoked such a feeling of amplitude. It was supplied with such an abundance of light and air; . . . it gave one the sense of being a room in the country rather than in the city."[30]

Platt's first apartment commission came from Frederick C. Culver, a real estate operator and previous Platt country house client. It was built by William J. Taylor, who had already constructed the Bryant Park Studios in 1901 on 40th Street and Sixth Avenue and the artists' studios on West 67th Street that had so impressed Herbert Croly. Platt's Studio Building (1905–6) was located at 131–135 East 66th Street, at the northeast corner of Lexington Avenue on the fashionable Upper East Side (fig. 5.4). Platt elected to use a masonry facade, which suggested "remotely but still palpably," to Croly, "the admirable Italian tradition of palatial street architecture."[31] The multi-roomed villa of the Italian countryside had been the favored source for many of Platt's domestic designs; it served as an estimable model for its urban counterpart. The substantial overhanging cornice and the robust doorway enframements give vitality to the very restrained facade, while the building's even street fenestration masked the basic apartment plan: the double-height studios were located on the rear interior courts. The striking studio apartments on 66th Street attracted a cross-section of influential New Yorkers, including actor Otis Skinner, artist and art critic Kenyon Cox, and stockbroker Charles Merrill. Platt was commissioned to design the interiors for many of the building's units, and he himself took an apartment there for his family (fig. 5.5). Because most of the costly apartments were not designed for working artists, the studio instead became an elegant, generously proportioned living room in the duplex units, surrounded with bedrooms, libraries, dining rooms, and service areas (fig. 5.6).[32]

Platt also designed several apartment houses for his major New York client, the Astor estate. The story of the Astors differs from the better-known scenario of New York real estate history that highlights the quick, speculative development and turnover of property. It is, by contrast, representative of a pattern of long-term ownership of real estate that was just as significant, if not more so, in the development of specific neighborhoods, and even of the city as a whole.[33] By the late nineteenth century, there were a number of individual and institutional landowners in Manhattan that had owned substantial property through several generations: the Rhinelanders, the Schermerhorns, the Goelets, the Astors, Trinity Church, and the Sailors Snug Harbor Estate. The Astors, like the others, held their land for decades and let lessees develop it while the value of the land increased with the growth of the city.[34]

FIG. 5.4
The Studio Building, 131–135 East 66th Street, designed 1905–6. (Illustrated in *Monograph of the Work of Charles A. Platt*, 1913, p. 140.)

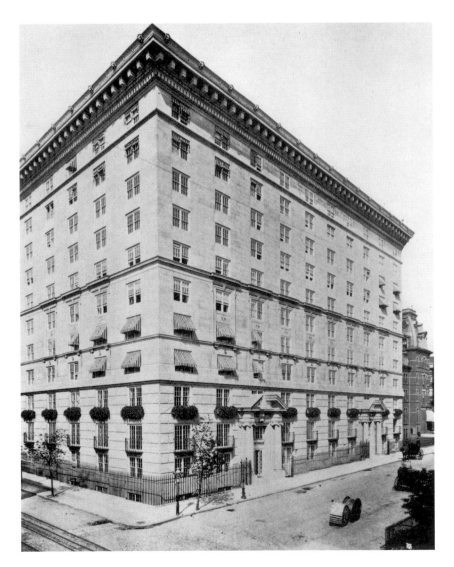

The foundation for the family fortune in real estate had been laid by John Jacob Astor (1763–1848), who invested his mercantile profits in Manhattan land. Through three generations this philosophy guided, with few exceptions, the management of the Astor fortune in real estate. When John Jacob Astor IV, his great grandson, inherited $65,000,000 in real estate in 1892, he introduced some changes into the management of his properties and became a more aggressive developer. He built the Astoria (1897), St. Regis (1904), and Knickerbocker (1904) Hotels to compete with the New Netherland (1892), Waldorf (1893), and Astor (1909) Hotels built by his cousin William Waldorf Astor.

When John Jacob Astor IV was drowned with the *Titanic* in 1912, his son, William Vincent Astor (1890–1959), usually known as Vincent Astor, inherited his real estate fortune. Vincent Astor would work with the Astor office managers—Nicholas Biddle, Douglas Robinson, James Roosevelt Roosevelt, and William Dobbyn—to alter radically the estate's landowning and development philosophy.[35] In the next two decades, land would be rapidly bought and sold, and profits would be plowed into major new buildings. Platt was hired by the estate in 1906 and would eventually receive twenty-four commissions from it, many of which were representative of Vincent Astor's new approach to his patrimony. Platt's lucrative connection with the Astor estate was another instance of how commissions came from his social networks. Platt was a friend of Nicholas Biddle, a fellow member of the Players club and the brother of Ellen Biddle Shipman, who was at first Platt's protégée and later a brilliant landscape architect in her own right.[36]

Vincent Astor followed the lead of his uncle William Waldorf Astor. William had seen the value of Astor-held land on the Upper West Side increase with the opening of the IRT subway line in 1904, which ran north on Broadway from Times Square to 145th Street. He built the Apthorp (1906–8) at Broadway and 79th Street, a building that

defined the central-court style for the next decade.[37] Vincent commissioned Platt to design the Astor Court apartments on the east side of Broadway between 89th and 90th streets (figs. 5.7, 5.8). Finished in 1915 at a cost of $1,500,000, the building had a U-shaped plan with a garden court and large, well-planned apartments for upper-middle-class tenants. The brick facade masked a steel frame, a construction element that had revolutionized apartment house size as much as it had changed the height of office buildings. Platt used a masonry-sheathed, two-story base with decorative ironwork and arranged carved balconies and shields on the upper floors to break up the large mass of the building.

While Vincent Astor was shrewdly follow-

FIG. 5.5
Fireplace wall of library, Charles A. Platt apartment, the Studio Building, 131–135 East 66th Street, designed 1905–6, photograph taken before 1913 (cat. no. 70).

FIG. 5.6
Plans of main and mezzanine floors, the Studio Building, 131–135 East 66th Street, about 1905 (cat. no. 69).

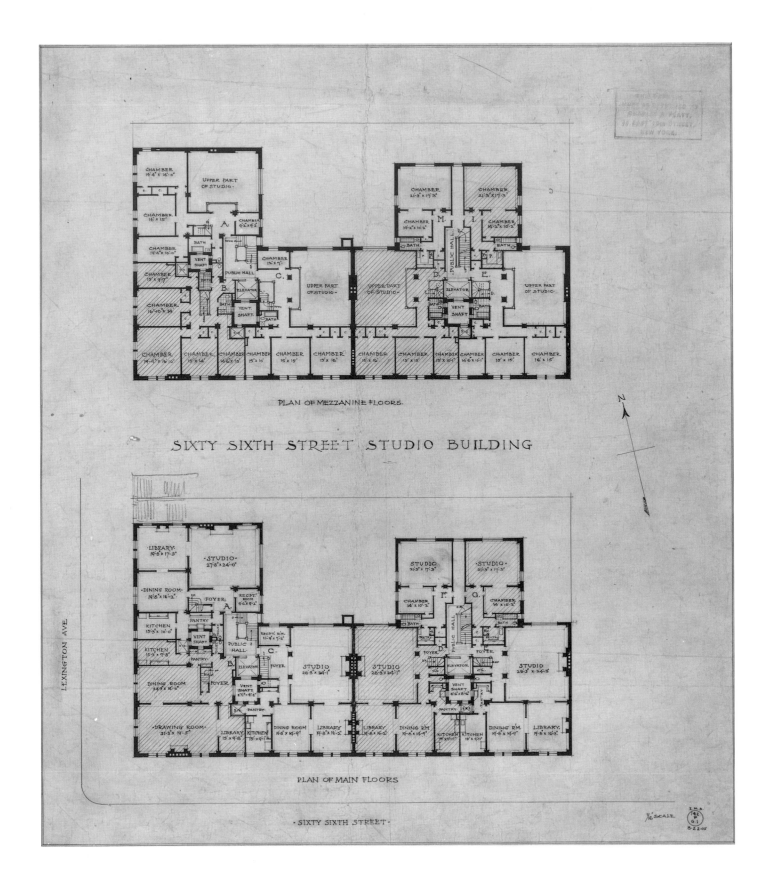

PLAN OF MEZZANINE FLOORS.

SIXTY SIXTH STREET STUDIO BUILDING

PLAN OF MAIN FLOORS

·SIXTY SIXTH STREET·

107

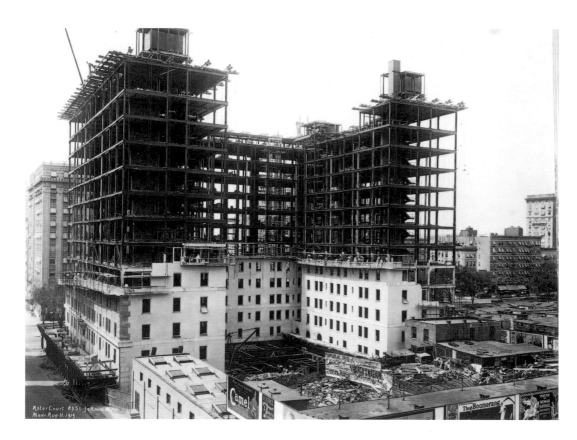

FIG. 5.7
Courtyard facade during construction, Astor Court, 2424 Broadway, August 11, 1915. Photography Collection, Miriam and Ira D. Wallach Division of Art, Prints and Photographs, The New York Public Library, Astor, Lenox, and Tilden Foundations.

FIG. 5.8
Broadway facade, Astor Court, 2424 Broadway, designed 1914–15.

ing a trend on the West Side, a decade later his buildings were the trendsetters in refashioning an Upper East Side neighborhood into an upper-class enclave known as "Gracie Square," an area where his great-grandfather, the first John Jacob Astor, had long ago lived on a country estate.[38] In 1927 and 1928, Platt designed two high-class apartment houses, 520 and 530 East 86th Street between York and East End Avenues, near Carl Schurz Park and Gracie Mansion. Although the apartment plans were not innovative and their neo-Georgian brick facades with stone trim were similar to many Park Avenue apartment

houses built after 1910, they were immediate market successes. Astor's apartments had been a gamble, built as they were adjacent to a district of tenements. With Astor's success, these tenements were soon displaced by the construction plans of other developers until East 86th Street became a wall of high-rise buildings.

Platt designed a third apartment for Astor around the corner at 120 East End Avenue, facing the park (figs. 5.9, 5.10). It was one of the last luxury buildings completed before the Great Depression, with apartments of ten to nineteen rooms featuring libraries, draw-

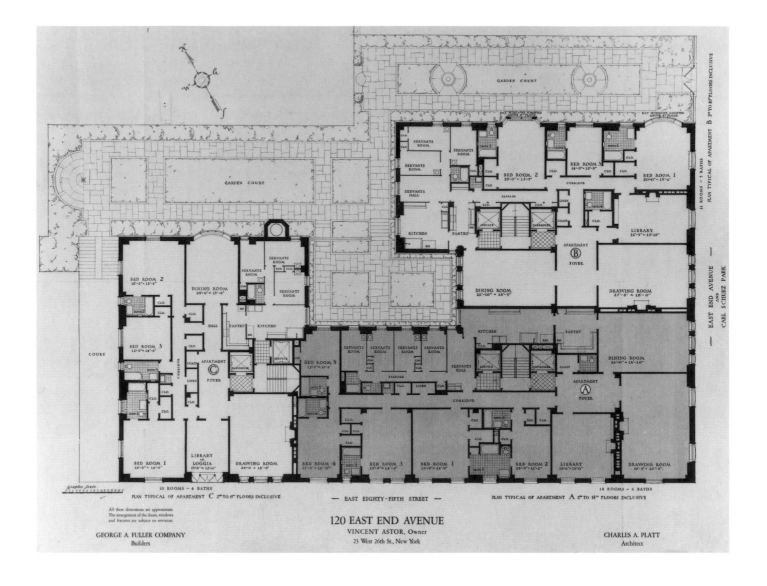

ing and dining rooms, servants' rooms, and several bedrooms. There was one twenty-three-room apartment that rented for $25,000 per year, and Astor himself had an apartment in the building that occupied one entire floor.[39] Each unit was served by its own elevator bank, an arrangement common to many upper-class buildings constructed on Fifth and Park Avenues in the 1920s. Although the building won the Medal of Honor of the New York Chapter of the American Institute of Architects for "exceptional excellence of plan and harmony between exterior design and interior arrangement," *New Yorker* architectural critic Lewis Mumford found the overall effect wanting.

Asking himself "how a man of impeccable taste like Mr. Platt proceeds with a big apartment house," he answered by describing the building as

a steel frame, treated by a marmoreal, and monumental classic formula; chaste, reserved, devoid of ornament except in the delicate iron guards on some of the rectangular sash windows. . . . The taste is excellent; the architectural conception, deficient.

Mumford was especially concerned with the plan, finding that although it met legal requirements, the building's narrow strip gardens did not provide enough space to

FIG. 5.10
Typical floor plan, 120 East End Avenue, 1929 (cat. no. 77).

allow sunlight and fresh air into the rooms on the lateral facades. The critic hence concluded that "Mr. Vincent Astor's standards would not do for the Amalgamated Clothing Workers."[40] This comment represented one of the very few occasions when Platt's work was ever criticized in the architectural press.

Platt's only major commercial designs in New York came from the Astor estate. Among them were the twelve-story Bawo & Dotter Building (1911–12) at 24 (later 20–28) West 33rd Street between Fifth and Sixth Avenues (fig. 5.11), and the fourteen-story 330 Fifth Avenue (1926) at the southeast corner of East 33rd Street and Fifth.[41] Located on property that had been in the Astor family for many decades, these two large and austere brick office buildings blended into the cityscape with few decorative devices to distinguish them from many others of the era. A two-story colonnade on the Bawo & Dotter

facade was a feature that appeared on a number of office buildings in the city before World War I. Platt's office blocks were designed to extract the best possible return for their owners given the zoning and building codes.

Another strategy that guided the Astor real estate investments was the renovation of long-held properties to improve their return until total redevelopment made sense. Vincent Astor employed this tactic in the Times Square area, where he owned a great deal of land. Legitimate theater and vaudeville, hotels and restaurants, newspaper offices and tenements all shared the district, and tourists and New Yorkers were drawn there by the profusion of popular entertainments and watering holes. As the cultural capital of the United States, New York attracted well-to-do tourists from around the country and abroad, and numerous luxury hotels competed from the 1890s onward for their custom. Hotels

FIG. 5.11
Elevation of the Bawo & Dotter Building, 24 (later 20–28) West 33rd Street, 1912 (cat. no. 74).

· EAST · ELEVATION ·

· THIRTY · THIRD · ST · ELEVATION ·
SCALE ⅛ INCH · 1 FOOT

· Nº 24 WEST · 33ᴿᴰ ST, BUILDING ·

were a good investment: impressive returns were possible, not only from the room charges but also from their splendid restaurants and bars that were elaborately and amusingly decorated. In the Knickerbocker, built in 1904 by Vincent's father at the corner of Broadway and 42nd Street, a mural of *Old King Cole* by Maxfield Parrish reigned over countless tipplers in the hotel's convivial bar. But with the passage of the Eighteenth Amendment and the advent of Prohibition in January 1919, the loss of liquor sales cut into the profit margins of many hotels, including the Knickerbocker, as people either drank illegally at home or in the numerous speakeasies that sprang up all over the city.

The Astor estate decided that an office building made more economic sense in the Times Square area and hired Platt to oversee the Knickerbocker Hotel's conversion in 1920. The $1,757,000 renovation remodeled bedrooms into offices, and the great public spaces of the hotel—lobby, restaurant, lounge—were transformed into commercial retail uses, in this case, a drug store and an enormous (4,000 square-foot) barber shop/beauty parlor, both designed by other architects. Platt created a grill, whose various rooms could seat 1,000, and where his own painted murals of garden and landscape subjects "enhanced the beauty of the place." One section of the restaurant was paneled in oak and known as the Old English Coffee Room. The main dining and dancing hall could be entered directly from 42nd Street or from the Times Square subway station; the subway entrance was a decided advantage in luring customers to the entertainment rooms.[42]

Platt had previous experience in restaurant design and architectural work for the Astor estate in the Times Square area. In 1910, he had designed the six-story, palazzo-style Longacre Building, with offices above retail space and the Shanley Restaurant at the rear street level.[43] The Longacre was located on the west side of Broadway, occupying the block front between 43rd and 44th Streets. The Astors owned the land on the side streets, behind the Longacre, and renovated the rundown brownstones there into "bachelor apartments."[44] Within ten years the apartments and the Longacre were sold at a healthy profit by Vincent Astor and replaced by the large Paramount Building (1927), which combined theater and office spaces, an appropriate use for the locale.

Adaptive reuse was also pursued by the Astors in more fashionable areas like the Upper East Side, where Platt completed a number of town house projects for the estate and individual clients. Soon after 1900, along the streets east of Fifth Avenue and north of 59th Street, many brownstones (row houses) that had been built between the 1860s and the 1890s were either renovated or demolished. Land costs were rising, but the cost of new construction was not yet prohibitive; for those who had less to spend, extensive renovation made sense for it allowed them to live in the right neighborhood, close to the cultural and religious institutions, clubs, and mercantile establishments that were important to their lifestyle. For the Astor estate, the high rentals obtainable in these desirable neighborhoods made renovation profitable.

From the 1880s onward, architectural critics such as Montgomery Schuyler had declared war on the rows of "nefarious" brownstones for the monotony of their similar facades.[45] By 1903, Herbert Croly reported that "for the most part people demand that the old houses shall be either utterly destroyed or subjected to such a drastic process of purging that every trace of the brownstone is removed."[46] The new wave of renovation and construction featured an eclectic succession of styles from the late 1890s to the 1930s: Italian or French Renaissance in masonry, Colonial Revival in brick with stone trim, and finally, in the 1920s, stucco and paint in a variety of fashions.

Unlike the brownstone era when large groups of identical houses, sometimes spanning an entire block front, had been built on speculation, each newly built or renovated

Entrance facade, 844 Fifth
Avenue, designed 1906.
(Illustrated in the *Architectural Record*, vol. 21, June
1907, p. 468.)

town house was commissioned by an individual client. This type of work constituted about one-third of Platt's New York projects.

Indeed, Platt's very first project for the Astor estate in 1906 had been the remodeling of a brownstone at 844 Fifth Avenue, adjacent to the French Renaissance-style mansion built for Mrs. Caroline Webster Schermerhorn Astor and her son John Jacob Astor IV in 1891 (fig. 5.12). This renovation required a design suitable to the location and capable of attracting a high-class tenant. Platt chose an Italian Renaissance-inspired facade with rusticated limestone covering the entire front wall, which was ornamented with a carved shield and garlands. With the addition of decorative ironwork on the ground-floor windows and in the areaway fence, the building was suitable for the "avenue of millionaires."

Platt had been instructed to retain the same floor levels as in the original building, a common means of holding down renovation costs. For this reason he used the "American" basement-type plan for the building, an approach that had gained favor after 1900 for new structures, too. This necessitated the removal of the high brownstone stoop and its replacement with a ground-level entry, one or two steps up or down from the sidewalk level as needed. Entrances were centered, with a service door at the side, if the building was wide enough. By moving the interior stair from the side of the building to the center of the plan, the full width of the building was recaptured for the public rooms—the dining room, the library, the drawing room—on the upper floors. This is what Platt did at 844 Fifth Avenue (and in subsequent town house plans), and with his careful design of the interiors, the result was a "residence of a family of refinement and wealth, . . . a more completely finished and better-looking dwelling than many private houses on Fifth Avenue which have cost twice as much."[47]

Given a second assignment by the Astor estate in 1911 to remodel a brownstone at 7 East 65th Street, Platt used a remarkably similar facade design.[48] In many of his city build-

ings, he found a mode that both he and his client liked and repeated it with small variations from building to building, giving his overall body of work in any particular building type a characteristic look. At 7 East 65th Street, he again used a rusticated facade. As was the case in many other brownstone renovations, the elimination of the stoop enabled him to enlarge the building on every level by bringing the front facade forward to the lot line.

Platt's town house commissions for other clients illustrate the importance of social and professional networks in obtaining work, as well as notable aspects of New York cultural life during the first decades of the twentieth century. Just as Platt was remodeling town houses for the Astor estate, he received a commission from the Roosevelt family, members of old Knickerbocker society. More specifically, his client was Mrs. Sara Delano Roosevelt, the mother of future president Franklin Delano Roosevelt and formidable mother-in-law of future social activist Eleanor Roosevelt. This commission may have come about through Platt's friendship with Nicholas Biddle or his working relationship with James Roosevelt Roosevelt. Biddle had been a suitor to Eleanor Roosevelt before she became engaged to Franklin, and he later served as an usher at their wedding. His social ties with the family, as well as his work with the Astor estate, would have made Biddle the logical person to ask about recommending an architect. James Roosevelt Roosevelt, the stepson of Sara Delano Roosevelt and half-brother of Franklin, was another advisor to William Backhouse Astor, Jr., and the Astor estate and would also have known Platt's work. He, too, could have advised Sara concerning the choice of an architect.[49]

In 1906, Mrs. Roosevelt bought two brownstones at 47–49 East 65th Street, between Madison and Park Avenues, with the intention of demolishing them and building anew. Previously, she and the young couple had lived within a few blocks of one another in the Murray Hill section of Man-hattan, where families of old wealth had remained in the 1880s and 1890s while the "new wealth" had built their chateaux further uptown on Fifth Avenue. With the imminent completion of the palatial new B. Altman & Company department store on Madison Avenue and 34th Street, a block away from her home, Mrs. Roosevelt felt that trade was encroaching on the residential neighborhood and looked to move uptown. Eleanor and Franklin needed more space for their expanding family, and she promised them a new home as a Christmas gift in 1905.[50]

The new house, completed in 1908, was Colonial Revival in style, a mode that was becoming quite popular on the Upper East Side for both residential and cultural buildings, and one that would be used by Platt in his town house designs during the next two decades (fig. 5.13). With its references to the urban housing of the late eighteenth and early nineteenth centuries, the Colonial Revival was particularly appealing to families who could trace their descent to the early years of the nation's history. Critic Montgomery Schuyler had gone so far as to extol the Federal-era row house as "the most respectable and artistic pattern of habitation New York has ever known."[51] The larger-scale interpretation of the Colonial Revival was introduced by McKim, Mead & White for New York houses and clubs in the 1890s. Carrère & Hastings, Delano & Aldrich, and Platt quickly followed their lead in designing a variety of public and private buildings in that style.

The six-story Roosevelt house appeared to be one great town mansion on the exterior but actually was internally divided into two homes, with identical floor plans, that shared an entry and vestibule and were connected on several of the upper floors.[52] In retrospect, Eleanor considered the result "a very remarkable piece of work." Platt, "an architect of great taste," had "made the most of every inch of space and built them so that the dining rooms and drawing rooms could be thrown together and make practically one big

FIG. 5.13
Entrance facade, the Roo-
sevelt residences, 47–49
East 65th Street, designed
1907.

room as the doors between them were very wide doors."[53] The large connecting spaces were a bonus for entertaining. However, the sliding doors also meant that Sara could come and go freely between the two units, denying Eleanor privacy and, for a time, authority with her children. "You were never quite sure when she would appear, day or night," Eleanor later wrote of her mother-in-law.[54]

Nonetheless, the house held its share of history. When Eleanor and Franklin went to Washington during World War I, they rented it to Mr. and Mrs. Thomas Lamont; Lamont was a partner of J. P. Morgan.[55] Franklin began his initial recovery from polio in the house in 1921, and his return to politics was plotted in its rooms over the next few years. Eleanor, too, made use of the large public spaces for meetings of her civic and political organizations and even held showings of furniture built by women workers in a factory she co-owned near Hyde Park, New York.[56]

A block away from the Roosevelt house, at 125 East 65th Street between Park and Lexington Avenues, Platt had designed a new town house for Frederic Schiller Lee in 1904–5 (fig. 5.14).[57] Lee was professor of physiology at the College of Physicians and Surgeons, Columbia University. His family background and achievements enhanced his social status, but the wherewithal to commission from Platt first a large town house (1906–7) and then a country house (1913) in Woodstock, Vermont, probably came from Lee's marriage in 1901 to Laura Billings, daughter of Frederick Billings, president of the Northern Pacific Railroad Company. She served on the Central Council of the Charity Organization Society (COS) and on the board of trustees of the Russell Sage Foundation. Through her COS work, she may have received a suggestion from Mrs. Lowell to approach Platt, or her husband may have met Platt as a fellow member of the Century.

In its styling, the Lee house was typical of other Colonial Revival buildings on the East Side. Platt drew on Federal-era buildings for

inspiration, placing a square, patterned transom light above the front door and flat arches over the second-floor windows. Because it had the advantage of two lots, like the Roosevelt house, the building Platt designed was 35 feet wide and only 68 feet deep. These proportions allowed him to plan a layout that was spacious and well lit, as was pointed out in an article in the *Architectural Record*: "The owner obtains thereby a residence which, instead of being narrow, dark and gloomy, becomes in its atmosphere clean, sweet, wholesome and liberal."[58] The most unusual feature of the house was a fourth-floor laboratory for the research work of Dr. Lee.

Another client from New York's intellectual circles was Norman Hapgood, editor of *Collier's Weekly*, one of the Progressive era's muckraking forums. In 1905 he commissioned Platt to remodel and redecorate the interior of a town house at 107 East 73rd Street, between Park and Lexington Avenues, one of a pair designed by Grosvenor Atterbury. Hapgood was a friend of Herbert Croly, a Cornish neighbor of Platt, and a clubmate at the Players.[59] Croly was so enthusiastic about the results of Platt's work for Hapgood that he featured the house in his book *Houses for Town or Country*, two years after he had written about it in the *Architectural Record*, extolling the "combination of simplicity of form with vivacity of effect which characterizes Mr. Platt's work."[60] It was not only the careful use of color and restrained use of architectural detail that created the warm, serene feeling for the house interior but also Platt's discipline in furnishing the rooms: "The sense of space and the proper relative importance of the architecture of the room are always preserved."[61] That Platt would select an "Adams mantel" or a refectory table or any number of other imported furnishings for his clients was not at all unusual. As Royal Cortissoz noted in his *Monograph* on Platt's work:

He has done more than any of his contemporaries to justify the vogue of those interiors which have

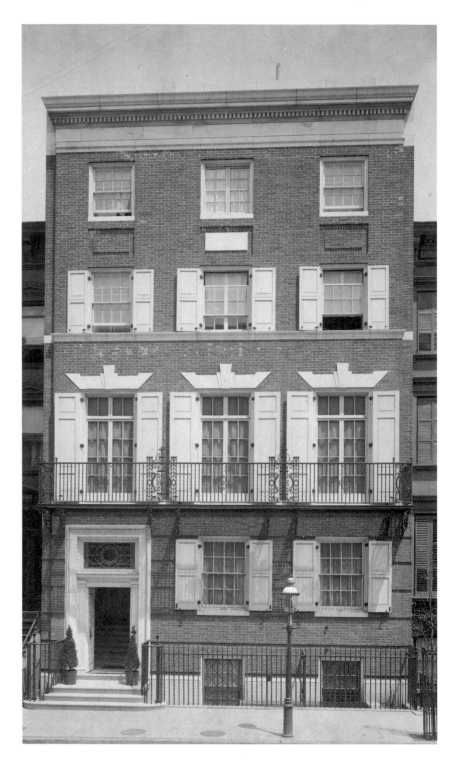

FIG. 5.14
Entrance facade, the Frederick S. Lee residence, 125 East 65th Street, designed 1905. Courtesy members of the Platt family.

come to express our cosmopolitan culture, the interiors filled with furniture and other objects rescued from Renaissance Europe and from antiquity. . . . It is a peculiarly modern development, interestingly allied with both the spread of education and the increase in wealth. [Platt's] *flair* for the right tapestry, the right old chair, or the right monumental carved mantelpiece is exactly equalled by his judgment in finding the right spots for them, and in harmonizing together the few such objects which he brings into a room.[62]

Many other architects with similar client lists were importing wall paneling, textiles, furnishings, and sculpture to use in their commissions. They, as did Platt, went on shopping trips to Europe and worked with dealers there to provide both the city and country residences of their clients with interesting, and often unique, furnishings.

More town house work for Platt came from the monied businessmen who bought his services for country houses too. Some of them were clients who had previously commissioned such buildings. For example, there was William Fahnestock, a stockbroker and corporate director, for whom Platt had previously designed Girdle Ridge (1909–24), a large country house and farm in Katonah, New York, and Oaklawn (1926–28), a house and stable in Newport, Rhode Island. Platt combined two town houses into one unit in the Villard Houses on Madison Avenue between 50th and 51st Streets. Both units had originally been bought by Harris Fahnestock, William's father, a successful investment and commercial banker, when they were developed by Henry Villard in the mid-1880s. Designed by McKim, Mead & White to resemble one large building but divided into six separate dwelling units, the Villard Houses were a landmark in their own time and introduced the Italian Renaissance palazzo style—which Platt had later reinterpreted with much originality in his own city buildings—to American cities. Platt made few structural changes, but his redecoration of the ornate, high-ceilinged rooms, substituting paler tones and slender moldings for the original dark paneling and heavy details, considerably lightened the rooms.[63]

Another client was Henry S. Morgan. He was the grandson of J. Pierpont Morgan, Sr., founder of the powerful banking house of J. P. Morgan & Company, and the son of J. P. Morgan, Jr., who had succeeded in maintaining the Morgan bank as a central institution in the New York capital markets.[64] Henry would later oversee the growth of Morgan Stanley, established in 1935, into a great investment bank. During the 1920s, he was in training as a banker, newly married, and seeking a home in New York City. Perhaps Thomas Lamont, a partner in J. P. Morgan & Company who had rented the Roosevelt house, recommended Platt to Henry. In 1925–26, Platt designed a Colonial Revival town house for him at 34 East 36th Street, across from the Morgan Library, which had been richly endowed with collections and funds by both J. P. Morgans.

Henry Morgan's six-story, Georgian-style home was surprisingly modest in appearance compared to the larger building Platt prepared for John T. Pratt at 6–9 East 61st Street in 1915 (fig. 5.15). The latter was his most elaborate domestic urban design, recalling aristocratic eighteenth-century London mansions; its rusticated limestone facade was embellished with intricate ornamental ironwork and stone carving. Pratt was one of nine children of Charles Pratt, the founder of a Brooklyn oil refinery that had merged with Standard Oil and had made Charles Pratt the second largest stockholder in that company after John D. Rockefeller. John Pratt was a corporate official for whom Platt had previously designed the Manor House at Glen Cove, Long Island (1911). This house, in turn, was situated near two other Platt projects for the Pratt family: estate entrance gates at Tower Hill (1900) for John Pratt's brother Herbert I. and a house for another brother, Frederick B., Poplar Hill (1926).[65]

*

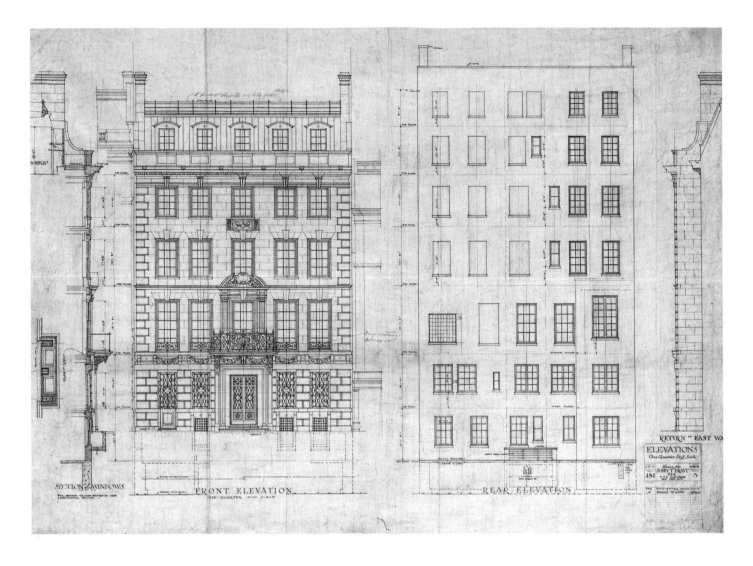

FRONT ELEVATION

REAR ELEVATION

SECTION THRU WINDOWS

FIG. 5.15
Front and rear elevations,
the John T. Pratt residence,
6–9 East 61st Street, 1915
(cat. no. 76).

Charles Platt's New York practice was very much shaped by the needs of a small, well-to-do clientele. Compared to the work of such contemporary firms as McKim, Mead & White, Carrère & Hastings, and Trowbridge & Livingston, it was limited both in terms of building type and stylistic range. But Platt clearly left his mark on the urban landscape of New York. The refined design and carefully considered scale of his town houses helped define the character of their neighborhoods for decades to follow and inspired his colleagues. Platt's work for the Astor estate, particularly his apartment houses and office buildings, exemplified a client-architect collaboration where aesthetics were not subsumed to profit. Finally, the Lowell foun-

tain continues to delight visitors to Bryant Park.

Despite all the productivity and the creative contributions of Platt and his peers (and their collaborators in the arts), the work of the era sometimes described as the "American Renaissance" was at odds with fundamental American values and changes in American culture. The notion of an elite cultural leadership, composed of those whom Herbert Croly called "constructive individuals," conflicted with democratic notions of merit and representation and with tendencies toward mass, consumer-driven culture. During Platt's own lifetime, the power of private patronage and professional autonomy was gradually curtailed by increasing government

regulation, taxation, public patronage, and markedly altered economic conditions. Over the long run, these tendencies would transform the relationship between architect and client and related artists, undermining the collaboration, the comprehensive control, and the grand dimensions of commissions that were characteristic of only a brief era in American cultural history and that came to a definitive end with the Great Depression. Platt was fortunate to live and work in New York before the world turned upside down.

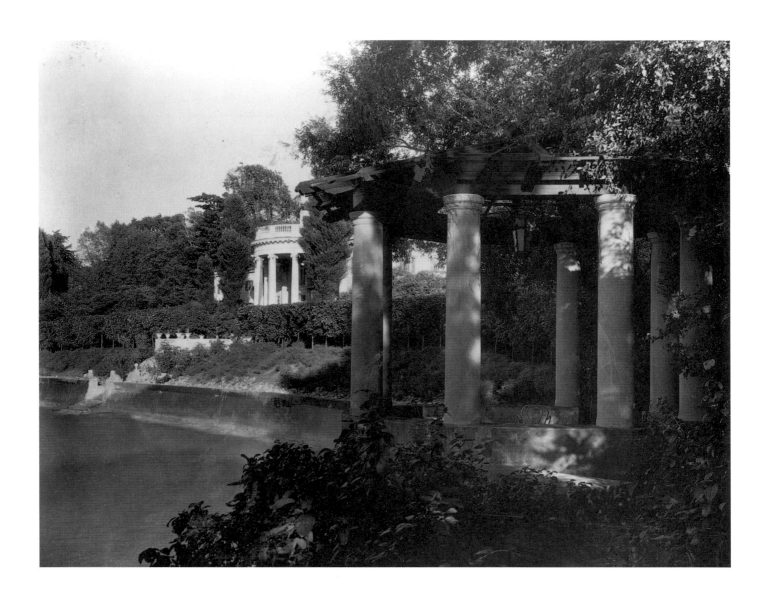

Gwinn: The Creation of a
New American Landscape

KEITH N. MORGAN

FROM 1906 THROUGH 1931, William Gwinn Mather, the President of the Cleveland-Cliffs Iron Company, and Charles A. Platt, artist and architect, were engaged in the creation of Gwinn, a country estate (figs. 6.1, 6.2) for Mather in the village of Bratenahl, east of Cleveland, Ohio, along the shore of Lake Erie. Gwinn is representative of Platt's mature work as a country house architect and landscape designer, coming at the end of his first decade of professional practice. His reputation as a domestic architect had been established by 1904, and the range of his commissions was truly national, as this and other projects of the later 1900s document. While based in New York, he executed designs for houses from Washington to Nashville to Chicago to Seattle, making periodic site visits and sending out supervisors and construction crews to achieve the high standards he set and his clients demanded. This one project can be used as a window into Platt's work as an architect and landscape architect and into his practice as a culture shaper of the early twentieth century.

The creation of Gwinn is meticulously detailed in the family archive that has previously not been available for inspection.[1] The wealth of correspondence, drawings, construction memoranda, and photographs allows for a thorough examination of the process and the product. Also, the patronage connections that extend naturally from Gwinn to a wide range of other projects demonstrate the network of individuals for whom Platt worked, the cultural motivations of this group, and the variety of his commissions throughout his career. Thus, the Gwinn story permits an analysis of Platt's work in general as well as an investigation of this country house in particular.

William Gwinn Mather (1857–1951) was typical of Platt's clients. Like many turn-of-the-century patrons who commissioned buildings from Platt, Mather had inherited and increased a fortune based in heavy industry and was descended from a long line of prominent Americans. Indeed, Platt worked for a number of very similar clients throughout the Great Lakes area in these years, families who made substantial money in timber, iron mining, railroads, and manufacturing. Bratenahl was typical of other communities, such as along the North Shore of Chicago, the Grosse Pointe area of Detroit, the Gold Coast of Long Island, or the hills of Westchester County, New York, where many of Platt's houses were built. Like Mather, his other clients often had a town house or apartment in the city and possibly a summer or resort house as well. Occasionally, Platt would design several of these residences. Platt was especially attractive to these clients

FIG. 6.1
View from lakefront pavilion, Gwinn, the William G. Mather residence, Cleveland, Ohio, designed 1907–8; alterations and additions 1911–20. Courtesy William Gwinn Mather Papers, Gwinn Archives, Cleveland, Ohio.

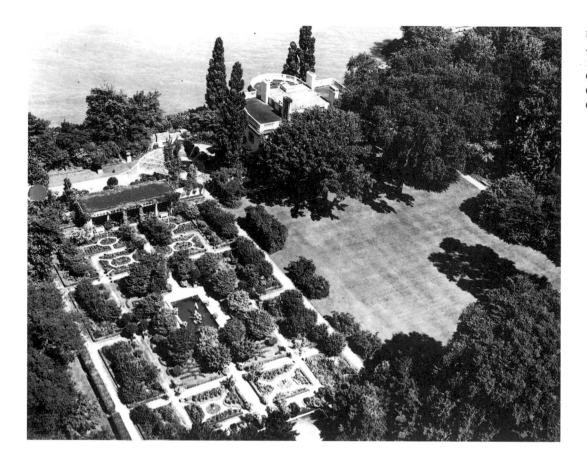

FIG. 6.2
Aerial view, Gwinn, about
1950. Courtesy William
Gwinn Mather Papers,
Gwinn Archives, Cleveland
Ohio.

because he provided the services of an archi-
tect and a landscape architect and would
supervise the purchase and installation of fur-
nishings and collections for the estates as well.

The Mather family had arrived in Massa-
chusetts in 1635 and counted the Reverends
Increase and Cotton Mather among their
direct ancestors.[2] In 1843, Samuel Livingston
Mather was sent out from Connecticut by his
family to dispose of land investments they
had made in northern Ohio. Seven years later,
he helped to found the Cleveland Iron Min-
ing Company, which developed the iron ore
potential of the Upper Peninsula of Michi-
gan. When the Sault Ste. Marie locks were
completed in 1855, the company inaugurat-
ed a fleet of ships that brought ore from the
Upper Peninsula fields to iron furnaces in
Cleveland. William Gwinn Mather joined the
company in 1878 and assumed the presi-
dency in 1890 upon the death of his father.
He came into this position in the middle of
negotiations to merge the Cleveland Iron

Mining Company and the Iron Cliffs Com-
pany, headed by Samuel J. Tilden, financier
and politician. Young Mather's rapid com-
pletion of this merger meant that he became
the president of the dominant mining opera-
tion in the Upper Peninsula. During the next
decades, he consolidated his position, grant-
ed substantial benefits to the miners, and
built communities with social services for the
workers, including one town that was named
Gwinn. Warren Manning, a landscape archi-
tect from Boston who had been trained in the
office of Frederick Law Olmsted, assisted
Mather in these projects. From 1899 until his
death in 1938, Manning executed fifty-nine
projects for Mather, beginning with the land-
scape for his cottage in Ishpeming, from
which he supervised his holdings in the Upper
Peninsula of Michigan.[3] With these accom-
plishments in business to his credit, Mather
turned his attention to the creation of another
Gwinn, a country house for himself and his
half sister outside of Cleveland.

Mather naturally sought Manning's advice when he first considered the possibility of building a lakeshore country estate. On September 20, 1906, Manning responded to a letter from Mather with recommendations on site and architect selection for a new house. He clearly assumed that he would be the landscape designer. In November, Mather asked him to stop in Cleveland and inspect three sites along the lake east of Cleveland. On November 14, Manning reviewed the merits of the three parcels and encouraged the purchase of lot C (fig. 6.3), with views directly off the lake and "an amphitheatre-like-bluff."[4]

The following January, Manning returned to his mission of identifying an appropriate architect. He sent Mather books and periodicals with pages marked and a description of the relative merits he found in the work of various designers. Manning felt a "long, low, home-like, unpretentious structure" would be most appropriate for the site, showing his desire that architecture be secondary to the landscape.[5] Although he observed that the "English type of house is more domestic and homelike" than any others, he admitted that many clients found the "absence of piazzas" objectionable.[6] He suggested several architects working in the English mode, such as Peabody & Stearns and Chapman & Frazer, both of Boston, or Cope & Stewardson in Philadelphia. He observed, however, that "the tendency now among American as well as English architects is to make simple stucco walls, with little in the way of ornamental features other than is represented by the grouping of windows and doors."[7] Platt was certainly a key exemplar of this contemporary interest in relatively unadorned, stucco buildings.

More interesting than Manning's commentary are Mather's handwritten notes in the margins of this letter. Following a reference to the Herbert Croly house (see figs. 1.8, 3.27) in Cornish, New Hampshire, Mather notes "French & Italian sentiment by C. A. Platt of N.Y.," and at the end of the letter, Mather scribbled a reference to the magazine, "'Indoors & Out, June 1906' Platt!!"[8] Obviously, even though Manning never mentions Platt by name in these letters, Mather had made his selection of architect from the illustrations provided. If his memory was good, Mather may have recalled a letter he had received on June 28, 1898, from Charles Lang Freer, railroad magnate and art collector, after a visit Mather made to Freer's new home on Ferry Avenue in Detroit. Freer recommended to Mather the services of his arch-

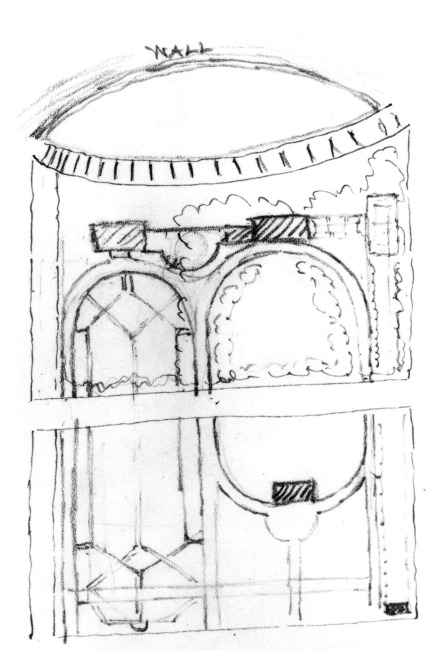

FIG. 6.3
Warren H. Manning, 1860–1938. Preliminary site plan for Lot C, 1906. Courtesy William Gwinn Mather Papers, Gwinn Archives, Cleveland, Ohio.

itect, Wilson Eyre of Philadelphia. He continued, "should you at any time have any landscape work of this kind or of even greater importance to undertake, you could do no better than to call to your aid my friend, Mr. Charles A. Platt, 107 East 27th Street, New York."[9] The fact that Mather chose an architect who was also a successful landscape designer indicates the importance he would give to the development of his gardens.

As a businessman accustomed to seeking professional advice, Mather quickly corresponded with a recent Platt client. Later in the month he received a letter of endorsement from the Reverend Joseph Hutcheson, for whom Platt had designed two houses.[10] Hutcheson attested that Platt was not only "a gentleman and artist" but also "business like and practical" and could "be trusted not only with the building of the house, but with its furnishing and especially with the garden."[11] Mather must have been pleased by Hutcheson's remark that "Mr. Platt has often said to me that the most successful work is produced when architect and client work harmoniously together," because Mather intended to be intimately involved with every element of his new house. When asked for his opinion of Platt, Manning admitted he did not know the architect but stated that "his designs for formal gardens in direct association with the house are perhaps more consistent and satisfactory than any others that I know of."[12] Manning warned Mather that Platt's gardens were "architects' gardens in which flowers are an incident . . . subordinate to architectural features." He continued, "I think Mr. Platt prefers to do all the work himself, and that he requires practically a free hand as regards cost." Obviously, the choice of Platt was an unhappy one for Manning because he realized he would have a smaller role in the creation of Gwinn than he had hoped. Manning, however, worked harmoniously with many architects whose designs extended to the landscape, and Platt frequently collaborated with landscape architects on designs for country estates.

Once Mather had made his selection, Platt quickly took command. They would correspond almost daily thereafter. Platt made periodic visits to the site, before and during construction, and Mather came to New York to confer and to visit special contractors, decorators, antiques dealers, and artists. On March 1, 1907, Mather wrote to his personal secretary, Charles G. Heer, giving him instructions for Platt's initial visit. Mather, who was not in Cleveland for Platt's first trip, wrote a program for his architect:

The house to be large enough to have a sitting room, parlor, den or office, dining room; and upstairs six to seven bed rooms for family and guests; four of them with bath rooms and of course corresponding accommodations for kitchen arrangements and servants.

Stable and garage accommodations for two horses; three or four carriages, three automobiles. A tennis court, vegetable and kitchen garden and of course principally the pleasure garden.[13]

Platt visited the same three sites that Manning had inspected the previous year, reinforced Manning's choice, and urged Mather to act quickly. As had Manning, Platt recognized the inherent drama of the lakefront site and the potential for a comprehensive landscape plan. At the time, Mather was vacationing in Bermuda and wrote formally asking Platt to make sketches for a house in "light, cheerful colors, . . . something of the Italian or Riviera effect."[14] On his return from Bermuda, Mather bought the property, inspected the preliminary sketches, and requested more information about the layout of the grounds.

In the same letter to Platt, Mather began a discussion of the costs he projected for the house:

I would like to have my expenditures, covering land, arrangement of ground and house not exceed $100,000. As you know, the land has already cost me $45,000.00, leaving $55,000.00 for the rest, not to include the furniture, but to include flooring, wainscoting, wall decorations, carvings, etc.[15]

Having been warned by Manning that Platt required "a free hand as regards cost," Mather perhaps hoped to constrain his architect right from the start. Platt responded that he did not think the house Mather wanted could be built for $55,000. He cited the comparable Hutcheson house, which had cost $54,000 three years before, and projected that the Mather house alone might be built for $50,000, leaving entirely too little for the site development, gardens, and service buildings. Platt felt that these auxiliary elements would cost approximately $30,000.[16] Two days later, Mather wrote that he placed "more store on the grounds than on the house," and though not wanting to be pretentious (a concern that Mather reiterated in his letters), he would not limit Platt to the original figure he mentioned.[17] This negotiation was only the first of many occasions when Platt would prod Mather to spend more than he had anticipated to achieve the result they both desired.

With the financial parameters temporarily established, the architect and client could turn to the plan and appearance of the estate. The property that Mather purchased was located in Bratenahl, formerly an agricultural district along Lake Erie, approximately five miles due east of the center of Cleveland. Large estates had already been constructed here along the lakeshore, including ones owned by William Mather's half brother Samuel, the Hannas, and other prominent families, many of whom still maintained houses on Euclid Avenue in central Cleveland as well.[18] While building Gwinn, Mather lived in a substantial house in town, but gradually his country house became his primary residence.

The Gwinn lot (fig. 6.4) consisted of approximately five and a half acres, with a frontage of nearly five hundred feet along the lake in the form of a natural amphitheater and an eighty-foot-high bluff. Lake Shore Boulevard, the major route into the city, bounded the property on the south, and proposed streets, which would be taken by Mather and his neighbors, were laid out to the east and west. Later, Mather would purchase an additional twenty-five acres across Lake Shore Boulevard where Platt would design service buildings and where Warren Manning would develop a wild garden of exceptional distinction.

Platt proposed an estate plan that located the house at the edge of the bluff, with the lake on one side and the gardens on the other. Platt was working on another lakefront property for Russell Alger in Grosse Pointe, Michigan, and would soon become involved with an even larger estate for Harold and Edith Rockefeller McCormick north of Chicago, so he had strong ideas about the potential of a water-based site.[19]

The geometry of Platt's planning schemes (fig. 6.5) was one of the elements that attracted clients and fellow architects to his work. With the house as the controlling element in the design, Platt choreographed a sequential and dramatic experience for the site. Visitors followed an entrance drive along the western boundary of the property and then turned 90 degrees to approach the main doorway on the short end of the house (fig. 6.6). The residence consisted of a rectangular mass, with the long facades parallel to the lake and a smaller rectangle for the service wing projecting on axis to the east. Stucco-covered walls and plantings prevented a view of the lake and of the gardens until the visitor entered the house. Platt provided a sudden and startling view of the lake through a monumental semicircular portico and over terraces connecting to the artificially concave lakeshore. The water, clouds, or sun in summer (fig. 6.7) and the frozen lake in winter made the view mesmerizing.

In total opposition, the land side afforded a tranquil expanse of green (fig. 6.8). A central panel of lawn, equal to the width of the main house and extending to the boulevard, was flanked by the formal garden, greenhouses, and gardener's cottage to the west, and a wild garden to the east (a tennis court shown on the original plan in this area was never built). The service drive clung to the eastern border of the property and was extended across Lake Shore Boulevard to

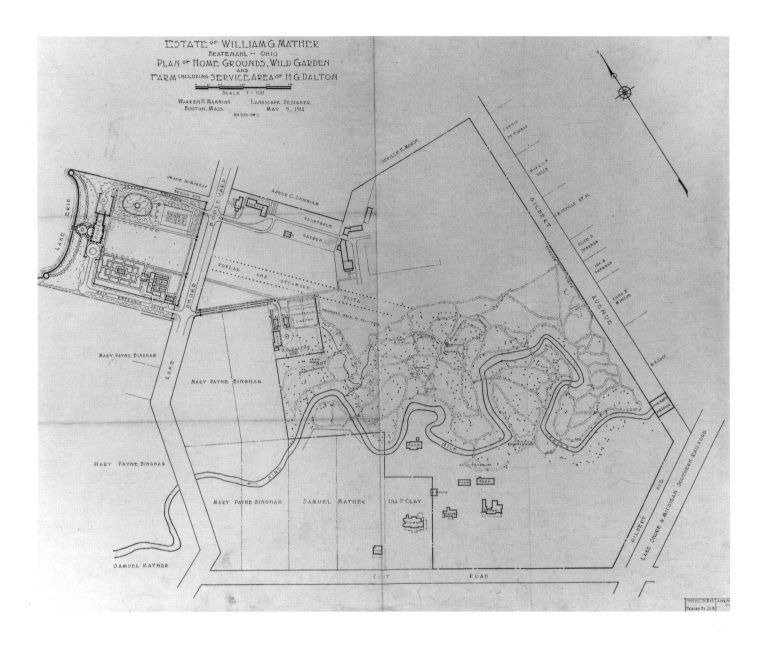

the southern parcel, where the stables, garage, coachman's house, and kitchen garden were located. Passersby were provided a partial glimpse of the estate through the iron fencing of the central section of the wall along the boulevard. Platt thus created three avenues of physical or visual access: for the guest, the passerby, and the servant. William Mather and his half sister enjoyed it all from within.

The style and materials of a potential house had been a concern for Mather and for Warren Manning from their earliest correspondence. True to Manning's prediction, Platt proposed a stucco-covered concrete structure, characteristic of his contemporary projects and of American architecture at large in the middle of the first decade of this century. Mather's suggestion of something French or Italian (or even the bright villas of Bermuda) was recast in the Renaissance-derived formula that had won Platt his national reputation. The most overt reference to a historical style is seen in the monumental lakeside portico, perhaps derived from the south facade of the White House in Wash-

FIG. 6.4
Warren H. Manning, 1860–1938. "Gwinn, . . . Plan of Home Grounds, Wild Garden," May 9, 1914. Ink on linen, 25 × 29 1/2 inches. Courtesy William Gwinn Mather Papers, Gwinn Archives, Cleveland, Ohio.

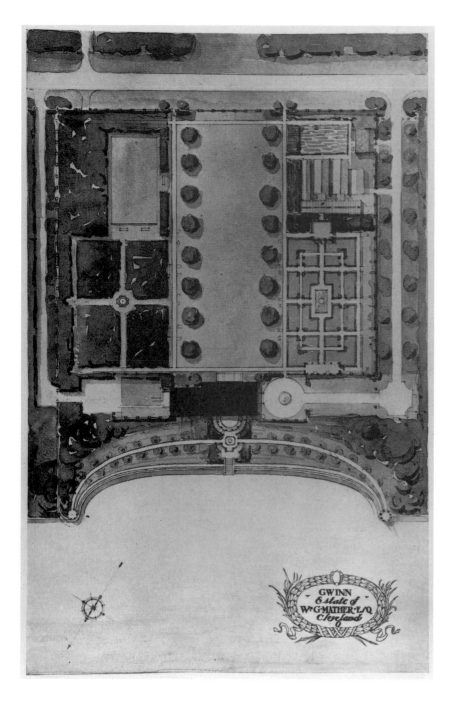

FIG. 6.5
Site plan, Gwinn. (Illustrated in *Monograph of the Work of Charles A. Platt,* 1913, p. 37.)

ington, among other possible references. Otherwise, the building exterior was a composition of massing and void with relatively little architectural detailing. The two-and-a-half-story, stuccoed mass was capped by a balustraded parapet that concealed the third-level windows. The balanced fenestration of the main elevations focused on the monumental portico of the lakefront and the three French doors providing access to the terrace overlooking the greensward.

On May 17, 1907, Platt forwarded the preliminary plan for the grounds, proposed floor plans, and one elevation for the house. Mather now informed Manning that he had selected Platt as his architect and landscape architect, but that they both hoped that Manning would consult on plant material for the gardens, which Manning agreed to do.[20] Although Platt set the pace for the initial development of the grounds north of Lake Shore Boulevard, Manning was an indispensable ally in the development of the landscape at large and would later create a much larger wild garden south of the boulevard.

Mather was very pleased with Platt's design but feared that the proposed treatment of the lakeshore would prove difficult and expensive. Platt's scheme depended upon the construction of a six-foot-high sea wall to create the architectural lakeshore design. Noting that Mather's brother's property had a sea wall as well, Platt convinced his client to have a local civil engineer, General Jared A. Smith, provide an estimate of the complication and expense. The waterside development would become the most memorable element of the estate.

The estimated cost for the entire commission had escalated to $65,000 for the house alone.[21] In addition, Platt charged a commission of 10 percent on anything built to his designs, which was essentially double the rates charged by Cleveland architects. Mather meticulously reviewed the plans, suggesting a reduction in size for the main house and more room for the servants.[22] He reminded Platt that "we must remember that the comfort of housekeeping depends almost entirely

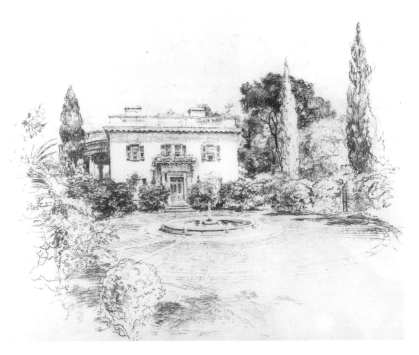

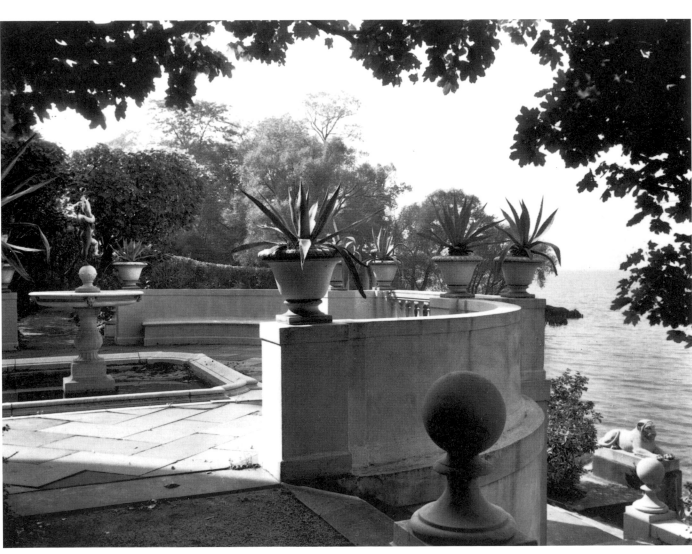

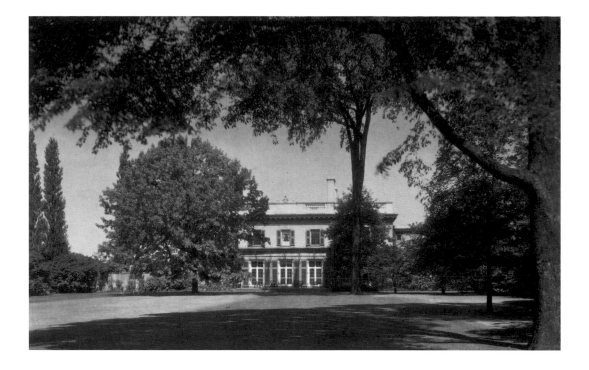

FIG. 6.8
Garden facade, Gwinn.
Courtesy William Gwinn
Mather Papers, Gwinn
Archives, Cleveland, Ohio.

upon willing servants which you cannot get unless you make them pretty comfortable."[23] On June 9, Platt responded to Mather's suggestion and reported that the house would now contain 200,000 cubic feet and cost approximately $80,000. Mather requested a comprehensive projection of the cost, which Platt provided on June 11, noting that the house, decorations, furnishings, gardener's cottage, stable and garage, walls, terraces, and gardens and landscape work should total $150,000, including contingencies but not the sea wall. Since the cost of the estate had essentially tripled from Mather's original expectations, he asked Platt to attempt to bring the house back to the original dimensions. In the end, however, after two months of correspondence, Platt's plans were accepted, and specifications were ready by mid-July.[24]

Beyond the question of scale and expense, the modifications in the plans for Gwinn focused on the interior arrangement of rooms and the extension of the house into the landscape on two sides. The earliest proposals (figs. 6.9, 6.10) included an inset monumental portico on the lake side and a pair of semi-circular, single-story bay windows flanking an uncovered terrace on the garden side. To complement his scheme for the concave harbor along the lake, Platt modified the waterfront elevation using a projecting portico as a semicircular, monumental form, with terraces and staircases spilling down to the water's edge. On the garden elevation, the corner window bays were removed, and an ironwork porch was added to the designs for the central terrace by June of 1907. As seen in their correspondence, the interaction of Platt and Mather during the several months of active refinement of the plans is a fascinating story to read, with the architect pushing to achieve his ideal and the client keeping a close eye on the escalating costs and the increasing scale of the estate.

The interior arrangement of the house (fig. 6.11) probably did not change significantly during this period of design gestation. The entrance hall on the western end of the house was flanked by a reception room, which was used as an office, on the lake side, and a withdrawing room, with a piano, on the garden side. Continuing east, the entrance hall passed the stairwell to the left and emptied

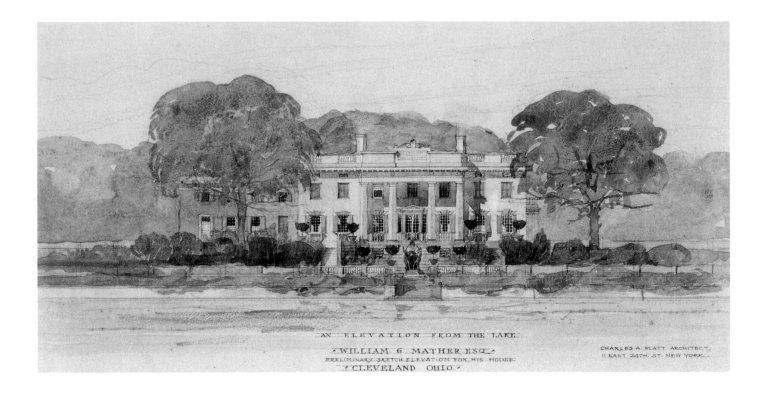

AN ELEVATION FROM THE LAKE

WILLIAM G MATHER ESQ

PRELIMINARY SKETCH ELEVATION FOR HIS HOUSE
CLEVELAND OHIO

CHARLES A PLATT ARCHITECT,
II EAST 24TH ST NEW YORK.

into the hall, overlooking the monumental portico and the terraces down to the water's edge. The central section of the garden side was filled by the library (fig. 6.12), with three French doors providing access to the terrace and gardens beyond. The central axis of the house ended in the dining room, which enjoyed a water view, and the morning room, which faced the greensward and grove. The service wing extended beyond the door of the dining room, through which the butler had to pass to receive visitors at the opposite end of the house. Occasionally, the geometrical balance and clarity of a Platt plan was at variance with the efficient functioning of a house. Although Platt slightly changed the configuration of the six upstairs bedrooms that Mather had initially requested, the number of bedrooms remained the determining factor in the scale and number of ground floor rooms, as Platt had warned Mather from the beginning.[25]

Building Gwinn was an extremely complex physical and financial operation. In addition to the client and the architect, the business loop included Mather's staff in Cleveland and Platt's assistants in New York. Bids were sought for nearly every element of construction, reviewed in Cleveland, and approved in New York through almost daily letters and telegrams. Charles G. Heer, Mather's personal secretary, and George Jacques, his head gardener, were key players in this process, as were F. H. Henderson, Platt's engineer, and Robert Dunbar and Charles Dixon, his site supervisors.[26] Over the course of the next three years, three different local architects were also hired to handle logistics, supervision, and occasionally the design of minor buildings.[27] Manning designed the planting for the area north of Lake Shore Boulevard and, after 1913, was consumed with the development of the wild garden on the property south of the boulevard. In 1914, when Mather was dissatisfied with the planting of the formal garden, Platt recommended that Ellen Shipman, a Cornish, New Hampshire, neighbor and a leading landscape architect with whom he frequently collaborated, be hired to redesign those plantings.[28] Platt also encouraged Mather to commission works by artists, many of whom were his

FIG. 6.9
Unexecuted study for the lake elevation, Gwinn, 1907 (cat. no. 83).

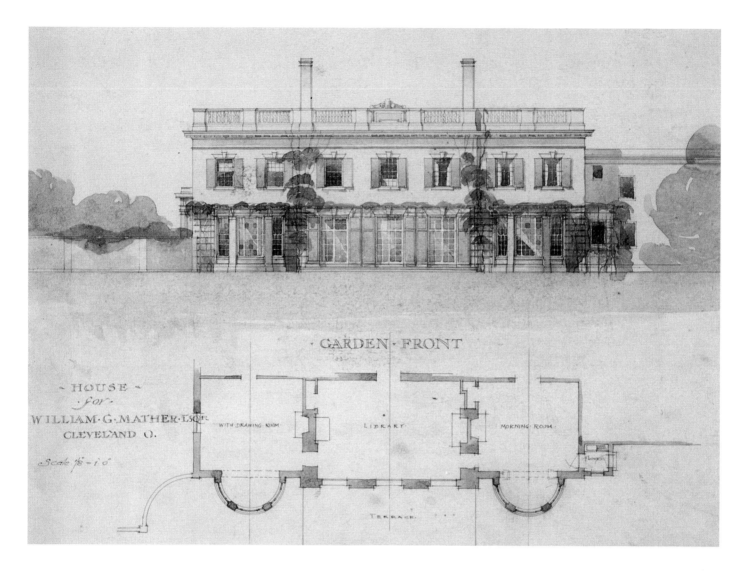

· GARDEN · FRONT ·

· HOUSE ·
· for ·
WILLIAM · G · MATHER · Esqr
CLEVELAND O.

Scale ⅛ - 1 0́

WITH DRAWING ROOM LIBRARY MORNING ROOM

TERRACE

FIG. 6.10
Unexecuted garden front
elevation and plan, Gwinn,
1907. Watercolor, ink, and
pencil highlighted with
gouache on tracing paper,
13 3/8 × 18 inches. Cour-
tesy William Gwinn Math-
er Papers, Gwinn Archives,
Cleveland, Ohio.

friends, for the gardens. Most important among these art works was the monumental vase (see fig. 6.15) that Paul Manship produced in 1915–16 for the end of the axis from the front door to the entrance drive, and the Pompeii-inspired mural decoration of the teahouse (fig. 6.13) in the formal garden, painted by J. Alden Twachtman in the fall of 1910.[29]

The specific contractors at work on the property often changed with each phase of construction, varying local workmen with New York–based builders for more specialized tasks. Changes had to be made to some of Platt's schemes to accommodate local building practices. For example, the local architect and the general contractor for the

main house advised against using poured concrete, noting that "local builders were not very familiar with concrete and that you could not, therefore, rely on them for a first class job."[30] The local contractor, J. W. Smith, advised building in brick, to be covered with stucco, instead. Smith was nevertheless selected to do the job, and the concrete work was a cause for concern on a continual basis thereafter. Long-distance supervision was often a problem as well, especially with the large number of subcontractors and specialists brought into the project. For example, a memorandum of January 13, 1909, lists fifty-nine workmen from thirteen different contractors at work on the property on that day.[31]

FIG. 6.11
First- and second-floor
plans, Gwinn. (Illustrated
in *Monograph,* 1913, p.
24.)

SECOND·FLOOR·PLAN

·FIRST·FLOOR·PLAN·

Within the house, however, Platt maintained tighter control. Six months after the start of construction, Platt was in Europe buying architectural elements, furniture, and decorative objects for his client. The initial expense account of $12,000 had to be doubled to pay for the acquisitions in Italy during December 1907 and January 1908.[32] By spring, Mather was pushing Platt for ideas on interior finish and color for his house. Platt explained:

I leave the color schemes to be worked out according to what may be obtained, and the longer this may be left, the better, as I often get valuable suggestions by standing in the rooms when they have reached a certain point of completion. . . .When the time comes, I propose to bring out with me to Cleveland a trunk full of things to try in the rooms and to talk over with you.[33]

Although he wanted to delay final decisions about interior decoration until he was on site, he did admit his intentions to "make the dining room and music room red, using an old red brocatel," stain the library woodwork a gray brown, and paint the woodwork of the hall and drawing room white. The color scheme and the limited role of antique architectural elements, such as the morning room mantel, seen at Gwinn is characteristic of Platt's houses in these years. Although Platt established the general program, he relied on Emil Feffercorn, a New York decorator, to acquire the fabrics, prepare the window treatments, and handle other logistics for the

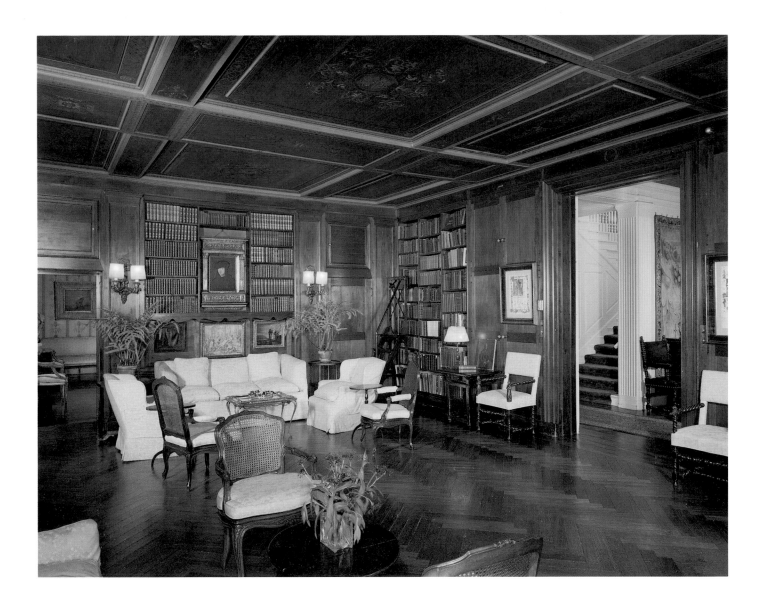

FIG. 6.12
Library, Gwinn.

interiors.[34] Most of these commissions were complete by June of 1909, when William Mather and his half sister, Katherine, moved into Gwinn, although the initial phase of construction would not be complete until February of 1910.

In addition to the furnishings, window treatments, tapestries, and other elements of interior decoration, Platt worked with Mather to acquire and improve the art collection for the house. He also consulted on conservation needs for objects that Mather already owned, such as a portrait of his ancestor, Cotton Mather;[35] and he purchased tapes-

tries, sculpture, and paintings for Mather in Europe on the initial buying trip in the winter of 1907–8 and on subsequent excursions.[36] He relied heavily upon Venice as a source for the works of art, choosing paintings or copies of objects from the schools of Canaletto, Longhi, and Marieschi. As in architecture, Platt's taste in pictures ran to the seventeenth and eighteenth centuries, and his placement of these objects reinforced the architectonic nature of the design. He generally favored cityscape views or architectural pastiches that he augmented with portraits, ranging from Francis I of France to images

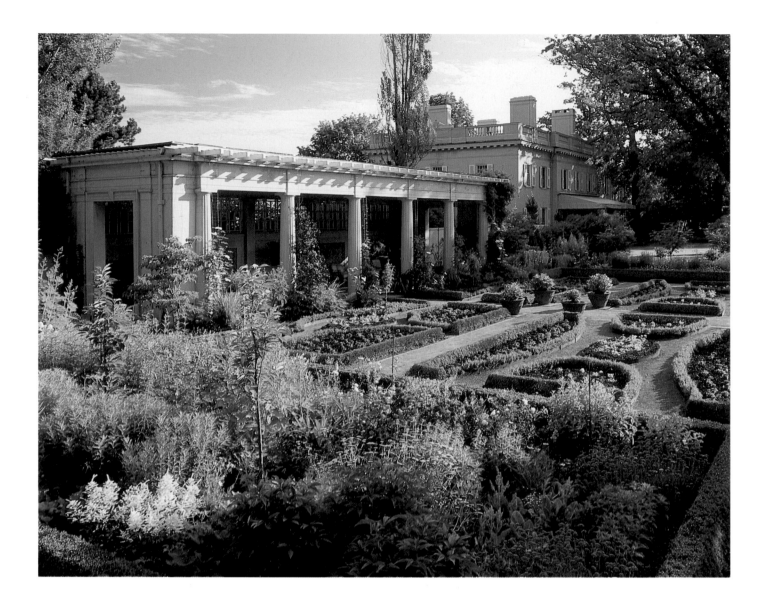

of young Italian girls, usually painted by unknown artists. The basic intention was to create the proper *mise-en-scene* rather than to build a great collection. Over time, however, Platt helped to refine the quality of the objects. He also provided Mather with one of his own etchings and with photographs that he had taken during his 1892 tour of Italian villas,[37] and he directed Mather and other patrons to the works of his artist friends. Gwinn thus possesses not only the Manship vase in the garden but a large number of turn-of-the-century canvases of women in interiors by his Cornish neighbor, Thomas Wilmer Dewing. Mather also purchased *The Moun-*

tain (fig. 6.14), a painting by Platt of the landscape near his summer home in Cornish, New Hampshire.

Once residing in the house (and with continued financial success), Mather saw new opportunities for embellishments, especially in the gardens. In the summer of 1910, Platt and Mather began plotting the erection of several fountains and statues in the gardens and on the terraces leading down to the lakeshore. Platt worked with the Piccirilli Studio of stonecarvers in New York City to produce three substantial fountains and a pair of recumbent lions to guard the staircase up from the lake. All of these designs were

FIG. 6.13
Pergola and formal garden, Gwinn.

FIG. 6.14
The Mountain (Mountain through the Poplars),
1890s (cat. no. 43).

directly based on Italian examples that Platt had known from his 1892 tour of the peninsula and subsequent visits. The landscaping was ornamented with a fountain of Fortuna, the statue modeled on a public fountain in Fano, Italy, for the formal garden; a fountain in the woodland garden that was a composite of several Italian examples; a copy of the Verrocchio *Boy with Dolphin* for the lakefront terrace; and a pair of lions modeled on ones at the base of the Campidoglio stairs and elsewhere in Rome for the lakeshore. The Fortuna fountain (fig. 6.15) was cast by Tiffany & Company in New York, Piccirilli provided the lions and the Verrochio reproduction, and Blum & Deldridge of Amherst, Ohio, cut the basins and installed the fountains. When Paul Manship's allegorical vase (fig. 6.16), showing scenes of Native American life and with stylized geometric orna-

Gwinn was featured in the November 1909 issue of the *Architectural Record*, both in a descriptive article on the house and in the editorial entitled "New Phases of American Domestic Design." The latter was written by Herbert Croly, Platt's Cornish neighbor, former client, and close friend.[38] Commenting on a series of recent houses designed for mid-westerners of wealth (while uniquely illus-

trating the editorial with photographs of Gwinn), Croly commented that:

an increasing number of very genuine personal successes are beginning to emerge above the architectural horizon—architects who are successes not merely because they have designed a large number of conspicuous buildings, but because their work is absolutely their own and is recognized as such by a loyal and a numerous following.[39]

In the article on Gwinn, the author (who was probably Croly, too) emphasized the intelligent and focused approach to planning:

The whole scheme should constitute a lesson to the many people who build houses on the Western

FIG. 6.15
Fortuna fountain, Gwinn. Courtesy William Gwinn Mather Papers, Gwinn Archives, Cleveland, Ohio.

lakes of the manner in which a water front may be treated to the best advantage, and it also affords one more bit of testimony to the peculiar merits of Mr. Platt as a landscape architect.[40]

By the winter of 1914, William Mather was content with what he and Platt had created, and the architect's services were not required again for more than a decade. Mather turned his attention to the wild garden being developed by Warren Manning across Lake Shore Boulevard. The subtle indication of a new phase of activity for Platt was the commission from Mather in 1927 to design a gate in the garden wall that would give easy access

to the adjacent estate of Elizabeth Clark Ring Ireland. Cleveland was taken by surprise when the bachelor married his neighbor, the widow of James Ireland, on May 18, 1929. Over the next two years, the new Mr. and Mrs. Mather employed Platt to make alterations to the interiors of Gwinn, redecorating especially the major bedrooms of the second floor and making some changes in the furnishing of the public rooms.

Gwinn's Patronage Network

The marriage of William Mather to Elizabeth Ireland (1891–1957) provides the perfect opportunity to move from Gwinn to the larger matrix of clients and commissions associated with Gwinn. The range of these buildings can be used as a grid for examining the expansion of Platt's practice and the evolution of his ideals in architecture. Although his association with Gwinn, the Mathers, or the Irelands is admittedly an artificial construct for a review of Platt's work in architecture, the advantage of this approach is in the clear connections between buildings and builders that are obvious when looking through this window.

As noted above, one of the first Platt designs that attracted Mather's attention when hunting for an architect was the photograph of the Herbert Croly house in Cornish, New Hampshire, that he saw in the magazine clippings sent by Warren Manning. Platt designed a modest frame residence in the summer of 1897 for Croly, who as one of the editors of the *Architectural Record* would become the most vocal supporter of Platt's work as an architect.[41] The Croly house is L-shaped in plan, with the entrance near the corner separating a drawing room and loggia in one direction and the dining room and service areas in the other (see fig. 1.8).[42] The perpendicular arms of the house sheltered a lushly planted and terraced garden, divided into three rectangular sections that culminated in a semicircular bench at the far end of the garden (see fig. 3.27).

Like other Platt designs of the 1890s and

first years of the new century, the Croly house achieved an integration of the loggia-extended and low-pitched roofs of his Italian villa models with the vernacular materials and informal character of the New England farmhouse. Perhaps for Mather, the intimate integration of house and landscape—the formal flower garden on one side and the view towards Mount Ascutney in Vermont on the other—recommended this designer immediately to him. But the Croly house can also serve as a paradigm of Platt's work for his Cornish neighbors in this transitional decade of his career.[43] The Croly house and garden resembled the schemes that he developed for his own residence (1890–1902) (see figs. 1.3, 1.4); for High Court, the Annie Lazarus estate (1891) (see fig. 1.6); for the Misses Lawrence, a pianist and her sister, residence (1896) (see fig. 1.7); or for Dingleton House (1902), the property of Emily and Augusta Slade, a sculptor and her sister (see book frontispiece and fig. 4.8). Indeed, at the turn of the twentieth century Cornish was one of the most distinctive cultural colonies, a place where the classical spirit in architecture and the other arts was universally worshipped. Charles Lang Freer, who was collecting the paintings of Cornish artists, already knew some of these houses when he recommended Platt to Mather in 1898.

Of course, Mather also knew about the Warren, Rhode Island, house that Platt had designed for the Reverend Joseph Hutcheson, to whom Mather had written for a recommendation. If the Croly house is prototypical of the simpler, early houses that Platt designed for his summer neighbors while still working as a painter, Villasera (fig. 6.17), the Hutcheson house (1903–6), is an excellent example of Platt's early mature work as a country house architect.[44] The scale has substantially increased, both for the house and the surrounding environment. The plan of the house and the grounds demonstrates that this self-made architect had quickly learned to master spatial organization. As would be true at Gwinn, Platt laid out the Hutcheson estate with the house as the central and controlling element. He designed a straight drive from the main road to the house, with the formal garden and service areas concealed from view on either side of the entrance driveway. After entering Villasera, the visitor was treated to a panoramic view of the Warren River to the west and then brought into the walled garden at the southeastern corner of the property. Here Platt used the mature trees of a former orchard as the canopy under which he laid out paths, pools, and fountains (see fig. 4.13). Typical of the middle of the first decade of this century, the materials for this house included the poured concrete that Platt chose to use at Gwinn as well. Monumental porticoes fronted the entrance and river elevations of the two-and-a-half-story mass. The assuredness with which Platt handled the classical orders and proportions here do not betray an amateur who had taken up the practice of architecture without academic training or apprenticeship.[45]

The new Mrs. Mather had as many connections to Platt and his architecture as had her husband. She had actually spent part of her childhood in a house Platt designed in 1904 for her father, Clark Lombard Ring, in Saginaw, Michigan (fig. 6.18).[46] The Ring house is an excellent counterpoint to the domestic image represented by the Hutcheson estate. A city residence with a smaller garden, the Ring house was built in brick with white stone and wooden trim. The architectural allusion is to Georgian England and colonial America, which Platt freely and adeptly intermeshed. The central brick section is seven-bays wide and two-and-a-half stories high, with a projecting, three-bay pedimented pavilion on the entrance facade. A single-story frame loggia and a service wing flanked the structure. The plan of the first floor is characteristic of Platt's spatial schemes at this stage in his career. The central three bays comprise an entrance stairhall and a music room on the garden facade, with the drawing room and loggia to the right and the dining room and service area to the left. The Ring house was one of the examples of contemporary American architecture select-

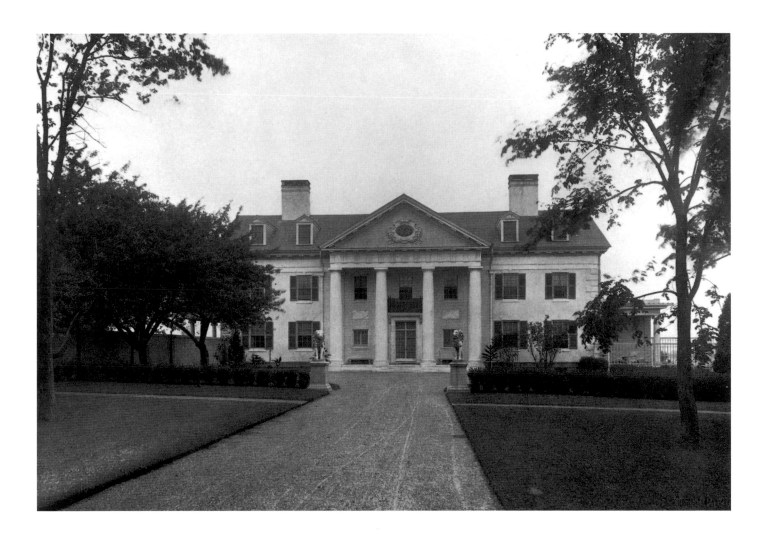

FIG. 6.17
Entrance facade, Villasera,
the Rev. Mr. and Mrs.
Joseph Hutcheson resi-
dence, Warren, Rhode
Island, designed 1903.
(Illustrated in *Monograph*,
1913, p. 42.)

ed by Hermann Muthesius for his book, *Landhaus und garten in Amerika* (1907), an important indication of increasing European interest in American domestic architecture.[47]

This architecturally incestuous relationship continued when Miss Elizabeth Ring married James Duane Ireland in 1913 and invited Platt the following year to design a house in Duluth, Minnesota.[48] Although probably never built, the brick massing and careful planning of this relatively modest residence shows why Platt was commissioned by another generation of this family.[49] Nor do the connections stop here. In 1909, Richard D. Merrill, the uncle of Elizabeth Ring Ireland, commissioned Platt to design a town house for him on Harvard Avenue in Seattle, Washington.[50] The Merrill house in stucco recalls the massing of the Ring house in Sag-

inaw. Both the Merrills's wealth, derived from northwest lumber, and that of the Rings, based in Michigan lumber, tied them automatically into the economic context and network in which William G. Mather also prospered.

William Mather's own ties to other Platt clients were equally strong. The earliest of these associations was with Charles Lang Freer, who had recommended Platt to Mather as a landscape architect in 1898 and who was one of the most important of Platt's patrons.[51] During the decade that Platt was not working for Mather, he designed and built the Freer Gallery of Art (1913–23) in Washington, D.C. (figs. 1.18, 1.19).[52] On March 7, 1914, Mather wrote to Platt that he had recently visited Freer, been shown the plans for the gallery in Washington, and

NORTH ELEVATION.

ELEVATION IN BATH C. ELEVATION IN BATH E.
DETAILS OF MARBLE SLABS BACK OF LAVATORIES.

SECOND FLOOR PLAN

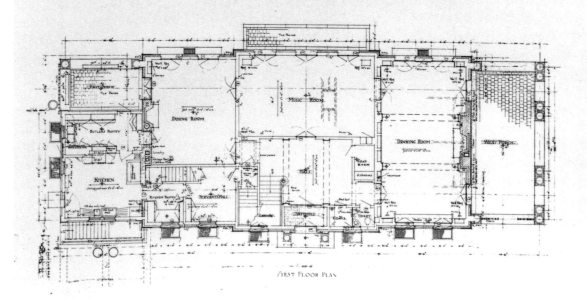

FIRST FLOOR PLAN

wanted Platt to talk with the director of the Cleveland Museum of Art about a Garden Court for the museum, similar to the design for the Freer Gallery.[53]

For many, the Freer Gallery of Art is the most satisfying of Platt's institutional commissions. As with country houses and commercial structures, Platt returned to the Renaissance for inspiration in museum design. The Freer Gallery is a rusticated limestone building with courtyard that strongly asserts its presence on the Mall in Washington, D.C., despite its larger neighbors. The designs were begun in 1913, construction finally commenced in 1918, and the building opened to critical acclaim in 1923.[54] In Freer, Platt found a client whose aesthetic sense was as highly developed as his own and whose opinion had to be taken seriously into considera-

tion. Having been trained as a painter, Platt was especially sensitive to the lighting needs of the Freer Gallery, and he invented a system of canvas louvers that could modulate the intensity and direction of the natural light at all times of day. The critical and popular success of the Freer Gallery led to other commissions for museum buildings, including a proposal for a National Gallery of Art that was never built after Congress failed to allocate funds. For Freer personally, Platt also designed a fascinating range of projects, from a garden for a men's club in Detroit to the mountaintop retreat where Freer spent the final years of his life.[55]

Concurrent with his work for Mather, Platt also designed a residence for Robert M. Schutz on Prospect Avenue in Hartford, Connecticut. Schutz and Mather had been classmates at Trinity College in Hartford, and both served as trustees of the school. Mather recommended Platt to Schutz, who might also have known of the architect from his numerous commissions in nearby Manchester and Rockville, Connecticut. The Schutz house, like the slightly earlier residence for C. L. Ring, spoke to the Georgian tradition in the colonies but incorporated the rich opportunities for formal gardens that Platt evolved from his study of Italy. Mather also invited Platt to design a chapel he planned to donate to Trinity College, a commission that Platt declined when he was told that it would have to be Gothic, an architectural style with which he had little familiarity and for which he had no enthusiasm.

Another important Cleveland client who was a member of the same orbit as William Mather was his Bratenahl neighbor Dan R. Hanna, newspaper publisher and the son of Senator Mark Hanna, for whom Platt designed three tall office buildings in the city. The Leader-News Building (fig. 6.19), a project of 1911, was one of the tallest structures Platt ever built. The rusticated limestone facades were capped by a deeply projecting cornice modeled on the Strozzi Palace in Florence. Described in the *Architectural Record* as "one of the handsomest and most distin-

guished office buildings in the country," the Leader-News Building showed Platt's initial attempt to control and improve the tall commercial building formula. The width of the streets onto which it faced and the local ordinance restricted the height of this structure to 150 feet, allowing Platt to design a building of balanced horizontal and vertical proportions. He successfully expressed the steel frame of the building by designing a rusticated limestone facade of shallow depth. Eight years later, Hanna commissioned two similar buildings in Cleveland to be named in honor of his father. The Hanna Building and the Hanna Building Annex were both representative of the restrained commercial architecture and apartment buildings that Platt designed for the Astor estate office in New York City throughout the first three decades of this century.

The direct patronage and family connections surrounding Gwinn do not bring to light all aspects of Platt's long and successful career as an architect and landscape architect. For example, this group of patrons had no direct ties to the numerous commissions that Platt executed as a campus planner and academic architect in the 1920s; and the large and lucrative practice in the urban architecture of New York City can only be suggested by the three projects for Dan Hanna in Cleveland. Nevertheless, the web of patronage that can be spun out from this one country house upon the shores of Lake Erie effectively documents the closely proscribed world for which Platt designed buildings and the com-

mon assumptions on the function and image of architecture held by this community and their executant.

Croly, Hutcheson, Ring, Ireland, Merrill, Freer, Schutz, Hanna, Mather, and most of Platt's other clients had amassed substantial fortunes in industry, real estate development, and stock speculation. They were liberally educated and eager to adopt a personal mode of living that reflected their background and their wealth. Platt, having emerged from a comparable environment, was ideally suited to share and shape this vision. His buildings celebrated the architectural inheritance of Western civilization, from the Italian Renaissance to Georgian England to colonial America. These buildings, individually and as a group, are icons of self-conscious economic, social, and cultural intentions. The Leader-News and Hanna Buildings clearly emphasized the importance and influence of the Hanna family in Cleveland. Charles Freer spent his life and his fortune to assemble one of the finest collections of Asian and American art and to present it to the nation in a building of comparable dignity and quality. Even the country houses, like Gwinn or the Ring and Merrill houses, have most frequently survived as public cultural institutions. All of these structures, and Platt's career at large, are projections of a new American landscape of power, wealth, sophistication, and public benefaction. No one mistook the message of these buildings in their time, and no one should today.

CHECKLIST OF THE EXHIBITION

✦⟶⊂═⊃⟵✦

NOTE: All works are by Charles A. Platt unless otherwise indicated. In all listings, height precedes width.

Fine Arts

Etchings

I.

A March Evening, 1881
Etching, 5 3/4 × 12 5/8 inches, second state
Rice 11
Addison Gallery of American Art, Phillips Academy, Andover, Massachusetts
Gift of anonymous donor
1930.39

(see fig. 2.3)

2.

Interior of Fish-Houses, 1881
Etching, 4 7/8 × 7 15/16 inches, second state
Rice 22
Addison Gallery of American Art, Phillips Academy, Andover, Massachusetts
Gift of anonymous donor
1930.58

(see fig. 2.8)

3.

Fishing Boats, 1881
Etching, 3 13/16 × 9 1/2 inches
Rice 23
Addison Gallery of American Art, Phillips Academy, Andover, Massachusetts
Gift of anonymous donor
1930.63

(see fig. 2.2)

4.

Portland on the St. John, 1882
Etching, 10 13/16 × 20 1/2 inches, second state
Rice 29
Addison Gallery of American Art, Phillips Academy, Andover, Massachusetts
Gift of anonymous donor
1930.76

(see fig. 2.4)

5.

Provincial Fishing Village, 1882
Etching, 13 1/4 × 24 5/8 inches
Rice 40
The Parrish Art Museum, Southampton, New York
Dunnigan Collection
1976.1.397

(see fig. 2.7)

6.

Lannion, 1883
Etching, 6 7/8 × 11 inches
Rice 42
Addison Gallery of American Art, Phillips
Academy, Andover, Massachusetts
Gift of anonymous donor
1930.101

(see fig. 2.19)

7.

Canal at Chartres, 1883
Etching, 16 1/8 × 10 15/16 inches, third
state
Rice 45
Addison Gallery of American Art, Phillips
Academy, Andover, Massachusetts
Gift of anonymous donor
1930.110

(see fig. 2.13)

8.

Rye, Sussex, 1884
Etching, 6 3/16 × 9 1/4 inches
Rice 52
Addison Gallery of American Art, Phillips
Academy, Andover, Massachusetts
Gift of anonymous donor
1930.119

(see fig. 2.18)

9.

Rue du Mont Cenis, Montmartre, 1884
Etching, 5 7/16 × 8 7/16 inches
Rice 50
Addison Gallery of American Art, Phillips
Academy, Andover, Massachusetts
Gift of anonymous donor
1930.117

(see fig. 2.12)

10.

Old Houses Near Bruges, 1884–88
Etching and drypoint, 10 1/8 × 17 1/16
inches, third state
Rice 58
Addison Gallery of American Art, Phillips
Academy, Andover, Massachusetts
Gift of anonymous donor
1930.128

(see fig. 2.20)

11.

Dordrecht (Old Warehouse), 1885
Etching, 10 11/16 × 16 7/8 inches
Rice 69
Addison Gallery of American Art, Phillips
Academy, Andover, Massachusetts
Gift of anonymous donor
1930.156

(see illus.)

12.

Pier at Larmor, 1885
Etching, 8 3/4 × 14 1/2 inches
Rice 62
Addison Gallery of American Art, Phillips
Academy, Andover, Massachusetts
Gift of anonymous donor
1930.142

(see fig. 2.21)

13.

Au Cinquième, Chartres, 1885
Etching, 12 1/2 × 7 3/4 inches
Rice 65
Addison Gallery of American Art, Phillips
Academy, Andover, Massachusetts
Gift of anonymous donor
1930.148

(see fig. 2.15)

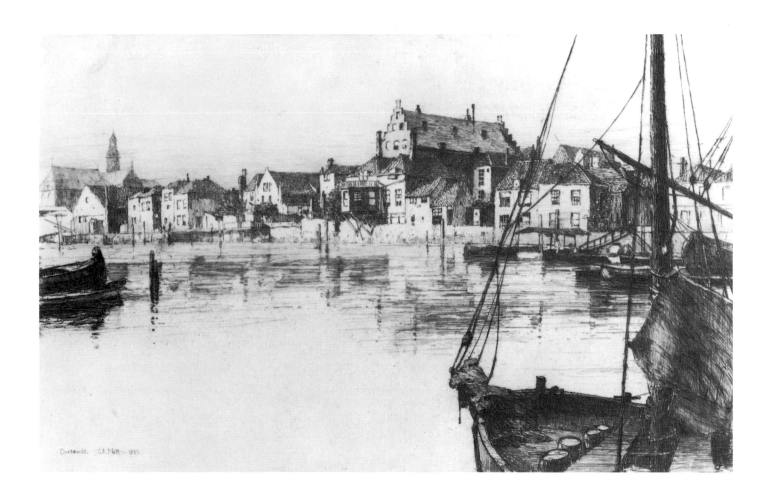

CAT. NO. 11
Dordrecht (Old Ware-house), 1885

14.

Hartford Bridge, 1885
Etching, 11 3/8 × 17 1/2 inches
Rice 70
Hood Museum of Art, Dartmouth College
Gift of Mrs. Hersey Egginton in memory
of her son, Everett Egginton, Class of 1921
Pr.954.20.487

(see fig. 3.19)

15.

Quai des Orfèvres, Paris, 1886
Etching, 17 5/16 × 11 1/8 inches, second
state
Rice 72
Addison Gallery of American Art, Phillips
Academy, Andover, Massachusetts
Gift of anonymous donor
1930.167

(see fig. 2.17)

16.

*A Fishing Camp (Mouth of the
Upsalquitch)*, 1886
Etching, 4 1/2 × 6 7/8 inches
Rice 74
Addison Gallery of American Art, Phillips
Academy, Andover, Massachusetts
Gift of anonymous donor
1930.173

(see fig. 2.23)

17.

Salmon Fishing (Upsalquitch Pool), 1886
Etching, 4 9/16 × 6 7/8 inches
Rice 75
Addison Gallery of American Art, Phillips
Academy, Andover, Massachusetts
Gift of anonymous donor
1930.174

(see fig. 2.22)

18.

A Brittany Landscape, 1887
Etching and drypoint, 8 5/8 × 12 1/8 inches
Rice 82
Addison Gallery of American Art, Phillips
Academy, Andover, Massachusetts
Gift of anonymous donor
1930.194

(see fig. 2.24)

19.

Low Tide, Honfleur, 1887
Etching and drypoint, 4 1/2 × 6 3/16 inches
Rice 84
Addison Gallery of American Art, Phillips
Academy, Andover, Massachusetts
Gift of anonymous donor
1930.196

(see fig. 2.11)

20.

Artichoke Bridge, 1888
Drypoint, 10 15/16 × 16 5/8 inches
Rice 95
Addison Gallery of American Art, Phillips
Academy, Andover, Massachusetts
Gift of anonymous donor
1930.224

(see fig. 2.25)

21.

Buttermilk Channel, 1889
Etching, 6 3/4 × 10 15/16 inches
Rice 107
Addison Gallery of American Art, Phillips
Academy, Andover, Massachusetts
Gift of anonymous donor
1930.261

(see fig. 2.26)

22.

The Two Sloops (East River), 1889
11 1/2 × 18 1/4 inches
Rice 108
Addison Gallery of American Art, Phillips
Academy, Andover, Massachusetts
Gift of anonymous donor
1930.265

(see fig. 2.27)

23.

The Mountain, 1920
Etching and drypoint, 10 1/4 × 7 inches
Not in Rice
Addison Gallery of American Art, Phillips
Academy, Andover, Massachusetts
Gift of anonymous donor
1930.285

(see fig. 2.28)

Paintings/Drawings

24.

Low Tide, 1883
Oil on canvas, 23 × 31 5/8 inches
Signed and dated lower left: *.C.A. Platt
1883;* canvas stamp, verso: *56 rue du
Cherche Midi. Paris / HARDY-ALAN/
Dorure Encadrements.*
Jeffrey W. Cooley, The Cooley Gallery, Inc.,
Old Lyme, Connecticut

(see fig. 3.2)

25.

The Artist's Studio, 1883
Oil on canvas, 24 1/4 × 19 3/4 inches
Signed and dated lower right: *C.A. Platt/83*
The Montclair Art Museum Permanent
Collection

(see fig. 3.3)

26.

Dordrecht (Dordrecht on the Maas), about
1883–84
Oil on canvas, 18 × 24 inches
Signed lower left: *C.A. Platt.*
Addison Gallery of American Art, Phillips
Academy, Andover, Massachusetts
Gift of anonymous donor
1928.46

(see fig. 3.6)

27.

*Landscape with Washerwomen (Peasants
and Poplars)*, about 1884–85
Oil on panel, 8 5/8 × 5 1/4 inches
Signed lower left: *C.A.P.*
Lent by Mr. Graham Williford

(see fig. 3.7)

28.

Breakwater at Larmor, about 1884
Oil on board, 5 3/4 × 9 inches
Unsigned
Lent by members of the Platt family

(see fig. 3.11)

29.

Low Tide, Larmor, 1884
Oil on canvas, 15 5/8 × 24 1/4 inches
Signed and dated, lower left: *.C.A. Platt.
1884.*; lower right [partially visible]: *C.A.
Platt 1884 / Low Tide. Larmor*
Lent by Mr. Graham Williford

(see fig. 3.10)

30.

The Quay, Larmor, 1884–85
Oil on canvas, 10 5/16 × 14 1/2 inches
Signed lower right: *C.A. Platt.*
Sterling and Francine Clark Art Institute

(see fig. 3.13)

31.

A Calm Afternoon (formerly titled
Brittany), 1885
Oil on canvas, 15 × 21 7/8 inches
Signed, lower left: - *C.A. Platt.*; inscribed on
stretcher: *"A Calm afternoon."* *C.A. Platt.
1885.*
The Century Association

(see fig. 3.14)

32.

The Etcher, 1885
Oil on canvas, 32 × 26 inches
Signed and dated, lower right: *.C.A. Platt.
Paris. 1885.*
St. Botolph Club, Boston

(see fig. 3.16)

33.

Garden Scene (Field of Flowers), about
1884–85
Oil on panel, 5 1/4 × 7 3/8 inches
Signed lower left: *C.A.P.*
Lent by members of the Platt family

(see illus.)

34.

Hartford, Connecticut, 1885
Oil on panel, 10 1/2 × 13 3/4 inches
Signed lower right: *C.A. Platt.*
The Fine Arts Collection of The Hartford
Steam Boiler Inspection and Insurance
Company

(see fig. 3.18)

35.

Orchard, East Hampton, about 1885
Oil on canvas, 13 × 20 inches
Signed lower left: *C.A. Platt.*
Spanierman Gallery, New York

(see fig. 3.20)

36.

A Corner in an Etcher's Studio, 1888
Oil on canvas, 21 3/4 × 19 3/4 inches
Signed and dated lower left: *C.A. Platt.
1888.*
The Fine Arts Collection of The Hartford
Steam Boiler Inspection and Insurance
Company

(see fig. 3.17)

37.

Women in a Field, 1888
Oil on canvas, 12 × 20 inches
Signed and dated lower left: *C.A. Platt. 88*
Hirschl & Adler Galleries, New York

(see fig. 3.21)

38.

Winter Hush, Cornish, about 1890
Oil on canvas, 14 1/8 × 20 inches
Signed lower left: *C.A. Platt.*
Lent by Mr. Graham Williford

(see fig. 3.23)

39.

High Court, after 1891
Oil on canvas, 42 × 54 inches
Signed lower right: *C.A. Platt.*
Lent by members of the Platt family

(see fig. 3.26)

40.

Hedge Walk, Quirinal Gardens (frontispiece
for *Italian Gardens*), about 1892–93
Watercolor on paper, 13 3/8 × 9 1/2 inches
(sight)
Signed lower right: *C.A. Platt.*
The Century Association

(see fig. 4.3)

41.

Clouds (Landscape near Cornish), about 1894
Oil on canvas, 26 × 35 1/8 inches
Signed lower right: *C.A. Platt.*
Museum of Fine Arts, Boston
Gift of Clement S. Houghton
37.1173

(see fig. 3.22)

42.

Larkspur (Garden at High Court, Cornish), about 1895
Oil on canvas, 24 × 20 inches
Signed lower right: *C.A. Platt.* Inscribed verso: *Larkspur.*
Lent by members of the Platt family

(see cover and fig. 4.1)

43.

The Mountain (Mountain through the Poplars), 1890s
Oil on canvas, 25 × 30 inches
Signed lower right: *C.A. Platt*
Private Collection

(see fig. 6.14)

44.

Garden in Winter (The Croly Garden, Cornish), after 1904
Oil on canvas, 20 × 24 inches
Unsigned
Lent by members of the Platt family

(see fig. 3.27)

45.

Windsor, about 1910
Oil on canvas, 35 × 26 inches
Signed lower right: *C.A. Platt*; inscribed on frame label: *Windsor / Mrs. C. A. Platt.*
Lent by members of the Platt family

(see fig. 3.24)

46.

Cornish Landscape, 1919
Oil on canvas, 26 3/8 × 33 inches
Signed lower right: *C.A. Platt.*
In the Collection of the Corcoran Gallery of Art
Museum Purchase, Gallery Fund

(see fig. 3.25)

47.

Thomas Wilmer Dewing, American, 1851–1938
Portrait of Charles A. Platt, 1893
Oil on panel, 9 3/4 × 7 3/4 inches
Signed and dated, lower left: *T.W. Dewing 1893.*
Lent by members of the Platt family

(see fig. 1.2)

Sketchbooks

48.

Sketchbook, about 1884–85
5 1/2 × 8 1/2 inches
Lent by members of the Platt family

(see figs. 3.8, 3.12)

49.

Sketchbook, 1880s
5 1/4 × 7 1/4 inches
Lent by members of the Platt family

50.

Sketchbook, 1880s
4 × 6 1/2 inches
Lent by members of the Platt family

Architecture and Landscape

NOTE: Although some drawings are signed or have been attributed to Platt or a particular member of his staff, most drawings are unsigned products of the Platt office.

Landscape Design and Country Houses

51.

Pavilion, Villa Lante, Bagnaia, about 1892
(illustration for *Italian Gardens*, 1894)
Gum bichromate print, 18 5/8 × 22 5/8
inches (sight)
Addison Gallery of American Art, Phillips
Academy, Andover, Massachusetts
Gift of Penelope Jencks in memory
of Gardner Platt Jencks
1993.53

(see fig. 4.5)

52.

Site plan, Villa Costansi, 1915
Ink and pencil on paper, 20 1/2 × 9 1/4
inches
Lent by members of the Platt family

(see illus.)

53.

Album of photographs depicting Italian
gardens either taken or collected by Platt
(open to Alley, Quirinal Gardens, Rome),
after 1892
15 × 12 1/2 inches
Charles A. Platt Architectural Office
Library, The Century Association

(see fig. 1.5)

54.

Charles A. Platt, *Italian Gardens*, 1894
New York: Harper Brothers, 1894
11 × 8 1/4 inches
Collection of Richard Cheek

(see figs. 4.3 – 4.5)

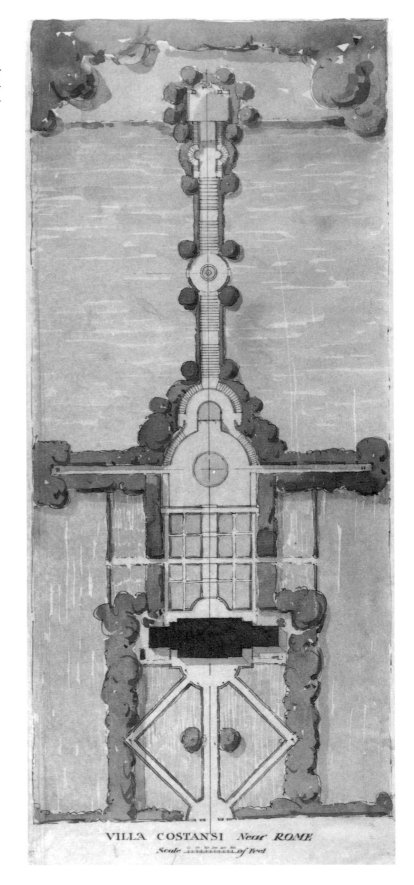

VILLA COSTANSI *Near* ROME
Scale [illegible] *of Feet*

55.

Guy Lowell, *American Gardens*, 1902
Boston: Bates & Guild, 1902
13 × 11 inches
Collection of Richard Cheek

56.

"Charles A. Platt, His Place at Cornish"
(site plan for the Platt residence, Cornish,
New Hampshire), 1892
Black ink and pencil on linen, 16 × 11 1/8
inches
Charles A. Platt Collection, Avery
Architectural and Fine Arts Library,
Columbia University

(see fig. 4.6)

57.

Rendering by Charles A. Platt of south
elevation of the Misses Grace and Edith
Lawrence residence, Plainfield, New
Hampshire, about 1896
Watercolor, pencil, and colored pencil on
paper mounted on board, 11 3/8 × 23 3/4
inches
Heirs of Lawrence Hoe Taylor and Edith
Howard Taylor

(see fig. 1.7)

58.

South elevation and first and second floor
plans, Harlackenden Hall, the Winston
Churchill residence, Cornish, New
Hampshire, 1901–4
Black and red ink on paper, 22 × 17 1/2
inches
Charles A. Platt Collection, Avery
Architectural and Fine Arts Library,
Columbia University

(see fig. 1.9)

59.

Site plan for Faulkner Farm, the Charles F.
Sprague residence, Brookline,
Massachusetts, 1897
Ink and pencil on linen, 12 1/2 × 18 inches
Charles A. Platt Collection, Avery
Architectural and Fine Arts Library,
Columbia University

(see fig. 4.9)

60.

Album of photographs taken about 1900,
from the Olmsted Archives, #299,
documenting Faulkner Farm, the Charles F.
Sprague residence, Brookline,
Massachusetts, designed 1896–97
Album containing seventy albumen prints,
13 × 16 inches (album)
National Park Service, Frederick Law
Olmsted National Historic Site

(see fig. 4.10)

61.

Garden terrace, Woodston, the Marshall
Slade residence, Mount Kisco, New York,
designed 1904–8
Gelatin silver print, 11 × 10 1/8 inches
Lent by members of the Platt family

(see Chronology)

62.

Rendering by Schell Lewis of rear elevation
of Timberline, the W. Hinckle Smith
residence, Bryn Mawr, Pennsylvania, 1907
Pencil on tracing paper, 12 3/8 × 19 inches
Charles A. Platt Collection, Avery
Architectural and Fine Arts Library,
Columbia University

(see fig. 1.12)

63.

Ground plans for Timberline, the
W. Hinckle Smith residence, Bryn Mawr,
Pennsylvania, 1908
Black ink, pencil, and red wash over
photostat on paper, highlighted with
gouache, 15 1/4 × 19 3/8 inches
Charles A. Platt Collection, Avery
Architectural and Fine Arts Library,
Columbia University

(see illus.)

64.

Preliminary sketch by Charles A. Platt for
surroundings of the Helen Sears residence,
Southborough, Massachusetts, June 12,
1913
Ink and pencil on linen, 16 1/2 × 11 1/4
inches
Charles A. Platt Collection, Avery
Architectural and Fine Arts Library,
Columbia University

(see Chronology)

65.

Composite of country house studies,
1910–20
Pen, pencil, crayon, watercolor, and
gouache on tracing paper mounted on
board, 22 1/8 × 28 1/8 inches
Charles A. Platt Collection, Avery
Architectural and Fine Arts Library,
Columbia University

(see fig. 1.13)

66.

"View from Garden," a Schell Lewis
rendering, dated November 20, 1917, of a
proposal for additions to Villa Turicum, the
Harold and Edith Rockefeller McCormick
residence, Lake Forest, Illinois, designed
1908–18
Pencil on tracing paper mounted on paper,
13 3/4 × 24 inches
Charles A. Platt Collection, Avery
Architectural and Fine Arts Library,
Columbia University

(see Chronology)

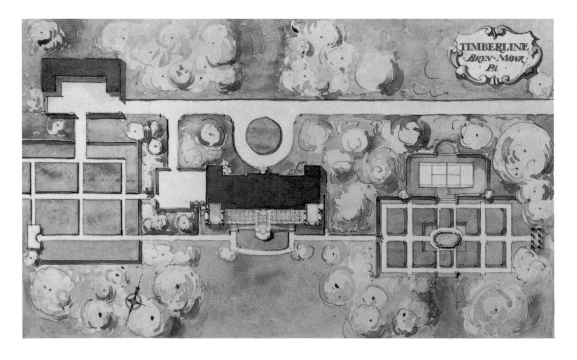

CAT. NO. 63
Ground plans for Timber-
line, the W. Hinckle Smith
residence, Bryn Mawr,
Pennsylvania, 1908

67.

Rendering by Schell Lewis, dated April 28, 1918, of wrought iron entrance gates for Villa Turicum, the Harold and Edith Rockefeller McCormick residence, Lake Forest, Illinois, designed 1908–18
Pencil on tracing paper, 17 × 29 1/2 inches
Charles A. Platt Collection, Avery Architectural and Fine Arts Library, Columbia University

(see fig. 1.14)

Urban and Public Commissions

68.

Rendering of the waterfront elevation of Richmond Beach Park, Huguenot, Staten Island, New York, 1902
Watercolor on tracing paper, 20 1/2 × 45 1/2 inches
National Academy of Design, New York City

(see fig. 5.2)

69.

Plans of main and mezzanine floors, the Studio Building, 131–135 East 66th Street, New York, New York, about 1905
Black and gray ink on linen, 20 1/4 × 17 3/4 inches
Charles A. Platt Collection, Avery Architectural and Fine Arts Library, Columbia University

(see fig. 5.6)

70.

Fireplace wall of library, Charles A. Platt apartment, the Studio Building, 131–135 East 66th Street, New York, New York, designed 1905–6, photograph taken before 1913
Gelatin silver print, 9 1/2 × 7 1/2 inches
Lent by members of the Platt family

(see fig. 5.5)

71.

Monograph of the Work of Charles A. Platt, with an Introduction by Royal Cortissoz, 1913 (open to Lowell fountain, dedicated 1912)
New York: The Architectural Book Publishing Co., 1913
16 1/2 × 12 1/2 inches
Collection of Richard Cheek

(see figs. 5.4, 4.12, 4.13, 6.5, 6.11, 6.16, 6.17)

72.

Facade elevation, the Leader-News Building, Cleveland, Ohio, 1911
Black and red ink and pencil on linen, 28 × 24 1/2 inches
Charles A. Platt Collection, Avery Architectural and Fine Arts Library, Columbia University

(see fig. 6.19)

73.

Corner detail from the Leader-News Building, Cleveland, Ohio, 1911
Charcoal on tracing paper (varnished?) and mounted on cloth, 18 1/2 × 27 3/16 inches
Charles A. Platt Collection, Avery Architectural and Fine Arts Library, Columbia University

(see illus.)

74.

Elevation of the Bawo & Dotter Building, 24 (later 20–28) West 33rd Street, New York, New York, 1912
Black and red ink and pencil on linen, 23 5/8 × 37 1/4 inches
Charles A. Platt Collection, Avery Architectural and Fine Arts Library, Columbia University

(see fig. 5.11)

75.

Album of construction photographs of
buildings designed by Charles A. Platt,
1911–31, vol. 6 of 14 (open to
photograph of Astor Court, August 11,
1915)
Album of gelatin silver prints, 10 1/4 × 29
inches (open)
Photography Collection, Miriam and Ira D.
Wallach Division of Art, Prints and
Photographs, The New York Public Library,
Astor, Lenox and Tilden Foundations

(see fig. 5.7)

76.

Front and rear elevations, the John T. Pratt
residence, 6–9 East 61st Street, New York,
New York, 1915
Black and gray ink and pencil on linen,
30 1/8 × 41 inches
Charles A. Platt Collection, Avery
Architectural and Fine Arts Library,
Columbia University
1974.002.03260

(see fig. 5.15)

77.

Typical floor plan, 120 East End Avenue,
New York, New York, 1929
Photomechanical reproduction on paper,
19 3/4 × 26 1/2 inches
Charles A. Platt Collection, Avery
Architectural and Fine Arts Library,
Columbia University

(see fig. 5.10)

78.

Advertising brochure, for 120 East End
Avenue, New York, New York, designed
1930–31
Photomechanical reproduction on paper,
9 × 30 inches (open)
Private Collection

CAT. NO. 82
Detail (by Schell Lewis?) of
Reading Room of the Oliv-
er Wendell Holmes
Library, Phillips Academy,
Andover, Massachusetts,
January 8, 1929

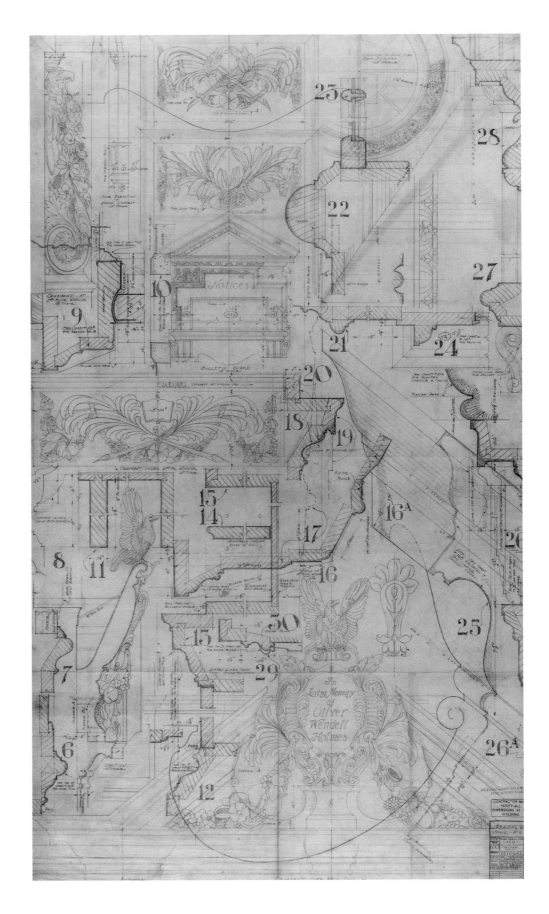

79.

Entrance facade, Freer Gallery of Art,
Washington, D.C., designed 1913, opened
1923, about 1923
Gelatin silver print, 5 1/2 × 9 1/2 inches
Lent by members of the Platt family

(see fig. 1.18)

80.

Elevation and sections, proposal for a
National Gallery of Art, Washington, D.C.,
1924
Photomechanical reproduction on paper,
19 1/2 × 24 inches
Charles A. Platt Collection, Avery
Architectural and Fine Arts Library,
Columbia University

(see fig. 1.20)

81.

Plan for the development of the campus,
University of Illinois, February 4, 1922
Black ink on linen, 35 1/2 × 27 inches
Charles A. Platt Collection, Avery
Architectural and Fine Arts Library,
Columbia University
1974.002.01484

(see fig. 4.16)

82.

Detail (by Schell Lewis?) of Reading Room
of the Oliver Wendell Holmes Library,
Phillips Academy, Andover, Massachusetts,
January 8, 1929
Pencil and colored crayon on tracing paper,
60 × 35 3/4 inches
Charles A. Platt Collection, Avery
Architectural and Fine Arts Library,
Columbia University
1974.002.03113

(see illus.)

"Gwinn"—A Case Study

NOTE: This section of the exhibition features pri-
marily modern copies of archival photographs and
other documentation of the commission mounted
on large didactic panels.

83.

Unexecuted study for the lake elevation,
Gwinn, the William G. Mather residence,
Cleveland, Ohio, 1907
Watercolor, ink, and pencil highlighted with
gouache on tracing paper, 8 × 15 3/4 inches
Private Collection

(see fig. 6.9)

84.

Rendering by Schell Lewis of the entrance
courtyard, Gwinn, the William G. Mather
residence, Cleveland, Ohio, 1909
Printed facsimile of a drawing on laid
Japanese paper, 16 1/8 × 22 1/8 inches
Private Collection

(see fig. 6.6)

CHRONOLOGY

Melissa Stroud and Keith N. Morgan

‹—≡◯≡—›

NOTE: Unless otherwise indicated, works cited under "Exhibitions" are oil paintings. Commissions listed are selected. For a complete list of architectural commissions, see Keith N. Morgan's *Charles A. Platt: The Artist as Architect.*

1861

Born October 16 in New York, New York, to John Henry and Mary Elizabeth Cheney Platt.

1878

Fall: Enrolls in the Antique School of the National Academy of Design.

1879

Joins the Art Students League for training in painting.

March: Registers for life drawing classes at the academy.

Summer: Bolton Landing, New York; meets Stephen Parrish (1846–1938), Philadelphia etcher, and becomes his informal pupil in etching.

1880

Summer: Gloucester, Massachusetts, with Parrish. Sketches for first etching.

December: Makes first plate, *Gloucester Harbor.*

1881

Joins the New York Etching Club.

EXHIBITIONS:

Museum of Fine Arts, Boston: six etchings in "Exhibition of American Etchings" arranged by Sylvester Rosa Koehler.

Pennsylvania Academy of the Fine Arts: *After Sunset, Gloucester.*

1882

May: Sails for Europe. Fellow travelers include George Henry Hall (1825–1913) and genre painter Jennie Brownscombe (1850–1936).

June: London, visits Francis Seymour Haden (1818–1910), founder of the Society of Painter-Etchers.

Summer: Paints at Chartres, then travels through Brittany and Normandy.

August: Grandcamp, Normandy, meets and sketches with American expatriate painter Frank Myers Boggs (1855–1926).

September: Honfleur with George Hall and Hall's family.

October: Paris, arranges to rent the studio of Henry Oliver Walker (1843–1929), with whom he would become close friends. Revisits Chartres.

November: Sells five paintings.

EXHIBITIONS:

New York Etching Club: fifteen etchings including *Portland on the St. John* (cat. no. 4) and *Interior of Fish-Houses* (cat. no. 2).

Society of Painter-Etchers, London: seven etchings, all of which sell.

National Academy of Design: *Outside of the Dikes*; *Haying on the Grand Pré Marshes, Nova Scotia.*

Pennsylvania Academy of the Fine Arts: *Nile's Farm, East Gloucester, Mass.*; *Boats at Ebb Tide.*

Boston Art Club: *Near Chartres* (watercolor).

1883

Unsuccessful attempt to gain entrance to the architectural division of the Ecole des Beaux-Arts.
Summer: England, then Holland. Dordrecht with Boggs. Trips to Antwerp. Acquaintance with Hague School painter Jacob Maris (1837–1899).

EXHIBITIONS:
Paris Salon: two etchings (a painting of Trouville harbor scene apparently rejected).
New York Etching Club: *Provincial Fishing Village* (cat. no. 5).
First International Special Exhibition of Graphic Art, Vienna (Ersten Internationalen Special [*sic*]—Ausstellung der Graphischen Künste in Wien).
National Academy of Design: *Chartres*; *Old House at Chartres*.
Pennsylvania Academy of the Fine Arts: *Old Houses at Chartres*; *Fishing Boats at Trouville*.

1884

Late May through mid-October: Larmor, Brittany, with friends from New York, Kenneth Cranford (1857–1930) and Dennis Miller Bunker (1861–1890), students at the Ecole des Beaux-Arts.
Winter: Enrolls at Académie Julian in the atelier of Gustave Rodolphe Boulanger (1824–1888) and Jules Joseph Lefebvre (1834–1911).

EXHIBITION:
Paris Salon: *Paysage Hollandais—Novembre*; *Environs de Bruges*.
National Academy of Design: *Old Court at Honfleur*; *Canal at Chartres*; *Canal at Dordrecht*; *A Dutch Riverside*.

1885

Summer: New York, to visit his ill father. Paints in Connecticut.
Fall: Honfleur with Stephen Parrish. Photographed Honfleur scenes.
November: First mention of Colonel and Mrs. Richard Hoe and their daughter, Annie Corbin Hoe, in letter to parents.

EXHIBITIONS:
New York Etching Club.
Paris Salon: *The Etcher* (cat. no. 32).
American Art Association: *Low Tide at Larmor* (possibly cat. no. 29).
National Academy of Design: *Effect of Morning Sunlight*; *The Coast of Marbilan [Morbihan]*; *The Quay, Lamor [Larmor]* (cat. no. 30).

1886

February and March: Meets the Hoe family at San Remo and travels through Genoa, Pisa, and Siena to Rome, where Platt and Annie announce their engagement.
April 10: Florence, marries Annie Corbin Hoe.
June: Annie's father dies, the newlyweds return to New York.
August: John Henry Platt dies.
October: Return to Paris.

EXHIBITIONS:
New York Etching Club: *Pier at Larmor* (cat. no. 12).
Boston Art Club: *Morning Effect/An Honfleur Alley* (watercolor); *Dutch Hayboats Being Towed* (watercolor).

1887

Nominated for membership in the Century Association; joins the Society of American Artists.
March 18: Annie dies in childbirth. Platt returns to New York.
Summer: Gloucester, Massachusetts, with friends Bunker and Walker.

1888

Summer: Travels to England with Bunker, continues on alone to Holland.

EXHIBITIONS:
National Academy of Design: *Interior of Studio*; *Landscape*.
Art Institute of Chicago: *A New England Homestead*; *Coast of Morbihan*.
Interstate Industrial Exhibition, Chicago: *Cape Ann Landscape*; *Coast of Brittany*; *Etcher's Studio*.
New York Etching Club.

1889

A Descriptive Catalogue of the Etched Works of Charles A. Platt, compiled by Richard Rice, published by the DeVinne Press, New York.
Joins the Players, a New York social club for members of the theater and men of letters.
Summer: First visit to Cornish, New Hampshire,

at the invitation of Walker, for whom Platt designs a summer house.

EXHIBITIONS:
Hermann Wunderlich Gallery, New York, New York: "Complete Etched Works of C. A. Platt," catalogue.
New York Etching Club: *Canal Boats and Tugs*.
National Academy of Design: *Low Tide* (possibly cat. no. 24); *A Dutch River*.
Pennsylvania Academy of the Fine Arts: *Landscape, Cape Cod*; *Marine*.
Art Institute of Chicago: *Havre* (watercolor).

1890

Purchases property and designs house and studio in Cornish where he will spend nearly every summer for the rest of his life (cat. no. 56). Dennis Bunker marries Eleanor Hardy and dies two months later.

EXHIBITIONS:
National Academy of Design: *Landscape with Sheep, Holland*; *Dutch Windmill*.
Art Institute of Chicago: *Landscape*; *Dutch River*.

COMMISSION:
High Court, summer residence for Miss Annie Lazarus, Cornish, New Hampshire (cat. nos. 39, 42).

1891

EXHIBITIONS:
New York Etching Club: *Low Tide, Honfleur* (cat. no. 19).
National Academy of Design: *Winter Landscape*.
Art Institute of Chicago: *On the French Coast* (watercolor); *The Quay at Havre* (watercolor).
Society of American Artists: *Winter Hush* (cat. no. 38).

1892

Enlarges and refines plan for the gardens of his Cornish property.
February through July: Italy with brother William to sketch, photograph, and measure the gardens of the Renaissance.
July: Paris, visits Eleanor Hardy Bunker.
July 16: William Platt drowns in Maine.

EXHIBITIONS:
New York Etching Club.

Art Institute of Chicago: *Winter Landscape* (watercolor).

1893

Signs contract with Harper and Bros. for book on Italian gardens comprising articles from *Harper's New Monthly Magazine* plus one thousand words and an original watercolor to be used as frontispiece (cat. no. 40).
July and August: *Harper's New Monthly Magazine* carries two articles entitled "Italian Gardens."
July 13: marries Eleanor Hardy Bunker in Boston.
Winter 1893–94: Rome with Eleanor.

EXHIBITION:
World Columbian Exposition in Chicago: two landscapes and seventeen etchings; wins medals for painting and etching.

1894

Italian Gardens published, the first illustrated book in English devoted to the Italian Renaissance garden (cat. nos. 40, 51, 54).
Draws up an itinerary for art collector and future client Charles Lang Freer's trip to Italy.

EXHIBITIONS:
Society of American Artists: *Clouds* (cat. no. 41), awarded the Webb Prize for landscape painting.
Art Institute of Chicago: *Dieppe* (watercolor).
Pennsylvania Academy of the Fine Arts: *Clouds*; *Spring*.
Boston Art Club: *Winter Landscape*; *Meadow, Winter* (watercolor); *At Cape Cod* (watercolor).

1895

First child, Sylvia, born.

EXHIBITIONS:
National Academy of Design: *A Canal*; *Winter Landscape*.
Art Institute of Chicago: *Ninfa* (watercolor).
Pennsylvania Academy of the Fine Arts: *Spring in Vermont*; *Winter Landscape*.

COMMISSION:
Residence for Dr. and Mrs. John Elliot, Needham, Massachusetts.

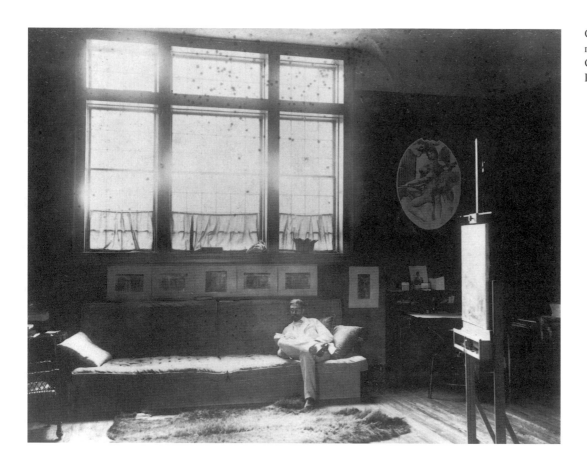

1896

EXHIBITIONS:
National Academy of Design: *Larkspur* (cat. no. 42); *Autumn in New Hampshire*; *Marshes— Cape Cod*.
Pennsylvania Academy of the Fine Arts: *A Garden in Winter*; *Autumn in New Hampshire*.
Boston Art Club: *Winter, Vermont*.

COMMISSION:
Residence for the Misses Grace and Edith Lawrence, Plainfield, New Hampshire (cat. no. 57).

1897

First son, William, born.

EXHIBITION:
National Academy of Design: *Ascutney*.

COMMISSIONS:
Residence for Herbert Croly, Cornish, New Hampshire.
Gardens for Faulkner Farm, residence of Mr. and Mrs. Charles F. Sprague, Brookline, Massachusetts (cat. nos. 59, 60).
Master plan for residential neighborhood development, LaSalle Gardens, for Colonel Frank J. Hecker, South Detroit, Michigan.

1898

Second son, Roger, born.
Changes occupation listing in New York City directory from "Artist" to "Architect."
Economic recession ends Hecker's "LaSalle Gardens" development.

1899

EXHIBITION:
Pennsylvania Academy of the Fine Arts: *Landscape*.

1900

December: Italy, to purchase sculpture and archi-

tectural fragments for various house and garden commissions.

1901

COMMISSIONS:
Gardens for Weld, residence of Mrs. Sprague's cousin, Mrs. Larz Anderson, and her diplomat husband, Brookline, Massachusetts.
Walled flower garden for Glen Elsinore, residence of Mrs. Randolph Clark, Pomfret, Connecticut.
Maxwell Court, residence for Francis T. Maxwell, Rockville, Connecticut.
Residence for Frank J. Cheney, Jr., Manchester, Connecticut.
Harlackenden Hall, residence for the author Winston Churchill, Cornish, New Hampshire (cat. no. 58).

1902

Receives first urban and public commissions.

COMMISSIONS:
Maxwell Memorial Library, Rockville, Connecticut.
Pavilions for the Richmond Beach Park Association, for Charles G. Schwab, Huguenot, Staten Island (cat. no. 68); and the Yondotega Club garden, Detroit, Michigan, on recommendation of Charles Lang Freer.

1903

COMMISSIONS:
The Hermitage, residence and studio for Herbert Adams, Cornish, New Hampshire.
Residence for Mr. and Mrs. Clark Lombard Ring, Saginaw, Michigan.
Villasera, residence for the Rev. and Mrs. Joseph Hutcheson, Warren, Rhode Island.

1904

First major assessment of Platt's architecture published: Herbert Croly, "The Architectural Work of Charles A. Platt," *Architectural Record* 15 (March).
Receives first new town house commission.

COMMISSIONS:
125 East 65th Street, for Mr. and Mrs. Frederick S. Lee, New York, New York.
Dingleton House, residence for Augusta and Emily Slade, Cornish, New Hampshire.
Woodston, residence for Mr. and Mrs. Marshall Slade, Mount Kisco, New York (cat. no. 61).
Sylvania, residence for Mr. and Mrs. John Jay Chapman, Barrytown, New York.

1905

Third son, Geoffrey, born.
Receives first commission for an apartment building.

COMMISSION:
The Studio Building, 131 East 66th Street, for Frederick C. Culver, New York, New York (cat. nos. 69, 70).

1906

Moves family to the Studio Building.
Receives first commission from the Astor estate office.

COMMISSIONS:
Renovation of a brownstone at 844 Fifth Avenue, New York, New York.
Eastover, residence for Mr. and Mrs. George T. Palmer, New London, Connecticut.
Alderbrook, residence for Mr. and Mrs. George L. Nichols, Katonah, New York.
Kellogg Lawn, residence for Mr. and Mrs. William Maxwell, Rockville, Connecticut.

1907

COMMISSIONS:
Double town house, 47–49 East 65th Street, New York, New York, for Sara Delano (Mrs. James) Roosevelt and her son and daughter-in-law, Franklin and Eleanor Roosevelt.
Gwinn, residence for William G. Mather, Cleveland, Ohio (cat. nos. 83, 84).
Timberline, residence for Mr. and Mrs. W. Hinckle Smith, Bryn Mawr, Pennsylvania (cat. nos. 62, 63).
Residence for Robert M. Schutz, Hartford, Connecticut.

EXHIBITIONS:
National Academy of Design: *Winter Landscape.*

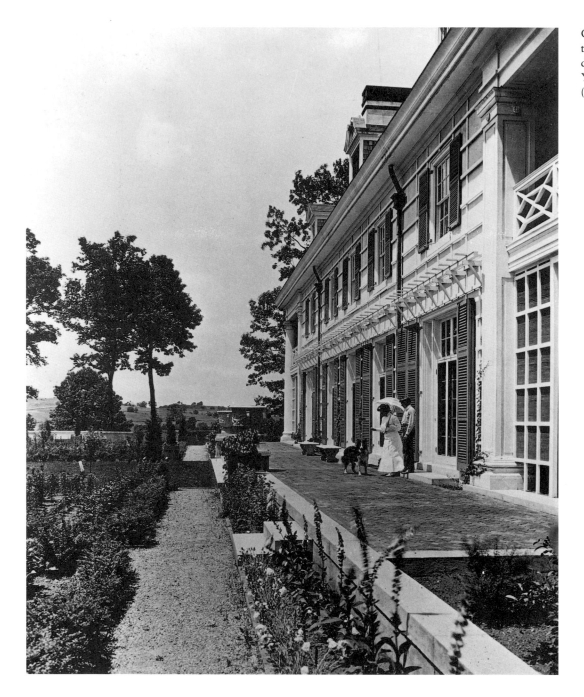

Frederick Keppel & Co., New York, New York "Etchings and Drypoints by C. A. Platt," catalogue with introduction by Mariana G. Van Rensselaer.

1908

COMMISSIONS:
Villa Turicum, residence for Harold and Edith Rockefeller McCormick, Lake Forest, Illinois (cat. nos. 66, 67).

The Moorings, residence for General and Mrs. Russell A. Alger, Jr., Grosse Pointe Farms, Michigan.

1909

COMMISSIONS:
The Manor House, residence for Mr. and Mrs. John T. Pratt, Glen Cove, New York.
Girdle Ridge, residence for Mr. and Mrs. William F. Fahnestock, Katonah, New York.

Preliminary sketch by Charles A. Platt for surroundings of the Helen Sears residence, Southborough, Massachusetts, June 12, 1913 (cat. no. 64).

Residence for Mr. and Mrs. Richard D. Merrill, Seattle, Washington.

1910

COMMISSIONS:

The Longacre Building, 1497 Broadway (43rd to 44th streets), for the Astor estate office, New York, New York.

1911

COMMISSIONS:

The Leader-News Company office building, for the Hanna family, Cleveland, Ohio (cat. nos. 72, 73).

Easterly, residence for Mr. and Mrs. Francis M. Weld, Huntington, New York.

1912

Dedication ceremony for Platt's fountain honoring Josephine Shaw Lowell, the Progressive-era reformer, in Bryant Park, New York, New York.

COMMISSION:

The Causeways, residence for Mr. and Mrs. James Parmalee, Washington, D.C.

1913

Fourth son, Charles, born.

Monograph of the Work of Charles A. Platt with an Introduction by Royal Cortissoz published by the Architectural Book Publishing Company (cat. no. 71).

COMMISSIONS:

The Freer Gallery of Art, a museum to house Charles Lang Freer's collection of American paintings and Asian art, Washington, D.C. (cat. no. 79).

Town house for Mr. and Mrs. Arthur Meeker, Chicago, Illinois.

Wolf Pen Farm, residence for Mr. and Mrs. J. Cameron Bradley, Southborough, Massachusetts.

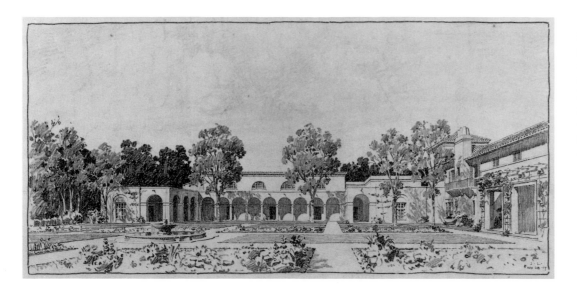

"View from Garden," a Schell Lewis rendering, dated November 20, 1917, of a proposal for additions to Villa Turicum, the Harold and Edith Rockefeller McCormick residence, Lake Forest, Illinois, designed 1908–18 (cat. no. 66).

1914

COMMISSION:
Astor Court Apartments, 2424 Broadway (89th to 90th Streets), for the Astor estate office.

1915

Moves his offices from 24th Street to 101 Park Avenue.
Platt becomes one of the first members of the Coffee House, a small, informal club.

COMMISSIONS:
6–9 East 61st Street, residence for Mr. and Mrs. John T. Pratt, New York, New York (cat. no. 76).
Seven Springs Farm, residence for Eugene and Agnes Meyer, Mount Kisco, New York.

1916–21

Member of United States National Commission of Fine Arts, responsible for the development of the public architecture, sculpture, landscaping, and monuments of Washington, D.C.

1917

COMMISSIONS:
Residence for Charles Lang Freer, Great Barrington, Massachusetts.
Kanawha, residence for Mr. and Mrs. William S. Speed, Louisville, Kentucky.

1919

Produces official design for Arlington Cemetery headstones commemorating World War I dead.

COMMISSIONS:
Hanna Building and Hanna Building Annex, Cleveland, Ohio.
Planning consultant, Homewood Campus, the Johns Hopkins University, Baltimore, Maryland, until 1933.

1920

COMMISSIONS:
Knickerbocker Hotel, Broadway and 42nd Street, New York, New York, renovation into commercial office space, for the Astor estate office.
Lyme Art Gallery, for the Lyme Art Association, Old Lyme, Connecticut.

EXHIBITIONS:
Brooklyn Institute of Arts: "Charles A. Platt and His Etchings."
Cleveland Museum of Art: "The Etchings of Charles A. Platt."

1921

Appointed by the University of Illinois, Champaign-Urbana, as architect and overseer of general campus plan (cat. no. 81).
Invited by Phillips Academy, Andover, Massachusetts, to advise and assist Guy Lowell in master plan for campus development.

1922

COMMISSION:
Interior remodeling of town house for Mr. and Mrs. William F. Fahnestock, 457 Madison Avenue (Villard Houses), New York City.

EXHIBITION:
Doll and Richards, Boston: group show of etchings.

1923

Freer Gallery of Art opens to the public.

1924

Platt's good friend, architect Henry Bacon, dies. Platt completes his projects.
May through June: Travels through Europe with son William to study the arrangement and lighting in museums in preparation for designing a National Gallery of Art, never commissioned (cat. no. 80).
Fall: William joins Platt office.

COMMISSIONS:
Poplar Hill, residence for Mr. and Mrs. Frederick B. Pratt, Glen Cove, New York.
Library, University at Illinois, Urbana, Illinois.

1925

Enters competition for the Theodore Roosevelt memorials, New York, New York, and Washington, D.C.

COMMISSIONS:
Town house for Henry S. Morgan, 34 East 36th Street, New York, New York.
Clark Wing, addition to the Corcoran Gallery of Art, Washington, D.C.

EXHIBITIONS:
John Herron Art Institute, Indianapolis: "Etchings by Charles A. Platt."
The Grolier Club, New York: "Exhibition of the Etched Works of Charles A. Platt."

1926

Begins five-year term as consulting architect to Dartmouth College and seven-year term as consulting architect to the University of Rochester.

COMMISSIONS:
Oaklawn, now Bois Dore, for Mr. and Mrs. William F. Fahnestock, Newport, Rhode Island.
Architecture Building, University of Illinois, Urbana, Illinois.

1927

Guy Lowell dies; Platt assumes unofficial control of the architectural development of Phillips Academy, working with Thomas Cochran, an academy trustee.

COMMISSIONS:
Interiors of Nourmahal, motor yacht, for the Astor estate office.
Astor Apartments, 528–540 (later 530) East 86th Street, New York, New York, for the Astor estate office.
Chapel, Military Cemetery, Suresnes, France.

1928

Elected president (1928–1931) of the Century Association, the first architect to hold the post.
Elected president (1928–1933) of the Board of Trustees of the American Academy in Rome.

COMMISSION:
Oliver Wendell Holmes Library and the Commons, Phillips Academy, Andover, Massachusetts (cat. no. 82).

1929

COMMISSIONS:
Deerfield Academy, Deerfield, Massachusetts, to oversee extensive building campaign, completed after his death by sons William and Geoffrey Platt.
Residence for Mr. and Mrs. H. Wendell Endicott, Dedham, Massachusetts.
Largest town house Platt ever designed: for Edith Rockefeller McCormick, Chicago, Illinois; never built.

1930

COMMISSION:
Last apartment building: 120 East End Avenue, for the Astor estate office (cat. nos. 77, 78).

1931

Geoffrey Platt joins Platt office.

1932

EXHIBITION:
National Academy of Design: *Winter Landscape*.

1933

September 12, dies. Buried Manchester, Connecticut.

1934

Memorial exhibition, New York Public Library: "Charles Adams Platt: Etcher."

1938

Memorial exhibition, American Academy of Arts and Letters, New York, New York: "Exhibition of the Work of Charles Adams Platt."

NOTES

∗⇌◎⇌∗

1. Charles A. Platt and the Promise of American Art

1. In 1913, major monographs were published on both Platt and Lutyens, the foremost country house architect of this generation in England. "Two Eminent Domestic Architects: A Comparison," *Architectural Review* 35 (March 1914): 61–63, presented Platt as the American architect comparable in current stature to Lutyens. Interestingly, Platt considered Lutyens to have "had more influence towards bad architecture than anyone in England," probably because of Lutyen's disrespectful use of historical forms. Interview of Henry Hope Reed, Jr., with Schell Lewis, the renderer for the Platt office, August 23, 1958. Papers of the Platt office, private collection.

2. *Monograph of the Work of Charles A. Platt, with an Introduction by Royal Cortissoz* (New York: Architectural Book Publishing Company, 1913). A reduced format, student edition was published in 1925, suggesting the continuing popularity and influence of Platt as an architect and landscape designer.

3. More attention has been paid to Platt's work as an etcher, as discussed by Maureen C. O'Brien in her essay for this catalogue. Among the earlier studies is her own excellent catalogue, co-authored with Patricia C. F. Mandel, *The American Painter-Etcher Movement* (Southampton, N.Y.: The Parrish Art Museum, 1984).

4. A fuller discussion of Platt's family and background can be found in my monograph, *Charles A. Platt: The Artist as Architect* (New York and Cambridge: The Architectural History Foundation, Inc., and MIT Press, 1985).

5. For the nineteenth-century genealogy of the Platt family, consult G. Lewis Platt, *The Platt Lineage* (New York: T. Whittaker, 1891).

6. A brief history of the Century Association can be found in "Historical Note," *The Century Yearbook* (New York: The Century Association, 1993), vii–viii. For a fuller account of the founding and early history of the club, see *The Century, 1847–1946* (New York: The Century Association, 1946).

7. The Cheney family and their role in the development of Manchester, Connecticut, is thoroughly discussed in William E. Buckley, *A New England Pattern: The History of Manchester, Connecticut* (Chester, Conn.: Pequot Press, 1973), 87 ff.

8. The standard references on the National Academy are Eliot Clark, *History of the National Academy of Design, 1825–1953* (New York: Columbia University Press, 1954); and Lois Marie Fink and Joshua C. Taylor, *Academy: The Academic Tradition in American Art* (Washington, D.C.: Smithsonian Institution Press, 1975).

9. See Marchal E. Landgren, *Years of Art: The Story of the Art Students League of New York* (New York: R. M. McBride & Co., 1940).

10. Ripley Hitchcock, *Etching in America: With Lists of American Etchers and Notable Collections of Prints* (New York: White, Stokes & Allen, 1886), 13. Platt endorsed the club's commitment to etching as a personal, noncommercial art form, although he was successful in selling his prints and did some book illustration work as well. See Maureen C. O'Brien's essay in this catalogue.

11. The Paris years from 1882 to 1886 are the best-documented period of Platt's career because of the letters to his family that have survived. Preserved with papers of the Platt office, private collection, these letters have been transcribed and amount to 166 single-spaced typed pages. They provide important information on where Platt traveled and what he saw, whom he met, what he thought, and the character of the education that he received in Paris.

12. Annie Corbin Hoe was born in New York in 1852, the daughter of Colonel Richard March Hoe and Mary Corbin Hoe. Charles Platt's friend, Charles C. Burlingham, provides the most substantial description of Platt's first wife: *Aunt Annie: Annie C. Hoe Platt, 1852–1887. A Sketch* (privately printed, 1957), passim.

13. Saint-Gaudens had first come to Cornish in the summer of 1885 and urged his friends to visit or join him there. A large community of fellow sculptors and other artists followed in the 1890s. The best general history of Cornish is Hugh Mason Wade, *A Brief History of Cornish, 1763–1974* (Hanover, N.H.: University Press of New England, 1975). For a comprehensive discussion of the work of painters at Cornish, see *A Circle of Friends: Art Colonies of Cornish and Dublin* (University Art Galleries, University of New Hampshire, 1985). Cornish is considered from the perspective of cultural geography in Deborah E. Van Buren, "The Cornish Colony: Expressions of Attachment to Place, 1885–1915," Ph.D. diss., George Washington University, 1987.

14. A fuller discussion and additional illustrations of Platt's work in Cornish can be found in my article, "Charles A. Platt's Houses and Gardens in Cornish, New Hampshire," *The Magazine ANTIQUES* 122 (July 1982): 117–29.

15. I have attempted to explain the significance and influence of Platt's tour and the book that resulted from it in my essay, "Al fresco: An Overview of Charles A. Platt's Italian Gardens," that appears in a new edition of Charles A. Platt, *Italian Gardens* (Portland, Oreg.: Sagapress, Inc., and Timber Press, 1993), 95–142.

16. Olmsted pointedly admitted in a letter to William Platt before his departure for this tour: "I am afraid that I do not think much of the fine and costly gardens of Italy." Olmsted advised his apprentice to observe the use of vines and plantings that seemed "natural and spontaneous to the place." Letter, Frederick Law Olmsted to William Platt, February 1, 1892, Letterpress F. L. Olmsted Collection, Manuscript Division, Library of Congress.

17. Charles A. Platt, *Italian Gardens* (New York: Harper Brothers, 1894). In addition to the essay by Rebecca Davidson in this catalogue, see also her discussion of Platt's book in her dissertation, "Images and Ideas of the Italian Garden in American Landscape Architecture," Ph.D. diss., Cornell University, 1994, 50–93.

18. Slightly more than one hundred of Platt's large format glass negatives from this trip survive in his studio in Cornish. They were reprinted for an exhibition, "The Italian Garden Photographs of Charles A. Platt," at the Bank of Boston, August–October 1993, and at the PaineWebber Gallery, New York City, January–April 1994.

19. In an August 29, 1890, letter to White, Platt wrote: "What I want to build is an Italian villa 3 sides of a court with a collonade [*sic*] in the middle. The wings to be one story and the main part two. Haven't you got some photos or something that would help in regard to detail? Can you give me the address of a man who will make a perspective of the plan? . . ." Stanford White Papers, New-York Historical Society, Platt letter file. As built, the wings of High Court were a full two stories.

20. Guy Lowell, *American Gardens* (Boston: Bates & Guild Co., 1902). Lowell was a Boston architect who briefly directed a program in landscape architecture at the Massachusetts Institute of Technology. For further discussion of Lowell, see Rebecca Davidson's dissertation, pp. 176–306. Platt would later collaborate with and then replace Lowell as the architect and campus planner for Phillips Academy, Andover, Massachusetts.

21. The most comprehensive review of this important garden can be found in Alan Emmet, "Faulkner Farm: An Italian Garden in Massachusetts," *Journal of Garden History* 6 (April–June 1986): 162–78. See also Rebecca Davidson's essay in this catalogue.

22. For a discussion of the various gardens at Weld, see Richard G. Kenworthy, "Bringing the World to Brookline: The Gardens of Larz and Isabel Anderson," *Journal of Garden History* 11 (October–December 1991): 224–41.

23. On his occupational listing see *Trow's General Directory of the Boroughs of Manhattan and Bronx, City of New York* (New York: Trow Publishing Co., 1897–98 and 1898–99). In the winter of 1914, Professor H. Langford Warren invited Platt to give a series of lectures on the country house to students in the School of Architecture at Harvard University. In the introduction to his initial lecture, Platt commented: "The reason I feel enthusiastic about the country house is, that I think it is the best opportunity at the present time to produce a work of art in architecture." Lecture notes, February 4, 1914. Papers of the Platt office, private collection.

24. For the most comprehensive listing of the architectural periodical articles on Platt and his projects, consult the bibliography of my dissertation, "The Architecture and Landscapes of Charles A. Platt (1861–1933)," Ph.D. diss., Brown University, 1980, 356 ff.

25. Herbert Croly, "The Work of Charles A. Platt," *Architectural Record* 15 (March 1904): 181–244.

26. Platt frequently collaborated, however, with other landscape architects, especially with Ellen Shipman for planting plans and the Olmsted office for large-scale landscaping and engineering.

27. Charles A. Platt, "Foreword" in R. W. Sexton, *Interior Architecture: The Design of Interiors of Modern American Homes* (New York: Architectural Book Publishing Company, 1927). This brief essay is one of the very few occasions on which Platt explained the philosophy of his work as an architect.

28. The commission for this house and two other buildings for the Maxwell family in Rockville probably came to Platt through his mother's family, the Cheneys, silk mill owners in nearby Manchester, Connecticut.

29. See Rebecca Davidson's discussion of Faulkner Farm and Maxwell Court in this catalogue.

30. See my essay on Gwinn in this catalogue.

31. The Pratt house and many other Platt commissions are discussed in Mark Hewitt, *The Architect and the American Country House* (New Haven: Yale University Press, 1990), 266. Hewitt's thorough treatment of this typology is the finest of the books recently published on the American country house movement; Platt's work is also discussed on pages 61–66.

32. The other major lakefront commission was the General Russell A. Alger, Jr., house, the Moorings, 1908–10, on Lake Superior in Grosse Pointe Farms, Michigan. See Morgan, *Charles A. Platt*, 112–22.

33. I have examined this series of commissions in my article: "The Patronage Matrix: Charles A. Platt, Architect, Charles L. Freer, Client," *Winterthur Portfolio* 17 (Summer/Autumn 1982): 121–34.

34. Platt's other museum commissions included: the Radeke (now Aldrich) Gallery, Museum of Art, Rhode Island School of Design, Providence, Rhode Island, 1905; the Lyme Art Association Gallery, Old Lyme, Connecticut, 1920–21; Wilkes-Barre Art Museum project, Wilkes-Barre, Pennsylvania, 1923; Columbus Gallery of Art, Columbus, Ohio, 1927; Lyman Allyn Museum, New London, Connecticut, 1928–30; the Addison Gallery of American Art, Phillips Academy, Andover, Massachusetts, 1929; and the Clark Wing of the Corcoran Gallery of Art, Washington, D.C., 1925–28.

35. In addition to developing the master plan, Platt designed a dozen buildings for the campus, independently or through supervising designs by James M. White, the resident campus architect. Platt was able to control this partnership from New York because he established an architectural formula for the campus—red brick, Georgian-inspired buildings with segmentally arched and hooded second-floor windows—that provided a consistent pattern throughout the university.

36. This Cochran paraphrasing of a conversation with Platt was reported in Claude Moore Fuess, *Independent Schoolmaster* (Boston: Little, Brown & Co., 1952). This source is generally useful for the background and progress on the redevelopment of Andover under the direction of Platt and Cochran.

37. For a fuller discussion of Platt's use of pho-tographs in the development of his etchings, see Maureen C. O'Brien's essay in this catalogue.

38. In his essay "Gardens and Photography" (in Monique Moser and Georges Teyssot, eds., *The Architecture of Western Gardens: A Design History from the Renaissance to the Present Day* [Cambridge, Mass.: The MIT Press, 1991], 472–77), Tony Mott emphasizes the significance of Platt's photographs and book in advancing the use of photographs to record and analyze the garden. He compares Platt's to the slightly later work of Eugene Atget in documenting the melancholy condition of the surviving French chateaux gardens of the seventeenth century. Mott also correctly relates Platt's photographs for *Italian Gardens* to the paintings of his friend and Cornish neighbor, Maxfield Parrish, who provided the illustrations for Edith Wharton's 1904 book, *Italian Villas and Their Gardens* (although Mott incorrectly uses the name of Platt's book for Wharton's in his text). It is indeed surprising that Wharton does not include Platt's book in her bibliography since Mott mentions that Parrish consulted Platt on the production of his illustrations, which were developed from photographs. For a further discussion of the interrelationship of Platt's and Wharton's books, see Rebecca Davidson's dissertation, pp. 148–75.

39. These photograph albums and most of the book collection are now preserved in the Platt Library of the Century Association in New York City.

40. "A Memoir by Geoffrey Platt," in Morgan, *Charles A. Platt*, 204. This memoir is a rich source for understanding Platt's character and relations with his family and colleagues.

41. The standard and most comprehensive treatment of this cultural movement is *The American Renaissance, 1876–1917* (Brooklyn: The Brooklyn Museum, 1979).

42. The richest treatment of the impact of the American Renaissance on city planning in the United States is found in William Henry Wilson, *The City Beautiful Movement* (Baltimore: The Johns Hopkins University Press, 1989).

43. In a letter to his family from Paris, dated April 19, 1884, Platt commented on his changing philosophy of art: "An artist should interest one's sense of the beautiful and make that his great object. He must have a subject to make his picture, but he should *use* the subject to make his picture and not the picture to render his subject" (papers of the Platt office, private collection). In this passage, he was criticizing the highly narrative character of contemporary German and English art. In this and other letters, he recorded his desertion of the picturesque subjects that had informed his earlier work and described his personal quest for "the beautiful." He defined the beautiful in opposition

to the picturesque, the "curious and extraordinary."

44. One of the earliest and most persuasive statements of the architectural goals of Platt's generation was made by A. D. F. Hamlin, professor of architecture at Columbia University, in his article, "The Battle of Styles," *Architectural Record* 1 (March 31, 1892): 265–74, and (June 30, 1892): 405–13.

45. Memorandum, Geoffrey Platt to the author, December 17, 1981. The story was recounted to Geoffrey Platt by Mrs. Lloyd Garrison, to whom Wright made the comment at a dinner party.

46. For a list of the commissions that Platt executed for sculptors, see Morgan, *Charles A. Platt*, 216 n2.

47. The current literature on Paul Manship does not include discussions of his collaborations with Platt. See the essay on Gwinn in this catalogue for fuller information. For Shipman, consult the forthcoming book by Judith B. Tankard to be published by Sagapress, Inc., for the Library of American Landscape History.

48. See, for example, Alan Trachtenberg, *The Incorporation of America: Culture and Society in the Gilded Age* (New York: Hill and Wang, 1982).

49. In one of his lectures to students in the School of Architecture at Harvard in February, 1914, Platt commented: "The surroundings of a monumental building to-day, owing to the introduction of the skyscraper, are so uncertain, and so rarely we find them good that they do not inspire a man to do his very best work." Papers of the Platt office, private collection.

50. Suzanne Stephens, "Architecture and Criticism in a Historical Context: The Case of Herbert Croly," in Elisabeth Blair MacDougall, ed., *The Architectural Historian in America. A Symposium in Celebration of the Fiftieth Anniversary of the Founding of the Society of Architectural Historians*, Studies in the History of Art, no. 35, Center for Advanced Study in the Visual Arts, Symposium Papers 19 (Washington, D.C.: The National Gallery of Art, 1990), 275–87. Stephens believes: "Croly's approach to evaluating buildings and the urban landscape . . . anticipate[s], albeit faintly, the recent architectural criticism based on a theoretical analysis of buildings now referred to as 'typology,' 'signification,' and 'contextualism'" (p. 276).

51. See especially Herbert Croly, "The Architectural Work of Charles A. Platt," *Architectural Record* (March 1904). This article was the first comprehensive review of Platt's work as an architect, written only six years after Platt promoted himself as an architect, without prior training.

52. Herbert Croly, *The Promise of American Life* (New York: The Macmillan Company, 1909), 443–45.

53. Ibid.

54. The clearest analysis of Herbert Croly's philosophy and his influence on architecture is found in Suzanne Ralston Lichtenstein's dissertation, "Editing Architecture: Architectural Record and the Growth of Modern Architecture, 1928–1939," Ph.D. diss., Cornell University, 1990.

55. Charles A. Platt, "Herbert Croly and Architecture," *The New Republic* 63 (July 16, 1930): 257. This essay was reprinted in *Architectural Record* 68 (August 1930): 138.

56. Ibid.

2. The Etchings of Charles A. Platt

1. Henry Russell Wray, with an introduction by Peter Moran, *A Review of Etching in the United States* (Philadelphia: R. C. Penfield, Publisher, 1893), 59–60.

2. Diary of Stephen Parrish, quoted by Maxfield Parrish, Jr., in *Stephen Parrish (1848–1938)* (Boston: Vose Galleries, Inc., 1982), 8–9. For an insightful essay on Parrish's etching career, see Thomas P. Bruhn, *American Etching: The 1880s* (Storrs, Conn.: The William Benton Museum of Art, University of Connecticut, 1985).

3. Bruhn, *American Etching: The 1880s*, 4–5.

4. Keith N. Morgan, "The Architecture and Landscape of Charles A. Platt (1861–1933)," Ph.D. diss., Brown University, 1978, 20.

5. Sylvester R. Koehler, "The Works of the American Etchers. XXV.—Charles A. Platt," *American Art Review* 2, no. 2 (1881): 150.

6. Museum of Fine Arts, Boston, Print Department, *Exhibition of American Etchings*, 1881. This exhibition was held from April 11 through May 9, 1881.

7. Koehler, "The Works of American Etchers," 150.

8. Stephen Parrish to Sylvester R. Koehler, July 24, 1881, in Sylvester R. Koehler Papers, Archives of American Art, Smithsonian Institution (Reel D189, Fr. 237).

9. See Philip Gilbert Hamerton, *Etching and Etchers* (London: 1868; revised, Boston: Roberts Brothers, 1876); and William C. Brownell, "Whistler in Painting and Etchings," *Scribner's Monthly Illustrated Magazine* 18 (August 1879): 481–95.

10. See Otto Bacher, *With Whistler in Venice* (New York: The Century Co., 1908), for an account of Whistler's impact on the young artists who met him in Venice in 1880.

11. Hamerton, *Etchings and Etchers* (1876 edition), 293.

12. It was customary for the New York Etching Club to print and bind a selection of small, original etchings with the catalogue of their annual exhibition. In 1883 the club catalogue included a reduced version of Platt's *Provincial Fishing Village* [R. 40a], which measured 2 5/8 × 4 7/8 inches as compared with the larger plate's dimensions of 13 1/4 × 24 5/8 inches. In 1886, one of Platt's largest etchings, *Deventer*, 1885 [R. 63; 14 × 27 1/2 inches], was also produced in a small version for the New York Etching Club catalogue.

13. Whistler's Venetian etchings could be seen in exhibitions at the Pennsylvania Academy of the Fine Arts, Philadelphia, and at the Union League Club, New York, in 1881. Platt might have seen them in either city.

14. M. [Mariana] G. Van Rensselaer, "American Etchers," *The Century Magazine* 25 (February 1883): 496.

15. M. [Mariana] G. Van Rensselaer, *American Etchers* [reprinted from *The Century Magazine* for February 1883, with a brief additional chapter reprinted in part from *The New York Star*, by Mrs. Schuyler Van Rensselaer, to which is added an account of Meryon and His Work by Frederick Keppel] (New York: Frederick Keppel & Co., 1886): 24.

16. See Vienna, *Illustrierter Katalog der ersten Internationalen Special* [sic]—*Ausstellung der Graphischen Künste in Wien* (Vienna: Verlag der Gesellschaft fur Vervielfaltigende Kunst, 1883).

17. Transcriptions of Platt's letters and his Chartres journal were made available through the courtesy of the Platt family, and comprise part of the papers of the Platt office, private collection.

18. Platt to his family, Antwerp, June 10, 1882.

19. For a discussion of Kimmel & Voigt's role in the production of American etchings in the 1880s, see Maureen C. O'Brien, "To Mr. Henry E. F. Voigt with the Compliments of the Etcher," in Maureen C. O'Brien and Patricia C. F Mandel, *The American Painter-Etcher Movement* (Southampton, N.Y.: The Parrish Art Museum, 1984).

20. Platt to his family, Antwerp, June 10, 1882.

21. Sketchbook in the collection of members of the Platt family.

22. Platt to his family, Vitre, July 19, 1882.

23. Platt to his family, Le Mans, July 13, 1882: "Here I saw a picture of the real Cathedral & I found the one I had explored was quite an unimportant church."

24. Platt to his family, Vitre, July 15, 1882.

25. Platt to his family, Grandcamp, August 7, 1882.

26. Platt to his family, Honfleur, September 26, 1882. One of Ferguson's photos even included Platt, "very small & quite as a detail in the background but I can be seen and the position and every thing about it is most natural."

27. The Howells essays appeared in *The Century Magazine* in six parts from February to October 1885.

28. Platt to his family, Paris, January 28, 1883.

29. Joseph Pennell, *The Adventures of an Illustrator* (Boston: Little, Brown and Company, 1925), 101, notes: "I thought I was paid like a prince for the plates, and in the end I was. Later I found that the Editors had offered the same, or a larger sum to Charles A. Platt, and he refused it."

30. Bruhn, *American Etching: The 1880s*, 84–85, describes this deluxe edition of Lamb's *Essays of Elia*, to which etchings were also contributed by J. D. Smillie, F. S. Church, and R. S. Gifford. Called the "Islington Edition," it was published by G. P. Putnam's Sons, New York, in November 1883.

31. Platt discussed gathering material for these commissions in a letter to his family from Paris, May 19, 1883. He particularly loved Oxford: "I could have spent a month meandering about the old place & had I not been obliged to hurry back here to do the etchings for Putnam's, I might have done it. . . ."

32. Edmondo de Amicis, *Holland and Its People*, Zuyder Zee edition (New York: G. P. Putnam's Sons, 1885). Bruhn, *American Etching: The 1880s*, 84 n2, notes that the edition was printed with twenty-five sets of proofs on satin.

33. Edmondo de Amicis, *Spain and the Spaniards*, Guadalquiver edition (New York: G. P. Putnam's Sons, 1885).

34. Platt to his family, Paris, March 5, 1885: "I am thinking of going to Spain. I have got some etchings to do for Putnams which I could do better on the spot than here in Paris. I fear, however, the price I shall be paid for the plates would hardly cover the expense of the journey & then I ought to be here to work in the school." He does not mention Spain in his next letter (March 28), in which he speaks of his successful entry to the spring Salon.

35. Platt to his family, Paris, November 5, 1883.

36. Platt to his family, Honfleur, September 27, 1885.

37. Platt to his family, Honfleur, October 10, 1885.

38. Platt to S. R. Koehler, Paris, April 15, 1885, in Sylvester R. Koehler Papers, Archives of American Art, Smithsonian Institution (Reel D189, Fr. 854).

39. The painting is *Canal at Chartres*, 1883, 22

× 15 1/2 inches. The Cooley Gallery, Old Lyme, Connecticut.

40. A photograph of this oil sketch, in the records of Jeffrey Brown of Brown-Corbin Fine Arts, was brought to my attention by Erica Hirshler.

41. Van Rensselaer, *American Etchers*, 1886, 24–25.

42. James McNeill Whistler, *The Gentle Art of Making Enemies* (London: William Heinemann, 1890), 76–77.

43. This print is listed by Koehler, "The Works of American Etchers. XXV — Charles Platt," 150, but is dropped from the catalogue of Platt's etchings by Rice. Rice's introduction notes that Platt made three reproductive etchings but does not name them.

44. Platt had a collection of Parrish's etchings that he might have brought along to Europe. Parrish's personal etching log, which notes the production and sale of each etching he made, records the gift of thirty-three etchings to Platt in 1882. This same log also records that Platt eventually gave an equal number to Parrish. I am grateful to Thomas P. Bruhn for making his facsimile of Parrish's log available.

45. Platt to his family, January 7, 1883.

46. Platt to his father, Chartres, July 11, 1882.

47. Platt Family Collection.

48. Platt to his family, Honfleur, September 25, 1882.

49. For a discussion of Platt's contacts with the artists of the Hague School, see Erica Hirshler's essay in this catalogue.

50. Platt to his family, April 19, 1884.

51. Platt to his family, June 29, 1884.

52. This was a well-known motif of Hague School painter Anton Mauve (see, for example, his *Scheveningen*, 1874, oil on canvas, 35 5/8 × 72 1/8 inches, The Burrell Collection, Glasgow Museums and Art Galleries, Glasgow, Scotland), who was represented by a painting of this subject in the New York collection of the designer and art dealer Daniel Cottier in 1883.

53. Dean Sage, *The Ristigouche and Its Salmon Fishing; with a Chapter on Angling Literature*, edition of 105 copies, 25 for sale in the United States (Edinburgh: printed by T. A. Constable for David Douglas, 1888).

54. S. R. Koehler, *Etching: An Outline of its Technical Processes and its History, with some remarks on collectors and collecting* (New York, London, Paris, Melbourne: Cassell & Co. Ltd., 1886), 160.

55. *Catalogue of an Exhibition of the Complete Etched Work of C. A. Platt* (New York: Hermann Wunderlich & Co., 1889); Richard A. Rice, *A Descriptive Catalogue of the Etched Work of*

Charles A. Platt (New York: The DeVinne Press, 1889).

56. *Official Catalogue of Exhibits, World's Columbian Exposition, Department K, Fine Arts* (Chicago: W. B. McConkey, 1893). The catalogue contains a listing of the seventeen etchings and two paintings exhibited by Platt.

57. Wray, *A Review of Etching*, 7.

58. James D. Smillie, introduction to *A Publication by the New York Etching Club* (New York: New York Etching Club, 1892), ix. Smillie follows this comment with a firm refutation, but the argument in fact reflects the dwindling market for etchings at this time.

59. After 1890, Platt produced very few etchings. Only three prints with later dates (*The Insel, Holland*, 1917; *The Mountain*, 1920; and *Meadow Brook*, 1920) appear in the 1925 Grolier Club catalogue of his work (see note 68).

60. *Catalogue of an Exhibition of Etchings and Dry-Points by C. A. Platt, with an Introductory Note by Mrs. Schuyler Van Rensselaer* (New York: Frederick Keppel & Co., 1907).

61. "And He Etches, Too," *New York Times*, June 8, 1907.

62. *Monograph of the Complete Work of Charles A. Platt with an introduction by Royal Cortissoz* (New York: Architectural Book Publishing Co., 1913), iv.

63. E. G. K., "Charles A. Platt and His Etchings," *Brooklyn Museum Quarterly* 7 (April 1920): 96–103.

64. "The Etchings of Charles A. Platt," *Bulletin of the Cleveland Museum of Art* 7 (February 1920): 110.

65. "Etchings by Charles A. Platt," *Bulletin of the Art Association of Indianapolis, John Herron Art Institute* (December 1925): 57–58.

66. Etchings by Frederick G. Hall and William H. Drury were also shown at the exhibition at Doll and Richards, Boston, from March 16 to April 4, 1922.

67. *Exhibition of the Etched Work of Charles A. Platt* (New York: The Grolier Club, 1925). The exhibition dates were January 22 to February 28, 1925.

68. See Joan Anderson, "Charles A. Platt: Architect, Etcher, Painter," *International Studio* 82 (December 1925): 180–88. Admiring the expression of personality in Platt's etchings, Anderson complained about the dominance of craftsmanship over aesthetic content in the etchings of the twentieth-century revival.

69. Frank Weitenkampf, "Charles Adams Platt — Etcher," *The Print Connoisseur* (April 1927): 87–91.

70. See Frank Weitenkampf, "Charles Adams Platt: Etcher," *Bulletin of the New York Public*

Library, Astor, Lenox and Tilden Foundations 38 (January 1934): 17–19.

71. Impressions of several of Platt's lithographs are in the collection of the Hood Museum of Art, Dartmouth College, Hanover, New Hampshire.

72. "Other Shows," *New York Times*, November 13, 1938. As a context for this criticism, it should be noted that the second review in this column was of a show of John Marin's watercolors at Alfred Stieglitz's An American Place gallery.

3. The Paintings of Charles A. Platt

1. Royal Cortissoz, "Introduction," *Monograph of the Work of Charles A. Platt* (New York: Architectural Book Publishing Co., 1913), ix. I would like to thank Theodore E. Stebbins, Jr., for his generous support during my work on this project. I am indebted to Deanna M. Griffin for her cheerful and thorough research assistance.

2. For Platt's early training, as well as for the biographical details of his life, see Keith N. Morgan, *Charles A. Platt: The Artist as Architect* (New York and Cambridge: The Architectural History Foundation, Inc., and M.I.T. Press, 1985), 7–10 (and throughout). Platt's instructors at the National Academy were Lemuel Wilmarth, James Wells Champney, and John George Brown. At the League he studied with William Merritt Chase and Walter Shirlaw.

3. See *Le Voyage de Paris: Les Americains dans les Ecoles d'Art* (Paris: Musée National de la Coopération Franco-américaine, Château de Blérancourt, 1990); and H. Barbara Weinberg, *The Lure of Paris: Nineteenth-Century American Painters and Their French Teachers* (New York: Abbeville Press, 1991).

4. Platt to his family, Chartres, June 30, 1882. Transcriptions of Platt's letters to his family (some of which take the form of a daily journal) were made available through the courtesy of members of the Platt family, and comprise part of the papers of the Platt office, private collection.

5. Platt to his family, Chartres, July 12, 1882.

6. May Alcott Niereker, *Studying Art Abroad and How to do it Cheaply* (Boston: Roberts Brothers, 1879), 62.

7. Cecilia Beaux, *Background with Figures* (Boston: Houghton Mifflin Company, 1930), 150. For information on the American artists' colonies at Pont-Aven and Concarneau, see David Sellin, *Americans in Brittany and Normandy 1860–1910* (Phoenix: Phoenix Art Museum, 1982).

8. Edward Simmons, *From Seven to Seventy: Memories of a Painter and a Yankee* (New York: Harper and Brothers, 1922), 141.

9. Platt to his family, Vitré, July 14, 1882.

10. Platt to his family, Grandcamp, August 12, 1882. Frank Boggs, a native of New York, first came to France to study scene-painting. He eventually became a French citizen. For more information on Boggs, see Theodore Child, "Frank Myers Boggs," *The Art Amateur* 11 (August 1884): 53–57.

11. Platt to his family, Honfleur, September 7, 1882.

12. Platt to his family, Paris, November 4, 1882. Walker studied with Léon Bonnat in Paris; he became known as a portrait painter and a muralist. Walker and Platt were reunited at the artistic community in Cornish, New Hampshire, which Walker encouraged Platt to join. Platt designed Walker's Cornish home in 1889.

13. Platt's situation was superior to that of many of his compatriots, since his father provided him with an allowance. His studio on the rue de la Victoire cost him one hundred francs per month (Platt to his family, Paris, November 4, 1882). By comparison, Arthur Wesley Dow, an American painter who arrived in Paris two years later, engaged a hotel room for twenty-five francs per month (Diary, October 17, 1884, Arthur Wesley Dow Papers, Archives of American Art, Smithsonian Institution), while Kenyon Cox rented a room for forty francs a month in 1877 (Kenyon Cox to his mother, October 28, 1877, in H. Wayne Morgan, ed., *An American Student in Paris: The Letters of Kenyon Cox, 1877–1882* [Kent, Ohio: The Kent State University Press, 1986], 39).

14. Platt to his family, Paris, December 9, 1882. Although Platt treated this subject many times, his large Salon project, if extant, has not been located.

15. Platt to his family, Paris, January 25, 1883.

16. "Jennings, . . . like all the rest of us, . . . cannot find terms sufficiently strong to characterize the hanging committees," Platt to his family, London, May 5, 1882. For details of the procedure of the Salon judging, and for Platt's Salon participation, see Lois Marie Fink, *American Art at Nineteenth-Century Paris Salons* (Washington, D.C.: Smithsonian Institution, 1990), 137–42, 381. The 1883 Salon included such American contributions as John Singer Sargent's *Daughters of Edward D. Boit* (Museum of Fine Arts, Boston) and James McNeill Whistler's portrait of his mother (Musée d'Orsay, Paris).

17. Boggs's *Port d'Isigny* was purchased for the Musée de Niort. See Susan Grant, "Whistler's Mother Was Not Alone: French Government Acquisitions of American Paintings, 1871–1900," *Archives of American Art Journal* 32 (1992): 2–15.

18. The most comprehensive study of American painters in Holland is Annette Stott's "American Painters Who Worked in the Netherlands, 1880–1914," Ph.D. diss., Boston University, 1986.

19. Platt to his family, Paris, November 5, 1883.

20. See *L'Ecole de la Haye, Les Maitres Hollandais du 19eme Siècle* (Paris: Grand Palais, 1983).

21. Platt to his family, Dordrecht, October 14, 1883.

22. Quoted in *L'Ecole de la Haye, Les Maitres Hollandais du 19eme Siècle*, 83.

23. Platt to his family, Paris, February 7, 1884.

24. Platt to his family, Dresden, April 19, 1884. In March, *The Art Amateur* reproduced one of Platt's watercolors, entitled *Mudboats at Dordrecht* (*The Art Amateur* 10 [March 1884]: 86).

25. Platt to his family, Paris, May 13, 1884.

26. Platt to his family, Larmor, May 1884.

27. Platt to his family, Dresden, April 19, 1884.

28. Platt's philosophy is related to that of the Aesthetic Movement, although he never specifically discussed that creed or mentioned its influential members in his early correspondence. Like most young painters of his day, Platt sought to move away from the meticulous, descriptive realism that had dominated American landscape painting. His interest in broadly painted, tonalist landscapes was reinforced (but not initiated) by his exposure to the Dutch painters of the Hague School.

29. Platt had given up his quarters on the rue de la Victoire. He now rented a room at 66 rue de Seine, on the Left Bank near the Ecole des Beaux-Arts, and a studio on the rue Notre Dame des Champs, a street in Montparnasse jammed with artists, including Carolus-Duran and Bouguereau.

30. For more information on the Académie Julian, see Weinberg, *The Lure of Paris: Nineteenth-Century American Painters and Their French Teachers*, 221–62.

31. Platt to his family, Paris, November 5, 1884.

32. Platt to his family, Paris, March 28, 1885.

33. Ibid. Platt's painting was described as one of a "few smaller pictures . . . worthy of remark. . . . [It is] clever in painting and true in color," (R. A. M. Stevenson, "The American Salon," *The Magazine of Art* 8 [1885]: 518).

34. Platt referred frequently in his familial letters to his purchase of commercial souvenir photographs of many of the sites he visited; he often complained of their poor quality and of their failure to capture the specific views he had admired during his travels. His own "blue prints" of Honfleur, mentioned in a letter of October 19, 1885 (from Paris), were apparently cyanotypes and would seem to predate his classmate Arthur Wesley Dow's earliest landscape cyanotypes by about

ten years. Platt continued to use photographs as a sketching device, but he also considered them finished works, as evidenced by his photographic illustrations for his book *Italian Gardens* (1894).

35. In his letters, Platt never mentioned the paintings of the impressionists, although he was not in Paris during any of their controversial exhibitions. He had arrived in Paris three months after the "Seventh Exhibition of Independent Artists," closed in 1882; their eighth group show was held from May 15 to June 15, 1886, when Platt was in Italy.

36. Platt to his family, Paris, February 8, 1886. Annie Hoe's portrait had been painted in 1880 by Abbott Thayer (reproduced in Nelson C. White, *Abbott H. Thayer, Painter and Naturalist* [Hartford: Connecticut Printers, 1951]).

37. Platt to his family, San Remo, February 23, 1886.

38. Platt to his family, Genoa, March 3, 1886.

39. Platt to his family, Siena, March 7, 1886.

40. Platt to his father, Paris, November 25, 1884.

41. Dennis Bunker to Eleanor Hardy, New York, n.d. [late 1889], Dennis Miller Bunker Papers, Archives of American Art, Smithsonian Institution.

42. Fig. 3.21 has been described as a Dutch landscape, but the anonymity of these green fields and plain cottages makes a precise identification difficult. This type of simple rural view was popular with the impressionist painters, whose work was introduced to America during the 1880s.

43. For the Cornish art colony, see Keith N. Morgan, "Charles Platt's Houses and Gardens in Cornish, New Hampshire," *The Magazine ANTIQUES* 122 (July 1982): 117–29; *A Circle of Friends: Art Colonies of Cornish and Dublin* (Durham: University of New Hampshire, 1985); Susan Hobbs, "Thomas Dewing in Cornish, 1885–1905," *The American Art Journal* 17 (Spring 1985): 2–32; and Deborah E. Van Buren, "The Cornish Colony: Expressions of Attachment to Place, 1885–1915," Ph.D. diss., George Washington University, 1987.

44. Dennis Bunker to Eleanor Hardy, Windsor, Vt., n.d. [July 1890], Dennis Miller Bunker Papers, Archives of American Art, Smithsonian Institution.

45. After a year's engagement, Eleanor Hardy married Dennis Bunker in October 1890. Bunker died of heart failure from meningitis in December that same year.

46. Maxfield Parrish [son of Platt's friend Stephen Parrish] to Daisy Deming, Cornish, N.H., September 3, 1893, Parrish Papers, Dartmouth College Library, Hanover, N.H. For further commentary and information on landscape painting in

Cornish, see Van Buren, "The Cornish Colony," 158–93.

47. Rose Standish Nichols, "A Hilltop Garden in New Hampshire," *The House Beautiful* 55 (March 1924): 237.

48. Platt to C. Powell Minnigerode, New York, December 30, 1919, Corcoran Gallery of Art Archives.

49. Platt to his family, Dresden, April 19, 1884.

4. Charles A. Platt and the Fine Art of Landscape Design

This essay is partially derived from my doctoral dissertation, "Images and Ideas of the Italian Garden in American Landscape Architecture," Cornell University, January 1994. At Cornell, I would like to thank Professors Mark Jarzombek, Leonard J. Mirin, Christian F. Otto, and Mary N. Woods for their critical readings and comments. I am also grateful to Keith N. Morgan for his encouragement, suggestions, and generous assistance. Charles A. Platt II was kind enough to read a draft of the essay and contributed valuable information regarding High Court and the Platt house and gardens.

1. Charles A. Platt, in John Taylor Boyd, Jr., "Colonial Homes of Great Dignity, . . . Sixteenth of a Series of Articles Entitled, 'The Country House as the American Architect Sees It,'" *Arts & Decoration* 35 (October 1931): 21.

2. Charles A. Platt, *Italian Gardens* (New York: Harper & Bros., 1894), 106.

3. The present brick house, built in 1896 by Platt, is a copy of the wood and stucco original, which burned shortly after it was completed. For contemporary photographs and the plan shown here, see "'High Court,' Near Windsor, Vt.— Designed by Charles A. Platt, Architect," *House and Garden* 2 (September 1902): 413–15.

4. Platt's own later comments on his method of design in a situation with a dominating and dramatic landscape, as published in "Where We Get Our Ideas of Country Places in America, Prepared from an Interview with Charles A. Platt," *Outing* 44 (June 1904): 352, are also revealing: ". . . to a house set upon a hill, the ground falling away from it with some abruptness, the whole site chosen for the view, the landscape gardener will give surroundings of the utmost simplicity that they may not compete with or disturb the larger influence without. This was recognized in the Frascati villas in Italy, which were terraced to give a view of the distant Campania, and in America, there was an example in High Court." See also Herbert Croly,

"The Architectural Work of Charles A. Platt," *Architectural Record* 15 (March 1904): 186–94, for a comparison of the differences between Platt's conception of the design of his own house and garden and that of High Court; in the former the garden was the dominant feature, in the latter, the views.

5. A. J. Downing, *A Treatise on the Theory and Practice of Landscape Gardening, Adapted to North America* (New York and London: Wiley and Putnam, 1841; 6th ed., 1859): 46–47. Although phrased in various ways, this sentiment appears in all editions of the *Treatise*. On Downing's importance, see George B. Tatum and Elisabeth Blair McDougall, eds., *Prophet with Honor: The Career of Andrew Jackson Downing, 1815–1852* (Philadelphia: Athenaeum of Philadelphia, and Washington, D.C.: Dumbarton Oaks, 1989); Therese O'Malley, Introduction to Downing's *Treatise* (Washington, D.C.: Dumbarton Oaks Research Library and Collections, 1991; facsimile reprint of the 1850 printing of the 4th ed., the last to be issued in Downing's lifetime, orig. pub. 1849), [v]–xii. Although much has been made of Downing's opposition to the formal garden as a suitable model for American landscape design, it should be noted that he also had some positive regard for it, particularly as it was associated with his own interpretation of Italian villa architecture. His appreciation of the Italian garden specifically, however, was based on the all-important "associations"—resonant with history, learning, and the arts—that allowed it to be "regarded with a degree of classic interest by every cultivated mind." As he wrote in the *Treatise* (1st ed., 1841), 314–17: "The modern Italian style recalls images of [that] land of painters and of the fine arts, where the imagination, the fancy, and taste, still revel in a world of beauty and grace. The great numbers of elegant forms which have grown out of this long cultivated feeling for the beautiful in the fine arts, in the shape of fine vases, statues, and other ornaments, which harmonize with, and are so well adapted to enrich, this style of architecture, combine to render it in the fine terraced gardens of Florence and other parts of Italy, one of the richest and most attractive styles in existence. Indeed we can hardly imagine a mode of building, which in the hands of a man of wealth and taste, could in this country be made productive of more beauty, convenience, and luxury, than the modern Italian style."

6. The best general source of information on Olmsted and his many works of landscape design is still Laura Wood Roper, *FLO: A Biography of Frederick Law Olmsted* (Baltimore: Johns Hopkins University Press, 1973). See also *The Papers of Frederick Law Olmsted,* 6 vols. to date, covering the years 1822–1874 (Baltimore: Johns Hopkins University Press, 1977–).

7. See, for example, Van Rensselaer's series of articles, "Landscape Gardening," in *American Architect and Building News* 22 (October 1, 1887): 157–59; (December 3, 1887): 263–64; 23 (January 7, 1888): 3–5; and a different series, with the same title, in *Garden and Forest* 1 (February 29–April 11, 1888), where it had won praise from such prominent horticultural writers as Liberty Hyde Bailey (see *Garden and Forest* 1 [March 28, 1888]: 58) and had established Van Rensselaer as an authority in matters of good taste in landscape design. Also of particular interest is her biographical essay, "Frederick Law Olmsted," *The Century Magazine* 46, n.s. 24 (October 1893): 860–67. Van Rensselaer's most significant contribution to the perception of the garden as a fine art, and particularly to a reconsideration of the merits of the formal garden, was her meticulous exposition of the principles of artistic composition as they could be applied to garden design in her book, *Art Out-of-Doors: Hints on Good Taste in Gardening* (New York: Charles Scribner's Sons, 1893; new and enlarged ed., 1925). For a summary of Van Rensselaer's contributions to architectural and landscape criticism, see Lisa Koenigsberg, "Mariana Van Rensselaer: An Architecture Critic in Context," in Ellen Perry Berkeley, ed., *Architecture: A Place for Women* (Washington: Smithsonian Institution Press, 1989): 41–54.

8. Jacob Burckhardt, *Der Cicerone* (Basel, 1855; London, 1873); idem, *Die Cultur der Renaissance in Italien* (Basel, 1860), *The Civilization of the Renaissance in Italy* (London, 1878); Walter Pater, *The Renaissance, Studies in Art and Poetry* (London and New York, 1873); John Addington Symonds, *Renaissance in Italy*, 7 vols. (London, 1875–86; New York, 1881–87). The literature dealing with the influence of Italy on American artists has been well summarized by Theodore E. Stebbins, Jr., in the introduction to the exhibition catalog, *The Lure of Italy: American Artists and the Italian Experience, 1760–1914* (Boston: Museum of Fine Arts; New York: Abrams, 1992), 19–27, with an extensive bibliography, 452–54.

9. Charles A. Platt, "Italian Gardens," *Harper's New Monthly Magazine* 87 (July 1893): 164–80; (August 1893): 393–406; idem, *Italian Gardens* (New York: Harper & Bros., 1894). A new edition, with an "Overview" by Keith N. Morgan, has recently been published (Portland, Oregon: Sagapress/Timber Press, 1993). The measured drawings reportedly made by Charles Platt on this trip have apparently not survived. All subsequent references to *Italian Gardens* are to Platt's 1894 book.

10. The best-known and most influential work on Italian gardens published in early twentieth-century America is Edith Wharton, *Italian Villas and Their Gardens* (New York: The Century Co., 1904).

11. For a thorough discussion of Platt's writings on the Italian garden, see Rebecca Warren Davidson, "Images and Ideas of the Italian Garden in American Landscape Architecture," Ph.D. diss., Cornell University, 1994, especially Chapter 1, "*Italian Gardens* in America." See also Keith Morgan's "Overview" in the new edition of *Italian Gardens*, especially pp. 115–36. An examination of Platt's influence on Wharton's book, which appears to have been considerable, although unacknowledged by her, may be found in Davidson, "Images and Ideas," 148–75.

12. So far as is known, Platt wrote only two other published works related to the subject of garden design. One was his contribution, "Villa," to Russell Sturgis, ed., *A Dictionary of Architecture and Building* (New York: Macmillan, 1901–3), 3: 995–1004. The other was a discussion of a little-known villa garden, the design of which he particularly admired: "A Renaissance Villa Near Rome [Villa Costansi (cat. no. 52)] with Photographs and Sketch Plan by Charles A. Platt," *Architectural Review* (Boston) 3, o.s. 20 (November 1915): 93–95. He also gave a few interviews to the popular and professional press, notably in "Where We Get Our Ideas of Country Places in America"; and Boyd, Jr., "Colonial Homes of Great Dignity . . .", both cited previously; and in Charles Downing Lay, "An Interview with Charles A. Platt," *Landscape Architecture* 2 (April 1912): 127–31.

13. Platt's knowledge of Italian gardens in particular won him the admiration and confidence of the Detroit industrialist Charles L. Freer, who would later become one of his most significant patrons. Platt organized a tour of Italian gardens for Freer in the 1890s.

14. See, for example, Henry Winthrop Sargent's remarks on Italian gardens in his notes to the sixth edition of Downing's *Treatise* (New York: A. O. Moore, 1859), 47–48, which were very similar to many nineteenth-century British discussions of the subject: ". . . most of the great places [in England], have more or less adopted the Italian or Architectural school on one or more sides of the house, as a sort of connection between art and nature. . . . the grade between the house and the park is let down, as it were, by a series of terraces, each divided from the other by heavy stone balustrades, surmounted, at regular intervals, with vases. . . . Flights of broad, heavy stone or marble steps conduct from one terrace to the other, and finally to the Park. The flat of the terrace, being laid out either in the most formal and precise parterre, or in extremely rich and intricate

bcds of arabesque patterns in scrolls, to resemble carpets. In either case, great use is made of statues and fountains, very elaborately designed and executed, and of Portugal Laurel, trimmed up to imitate orange-trees in tubs; as, also, of the Irish and Golden Yew, and other pyramidal evergreens, either planted in the ground, or in boxes, and, also, of different-colored gravel in the division of the beds, the whole producing, when seen from the windows of the house, a brilliant combination, which, with the soft, verdant park as a background, is inexpressibly gay and effective."

15. Platt, *Italian Gardens*, 6.

16. Ibid., 8.

17. Such influential nineteenth-century writers as J. C. Loudon, Edouard André, and Downing himself, for example, had all included similar discussions of the basic principles of landscape design in their treatises. See, in particular, Loudon, "The Principles of Landscape-Gardening," *An Encyclopaedia of Gardening* (London: Longman, 1835; orig. pub. 1822), 1163–70; Downing, "The Beautiful and the Picturesque; Their Distinctive Characteristics," "The Principles of Unity, Harmony, and Variety," *Treatise*, 4th ed., 63–66, 80–84; André, "Esthétique: Caractères du beau: Harmonie.—Utilité, Convenance.—Inspiration.—Variété," *L'art des jardins: traité generale de la composition des parcs et jardins* (Paris: G. Masson, 1879), 100–102. Platt's book, it should be reiterated, contains no such rigorous (or, some might say, tedious) exposition, yet such principles are nonetheless present in his work.

18. Platt's application of this idea to his own work is apparent in his remarks quoted in Wilhelm Miller, "An 'Italian Garden' That is Full of Flowers," *Country Life in America* 7 (March 1905): 491–92: "I think that the term 'Italian Garden' is being too liberally applied to the formal garden in this country, and while I am guided mainly by principles of design derived from the Italian examples, I should not call the Anderson garden [Weld, see discussion in later text] an Italian garden any more than I should call one of my houses an Italian house."

19. The chief sources of published information on Platt's landscape designs are Croly, "Work of Platt"; *Monograph of the Work of Charles A. Platt with an Introduction by Royal Cortissoz* (New York: Architectural Book Publishing Company, 1913); Norman T. Newton, *Design on the Land: The Development of Landscape Architecture* (Cambridge, Mass.: Harvard University Press, 1971), 372–84; Keith N. Morgan, "The Architecture and Landscapes of Charles A. Platt (1861–1933)," Ph.D. diss., Brown University, 1978; idem, "Charles A. Platt's Houses and Gardens in Cornish, New Hampshire," *The Magazine*

ANTIQUES 122 (July 1982): 117–29; idem, *Charles A. Platt: The Artist as Architect* (New York: Architectural History Foundation, and Cambridge, Mass.: MIT Press, 1985). The number of Platt's landscape commissions was derived by checking the notes in Morgan's comprehensive checklist of Platt's oeuvre, "List of Buildings, Gardens, and Projects," *Charles A. Platt*, 239–62, for the inclusion of "garden" or "landscape."

20. For recent discussions of Platt's work in Cornish and environs, see Morgan, "Platt's Houses and Gardens in Cornish"; and *A Circle of Friends: Art Colonies of Cornish and Dublin* (Durham, N.H.: University Art Galleries, University of New Hampshire, 1985), 131.

21. Augustus Saint-Gaudens, *The Reminiscences of Augustus Saint-Gaudens*, 2 vols. (New York: The Century Co., 1913). Basic information on Cornish can be found in Hugh Mason Wade, *A Brief History of Cornish, 1763–1974* (Hanover, N.H.: University Press of New England, 1975). For the artists who lived and worked there, see *A Circle of Friends*; and Deborah Elizabeth Van Buren, "The Cornish Colony: Expressions of Attachment to Place, 1885–1915," Ph.D. diss., George Washington University, 1987.

22. The best contemporary account of the Cornish gardening phenomenon is Frances Duncan, "The Gardens of Cornish," *The Century Magazine* 72 (May 1906): 3–19. Five Cornish gardens were also featured in Guy Lowell's important compilation of the work of early twentieth-century landscape architects, *American Gardens* (Boston: Bates & Guild, 1902), including Platt's own garden and his design for Herbert Croly. *American Gardens* also illustrated four additional designs by Platt, giving his work more prominence than that of any other designer.

23. Ellen Biddle Shipman, "Garden Note Book," unpaginated, Ellen Shipman Papers, Cornell University Library, Department of Manuscripts and University Archives, Ithaca, New York. Shipman (1869–1950), whose early career was aided and encouraged by Platt, with whom she also collaborated on a number of projects, went on to develop a highly successful career as a landscape architect with a national clientele. For an overview of Shipman's career, concentrating particularly on her formative experiences in Cornish, see Deborah Kay Meador, "The Making of a Landscape Architect: Ellen Biddle Shipman and Her Years at the Cornish Art Colony," M.L.A. thesis, Cornell University, 1989; see also Deborah E. Van Buren, "Landscape Architecture and Gardens in the Cornish Colony: The Careers of Rose Nichols, Ellen Shipman and Frances Duncan," *Women's Studies* 14 (1988): 367–88.

24. Rose Standish Nichols, "A Hilltop Garden

in New Hampshire," *The House Beautiful* 55 (March 1924): 237.

25. For a detailed analysis of the gardens at Aspet, see Marion Pressley and Cynthia Zaitzevsky, *Cultural Landscape Report for Saint-Gaudens National Historic Site* (Boston: National Park Service, North Atlantic Region, 1993).

26. For a further description of this view and for contemporary photographs, see Herbert Croly, "The House and Garden of Mr. Charles A. Platt," *House and Garden* 1 (December 1901): 10–17. It is indicative of the esteem in which Platt's work was held by his contemporaries that this article was included in the inaugural issue of *House and Garden*.

27. Louise Shelton, *Beautiful Gardens in America*, rev. ed. (New York: Charles Scribner's Sons, 1924; orig. pub. 1915), 23. See also Croly, "House and Garden of Mr. Charles A. Platt," 12–14: "With the exception of a few hollyhocks the principal beds are filled entirely with hardy perennial flowers, and they have flowering shrubs in the corners. Spirea, rose rugosa, hydrangeas, lilacs and the like, predominate and form a rich green background for such perennials as peonies, larkspur, phlox, bergamot, wild asters, and tall helenium." These gardens have now been simplified almost entirely to grass. Eleanor Platt's involvement with planting and caring for the gardens is confirmed by her grandson, Charles A. Platt II, who, in a letter to the author March 5, 1994, states that "she loved the gardens and described them to me as 'my art.'"

28. As one may infer from Royal Cortissoz's remarks in his Introduction to Platt's *Monograph*, iii: "He [Platt] recalls his first artistic effort, which was to devise paper imitations of things seen, horses, carriages and the like, and, more particularly, houses. Once he even composed a complete country house with its surroundings and with divers inhabitants to give it the last touch of verisimilitude."

29. For a recent account of Platt's work at Faulkner Farm, particularly informative concerning architect-patron relationships, see Alan Emmet, "Faulkner Farm: An Italian Garden in Massachusetts," *Journal of Garden History* 6 (April–June 1986): 162–78. Faulkner Farm is still owned by descendants of the Spragues but is presently leased as office space to a corporate client, and the gardens are neglected.

30. Platt, *Italian Gardens*, 16.

31. See especially Morgan, *Charles A. Platt*, 49–51.

32. Although the Villa Gamberaia is not included in Platt's articles or in his book on Italian gardens, the significant correspondences between it and his basic approach to designing house, garden, and landscape connections make it difficult to believe that he did not know it well. Indeed, Platt may have been referring to Gamberaia (although he does not name any villa specifically) when he wrote in *Italian Gardens*, pp. 138–40: "There are many interesting small gardens surrounding Florence, most of them being occupied by their owners, and are somewhat difficult of access to a stranger. If, however, he is fortunate enough to gain admittance, he will find something of interest in almost every one." The absence of photographs of Gamberaia in his book may only be indicative of its relative inaccessibility, which continued to be the case even after its purchase, c. 1895, by the Princess Giovanna Ghyka, sister of Queen Natalie of Servia, as Mrs. Aubrey Le Blond, *The Old Gardens of Italy, How to Visit Them* (London: John Lane, The Bodley Head, and New York: John Lane, 1912), 87, noted: "Under no circumstances is it possible to see the garden while the family is in residence, but when they are absent permission may be applied for from the Princess's agent in Florence." Platt also drew on his knowledge of other Italian villas, of course—notably the Villa Lante, as mentioned previously—for the design of Faulkner Farm.

33. Judith A. Kinnard in "The Villa Gamberaia in Settignano: The Street in the Garden," *Journal of Garden History* 6 (January–March 1986), esp. pp. 5–11, has written about "the curious villa-garden relationship" at Gamberaia, noting that the villa "was the result of several separate building phases" and that "the primary constraints on the composition of the garden must have been this existing house and the irregular shape of the property."

34. See particularly Barr Ferree, *American Estates and Gardens* (New York: Munn & Co., 1904), 131–37, where, significantly, only one photograph pictured the house exclusively, while eight were devoted to the gardens; Charles H. Caffin, "Formal Gardens and a New England Example," *Harpers New Monthly Magazine* 99 (September 1899): 557–65; Ralph Adams Cram, "Faulkner Farm, Brookline, Massachusetts," *House and Garden* 1 (August 1901): 1–11; idem, "The Sculptures of Faulkner Farm," *House and Garden* 1 (September 1901): 1–10; Brooke Fisher, "Faulkner Farm," *The New England Magazine*, n.s. 25 (January 1902): 577–88; Croly, "Work of Platt," 195–203.

35. *Trow's General Directory of the Borough of Manhattan and Bronx, City of New York* (New York: Trow Publishing Co., 1897–98 and 1898–99), as discovered by Keith Morgan; see Morgan, *Charles A. Platt*, 64 and 220 n65.

36. Samuel Howe, "American Homes and Gardens: The Weld Garden, Brookline, Massachu-

sctts," *Country Life* (London) 43 (May 18, 1918): 466, 468. The same conclusion was reached by Herbert Croly, "Work of Platt," 204.

37. All these gardens are described in a recent article by Richard G. Kenworthy, "Bringing the World to Brookline: The Gardens of Larz and Isabel Anderson," *Journal of Garden History* 11 (October–December 1991): 224–41. Mrs. Anderson was a cousin of Mrs. Sprague of Faulkner Farm, which certainly aided Platt in obtaining the commission for Weld; see Morgan, *Charles A. Platt*, 55–56.

38. Platt himself bought a number of these pieces on his trips to Italy. Others were purchased by the Andersons while Larz was serving at the embassy in Rome from 1894 to 1897. At her death in 1948, Isabel Anderson left Weld to the City of Brookline. In the 1950s, the city built an ice-skating rink/tennis court in place of the Italian garden, in the process destroying most of the plantings and decorative elements. Fragments of one of the gazebos remain, encased in chain-link fence; portions of the pergola have been preserved and re-erected on the bowling green. The "Larz Anderson Park," as it is now known, also houses a Museum of Transportation in the Andersons' former carriage house. Though Platt's garden is gone, the park nevertheless forms a welcome open space in what is now a crowded city, and from the site of the bowling green and demolished residence, one can still enjoy his carefully orchestrated views of the city of Boston and the distant landscape.

39. For more contemporary photographs of this garden, particularly significant for their depiction of an exuberance of plantings within an architectural framework, see Miller, "An 'Italian Garden' That Is Full of Flowers," where Weld was called "among the world's masterpieces in garden architecture." Weld was probably the most photographed and discussed garden in America in the early twentieth century. Richard G. Kenworthy's bibliography, "Published Records of Italianate Gardens in America," *Journal of Garden History* 10 (January–March 1990): 31–34, lists over sixty references to Weld.

40. Platt mentions the presence and use of flowers at nearly every one of the nineteen villas he discusses in *Italian Gardens*, and the reader cannot fail to grasp their vital importance to him. He wrote, for example, of "the profusion of flowers" at the Villa Lante, a "great many flowers" formerly grown at the Villa Borghese, and the "beds filled with flowers" at the Quirinal. At the Villa Albani, he laments that "the flower garden has no flowers in it!" The flower garden at the Villa Castello (fig. 4.4), which, along with the Villa Borghese, I believe to be Platt's primary sources for the sunken garden of Weld, impressed him as "one of the most beautiful in Italy," with its "architectural terrace, above which is a grove of ilex and cypress trees." Little is known about Platt's abilities as a plantsman, but he undoubtedly acquired some knowledge of flowers from his wife Eleanor and from his acquaintances in Cornish who were avid gardeners, such as Ellen Shipman. As noted above, Platt later employed Shipman to work with him on a number of his gardens. Meador, "Making of a Landscape Architect," pp. 104–5, lists fourteen Shipman/Platt collaborations, derived from Morgan, *Charles A. Platt*, and from the index to the Ellen Shipman Papers, Department of Manuscripts and University Archives, Cornell University Library. In addition, Shipman worked on the gardens at Gwinn after Platt's death and on such projects as Longue Vue, in New Orleans, where she created the gardens for the house designed by architects William and Geoffrey Platt, Charles Platt's sons.

41. On Platt's work at Illinois and other college campuses, see the account in Morgan, *Charles A. Platt*, 175–96.

42. *The National Commission of Fine Arts, Eleventh Report, January 1, 1926–June 30, 1929* (Washington, D.C.: Government Printing Office, 1930), 97: "At a special committee meeting held in New York City on May 7, 1928, which was attended by Mr. Charles A. Platt, Mr. Benjamin W. Morris, Mr. Ferruccio Vitale, with Mr. Peaslee, the suggestion of Mr. Platt was adopted, to change the character of the exedra from a walled structure to a parapet. . . ."

43. Aymar Embury II, "Charles A. Platt—His Work," *Architecture* 26 (August 15, 1912): 130.

44. Croly, "Work of Platt," 183.

45. For further discussion of this issue, see Newton, *Design on the Land*, esp. pp. 427–46.

5. Charles A. Platt in New York, 1900–1933

For their helpful comments in shaping this essay, I thank Andrew S. Dolkart, Barbara MacAdam, Keith N. Morgan, Timothy Rub, and Carol Willis; for assistance with plans and drawings, Janet Parks of the Avery Architectural and Fine Arts Library; and for indispensable backup at home, Gregory Nolan and Agnes Nolan.

1. For background on Platt's country houses, see the essays by Keith N. Morgan in this catalogue, and Keith N. Morgan, *Charles A. Platt: The Artist as Architect* (New York and Cambridge: The Architectural History Foundation and MIT Press, 1985).

2. On Croly's life (1869–1930) and career, which included publication of an influential treatise of political philosophy, *The Promise of American Life* (1909), and the founding editorship of *The New Republic* in 1914, see David W. Levy, *Herbert Croly of* The New Republic (Princeton, N.J.: Princeton University Press, 1985). For Croly's influence in New York, see also Thomas Bender, *New York Intellect* (New York: Alfred A. Knopf, Inc., 1987), 222–28 and passim. See also Keith Morgan's introductory essay in this volume.

3. On Cortissoz, see H. Wayne Morgan, *Keepers of Culture: The Art Thought of Kenyon Cox, Royal Cortissoz, and Frank Jewett Mather* (Kent, Ohio: Kent State University Press, 1989). Cortissoz wrote the introduction for the *Monograph of the Work of Charles A. Platt* (New York: The Architectural Book Publishing Company, 1913).

4. Mrs. Schuyler Van Rensselaer, "Architecture as a Profession," *The Chautauquan* 7 (April 1887): 453.

5. In reference to competitions, Platt once stated, "My colleagues say I can't win prizes any more. Painters say I'm an architect and architects say I'm a painter." Interview, William Platt with Henry Hope Reed, Jr., n.d., papers of the Platt office, private collection. Morgan suggests that Platt did not like competitions because he could not consult carefully with the client from the beginning of the design process. Morgan, *Charles A. Platt*, 175.

6. Morgan, *Charles A. Platt*, 236.

7. William Adams Delano, "Memoirs of Centurian Architects," in *The Century 1847–1946* (New York: The Century Association, 1947), 216.

8. The Grolier was founded in 1884. Of the more than 120 exhibitions to precede Platt's in January 1925, only four had been concerned with etchings (Rudolph Ruzicka, Mahonri Young, Mary Cassatt, and Charles H. Woodbury). Fine arts dealer Edward G. Kennedy organized the show for the club in its new building, completed in 1917, to a design by Bertram Grosvenor Goodhue. File, Platt Exhibition, Grolier Club Archives; *The Grolier Club 1884–1984* (New York: 1984); *Grolier 75*; *Exhibition of the Etched Work of Charles A. Platt* (New York: The Grolier Club, January 22 to February 28, 1925).

9. Robert Stewart, "Clubs and Club Life in New York," *Munsey's Magazine* 22 (October 1899): 105–22; Robert Stern et al., *New York 1900* (New York: Rizzoli, 1983), 226–45.

10. *The Century 1847–1946*, 5ff. See also Thomas Bender, *New York Intellect* (New York: Alfred A. Knopf, 1987; Baltimore: Johns Hopkins University Press, 1988), 139–40ff.

11. Robert A. M. Stern et al., *New York 1900* (New York: Rizzoli, 1983), 232.

12. See Delano, "Memoirs of Centurian Architects," and "Membership List," *The Century 1847–1946*, 363–413.

13. "A Memoir by Geoffrey Platt," in Morgan, *Charles A. Platt*, 202; F. J. Mather, "The Century and American Art," *The Century 1847–1946*, 169.

14. Delano, "Memoirs of Centurian Architects," 216.

15. Arthur Maurice, "Of Ghosts and Other Things," in Henry Wysham Lanier, ed., *The Players' Book: A Half-Century of Fact, Feeling, Fun and Folklore* (New York: The Players, 1938), 244. On the history of the club, see Lanier and Carole Klein, *Gramercy Park: An American Bloomsbury* (Athens, Ohio: Ohio University Press, 1987).

16. Quotations are from "Some Notes About the Coffee House, A Private Club," New York (n.p.), January 1993. Other sources include Membership Lists, 1916 and 1918; William Adams Delano, "Oral History," Special Collections, Columbia University Libraries, 1948, 8: "From the beginning Frank Crowninshield was its heart and life-blood."

17. Embarrassed to be known as a slumlord, as had been true of his father, Vincent disposed of the last of the Astor tenements in 1934 by selling them to the city. Some of the buildings were demolished, and the rest were renovated to become First Houses, the first public housing project in New York. See "Vincent Astor — Landlord," *Architectural Forum* 61 (July 1934): 73–75. For the controversy about the sale value of the land and how much Astor and the city did or did not benefit, see Peter Marcuse, "The Beginnings of Public Housing in New York," *Journal of Urban History* 12 (August 1986): 356–60.

18. Herbert Croly, "The Architectural Work of Charles A. Platt," *Architectural Record* 15 (March 1904), 227. On the Richmond project, see also Morgan, *Charles A. Platt*, 130–31.

19. Croly, "The Architectural Work of Charles A. Platt," 228–29.

20. Sources on Lowell and the memorial fountain include: William Rhinelander Stewart, comp., *The Philanthropic Work of Josephine Shaw Lowell* (New York: Macmillan, 1911); Lloyd C. Taylor, Jr., "Josephine Shaw Lowell and American Philanthropy," *New York History* 44 (October 1963): 336–64; *In Memoriam Josephine Shaw Lowell* (The Charity Organization Society of the City of New York, 1906); Program for Dedication Exercises, May 12, 1912, New York Public Library; Seth Low Papers and Community Service Society Papers (CSS), Special Collections, Butler Library, Columbia University; *Annual Reports*, Department of Parks, New York; files and scrap-

books of the Art Commission of the City of New York; Lowell entries in the *Dictionary of American Biography* and *Notable American Women*; "Bryant Fountain Honors Mrs. Lowell," *New York Times*, May 12, 1912, 12.

21. Burlingham was related to Platt's first wife and thus had known the architect since the 1880s. I discuss the commission for the Lee house later in this essay.

22. When jelly and berries were served, Burlingham recalled Mrs. Lowell asking Platt, "Will you have jerries or bellies?" He answered, "I think I'd like a few jerries on my belly." CSS Collection, COS Box 143, Folder, "The 100th Anniversary Ceremony of Birth of Josephine Shaw Lowell, December 16, 1943." The CSS was the successor to the COS.

23. The subcommittee of the Art Commission that recommended approval of the preliminary scheme was composed of Herbert Adams (a former Platt client and Cornish neighbor), Robert W. de Forest (president of the COS), and Arnold Brummer. Archives of the Art Commission of the City of New York, Art Commission Folder 416 A–K.

24. There is no evidence to explain why the Lowell fountain was moved from Corlears Hook to Bryant Park. On the history of Bryant Park and its sculpture, see Margot Gayle and Michele Cohen, *Manhattan Outdoor Sculpture* (New York: Prentice Hall Press, 1988), 145, 151–52. The Bryant memorial was dedicated in October 1911. *Annual Report for 1911*, Department of Parks, 13; *New York Post*, May 21, 1912.

25. Various accounts give the cost as $15,000 or $20,000. Stewart, *The Philanthropic Work*, 549. Commissioner Stover, "Bryant Fountain Honors Mrs. Lowell," *New York Times*, May 12, 1912, 12.

26. During a renovation in the 1930s, the fountain was moved to the west side of the park, just inside the Sixth Avenue entrance on axis with 41st Street and the center of the library. It was beautifully restored in 1990 during yet another rebuilding of the park.

27. On the views of McKim, Mead & White, see Henry W. Desmond and Herbert Croly, "The Work of McKim, Mead & White," *Architectural Record* 20 (September 1906): 214–41. On Platt's position, see Morgan, *Charles A. Platt*, 154–55, and introductory essay in this volume.

28. On speculative development, see Andrew S. Dolkart and Susan Tunick, *George & Edward Blum: Texture and Design in New York Apartment House Architecture* (New York: The Friends of Terra Cotta Press, 1993).

29. There are several histories of the apartment house in New York: Andrew Alpern's *Apartments for the Affluent: A Historical Survey of Buildings in New York* (New York: McGraw-Hill, 1975), and his *Luxury Apartment Houses of Manhattan* (New York: Dover Publications, 1993); Elizabeth Collins Cromley, *Alone Together, A History of New York's Early Apartments* (Ithaca: Cornell University Press, 1990); Elizabeth Hawes, *New York, New York: How the Apartment House Transformed the Life of the City, 1869–1930* (New York: Alfred A. Knopf, 1993); and Stern's *New York 1900*, 279–305, and *New York 1930* (New York: Rizzoli International, 1987), 384–424. Dozens of articles in the architectural press tracked the development of the apartment house.

30. A. C. David [Herbert Croly], "A Cooperative Apartment House in New York, Designed by Charles A. Platt," *Architectural Review* 24 (July 1908): 16.

31. Ibid., 16–17.

32. Although the Studio Building was a financial success, when Platt was retained by William Taylor to build an apartment house behind it at 130–134 East 67th Street, the studio design was eliminated in favor of simple duplexes and smaller apartments. Platt designed it in conjunction with the firm of Rossiter & Wright. Alpern, *Apartments for the Affluent*, 44; Barry Bergdoll, "130–34 East 67th Street Apartment Building Designation Report," New York City Landmarks Preservation Commission, 1980.

33. The best account of how long-term landholding shaped aspects of the New York real estate market is Elizabeth Blackmar, *Manhattan for Rent, 1785–1850* (Ithaca, N.Y.: Cornell University Press, 1989).

34. On the Astors, see "Vincent Astor—Landlord"; Lucy Kavaler, *The Astors: A Family Chronicle of Pomp and Power* (New York: Dodd, Mead & Company, 1966); David Sinclair, *Dynasty: The Astors and Their Times* (London: J. M. Dent & Sons, 1983), and John D. Gates, *The Astor Family* (Garden City, N.Y.: Doubleday & Company, Inc., 1981).

35. Sinclair, *Dynasty*, 217, 219.

36. On Ellen Biddle Shipman, see *New York Times* obituary March 29, 1950, 29; and William H. Tischler, ed., *American Landscape Architecture* (Washington, D.C.: Preservation Press, 1989), 90–91, 94, 133. She was married to Louis Shipman, a playwright and a clubmate of Platt. See also essays by Rebecca Davidson and Keith Morgan in this volume.

37. John Tauranac and Christopher Little, *Elegant New York: The Builders and the Buildings* (New York: Abbeville Press, 1985), 241, 243. At its completion, the Apthorp was the city's largest

apartment house on a 204-by-208-foot site, with twelve stories and one hundred apartments.

38. Kavaler, *The Astors*, 36, 88; "Vincent Astor—Landlord," 73.

39. Alpern, *Apartments for the Affluent*, 134–35; "Vincent Astor—Landlord," 73–75.

40. Lewis Mumford, "The Sky Line, Medals and Mentions," *The New Yorker*, April 16, 1932, 36, 38; advertisement of the award is on 39. Mumford's reference was to the union-sponsored apartment complexes built in the Bronx with more greenspace and, therefore, better light and air than on East End Avenue.

41. Platt designed and renovated smaller office buildings for the Astor estate. See Morgan, *Charles A. Platt*, and note 43 below.

42. "Vincent Astor—Landlord," 75; "The Knickerbocker Building, New York," *Architecture and Building* 53 (November 1921): 88–89, pls.185–188; Stern, *New York 1930*, 201. Platt did renovation work on two other Astor estate hotels in New York: the Astor House Hotel (1915) at Broadway and Vesey Street, and the Saint Regis Hotel (1925) at Fifth Avenue and 55th Street. See Morgan, *Charles A. Platt*, 250, 256.

43. Platt also did two small office buildings for the Astors, at 18 West 33rd Street (1912, six stories) and at the northwest corner of Broadway and Vesey Street (1912–13, seven stories). Both have rusticated neo-Renaissance facades much in the vein of his Longacre Building and town house renovations several years earlier (see essay below) for the Astor estate but lacking some of their refinement and ornamental touches, as befitted their commercial use. The Broadway building may have been a completely renovated and enlarged section of the old Astor Hotel, New York's first major modern hostelry built by John Jacob Astor in 1836.

44. The apartments, designed by Evarts Tracy, had a central garden. Renamed "Westover Court," they were the precursors of a number of projects in the teens and twenties that would consolidate old groups of brownstones in such areas as Turtle Bay, Greenwich Village, and Gracie Square. See Frank Chouteau Brown, "Tendencies in Apartment House Design. Part II. Examples of Remodeling (Continued)," *Architectural Record* (July 1921): 55ff. Platt renovated tenements, and other architects renovated brownstones, into apartments for the Astor estate in the Gracie Square area. See "Vincent Astor—Landlord," 73, and plans in the Charles A. Platt Collection, Avery Architectural and Fine Arts Library, Columbia University.

45. Montgomery Schuyler, "The Small City House in New York," *Architectural Record* 8 (April–June 1899): 368, and "The New New York

House," *Architectural Record* 19 (February 1906): 83–84.

46. Herbert Croly, "The Renovation of the New York Brownstone District," *Architectural Record* 13 (June 1903), as cited in the *Upper East Side Historic District Designation Report* (UESHDDR), vol. 1 (New York: New York City Landmarks Preservation Commission, 1981), 19.

47. "Residence, 844 Fifth Avenue, New York," *Architectural Record* 21 (June 1907): 469.

48. Morgan, *Charles A. Platt*, 138–39, 248.

49. On Nicholas Biddle and the Roosevelt family, see Blanche Wiesen Cook, *Eleanor Roosevelt Vol. I 1884–1933* (New York: Viking Penguin, 1992), 131, 152–53, 166; and Joseph Lash, *Eleanor and Franklin* (New York: W. W. Norton & Co., 1971), 134, 137, 139. James Roosevelt Roosevelt was married to Helen Schermerhorn Astor, daughter of William Backhouse Astor, Jr. See Kavaler, *The Astors*, 121.

50. Rita Halle Kleeman, *Gracious Lady: The Life of Sara Delano Roosevelt* (New York: D. Appleton-Century Co., 1933), 255. Lash, *Eleanor and Franklin*, 160.

51. Schuyler, "The Small City House in New York," 365. On the Colonial Revival, see William B. Rhoads, *The Colonial Revival* (New York & London: Garland Publishing, 1977); and Alan Axelrod, ed., *The Colonial Revival in America* (New York: W. W. Norton & Co., 1985).

52. Lash says in *Eleanor and Franklin*, 160, that Mrs. Sara Roosevelt suggested to Platt that he use as his model for the unified facade two identical town houses at 6–8 East 76th Street, known as the Ludlow-Parish houses, built in 1895–96 and designed by the firm of Parish & Schroeder. They were owned by Eleanor's aunts (and thus Sara's relatives, too), and although two separate buildings, their mirror images gave the appearance of being one grand Italian Renaissance palace. However, McKim, Mead & White had previously designed a double-size house for H. A. C. Taylor at 2–3 East 72nd Street in 1894, and Richard Morris Hunt's design for Mrs. Astor was a double house, too.

53. Eleanor Roosevelt, *This Is My Story* (New York: Harper & Brothers, 1937), 152. At the time, she had left all of the design decisions to Franklin and Sara and found that she was unhappy with the result. She reported in her autobiography that she wept a few weeks after moving into the new house, telling Franklin, "I said I did not like to live in a house which was not in any way mine, one that I had done nothing about and which did not represent the way I wanted to live" (*This is My Story*, 162).

54. Eleanor Roosevelt, "I Remember Hyde Park: A Final Reminiscence," posthumous, *McCall's*, February 1963, 73.

55. Cook, *Eleanor Roosevelt*, 418.

56. Ibid., 332. The house remained with the family until it was sold in 1942 to Hunter College after the death of Sara; Eleanor Roosevelt, *The Autobiography of Eleanor Roosevelt* (New York: Harper & Row, 1961), 235. The house was designated a New York City Landmark in 1973.

57. The biographical information on Lee is from the DAB and the UESHDDR, II, 233, 245. Work on the new Lee town house (which replaced two brownstones) was preceded by a renovation project for Lee on the same block on 65th Street between Park and Lexington Avenues: Platt altered an 1869 brownstone for Lee, adding one story to the building in 1904, UESHDDR, II, 262.

58. "The House of Mr. Frederic S. Lee," *Architectural Record* 20 (November 1908): 427.

59. On Hapgood, see DAB; Bender, *New York Intellect*, 310; and Levy, *Herbert Croly*, 80.

60. "House of Mr. Norman Hapgood," *Architectural Record* 18 (July 1905): 18; William Herbert [Herbert Croly], *Houses for Town and Country* (New York: 1907), chapter 2.

61. "House of Mr. Norman Hapgood," 22.

62. "Introduction," *Monograph*, viii. The riches of American collections are reflected in the items displayed in the "Loan Exhibition of the Arts of the Italian Renaissance," which was held at the Metropolitan Museum of Art in the spring and summer of 1923. Platt loaned two paintings. See *Bulletin of the Metropolitan Museum of Art*, May 1923: 107–14.

63. William C. Shopsin and Mosette Glaser Broderick, *The Villard Houses* (New York: The Viking Press, 1980). The Villard Houses were eventually designated official New York City Landmarks and preserved as part of the construction of the Helmsley Palace Hotel. Platt would probably be pleased that the Fahnestock wing is used by several architectural and preservation organizations including the Municipal Art Society, the Architectural League of New York, and the New York Chapter of the American Institute of Architects.

64. Ron Chernow, *The House of Morgan* (New York: Simon & Schuster, 1990).

65. See Steven M. Bedford, "Country and City: Some Formal Comparisons," in Richard Guy Wilson et al., eds., *The Long Island Country House 1870–1930* (Southampton, N.Y.: The Parrish Art Museum, 1988), 72, 74; and Liisa and Donald Sclare, *Beaux-Arts Estates: A Guide to the Architecture of Long Island* (New York: The Viking Press, 1979).

6. Gwinn: The Creation of a New American Landscape

1. I am deeply indebted to Lucy Ireland Weller for her kindness in making the Gwinn Archives available for inspection, and to William Tepley, Grounds Superintendent of Gwinn, for his help with my research. The development of the gardens of Gwinn is the subject of a recent book by Robin Karson, *Gwinn: An American Garden* (Portland, Oreg.: Timber Press and Sagapress, Inc., for the Library of American Landscape History, forthcoming).

2. The major source for my information on Mather and the development of the Cleveland-Cliffs Iron Company is: "A Bond of Interest: Tracing more than 130 years of developing interrelationship between the Cleveland-Cliffs Iron Company and the Michigan communities which have been its partners in progress," *Harlow's Wooden Man, Quarterly Journal of the Marquette Historical Society, Inc.* 13 (Fall 1977): 3–31.

3. Robin Karson, manuscript for *Gwinn: An American Garden*, p. 21.

4. Warren Manning to William Mather, November 14, 1906, William Gwinn Mather Papers, Gwinn Archives, Cleveland, Ohio, file I-1.

5. Manning to Mather, January 4, 1907, ibid.

6. Manning to Mather, September 20, 1906, ibid.

7. Manning to Mather, January 4, 1907, ibid.

8. The June issue of *Indoors and Out* includes an article by R. Clipton Sturgis, "Of What Shall the House Be Built?" 2, no. 3, 101–11, in which Platt's Harlackenden Hall, the Winston Churchill house in Cornish, New Hampshire (1898–1902), and Cherry Hill, the Dr. Arthur T. Cabot estate in Canton, Massachusetts (1902), are illustrated.

9. Charles L. Freer to Mather, June 28, 1898, Archives of the Freer Gallery of Art, Smithsonian Institution, Washington, D.C.

10. These houses included first a small cottage (1901) for Hutcheson on the grounds of another Platt estate, North Farm (1902), for Howard L. Clark at Bristol, Rhode Island, and Villasera (1903–6), a country house nearby in Warren, Rhode Island, built after the Reverend Hutcheson married Mrs. John Waterman. For further information on these and other Platt projects, consult: *Monograph of the Work of Charles A. Platt with an Introduction by Royal Cortissoz* (New York: Architectural Book Publishing Company, 1913; student edition, 1925); and Keith N. Morgan, *Charles A. Platt: The Artist as Architect* (New York and Cambridge: The Architectural History Foundation, Inc., and MIT Press, 1985).

11. The Reverend Joseph Hutcheson to Man-

ning, not dated but bound into the notebooks between letters of January 4 and February 11, 1907. William Gwinn Mather Papers, Gwinn Archives, Cleveland, Ohio, file I-1.

12. Manning to Mather, February 11, 1907, ibid. The other architects that Manning recommended in this letter include McKim, Mead & White; Carrère & Hastings; Wilson Eyre; Cope & Stewardson; and Howard Van Doren Shaw.

13. Mather to Charles A. Platt, March 1, 1907, ibid.

14. Mather to Platt, March 22, 1907, ibid.

15. Mather to Platt, April 27, 1907, ibid.

16. Platt to Mather, May 1, 1907, ibid., file I-2. Platt also responded to Mather's inquiry concerning the purchase of additional land south of Lake Shore Boulevard for the possible accommodation of stables and vegetable gardens.

17. Mather to Platt, May 3, 1907, ibid.

18. While Gwinn was under construction, Samuel Mather was building a large town house (1906–10) on Euclid Avenue in Cleveland to designs of local architect Charles Schweinfurth. See Mary Peale Schofield, *Landmark Architecture of Cleveland* (Pittsburgh: Ober Park Associates, Inc., 1976), 124. This house was one of the last large houses to be built on Euclid Avenue.

19. The second and larger lakefront project would be Villa Turicum, the country place of Harold and Edith Rockefeller McCormick at Lake Forest, Illinois (1908–18). All three lakefront estates are discussed in: Phil M. Riley, "The Spirit of the Renaissance on the Great Lakes. Three Mid-Western Homes, designed by Charles A. Platt," *Country Life* 12 (September 1912): 28–30.

20. Mather to Manning, May 28, 1907; Manning to Mather, June 1, 1907, William Gwinn Mather Papers, Gwinn Archives, Cleveland, Ohio, file I-2.

21. Platt to Mather, May 17, 1907, ibid. The house contained 177,000 cubic feet at this point.

22. Mather to Platt, June 11, 1907, ibid. To decrease expenses, Mather delayed the completion of a basement-level billiard room. It is important to remember that Mather was a bachelor with another house on Euclid Avenue in Cleveland and proposed to share this country house with a maiden half sister.

23. The concern for the comfort of his servants corresponds to the provisions Mather made for innovative medical and social services for the mine workers of the Cleveland-Cliffs Iron Company (see note 2 above). In his next letter, June 5, 1907, Mather returned to the spatial needs of the servants, demanding that the hallways in the service wing be at least three-feet, six-inches wide and their bedrooms at least twelve-by-twelve feet, plus closet space.

24. Platt to Mather, July 12, 1907, William Gwinn Mather Papers, Gwinn Archives, Cleveland, Ohio, file I-3. Platt reported: "The plans of your house are now completed and the specifications are very nearly done. . . ."

25. Mather complained about too many rooms downstairs in a letter of June 11, 1907, and even proposed making one downstairs room into a bedroom. Platt advised against this change and slowly convinced his client that the original plan had merit.

26. For a further discussion of the Platt office personnel and structure, see Morgan, *Charles A. Platt*, 73–77.

27. These architects were Abram Garfield from June 1907 through April 1908, Dercum & Beer in 1910, and Bohnard & Parson in 1911. William Gwinn Mather Papers, Gwinn Archives, Cleveland, Ohio, passim.

28. Throughout 1914, Platt, Mather, and Shipman corresponded about landscape problems. Shipman was primarily concerned with the formal garden. Mather had been dissatisfied with the color coordination and the inconsistency of bloom throughout the growing season. Shipman was a nationally recognized expert in plant material and the color relationship of plants. See also the monograph by Robin Karson on the gardens of Gwinn and the forthcoming book by Judith Tankard on Ellen Shipman.

29. J. Alden Twachtman, the son of Platt's friend John Twachtman, was commissioned to paint murals in a Pompeiian manner for the teahouse. Platt had used similar murals in garden buildings at his own house in Cornish and at Faulkner Farm, the Charles F. Sprague residence in Brookline, Massachusetts, 1897–98. Platt and Paul Manship became friends in the early 1910s when Platt first saw and admired Manship's work. He commissioned Manship to execute six statues for his gardens at Villa Turicum, the McCormick estate in Lake Forest, Illinois, and convinced Mather to hire Manship for this vase. The allegorical decoration of this vase shows warfare among Native Americans, a theme that seems to have no particular relevance to Gwinn. The vase was placed on steel roller bearings so that it can be turned.

30. Mather to Platt, July 18, 1907, William Gwinn Mather Papers, Gwinn Archives, Cleveland, Ohio, file I-3.

31. Robert C. Dunbar, Platt's site supervisor, to Mather, January 13, 1909. Here and elsewhere the specific contractors and their responsibilities are detailed. Ibid., file E-4.

32. A bill dated February 15, 1908, details purchases in the amount of $23,590.75 made by Platt for Mather in Europe. Objects were being sent to

Cleveland from Paris (the source for approximately half of the goods), Venice, Bologna, Florence, and Naples. The range of objects included furniture, ceramics, fireplace hardware, and paintings. William Gwinn Mather Papers, Gwinn Archives, Cleveland, Ohio, file E-2.

33. Platt to Mather, May 12, 1908, ibid., file E-3. Platt also recommended that Mather hang plain papers in the upstairs bedrooms.

34. Invoice of Emil Feffercorn to William Mather, April 29, 1909, lists all of the projects, room by room, and the expenses for interior decoration to date.

35. The portrait of Cotton Mather is a copy of one in the collection of Harvard University. Letter from Lucy Ireland to author, February 17, 1994.

36. Accompanying his letter to Mather of February 14, 1907, Platt includes a list of all the objects he had purchased in Europe. In Paris, he secured one unidentified painting from a dealer named Philibes and a portrait of a young girl from Tedeschi in Florence. Venice was more lucrative, producing one painting of the School of Canaletto from Piccoli, two copies after Longhi and a portrait of an old man from Salvadori, and two pictures of the School of Longhi and a portrait of Francis I from Castallan. The portrait of Francis I was appraised at $2,500; all of the other pictures were valued at $500 or less, indicating their role as decorative objects rather than as fine works of art. William Gwinn Mather Papers, Gwinn Archives, Cleveland, Ohio, file E-2.

37. In a letter of August 3, 1910, Mather announced the arrival of "the Marieschi painting from Ongania of Venice, being the one of which you saw a photograph." He also reported that another "picture from Barozzi of Venice is not yet here." He continued: "I thank you very much for the photographs of the Italian gardens. They are charming, and I wish again particularly to express my appreciation of your kindness in giving me the beautiful specimen of your own etching." Ibid., file E-7. The Mathers ultimately acquired twenty-nine etchings and four lithographs by Platt.

38. Herbert Croly signed the editorial with one of his common pseudonyms, A. C. David. "New Phases of American Domestic Architecture," the Architectural Record 26 (November 1909): 309–12. "The House of William G. Mather: Charles A. Platt, Architect," 313–20, was probably written by Croly as well, although it is unsigned.

39. Croly, "New Phases," 311. This editorial contains many of the issues that Croly developed in his final chapter of The Promise of American Life (New York: The Macmillan Co., 1909).

40. "House of William G. Mather," 315.

41. For further information on Croly as an architectural critic, see David Levy, Herbert Croly of the New Republic (Princeton: Princeton University Press, 1985). Platt also wrote a brief memoir of Croly, entitled "Herbert Croly and Architecture," which appeared in the New Republic, 63, and was reprinted in the Architectural Record 68 (August 1930): 138.

42. Croly provided his own description of the property in an article, "A Small New Hampshire Garden," that appeared in House and Garden (May 1902): 199–204. Platt extended the service wing in 1902, converting the original kitchen into a dining room and adding a new kitchen beyond.

43. For a review of Platt's work in Cornish, see Keith N. Morgan, "Charles A. Platt's Houses and Gardens in Cornish, New Hampshire," The Magazine ANTIQUES 122 (July 1982): 117–29.

44. The Hutcheson house and other projects completed to date were featured in the first important assessment of Platt's work as an architect: Herbert Croly, "The Work of Charles A. Platt," Architectural Record 15 (March 1904): 181–244.

45. Villasera was demolished in the mid-1970s. A surviving house that is very similar to the design of Villasera is the country house that Platt designed for the literary critic John Jay Chapman, Sylvania, Barrytown, New York, 1904–9.

46. Since Ring made his fortune in lumber, he may have known Mather through business activities in the Upper Peninsula of Michigan. Ring may also have been a friend of Charles L. Freer, who mentions the Saginaw commission in one of his letters to Platt (Freer Correspondence, December 5, 1904. Freer Gallery of Art Archives, Washington, D.C.). The Ring house is now the Saginaw Art Museum. Its Platt-designed gardens have recently been replanted, and the drawing room has been refurnished to reflect the original intentions of Platt and the Rings.

47. Hermann Muthesius, Landhaus und garten in Amerika (Berlin, 1907), 199 and 216. This book follows the earlier study of British architecture published by Muthesius, a cultural officer of the German Embassy.

48. James D. Ireland moved to 923 East Superior Street in Duluth in 1914. The house on that site has since been demolished. Blueprints for the Platt house are preserved in the Gwinn Archives. James Ireland was the Duluth manager of the M. A. Hanna Mining Co. Platt would later design three commercial buildings in Cleveland for the Hanna family. The Irelands moved to Cleveland in 1918, and Mr. Ireland died in 1928. I am indebted to Patricia Maus of the Northeast Minnesota Historical Center and to Jill Fisher of the Duluth Planning Office for their assistance in documenting the Ireland house.

49. This occurrence was not the only time when the child of a Platt client commissioned Platt

to design a house. Mrs. H. Wendell Endicott commissioned Platt to design a country house (1931–34) for her in Dedham, Massachusetts. She had grown up in Maxwell Court, the Francis T. Maxwell residence (1901–3) that Platt designed at Rockville, Connecticut.

50. Platt added a garage to the property in 1922 and a new fountain in 1929. He also provided preliminary designs in 1923 for the development of land in The Highlands section of Seattle and unexecuted designs for a country house on Bainbridge Island, Washington, in 1926.

51. For a discussion of Platt's relationship with Charles Freer, see Keith N. Morgan, "The Patronage Matrix: Charles A. Platt, Architect, Charles L. Freer, Client," *Winterthur Portfolio* 17 (Summer/ Autumn 1982): 121–34.

52. For the most recent and thorough discussion of Charles Freer and his collection, see Thomas Lawton and Linda Merrill, *Freer: A Legacy of Art* (Washington, D.C.: Freer Gallery of Art, Smithsonian Institution in association with Harry N. Abrams, 1993).

53. Mather to Platt, March 7, 1914, William Gwinn Mather Papers, Gwinn Archives, Cleveland, Ohio, file B-1. Nothing resulted from the contact with the Cleveland Museum of Art.

54. Charles Lang Freer did not live to see his museum completed. He died in 1919 from congenital syphilis.

55. For these Freer commissions, see Morgan, "The Patronage Matrix."

SELECTED BIBLIOGRAPHY

⊷═◉═⊶

NOTE: For a more comprehensive bibliography, particularly as regards Platt's architectural projects, see Keith N. Morgan's Ph.D. dissertation cited below and the notes to his book, *Charles A. Platt: The Artist as Architect*. The footnotes to essays in this catalogue also contain valuable references.

Archival Sources

Archives of American Art, Smithsonian Institution, Washington, D.C. Dennis Miller Bunker Papers and Prints Division, New York Public Library, Charles A. Platt File.

The Century Association, New York, New York. Charles A. Platt Library.

Columbia University, New York, New York. Avery Architectural and Fine Arts Library, Charles A. Platt Collection.

Corcoran Gallery of Art, Washington, D.C. Archives, Platt Correspondence.

Cornell University Library, Ithaca, New York. Department of Manuscripts and University Archives, Ellen Shipman Papers.

Freer Gallery of Art, Washington, D.C. Archives, Charles L. Freer Papers.

Gwinn, Cleveland, Ohio. William Gwinn Mather Papers.

Library of Congress, Washington, D.C. Manuscript Division, Barry Faulkner Papers, Agnes E. Meyer Papers, and Frederick Law Olmsted Papers.

Papers of the Platt Office, Private Collection. Phillips Academy, Andover, Massachusetts. Archives, Thomas Cochran, James Sawyer, and Charles Platt Correspondence.

University of Illinois, Urbana, Illinois. Archives, David Kinley Papers.

Yale University, New Haven, Connecticut. Beinecke Library, Royal Cortissoz Papers, Charles A. Platt Letter File.

General Sources on Platt

American Academy of Arts and Letters. *Exhibition of the Works of Charles A. Platt*. New York: American Academy of Arts and Letters, 1938.

Anderson, Joan. "Charles A. Platt: Architect, Etcher, Painter." *International Studio* 82 (December 1925): 180–88.

Burlingham, Charles C. *Aunt Annie: Annie C. Hoe Platt, 1852–1887. A Sketch*. New York: published by the author, 1957.

——. "Reminiscences of Charles A. Platt." Typescript. Collection of the Charles A. Platt family.

A Circle of Friends: Art Colonies of Cornish and Dublin. Durham, New Hampshire: University Art Galleries, University of New Hampshire, and the Thorne-Sagendorph Art Gallery, Keene State College, 1985.

Cortissoz, Royal. "Appreciation." *Architecture* 68 (November 1933): 271. Also published in *Pencil Points* 14 (November 1933): 481ff., and *Architectural Forum* 59 (October 1933): 17.

——. "Charles A. Platt, FAIA, Etcher, Landscape Painter, Landscape Architect, Mural Painter, Architect." *Pencil Points* 14 (November 1933): 481.

——. "Charles A. Platt." *American Magazine of Art* 27 (July 1934): 383–89.

——. "Charles Adams Platt." *Architectural Forum* 70 (March 1939): 205.

Embury, Aymar. "Charles A. Platt. His Work." *Architecture* 26 (August 1912): 130–31.

Farley, James L. "The Cornish Colony." *Dartmouth College Library Bulletin* 14 (November 1973): 6–17.

Lay, Charles D. "An Interview with Charles Adams Platt." *Landscape Architecture* 2 (1911–1912): 127–31.

Merrill, Clement S. "Charles A. Platt, An Appreciation." *Architectural Record* 74 (November 1933): 338.

Monograph of the Work of Charles A. Platt with
an Introduction by Royal Cortissoz. New
York: The Architectural Book Publishing Co.,
1913.

Moore, Charles. "Charles A. Platt." Dictionary
of American Biography. New York: Charles
Scribner's Sons, 1935.

Morgan, Keith N. "The Architecture and Land-
scapes of Charles A. Platt (1861–1933)." Ph.D.
diss., Brown University, 1978.

———. "Charles A. Platt's Houses and Gardens in
Cornish, New Hampshire." The Magazine
ANTIQUES 122 (July 1982): 117–29.

———. "The Patronage Matrix. Charles A. Platt,
Architect, Charles L. Freer, Client." Winterthur
Portfolio 17 (Summer/Autumn 1982): 121–
34.

———. Charles A. Platt: The Artist as Architect.
New York: The Architectural History Founda-
tion, Inc.; Cambridge and London: The MIT
Press, 1985.

Platt, G. Lewis. The Platt Lineage. New York:
T. Whittaker, 1891.

"Portrait." American Architect 142 (November
1932): 30.

Van Buren, Deborah Elizabeth. "The Cornish
Colony: Expressions of Attachment to Place,
1885–1915." Ph.D. diss., The George Wash-
ington University, 1987.

Sources on Etchings

"And He Etches Too." New York Times, June 8,
1907.

Bruhn, Thomas P. American Etching: The 1880s.
Storrs, Conn.: The William Benton Museum of
Art, University of Connecticut, 1985.

Catalogue of an Exhibition of the Complete
Etched Work of C.A. Platt. New York: Her-
mann Wunderlich & Co., 1889.

Catalogue of an Exhibition of Etchings and Dry-
Points by C. A. Platt at Frederick Keppel and
Co., June 4 to June 29, 1907. Introduction by
Mrs. Schuyler Van Rensselaer. New York:
F. Keppel and Company, 1907.

Catalogue of the New York Etching Club Exhibi-
tion, 1882–1889. New York: New York Etch-
ing Club.

E. G. K. "Charles A. Platt and His Etchings."
Brooklyn Museum Quarterly 7 (April 1920):
96–103.

"Etchings of Charles A. Platt." Art in America 22
(June 1934): 110.

"Etchings by Charles A. Platt." Bulletin of the Art

Association of Indianapolis, John Herron Art
Institute (December 1925): 57–58.

"The Etchings of Charles A. Platt." Bulletin of the
Cleveland Museum of Art 7 (February 1920):
110.

Exhibition of American Etchings. Boston Muse-
um of Fine Arts, Print Department, 1881.

Exhibition of the Etched Work of Charles A. Platt.
New York: Grolier Club, 1925.

Hitchcock, James Ripley Wellman. Important
New Etchings by American Artists. Original
Etchings by C.A. Platt [and others]. New York:
Frederick A. Stokes and Brother, 1888.

Illustrierter Katalog der ersten Internationalen
Special [sic]—Ausstellung der Graphischen
Künste in Wien. Vienna: Verlag der Gesell-
schaft fur Vervielfaltigende Kunst, 1883.

Koehler, Sylvester R. "The Works of American
Etchers, 25—Charles A. Platt." American Art
Review 2 (1881): 150.

———. Etching: An Outline of its Technical
Processes and its History, with some remarks
on collectors and collecting. New York, Lon-
don, Paris, Melbourne: Cassell & Co. Ltd.,
1886.

"Library Holds Platt Exhibition." Art News 32
(January 27, 1934): 8.

Mandel, Patricia C. F. "A Look at the New York
Etching Club 1877–1894." Imprint 4 (April
1979): 31–35.

O'Brien, Maureen C. The New York Etching Club
1877–1894: American Etchings from the Col-
lection of William Frost Mobley. Montclair,
N.J.: The Montclair Art Museum. (Catalogue
for an exhibition held March 18 to April 29,
1979.) Introduction by Kathryn E. Gamble.

O'Brien, Maureen C., and Patricia C. F. Mandel.
The American Painter-Etcher Movement.
Southampton, New York: The Parrish Art
Museum, 1984.

Parrish, Maxfield, Jr. Stephen Parrish (1848–
1938). Boston: Vose Galleries, Inc., 1982.

Pennell, Joseph. The Adventures of an Illustrator.
Boston: Little, Brown and Company, 1925.

"Platt as Etcher." Art Digest 8 (February 1, 1934):
20.

A Publication by the New York Etching Club.
New York: New York Etching Club, 1891–93.

Rice, Richard A. A Descriptive Catalogue of the
Etched Works of Charles A. Platt. New York:
The DeVinne Press, 1889.

Sage, Dean. The Ristigouche and Its Salmon Fish-
ing. Edinburgh: David Douglass, 1888.

Schneider, Rona. "The American Etching Revival:
Its French Sources and Early Years." The
American Art Journal 14 (Autumn 1982).

———. The Quiet Interlude: American Etchings
of the Late Nineteenth Century. Amherst,

Mass.: Mead Art Center, Amherst College. (Catalogue for an exhibition held April 5 to May 6, 1984.)

Van Rensselaer, Marianna G. "American Etchers." *The Century Magazine* 25 (February 1883): 496.

Weitenkampf, Frank. "Charles Adams Platt — Etcher." *The Print Connoisseur* (April 1927): 87–91.

———. "Charles Adams Platt: Etcher." *Bulletin of the New York Public Library, Astor, Lenox and Tilden Foundations* 38 (January 1934): 17–19.

Wray, Henry R. *A Review of Etching in the United States.* Preface by Peter Moran. Philadelphia: R.C. Penfield, Publisher, 1893.

Sources on Painting

Fink, Lois Marie. *American Art at Nineteenth-Century Paris Salons.* Washington, D.C.: Smithsonian Institution, 1990.

Fink, Lois M., and Joshua C. Taylor. *Academy: The Academic Tradition in American Art.* Washington, D.C.: Smithsonian Institution Press, 1975.

Gammell, Ives. *Dennis M. Bunker.* New York: Coward-McCann, Inc., 1953.

Hirshler, Erica E. *Dennis Miller Bunker: American Impressionist.* Boston: Museum of Fine Arts, 1995.

Landgren, Marchal E. *Years of Art: The Story of the Art Students League of New York.* New York: R. M. McBride, 1940.

Sellin, David. *Americans in Brittany and Normandy, 1860–1910.* Phoenix: Phoenix Art Museum, 1982.

Stevenson, R. A. M. "The American Salon." *The Magazine of Art* 8 (1885): 518.

Stott, Annette. "American Painters Who Worked in the Netherlands, 1880–1914." Ph.D. diss., Boston University, 1986.

Weinberg, H. Barbara. *The Lure of Paris: Nineteenth-Century American Painters and Their French Teachers.* New York: Abbeville Press, 1991.

Sources on Landscape Architecture

André, Edouard. *L'art des jardins: traité generale de la composition des parcs et jardins.* Paris, 1879.

Baker, John Cordis, ed. *American Country Houses and Their Gardens.* Philadelphia: House & Garden, 1906.

Caffin, Charles H. "Formal Gardens and a New England Example." *Harpers New Monthly Magazine* 99 (September 1899): 557–65.

Cram, Ralph A. "Faulkner Farm, Brookline, Massachusetts." *House and Garden* 1 (August 1901): 1–11.

———. "The Sculptures of Faulkner Farm." *House and Garden* 1 (September 1901): 1–10.

Croly, Herbert. "The House and Garden of Mr. Charles A. Platt." *House and Garden* 1 (December 1901): 10–17.

———. "A Small New Hampshire Garden." *House and Garden* (May 1902): 199–204.

Davidson, Rebecca W. "Images and Ideas of the Italian Garden in American Landscape Architecture." Ph.D. diss., Cornell University, 1994.

Downing, A. J. *A Treatise on the Theory and Practice of Landscape Gardening, Adapted to North America.* 6th ed. New York and London: Wiley and Putnam, 1859, 46–47.

Duncan, Frances. "The Gardens of Cornish." *The Century Magazine* 72 (May 1906): 3–19.

Elwood, Philip H. *American Landscape Architecture.* New York: The Architectural Book Publishing Co., 1924.

Emmet, Alan. "Faulkner Farm: An Italian Garden in Massachusetts." *Journal of Garden History* 6 (April–June 1986): 162–78.

Ferree, Barr. *American Estates and Gardens.* New York: Munn & Co., 1904.

Fisher, Brooke. "Faulkner Farm." *The New England Magazine,* n.s., 25 (January 1902): 577–88.

Griswold, Mac, and Eleanor Weller. *The Golden Age of American Gardens: Proud Owners, Private Estates, 1890–1940.* New York: Harry N. Abrams, Inc., 1991.

Howe, Samuel. "The Garden Work of Charles A. Platt." *American Architecture* 101 (May 1, 1912): 198–201.

———. "American Homes and Gardens: The Weld Garden, Brookline, Massachusetts." *Country Life* 43 (May 18, 1918): 466–68.

Karson, Robin. "Gwinn: A Collaborative Design by Charles A. Platt and Warren H. Manning." *Journal of the New England Garden History Society* 3 (Fall 1993): 23–33.

———. *Gwinn: An American Garden.* Portland, Oreg.: Timber Press and Sagapress, Inc., for the Library of American Landscape History, forthcoming.

Kenworthy, Richard G. "Published Records of Italianate Gardens in America." *Journal of Garden History* 10 (January–March 1990): 31–34.

———. "Bringing the World to Brookline: The Gardens of Larz and Isabel Anderson." *Journal of Garden History* 11 (October–December 1991): 224–41.

Lowell, Guy. *American Gardens*. Boston: Bates & Guild, 1902.

Miller, Wilhelm. "An 'Italian Garden' That is Full of Flowers." *Country Life in America* 7 (March 1905): 491–92.

Muthesius, Hermann. *Landhaus und garten in Amerika*. Berlin, 1907.

"The New Hampshire Garden of Charles A. Platt, Designed for Its Cornish Site by Its Architect Owner." *House and Garden* 45 (April 1924): 66–67.

Newton, Norman T. *Design on the Land: The Development of Landscape Architecture*. Cambridge: Harvard University Press, 1971.

Nichols, Rose Standish. "A Hilltop Garden in New Hampshire." *The House Beautiful* 55 (March 1924): 237.

"An Orchard Garden: The Estate of Rev. Mr. Joseph Hutcheson at Warren, Rhode Island." *Architectural Record* 20 (October 1906): 269–80.

Platt, Charles A. "Italian Gardens." *Harpers Magazine* 87 (July 1893): 165–80; (August 1893): 393–406.

———. *Italian Gardens*. New York: Harper Brothers, 1894. New edition published by Sagapress, Inc., and Timber Press, 1993, with an overview essay by Keith N. Morgan.

———. "A Renaissance Villa near Rome: Villa Costanzi, with Photograph and Sketch Plan by Charles A. Platt." *Architectural Review* 3 (November 1915): 93–95.

Pray, James Sturgis. "The Italian Garden." *American Architect and Building News* 67 (February 10, 1900): 43–45; (February 17, 1900): 51–52; (March 17, 1900): 83–85; (March 24, 1900): 91–92.

Roper, Laura W. *FLO: A Biography of Frederick Law Olmsted*. Baltimore: Johns Hopkins University Press, 1973.

Shelton, Louise. *Beautiful Gardens in America*. Rev. ed. New York: Charles Scribner's Sons, 1924; orig. pub. 1915.

Tankard, Judith B. *Ellen Shipman* [working title]. Sagaponack, N.Y.: Sagapress, Inc., in association with the Library of American Landscape History, forthcoming.

Van Rensselaer, Mariana G. *Art Out-of-Doors: Hints on Good Taste in Gardening*. New York: Charles Scribner's Sons, 1893. New and enlarged edition, 1925.

Visentini, Margherita Azzi. "The Italian Garden in America: 1890s–1920s." In *The Italian Presence in American Art 1860–1920*, edited by Irma B. Jaffe. New York: Fordham University Press, 1992.

"Weld: A Formal Garden." *Architecture* 19 (1909): 56.

Wharton, Edith. *Italian Villas and Their Gardens*. New York: The Century Co., 1905.

Sources on Architecture

"As He is Known, Being Brief Sketches of Contemporary Members of the Architectural Profession." *Brickbuilder* 24 (1915): 316.

Aslet, Clive. *The American Country House*. New Haven and London: Yale University Press, 1990.

"Astor Court Apartments. Broadway, 89th to 90th Street, New York." *Architecture* 34 (1916): 134–45.

"Astor Court Apartments, New York." *American Architect* 110 (November 29, 1916): 331.

"A Contemporary Westover: The Residence of Mr. George T. Palmer, New London, Connecticut." *Architectural Record* 22 (September 1907): 288–98.

"A Cornish House and Garden." *Architectural Record* 22 (September 1907): 288–98.

Cortissoz, Royal. "National Gallery of Art." *Magazine of Art* 16 (March 1925): 115–20.

"Country House of F. M. Weld, Esquire, Huntington, Long Island." *American Architect* 108 (July 7, 1915): 2063.

"The Country Place of George L. Nichols, Esquire." *Architectural Record* 29 (April 1911): 310–17.

Croly, Herbert. "The Contemporary New York Residence." *Architectural Record* 12 (December 1902): 707–22.

———. [A. C. David, pseud.]. "A Co-operative Studio Building." *Architectural Record* 14 (October 1903): 233–54.

———. "The Architectural Work of Charles A. Platt." *Architectural Record* 15 (March 1904): 181–244.

———. "The American Country Estate." *Architectural Record* 17 (July 1905): 1–7.

———. "House for Mr. Norman Hapgood." *Architectural Record* 18 (1905).

———. [William Herbert, pseud.]. *Houses for Town and Country*. New York: Dupfield and Co., 1907.

———. [A. C. David, pseud.]. "A Cooperative Apartment House in New York, Designed by Charles A. Platt." *Architectural Review* 24 (July 1908): 16.

———. "English Renaissance at Its Best: The House of James Parmalee of Washington, D.C." *Architectural Record* 36 (August 1914): 81–97.

———. "A Waterfront Villa: The House of Russell A. Alger, Jr." *Architectural Record* 36 (December 1914): 481–86.

———. "Pidgeon Hill, Residence of Meredith Hare, Huntington, Long Island." *Architectural Record* 48 (September 1920): 178–91.

Dahler, Jerauld. "Charcoal Studies from the Office of Charles A. Platt." *Architecture* 31 (1915): 125–39, 147–61.

Desmond, Harry W., and Herbert Croly. *Stately Homes in America: From Colonial Times to the Present.* New York: D. Appleton and Company, 1905.

"'Dingleton House,' Cornish, N.H.: Mr. Charles A. Platt, Architect." *American Architect* 101, no. 1898 (May 8, 1912).

Dow, Joy Wheeler. *American Renaissance. A Review of Domestic Architecture.* New York: T. Comstock, 1904.

Edgell, G. H. *The American Architecture of Today.* New York: Charles Scribner's Sons, 1928.

"The Freer Gallery of Art, Washington, D.C.: Charles A. Platt, Architect." *Architecture* 48 (September 1923): 293–97.

"Gymnasium for University of Illinois, Urbana, Illinois." *American Architect* 132 (October 20, 1927): 541–44.

"The Hanna Building and Annex, Cleveland, Ohio." *Architectural Record* 101 (January 1922): 16–22.

Hewitt, Mark Alan. *The Architect and the American Country House.* New Haven and London: Yale University Press, 1990.

"'High Court,' Near Windsor, Vermont — Designed by Charles A. Platt, Architect." *House and Garden* 2 (September 1902): 413–15.

"A House at Bryn Mawr, Pennsylvania." *Architectural Record* 32 (October 1912): 280–86.

"House at Clifford V. Brokaw." *Architectural Record* 40 (October 1916): 383–85.

"The House of Frederick S. Lee. New York City." *Architectural Record* 20 (November 1906): 427–36.

"The House and Garden of Mr. F. C. Culver." *Architectural Record* 20 (October 1906): 335–40.

"House of Henry Howard, Esquire, Brookline, Massachusetts." *American Architect and Building News* 93 (April 29, 1908): 145.

"House, John T. Pratt, 7 East 61st Street, New York." *Architecture* 35 (June 1917): 95–101.

"The House of Mr. J. J. Chapman at Barrytown, New York." *Architectural Record* 24 (September 1908): 207–17.

"A House at Mt. Kisco, New York." *Architectural Forum* 33 (1920): 123–30.

"House of M. Slade at Mt. Kisco." *Architectural Record* 22 (September 1907): 261–71.

"The House of William G. Mather." *Architectural Record* 26 (November 1909): 313–20.

"The House of William Maxwell, Rockville, Conn." *Architectural Review* 26 (December 1909): 12.

"Interiors." *American Architect* 102 (July 31, 1912): 1910.

Klauder, Charles Z., and Herbert C. Wise. *College Architecture in America.* New York: Charles Scribner's Sons, 1929.

"The Knickerbocker Building, New York." *Architecture and Building* 53 (November 1921): 88–89.

Lash, Joseph P. *Eleanor and Franklin.* New York: W. W. Norton & Co., 1971.

Lawton, Thomas, and Linda Merrill. *Freer: A Legacy of Art.* Washington, D.C.: Freer Gallery of Art, Smithsonian Institution; New York: H. N. Abrams, 1993.

"The Leader-News Building, Cleveland, Ohio." *Architectural Record* 33 (June 1913): 501–17.

Litchfield, Electus D. "Cooperative Apartments." *Architectural Forum* 53 (September 1930): 313.

"The Manor House: Estate of John T. Pratt." *Architectural Record* 46 (October 1919): 296–97.

"The Manor House, Glen Cove, Long Island." *Brickbuilder* 21 (1912): 1–3.

Meyer, Agnes E. *Charles Lang Freer and His Gallery.* Washington, D.C.: Freer Gallery of Art, 1970.

Morgan, Keith N. "Charles Platt's Designs for the Corcoran Gallery Additions." *The William A. Clark Collection.* Washington, D.C.: Corcoran Gallery of Art, 1978.

Mumford, Lewis. "The Sky Line, Medals and Mentions." *The New Yorker* (April 16, 1932): 36–38.

Patterson, Augusta Owen. *American Homes of To-Day: Their Architectural Style, Their Environment, Their Characteristics.* New York: The Macmillan Co., 1924.

Platt, Charles A. "Villa." In *A Dictionary of Architecture and Building*, edited by Russell Sturgis. New York: The Macmillan Co., 1901.

———. "Foreword." In *Interior Architecture: The Design of Interiors of Modern American Homes*, R. W. Sexton. New York: Architectural Book Publishing Company, 1927).

———. "Herbert Croly and Architecture." *Architectural Record* 68 (August 1930): 138. (First published in *New Republic* 63.)

"The Renaissance Villa of Italy Developed into a

Complete Residential Type for Use in America." *Architectural Record* 31 (March 1912): 201–25.

"Residence, 844 Fifth Avenue, New York." *Architectural Record* 21 (June 1907): 467–72.

"Residence of W. Hinckle Smith, Esquire." *Architectural Record* 32 (1912): 280–86.

Riley, Phil M. "The Spirit of the Renaissance on the Great Lakes. Three Mid-Western Homes, designed by Charles A. Platt." *Country Life* 12 (September 1912): 28–30.

Smith, Hugh A. *The University of Rochester: A Story of Expansion and Its Background.* Rochester, New York: University of Rochester, 1930.

"Studio Apartments." *Architectural Review* 16 (1908): 13–14, 16–18, 19–22.

Tallmadge, Thomas E. *The Story of Architecture in America.* New York: W. W. Norton and Co., 1927.

Tilton, Leon D., and Thomas E. O'Donnell. *History of the Growth and Development of the Campus of the University of Illinois.* Urbana, Illinois: University of Illinois Press, 1930.

University of Illinois. *The Library Building.* Urbana, Illinois: University of Illinois Press, 1929.

"Vincent Astor Apartments, New York City: Charles A. Platt, Architect." *Architectural Record* 67 (March 1930): 220–21.

"Vista from an Architect's Studio." *Architectural Review* 34 (August 1913): 9.

"Where We Get Our Ideas of Country Places in America, Prepared from an Interview with Charles A. Platt." *Outing* 44 (June 1904): 352.

"Work by Charles A. Platt." *American Architect* 101 (May 8, 1912): 1898.

Yarnall, Sophia. "Box Hill, the Estate of A. J. Drexel Paul, Esquire." *Country Life* 72 (October 1937): 62–68.

Sources on Cultural History

Bender, Thomas. *New York Intellect.* New York: Alfred A. Knopf, 1987; Baltimore: Johns Hopkins University Press, 1988.

The Brooklyn Museum. *The American Renaissance, 1876–1917.* Brooklyn: The Brooklyn Museum, 1979.

Clark, Eliot. *History of the National Academy of Design 1825–1953.* New York: Columbia University Press, 1954.

Croly, Herbert. *The Promise of American Life.* New York: The Macmillan Co., 1909; Indianapolis: The Bobbs-Merrill Co., 1965.

Delano, Warren. *The Century, 1847–1946.* New York: The Century Association, 1947.

Duffus, Robert L. *The American Renaissance.* New York: Alfred A. Knopf, 1928.

Hawes, Elizabeth. *New York, New York: How the Apartment House Transformed the Life of the City (1869–1930).* New York: Alfred A. Knopf, 1993.

Hills, Patricia. *Turn-of-the-Century America.* New York: Whitney Museum of American Art, 1977.

Kavaler, Lucy. *The Astors: A Family Chronicle of Pomp and Power.* New York: Dodd, Mead & Co., 1966.

Levy, David. *Herbert Croly of the New Republic.* Princeton: Princeton University Press, 1985.

Rhoads, William B. *The Colonial Revival.* New York and London: Garland Publishing, 1977.

Saint-Gaudens, Augustus. *The Reminiscences of Augustus Saint-Gaudens.* New York: The Century Co., 1913.

Stebbins, Theodore E., Jr. Introduction to the exhibition catalogue, *The Lure of Italy: American Artists and the Italian Experience, 1760–1914.* Boston: Museum of Fine Arts; New York: Harry N. Abrams, Inc., 1992.

Stern, Robert. *New York 1900.* New York: Rizzoli International, 1983, 226–45.

———. *New York 1930.* New York: Rizzoli International, 1987.

Tauranac, John, and Christopher Little. *Elegant New York: The Builders and the Buildings.* New York: Abbeville Press, 1985.

"Vincent Astor—Landlord." *Architectural Forum* 61 (July 1934): 73–75.

Wade, Hugh Mason. *A Brief History of Cornish, 1763–1974.* Hanover, New Hampshire: University Press of New England, 1975.

Yegül, Fikret. *Gentlemen of Instinct and Breeding. Architecture at the American Academy in Rome, 1894–1940.* New York and Oxford, England: Oxford University Press, 1991.

PHOTO CREDITS

⟡

Walter P. Browning: fig. 6.7

Cathy Carver: fig. 2.16

Richard Cheek: figs. 1.1, 1.4, 1.6, 1.10, 1.22, 5.8, 5.13, 5.15, 6.12, 6.13

Geoffrey Clements: fig. 3.14

Mick Hales: book frontispiece

Greg Heins: fig. 2.14

Helga Photo Studio: fig. 3.21

Richard Hurley: fig. 2.7

John Marcy, Northampton Photographic Arts: fig. 1.15

Museum of Fine Arts, Boston: fig. 3.15

Jeffrey Nintzel: figs. 1.2, 1.3, 1.7, 2.1, 2.5, 2.6, 2.29, 3.4, 3.7, 3.8, 3.11, 3.12, 3.19, 3.24, 4.1 (and cover), 4.2, 4.4, 4.7, 4.8, 4.11, 4.13, 4.14, 5.4, 5.5, 5.12, 6.5, 6.11, 6.17, 6.18; cat. nos. 33, 52

Dwight Primiano Photography: fig. 1.13

Redlich Photography: fig. 3.2

Tony Rinaldo: fig. 3.16

Alajos Schuszler: fig. 5.3

Unless otherwise noted in captions, all other photographs are provided by and reproduced with permission of the lender.

INDEX